BIRDS OF THE WORLD
Photographs by Gilles Martin

To Houria

BIRDS OF THE WORLD

Photographs by Gilles Martin

Text by Myriam Baran

Translated from the French by Simon Jones

Harry N. Abrams, Inc., Publishers

Contents

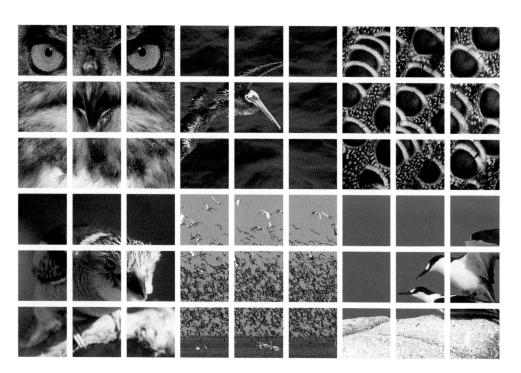

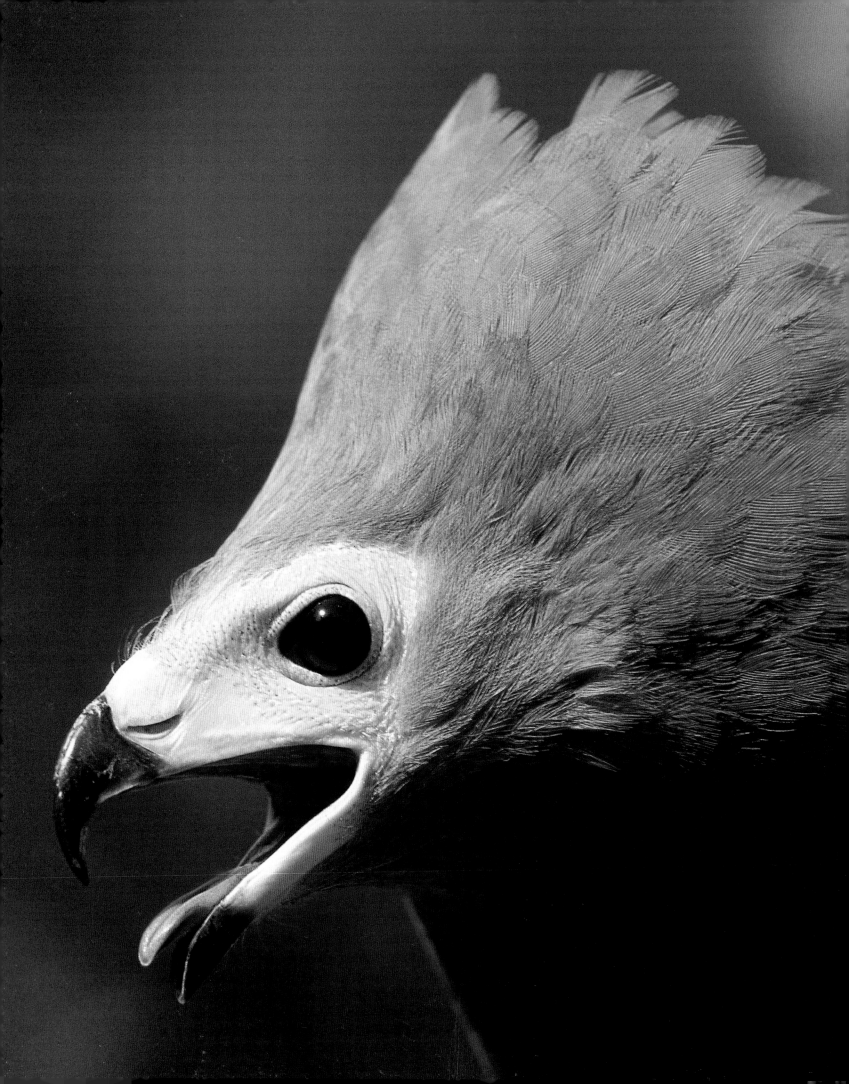

Preface

Here is a book that reads like a journey. It is an *Alice in Wonderland*, filled with representatives of the world's some 10,000 wonders. It explores all habitats, from high mountains to vast oceans, from the polar ice caps to the dense equatorial jungle. It is a voyage to the heart of the world of birds that along the way acquaints us with some charismatic characters—some with beauty, others with intriguing behavior, and still others with astonishing abilities.

This book describes all this and more. It is a poem dedicated to the ineffable beauty of the winged kingdom, an ode to its wild riches and astonishing uniqueness, all seen through the eye of the photographer, who captures both intimate detail and the big picture.

This is the first time that a single photographer has created such a huge collection, with specimens from more than forty countries and all the continents. Gilles Martin worked at all latitudes and in all climates, from winter temperatures on the Japanese island of Hokkaido of 23 °F (31 °C) below zero to a summery 104 °F (40 °C) in Australia's Simpson Desert. He spent thousands of hours in various blinds waiting for his subjects to appear, and he was always amazed by what he saw in his lens. Twenty-four years of work stands between the shooting of the first photo and the last.

Perseverance, tenacity, and ingenuity have been the watchwords of this work from long distance, for the feathered tribe often plays hard to get. Sometimes it is necessary to steal its little secrets. Gilles Martin traveled the world armed with a whole arsenal of homemade equipment, such as floating blinds and little robots. But what excitement when he was able to capture a grebe furtively laying its egg! Such moments achieve a rare intensity, and they erase the memory of the disappointments that inevitably punctuate the life of a wildlife photographer.

Allow yourself to be enraptured by the magic of Gilles Martin's images, which the pen of Myriam Baran brings to life—the pen of an ethologist and naturalist, which reveals the many secret faces of these jewels of nature. So close to us and yet so far away, they never fail to fascinate.

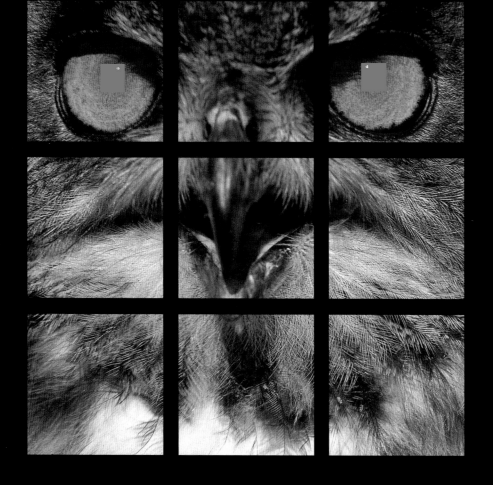

From *T. rex* to the Hummingbird

In the beginning were the dinosaurs. These Jurassic-period monsters, whose name is derived from the Greek for "terrible lizard," were not content merely to make the earth quake beneath their step. Before fading away forever into the mists of a distant past, they produced a true marvel of delicacy and technology—the hummingbird. The colossal *Tyrannosaurus rex* is the forefather of the gentle dove and of the other nearly 10,000 known species of birds.

It seems that in order to regulate their body temperature, certain reptiles were quick to exchange their scales for feathers. With this job done, they were able to venture into the air. Exactly how they achieved flight is unknown. Perhaps they spread their forelimbs to keep their balance while running fast, or maybe they glided from branch to branch or used these limbs to break their fall when jumping from trees down to the ground.

Archaeopteryx, which lived at a time when the continents still formed a single mass, is the oldest known winged creature. Regarded as the missing link between reptiles and birds, it shares features with both classes.

The closest *Archaeopteryx* descendants didn't manage to master the art of flying for many more years, during the much more recent Cretaceous period. Having pulled off the tremendous feat of conquering the air, they diversified in all directions. Though all have two legs, two wings, a bill, and feathers, birds in their astonishing variety have been immensely successful in colonizing the planet. No habitat is beyond their reach. From the heart of the oceans to the highest reaches of the atmosphere, they are everywhere, and everywhere their readiness to adapt is fascinating. In this capacity, birds owe much to a truly extraordinary ability, one humans have envied since the dawn of time: the power of flight.

The first person to speculate that birds were directly descended from reptiles was Thomas Huxley, at the end of the nineteenth century. To back up his assertion, he compiled a detailed study of the hind limbs of a megalosaurus and an ostrich that revealed thirty-five features common to the two. As it turns out, however, and contrary to what all logic might suggest, the ancestors of birds are not the pterosaurs. These flying reptiles of the Jurassic period became extinct at the same time as all other dinosaurs, and they left no descendants. This is what is known as an evolutionary cul-de-sac. Birds are in fact descended from theropods, a group whose most fearsome member was unquestionably the ferocious *Tyrannosaurus rex.*

Theropods and birds share a number of features, the most important being U-shaped clavicles, a diagnostic feature that confirms parentage. This small bone, part of the articulation of the shoulder, is known in birds as the wishbone. In these dinosaurs, it supported the short forelimbs

with which theropods caught their prey. It played a crucial role in their descendants' development of the power of flight. Apart from this wishbone, theropods display several other avian characteristics. They walked on two legs, had hollow bones, and laid eggs with shells. Some even had warm blood and feathers, which are after all nothing more than modified scales.

The theory of natural selection applies to the transformation of dinosaurs into birds. The theory states that, over time, individuals belonging to a given species show changes in their bodies or behavior. The struggle for survival acts as a sorting process, eliminating the individuals that perform less well. On the other hand, any mutation that improves the chance of survival is rapidly propagated, and the individuals that carry it are more successful at all levels, including that of reproduction. Natural selection thus favors a continuous process of adaptation. The acquisition of the power of flight does not only allow rapid movement—it is a self-defense strategy that offers great safety in an exclusively terrestrial world. Flight makes it possible to roost or lay eggs in the treetops, or in other places safe from predators that operate on the ground. New sources of food, such as flying insects and fish swimming near the water's surface, become accessible. All this confers an immense evolutionary advantage on the individuals in possession of such prowess—an advantage their innumerable descendants have used to good effect.

Feathers Make the Bird

Since feathers made their appearance before any creature could actually fly, they clearly served other purposes on their way to becoming the main tool for this mode of locomotion. Initially, their purpose was probably to conserve body heat in changing weather conditions. They may also have helped in camouflage, or, on the contrary, acted as ceremonial dress to attract sexual partners.

Having acquired their covering of feathers, all that remained for the theropods was to attempt flight. How they did so remains a mystery. The various theories fall into two main groups: either they spread their forelimbs while running fast, thus relieving themselves of some weight, or they learned to soften their landing when jumping down from the branches of trees they had climbed.

From these lengthened leaps, these ancestors of birds gradually acquired the power of flight through the transformation of the bones of their forepaws, which fused over time to form a wing. Their front legs slowly lost their prehensile function and were devoted exclusively to movement. Their feathers lengthened and grew stronger, providing the greatest surface area for the least weight and thus maximizing lift. Bones became lighter, as did the tail, which became shorter and covered with feathers, acting as a balancing aid.

Of Feathers and Scales

Just as the theropods had many avian features, at the other end of the scale, we find that present-day birds retain many reptilian characteristics, such as scaly feet, horny bills, and the appendages of colored skin that adorn many of their heads.

The first known bird is the famous *Archaeopteryx*, of which only four more or less complete skeletons have ever been discovered, all in a Bavarian limestone quarry in the mid-nineteenth

Opposite

Whooper swan

Cygnus cygnus

Hokkaido, Japan

The strong bond of a pair that mates for life is the best survival strategy for this species, which inhabits the far north and waits on average until the age of five before breeding. The family remains together for a whole year to give the young their best chance of survival in a climate where summer makes only a brief appearance. Immature birds stand out because of their gray plumage.

Pages 12 and 13

Franklin's gull

Larus pipixcan

Pisco, Peru

The gull family is found all over the world, perfectly illustrating the success birds have enjoyed as colonizers. Gulls adapt to all environments, including those dominated by human activity, such as refuse dumps, where they find plentiful food.

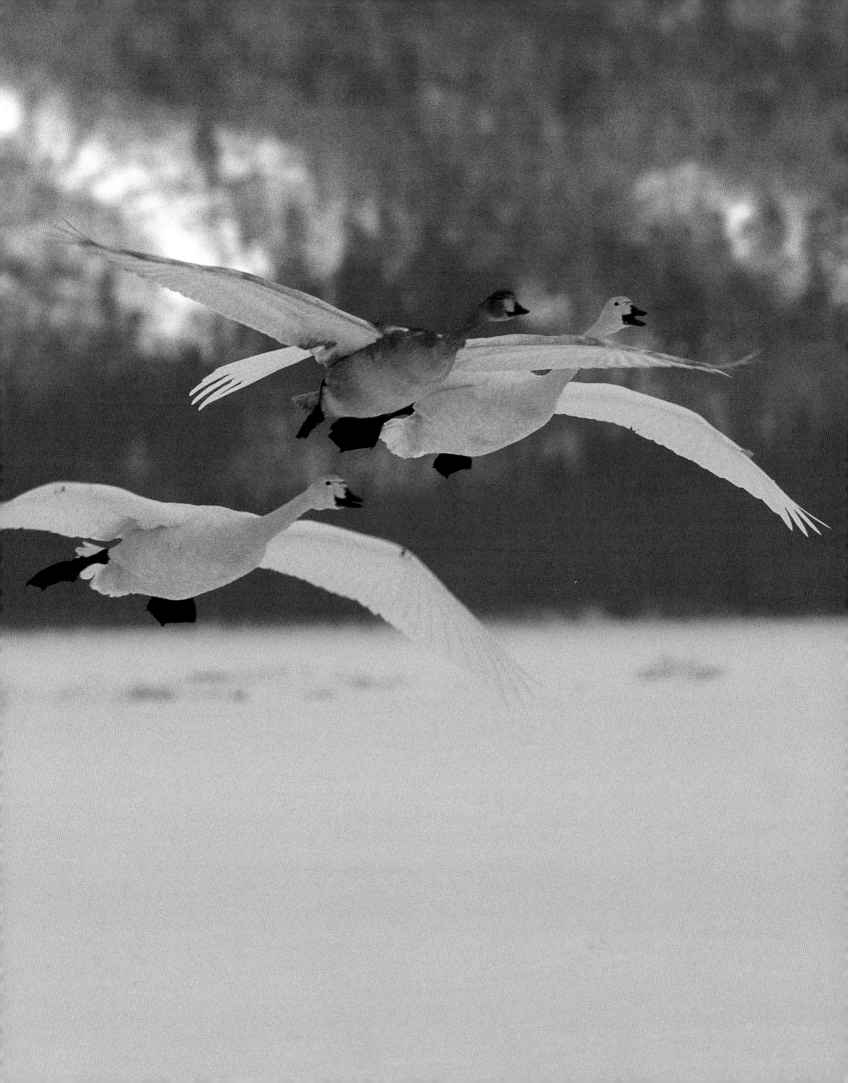

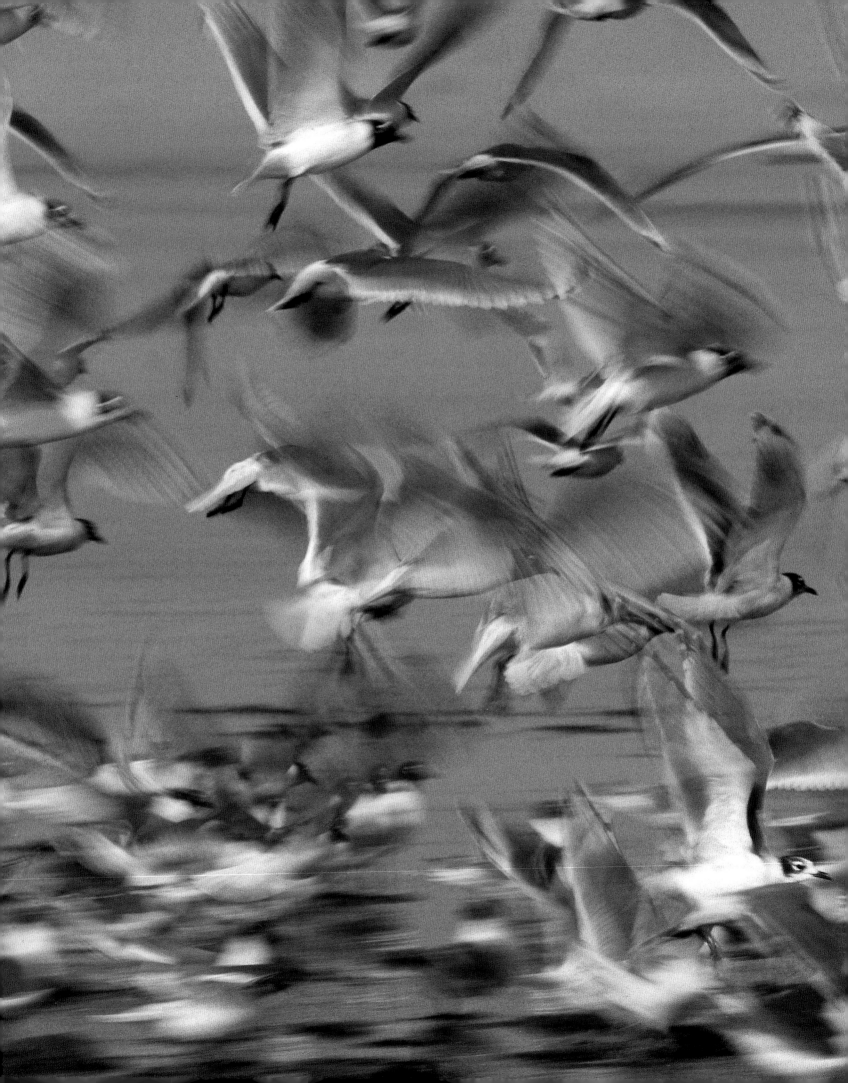

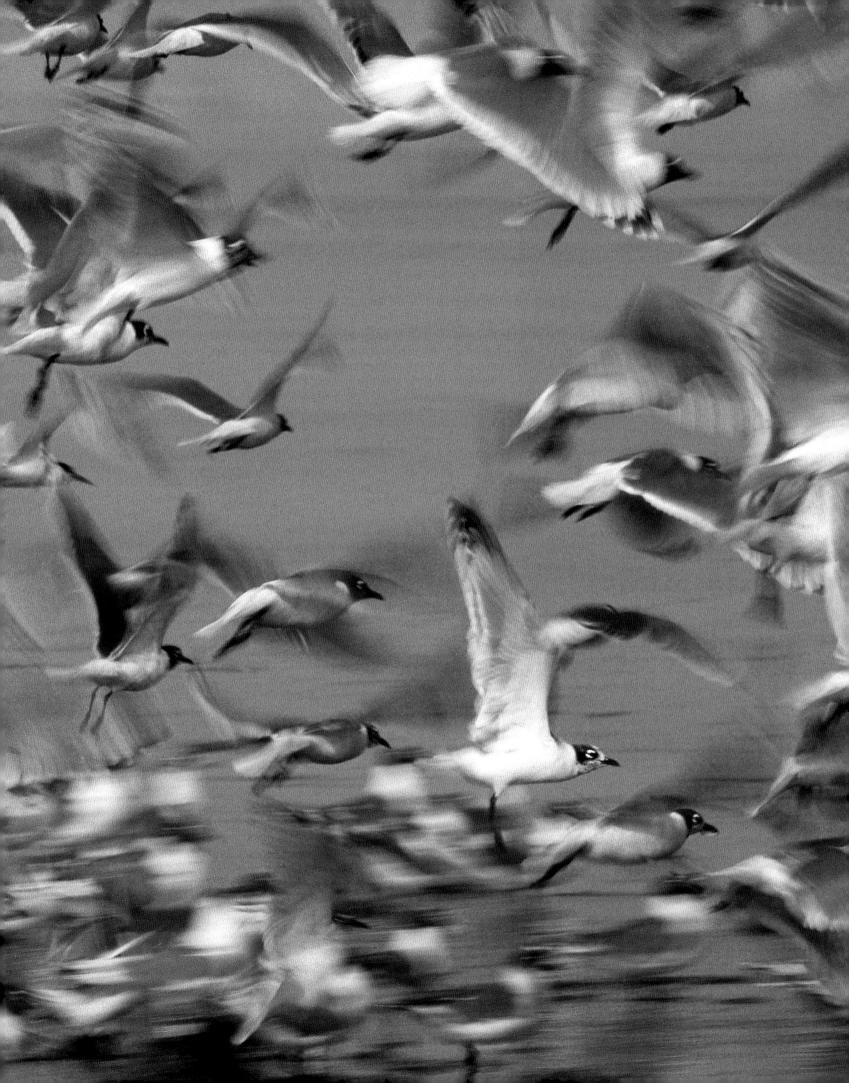

century. This veritable link between reptiles and birds lived 140 million years ago, when the continents were still a single landmass. Its name means "ancient wing," and it possesses features of both the reptile and the bird. Its sternum had no keel and thus lacked a fixing point for powerful wing muscles. These were probably attached to the wishbone. *Archaeopteryx* was certainly clumsy in the air, with an erratic flight. Incapable of taking off from the ground, it needed to climb up tree trunks using its clawed feet and wings, and then launch itself into a glide from one tree to another. It was a modest-size bird, as big as a magpie, with a long bony tail, a bill armed with pointed teeth, four clawed toes (one of which could be opposed), and ribs in the abdominal area. The hoatzin, a strange bird of the South American forests, retains some of the features of *Archaeopteryx*. The wings of the young birds have two claws that allow them to heave themselves up in the trees. These claws disappear after a few weeks in what seems almost a brief summary of the evolution of birds.

The Cretaceous period (100 to 65 million years ago) saw the birth of the descendants of *Archaeopteryx*, of which the best known are *Hesperornis*, a kind of enormous toothed penguin about 6 feet (almost 2 meters) tall, and *Ichthyornis*, which was close to present-day terns. *Ichthyornis*, which had a protruding sternum and probably no teeth, was one of the first birds to possess the power of flight, and was thus similar to modern birds. It was discovered in Kansas in 1870.

Taking Wing All Over the World

Having conquered the air, birds began to diversify. It was not until the much more recent Pleistocene epoch, 2 million to 10,000 years ago, that birds reached their high point. About 12,000 species have been described from this period, or about 2,000 more than at present.

It is estimated that between 1.5 million and 2 million bird species have existed since *Archaeopteryx*. Sadly, because fossils are extremely rare, it is not possible to describe them. The chief reason for this paucity of archaeological material is that bird skeletons, with their hollow, easily broken bones, are extremely fragile and not often preserved.

The fossils of land birds are even more rare. Their bodies often make a meal for predators or carrion eaters, and thus their bones cannot sink into the sedimentary strata beloved of researchers. This is why more seabirds than other species are found preserved in the accumulated silt at the bottom of lagoons or ancient seas, now dried up. The same goes for giant birds, which are also disproportionately represented among fossils.

Many flightless species have been found on oceanic islands that are devoid of predators. Giant moas, some more than 8 feet (2.5 meters) tall, and wingless geese lived in New Zealand until the arrival of the Maoris, for whom they proved an easy quarry. Madagascar was home to the gigantic *Aepyornis titan*, which was 10 feet (3 meters) tall and gave rise to the story in the *Thousand and One Nights* of Sinbad the Sailor's fabulous bird that carried elephants in its talons. These giants, among which the dodo of the Mascarene Islands is probably the best known, have all disappeared—victims of human activity. However, smaller flightless birds survive all over the world, always in places where there are no predators or competitors. There are about forty species belonging to several families, including a parrot, the famous flightless cormorant, and various rails, a particularly well-represented family.

Opposite

Imperial eagle

Aquila heliaca

Europe

All birds of prey resemble each other. However, scientists believe that their origins are all different and that these birds have come to resemble each other only because their ways of life do, a phenomenon called convergent evolution.

Pages 16 and 17

Toco toucan

Ramphastos toco

Peru

Although the toucan's bill is disproportionately large, its horny covering conceals branched bony fibers that are strong but extremely light.

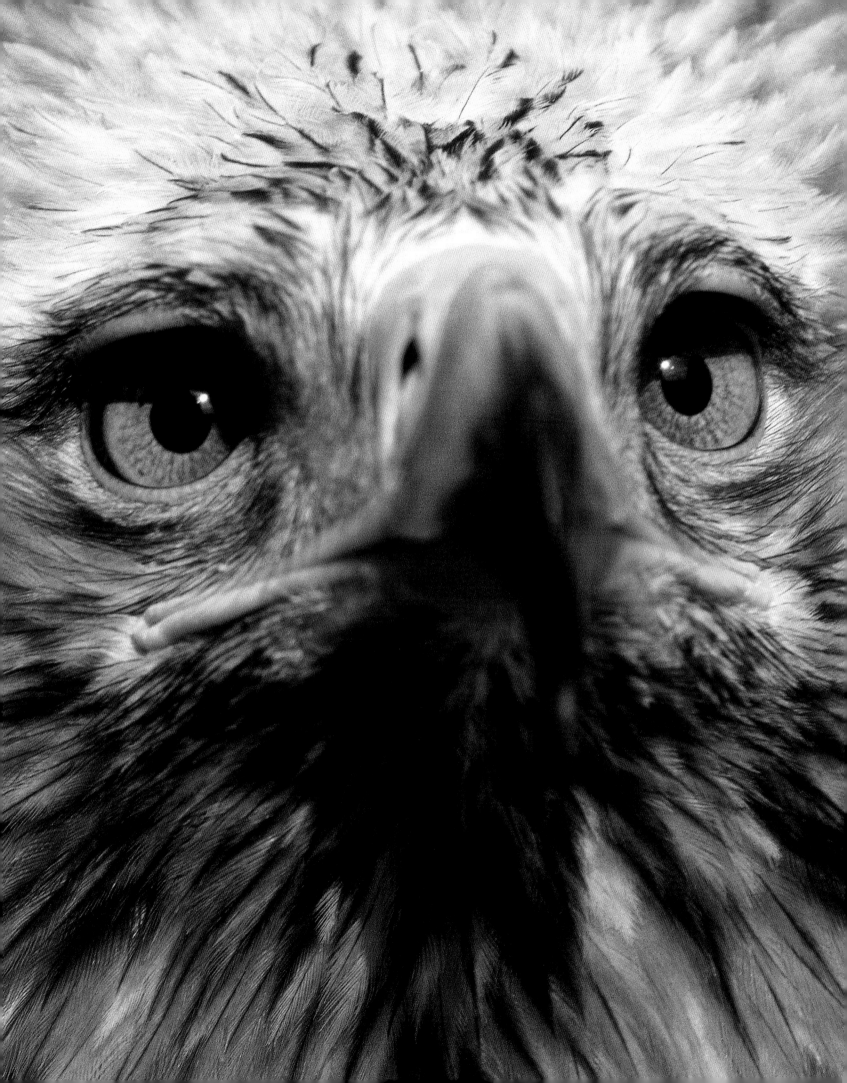

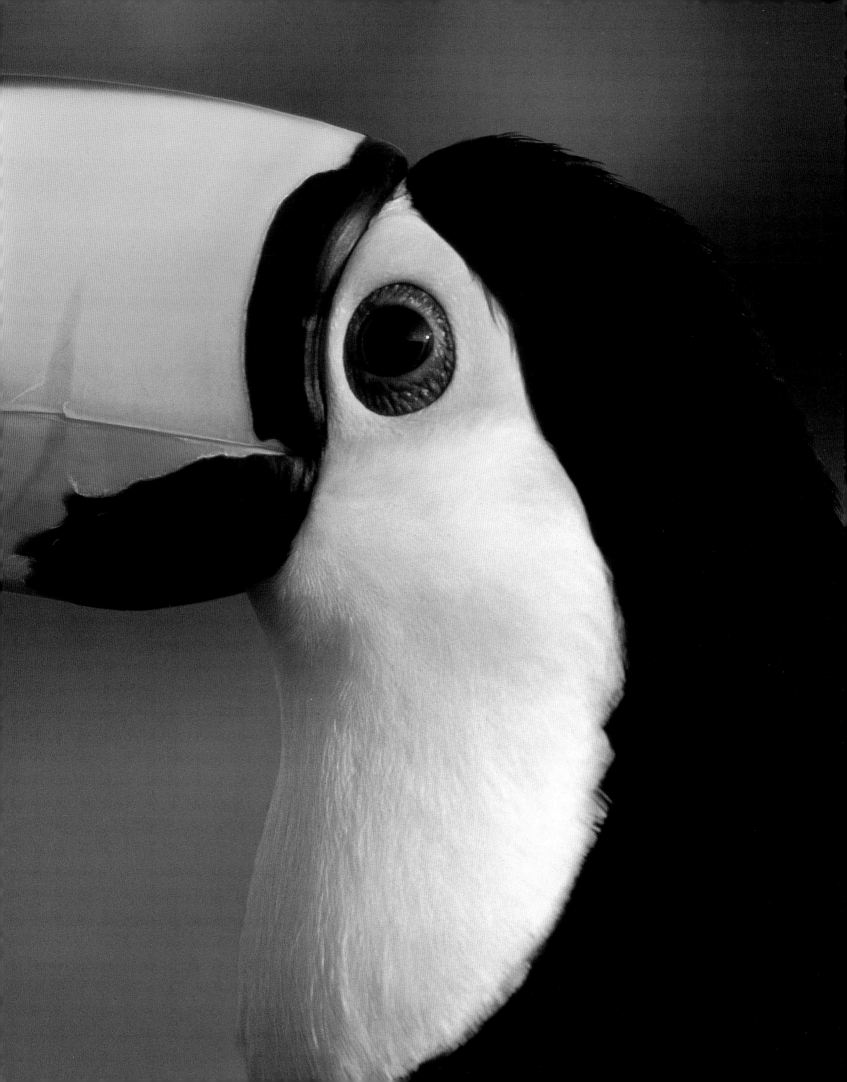

Classifying Species: A Science in Itself

The explosive growth in bird species during the Pleistocene epoch considerably increased the number of types, sizes, and habits of birds. This necessitated the classification of the different kinds of bird, a science known as taxonomy.

The first taxonomists classified birds according to their physical appearance, taking into

Below

Gray heron

Ardea cinerea

Cosmoledo Atoll, Seychelles

Blacktip reef sharks do not intimidate this heron that, despite its apparent fragility, is also a powerfully armed predator.

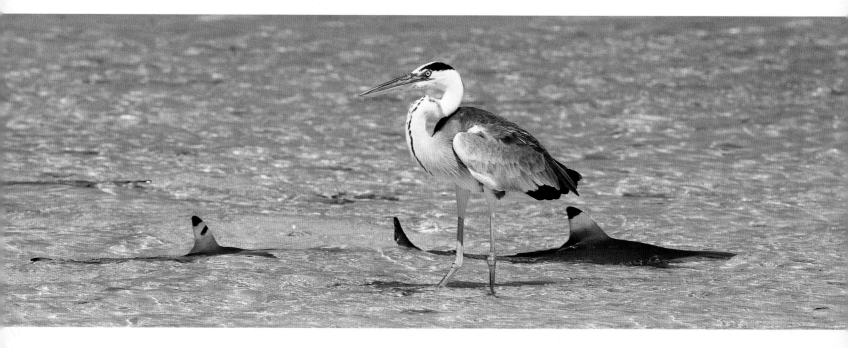

account size, morphology, and plumage color. Although this method had the virtue of simplicity, it was imprecise and sometimes downright wrong. Some birds were classified as belonging to the same species when in fact they were not related at all. Adults and juveniles, males and females, and many others were classified separately, because birds at different stages of life can take on extremely different appearances.

The evolution of scientific methods has, however, allowed more rigorous classification. Different branches of science have contributed, such as biology, physiology, paleontology, ecology, ethology, and biochemistry. Analysis of DNA, the essential component of genetic material, has made it possible to establish family links among birds that were difficult to classify.

Opposite

Wood stork

Mycteria americana

Chacahua Lagoons, Mexico

It is often necessary to identify a bird while it is in flight. The flying profile of the wood stork, with its legs and neck completely extended, is characteristic. Waders generally fly with their necks drawn in, concentrating their weight toward the middle of the body.

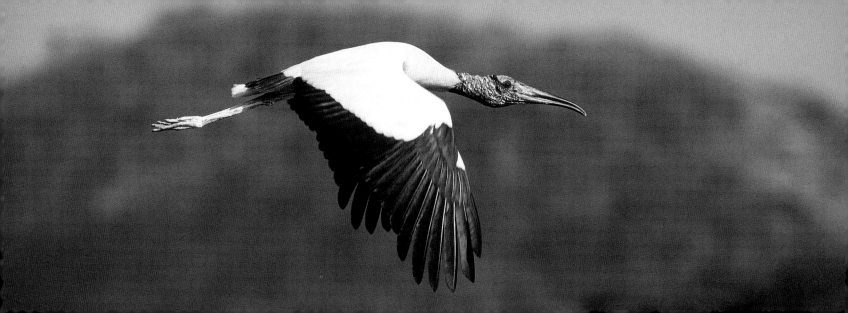

Species and Speciation

A species is a group of individuals that reproduce among themselves but do not breed with the neighboring population: it is the basic unit of classification. It can be subdivided into different populations that are isolated by geographical barriers, such as mountains or oceans. In such cases, genetic changes can be observed in these isolated populations, which after a certain number of generations give rise to a separate species. This phenomenon is called speciation. The more restricted a population, the less genetic mixing is possible and the faster speciation takes place.

A physical or behavioral change can be as powerful as geographical isolation in leading to the evolution of a new species. Thus, for example, a variation in plumage might mean that "traditional" females are no longer attracted to "new" males. A change in other characteristics, such as song or important gestures in mating rituals, might also lead to lack of interest from habitual sexual partners and, thus, to the isolation favoring speciation.

Sometimes continuity can be observed between one population and a new one. Multiple subspecies, or races, can interbreed until they become too distant, at which point they are considered two separate species. The herring gull and lesser black-backed gull are perfect examples. These two separate Northern European species are linked by a "ring" of eight races around the world, all of which can interbreed.

Darwinian natural selection is the driving force that allows new species to appear. In certain cases, different species adapt to a highly restrictive environment in similar ways. Their members then display physical similarities. Auks and penguins, for instance, are completely unrelated, despite appearances. The former live in the Northern Hemisphere and are closely related to gulls. The latter live in the south of the Southern Hemisphere and are cousins of albatrosses and petrels. Toucans, which live in America, and hornbills, which inhabit Africa, both have bulky, helmetlike bills—another example of the same phenomenon, which also occurs in tropical regions.

Classification and Naming: Two Essential Jobs

Taxonomy classifies organisms by means of various units that fit together like those Russian nesting dolls. Together, a number of similar bird species make up a genus; genera are grouped into families, and families into orders.

Formerly, the class Aves (birds) was divided into three subclasses: the impennates, ratites, and carinates. The first were the penguins, marine palmipeds whose wings had become flippers. They had abandoned aerial flight in favor of swimming, which is really underwater flight that requires the same muscular power. For this reason, their breastbone remained well developed. The ratites comprised running birds that had completely lost the power of flight: ostriches, rheas, emus, cassowaries, and kiwis. These birds owed their name to their breastbone, which is as flat as a raft—*ratis* in Latin. By contrast, the carinates comprised all flying birds, the name referring to the presence of a *carina* (keel) on their sternum, to which the powerful pectoral muscles, which moved the wings, were attached.

This arbitrary classification has been abandoned. According to the criteria applied by the various classifiers, the bird class is divided into almost thirty orders, comprising between 150 and 200 families.

Page 20

Steller's sea eagle

Haliaeetus pelagicus

Hokkaido, Japan

These raptors specialize in catching fish and the adaptations they display make this job as easy as possible. Combined with the pads on their feet, their curved, extremely sharp talons give them a better grip on slippery prey.

Page 21

White tern

Gygis alba

Tuamotu Islands, French Polynesia

The white tern is unusual among seabirds in having sharp claws that enable it to cling to branches. Its translucent wings provide good camouflage against the bright sky and the surface of the water in the tropical regions where it lives.

Opposite

Black-headed gull

Larus ridibundus

Brenne, France

This species, seen here in its summer plumage, belongs to the large family of gulls, which comprises almost forty-five species. Of those, thirty-eight belong to the *Larus* genus.

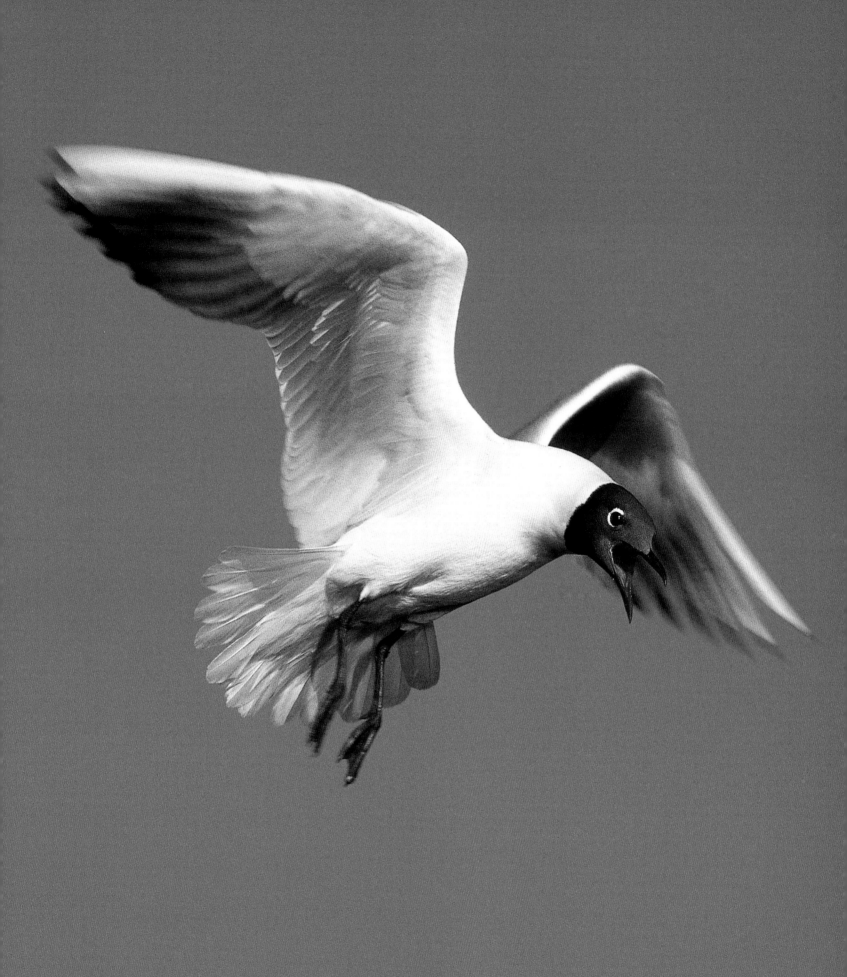

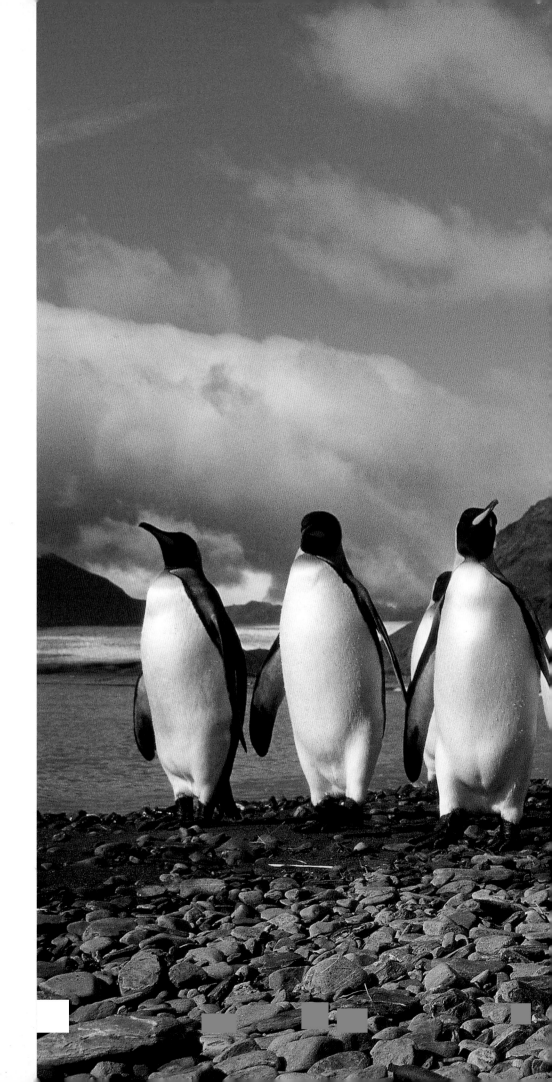

King penguin

Aptenodytes patagonica

South Georgia Island, Antarctica

All eighteen species of penguins, grouped in six genera, live exclusively in the Southern Hemisphere. Penguins should not be confused with auks, their counterparts in the Northern Hemisphere, to which they are not related but with which they share similar living conditions.

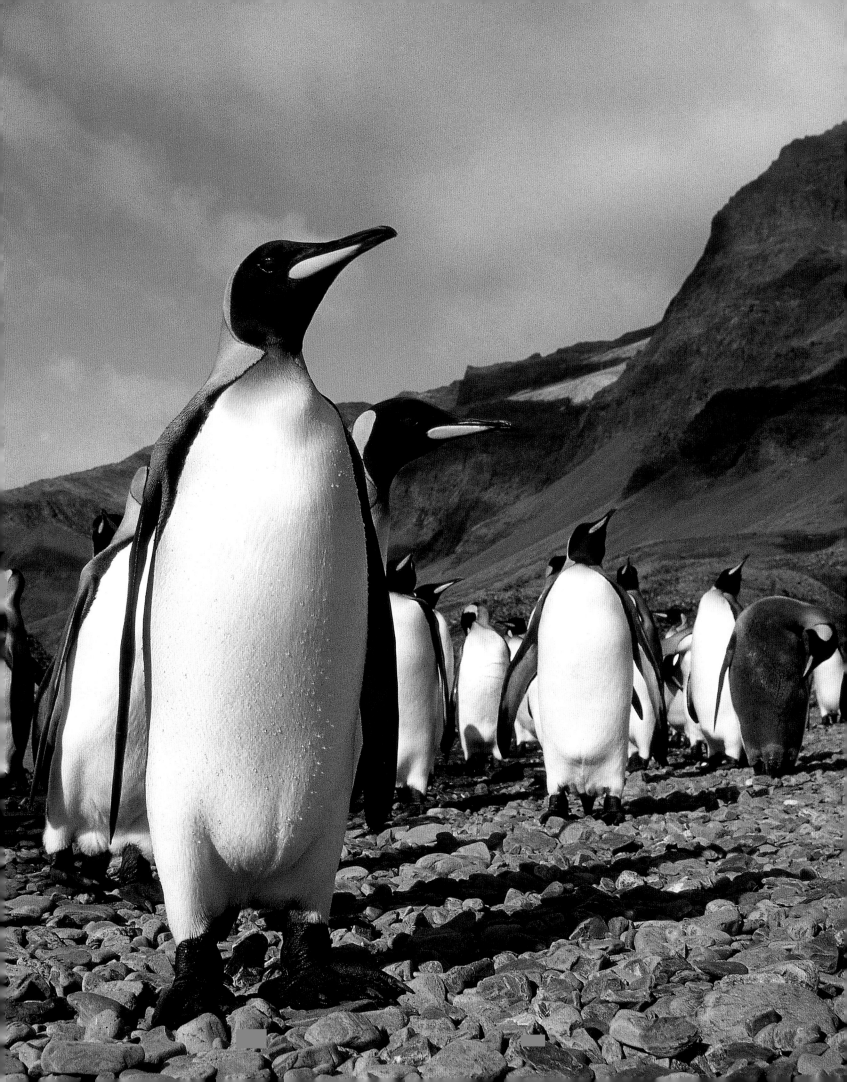

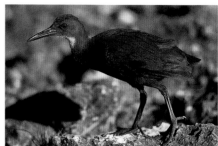

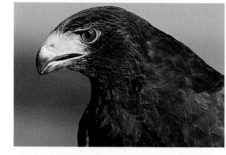

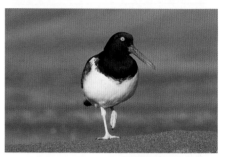

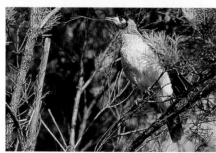

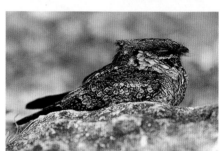

1. Crested pigeon
2. Harris hawk
3. Noisy miner
4. White-throated rail
5. American oystercatcher
6. Madagascar nightjar
7. Graylag goose
8. Blakiston's fish owl
9. Great white pelican
10. Common moorhen
11. Caspian tern
12. Little bee-eater
13. Pied wagtail
14. Yellow-billed oxpecker
15. Greater hoopoe-lark

1	4
2	5
3	6

7	10	13
8	11	14
9	12	15

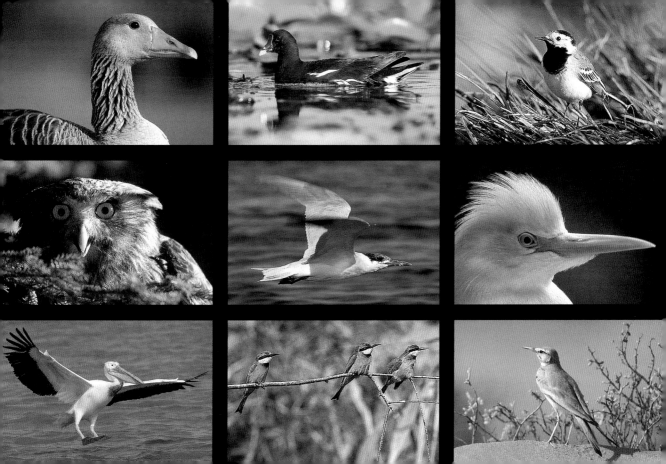

From *T. rex* to the Hummingbird

Taxonomy, whose founding father was the Swedish naturalist Carl von Linné, gives each organism a name consisting of two elements, always written in italics: its genus and its species. So that it can be understood internationally, the classification of living organisms is in Latin. Linné, whose system was universally adopted after the publication of his book *Systema naturae* in 1758, took this concept so seriously that he Latinized his own name, to Carolus Linnaeus.

Certain orders of the bird class comprise only one family, which in some cases contains just one species. Thus the ostrich, which science has named *Struthio camelus*, belongs to the family of the Struthionidae, and the order of the Struthioniformes. By contrast, the order of the Passeriformes (passerine birds) comprises almost sixty families. The biggest family, that of the flycatchers and other warblers, is scientifically known as Muscicapidae, and contains 1,200 species, including the melancholy nightingale.

The precision of scientific classification seems to fix the profusion of life permanently in an unchanging structure. This impression is magnified by the erroneous belief that the behavior of a given species does not vary. On the contrary, variation and selection are active processes. In its day-to-day life, a bird is constantly faced with choices, to which it responds in an empirical fashion, improving or not its living conditions and even chances of survival. Everywhere, at all times, evolution is working and pursuing its endless course. We can all witness it—all that is needed is to be sufficiently observant. We are all players in this process, which is an essential component of life and one we must take into account. Human actions drive some species to extinction, save others, and contribute to the creation of new races.

Opposite

Steller's sea eagle

Haliaeetus pelagicus

Hokkaido, Japan

This superb raptor, known in Japanese as *o-washi* ("great eagle"), leaves Siberia at the end of summer to winter at the northeast of the island of Hokkaido. Ice floes are its banquet tables, where it consumes its meals of fish or feeds on the bodies of seals or whooper swans...the great cycle of life.

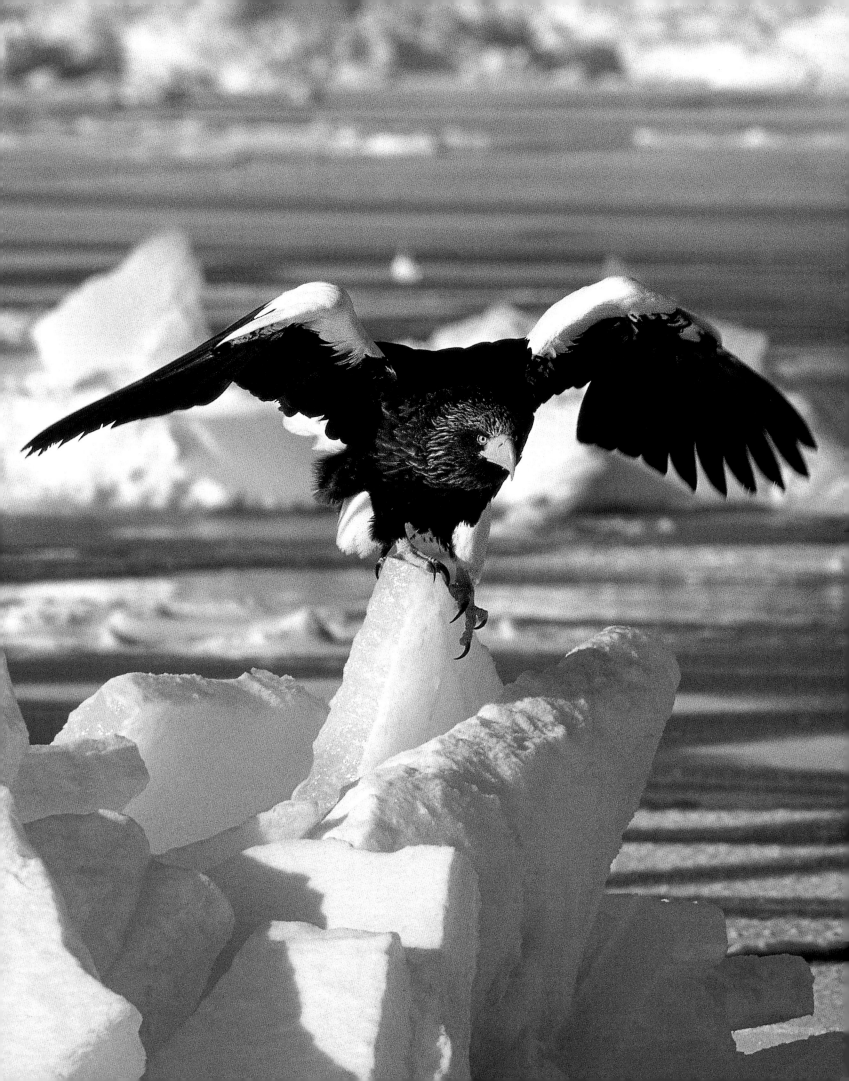

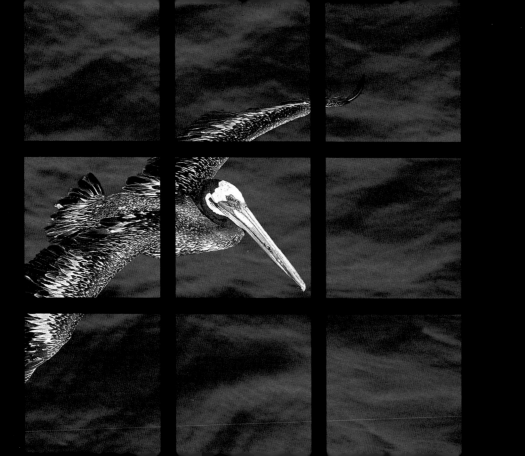

Conquest of the Air

Opposite

Brown pelican

Pelecanus occidentalis

Pisco, Peru

Though big and heavy, pelicans are still powerful flyers. Their broad, rounded wings have a large surface area compared to their body weight, enabling them to ride rising air currents to great heights.

To reach the sun—without burning his wings. Icarus's dream, and that of so many other humans, is perfectly illustrated among the technological wonders fashioned by nature. Designed for flying, birds have been able to colonize all habitats thanks to this extraordinary means of expansion. As a quid pro quo, they have had to sacrifice several organs and modify their whole body to meet the constraints imposed by flight. Minimum weight and maximum muscular power are the two indispensable demands made by mastery of the air. Each organ, each sinew, each tiny feather of a bird's body is designed to comply with them as much as possible.

Our most sophisticated aircraft are no more than inferior, crudely made copies of these most perfect of winged creatures. A bird's wing is simultaneously a propeller and a surface that generates lift—combining the highly complex mechanism of an aircraft's wing with that of a helicopter's rotors. From the gliding flight of large soaring birds to the blurringly fast flapping of hummingbirds, nature has made birds an astonishing field of experimentation, which it explores incessantly in the boldest of ways.

Despite the enormous advantage flight offers, certain birds have nevertheless deliberately relinquished it to devote themselves to running or swimming. Ostriches and penguins are the best-known examples, though the latter has retained the power of flight for use solely under water. In abandoning the air, penguins have conquered the underwater world, which they explore with the same ease as their airborne cousins, enjoying the same wonderful freedom.

The constraints imposed by flight have given birds a structure that is identical all over the globe, limiting both their size and their weight. The latter, which is chiefly due to the bulky breast and leg muscles, is concentrated around the body's center of gravity, improving their stability in flight. Muscle mass is concentrated on the lower side of the thorax and the very top of the legs. The toes are moved by tendons that are as thin as filament cables, transmitting power like cords and pulleys.

The Incomparable Lightness of These Beings

Beyond being extremely light, birds must also be very strong, with a skeleton that is able to withstand the shocks and great forces exerted by landing. Their pelvis is thus extremely rigid, and many vertebrae are fused. The vertebrae in the neck are extremely mobile, allowing the head a wide range of positions.

But it is in their lightness that birds truly excel. They show an astonishing number of weight-saving adaptations, both anatomical and physiological. The most original of these is in the skeleton: bird bones are hollow. However, to ensure maximum strength, they are reinforced by a lattice of struts, which connect exactly where the bone is most fragile and where the risk of fracture is highest.

In their quest for lightness, the list of organs birds have had to do without is a long one: the bladder, teeth, external ears, skin glands, the penis in males, one ovary in females, and so forth. Eggs are laid at an early stage of their development, which is completed after they leave the female's body. Urine and feces are not separated as in mammals, and are excreted very frequently during the day as droppings. Even pus is dry, with no excess water to increase total body weight.

Big-Hearted Creatures

As well as lightness, flight demands the immediate production of energy—for example, in the sudden need to take to the air and escape a predator, or in migrations spanning thousands of miles. This power depends on an extremely efficient cardiovascular system.

A bird's heart is a very large muscle with four cavities: two auricles, which receive blood, and two ventricles, which send it back around the body. The right side of the heart runs the circulation to and from the lungs, which clean the blood and reoxygenate it. The left pumps blood all around the body, nourishing all its cells. This system is so efficient that freshly oxygenated and unoxygenated blood never come into contact with each other. In a hummingbird, whose flight consumes huge amounts of energy, the heart beats at the incredible rate of 1,000 times a minute. The hearts of our familiar robins and sparrows, whose flight is less spectacular, pump blood at about 500 beats per minute, which is still a prodigious speed compared with a human's heart rate of about seventy beats per minute.

An efficient pump is only effective when it is complemented by an adequate ventilation system. Here, too, birds have extraordinary abilities. Although their lungs are relatively small, they possess the most powerful breathing system in the animal kingdom. Air sacs in other organs and even in the hollow bones back up the lungs themselves, creating a continuous air current, so that the bird uses its entire body to breathe. In flight, respiration is synchronized with wingbeats. Tests on sparrows have revealed that they breathe fifty times per minute at rest, a rate that rises as high as 212 times a minute after flying. By contrast, a human breathes ten times a minute. And there is more: birds breathe using a one-way system, in contrast to our two-way system. This reduces the amount of stagnant air that lingers in the lungs and maintains a rich oxygen supply to the bloodstream. As birds have no sweat glands, the air sacs also act as a cooling system to dissipate the heat generated by flight. From a purely mechanical point of view, it could be said that birds have chosen an air-cooled system, whereas mammals are water-cooled.

Opposite

White-tailed tropicbird

Phaeton lepturus

Astove Island, Indian Ocean

The long central feathers of its pointed tail give this bird its spectacular beauty. Its highly sophisticated flying style is based on rapid, powerful wingbeats; only rarely does it glide at great height.

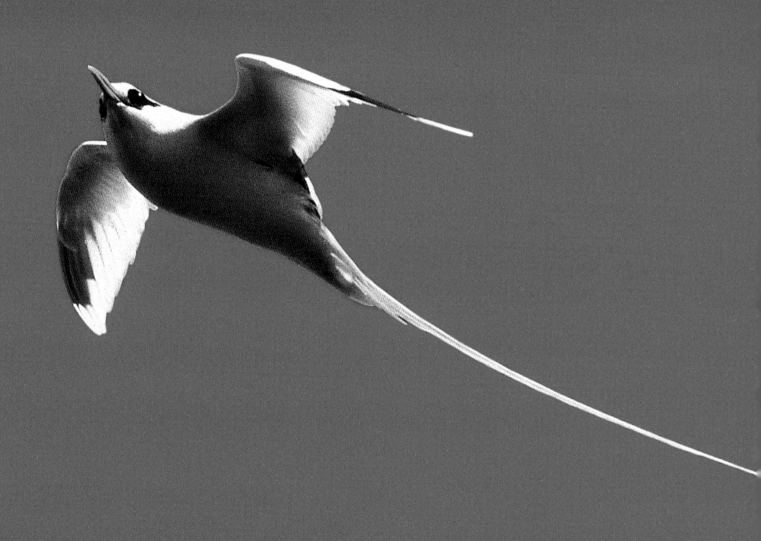

Miniature Power Stations

We have seen the engine's fueling and cooling systems; all that remains to examine is the engine itself. This consists of the muscles that produce the power needed for movement. Birds' muscles contain three kinds of muscle fiber. The first type is white, thick, and filled with glycogen, a sugar with very high energy content. It supplies large amounts of power quickly, allowing the sudden rapid flight necessary, for example, to escape a predator. The drawback is that use of this muscle type produces a lot of waste, which causes muscle fatigue. It therefore cannot be used for long periods. The second type of muscle fiber is red and fine. It uses a very different kind of metabolism, burning fat rather than sugar, and produces very little waste because it leaves almost none of its fuel unburnt. These fibers are used for long-distance flight and migration. The third muscle type is a combination of the first two, which uses both kinds of metabolism.

Flight may be powerful, but it also consumes large amounts of energy. Birds therefore have a much higher metabolic rate than mammals, which gives them a much higher body temperature, between 104 and 110.3 °F (40 and 43.5 °C).

The bulky muscles that power the wings obviously play a crucial role in flight. However, small muscles that lie just beneath the skin aid them discreetly but very efficiently. These control the follicles of almost every feather, which they can move in any direction, controlling the bird's maneuvers in the air with a high degree of precision.

Birds are thus both highly efficient and complex flying creatures, whose entire biology is adapted to the demands of this mode of travel. Flight itself is as varied in its details as it is apparently uniform—there is more to flight than two beating wings simply propelling a body through space.

Masters of Aerodynamics

The cross-section of a bird's wing and that of an aircraft's are similar: a convex upper surface and a concave lower one, a rounded leading edge, and a tapered trailing one. Since the upper and lower surfaces are unequal in area, air does not flow over them in the same way. The difference in pressure between them produces a lift that pushes the flying object upward. Birds respond to the laws of aeronautics, a very exact science that governs the movement of bodies through the air, with a talent that is the envy of many an engineer and high-flying pilot. Both wings and feathers change shape constantly during flight in response to air currents and turbulence, always offering the best aerodynamic profile. Thanks to this ability to reduce friction, a bird uses far less energy than an aircraft.

Takeoff and landing are made much easier by a small tuft of feathers known as the bastard wing or alula, down near the thumb at the leading edge of the wing. The function of the alula is to correct the wing's angle of attack, reducing turbulence above it. When the alula is outstretched forward, it allows the bird to climb 10 to 20 percent faster at slow speeds. Some birds are unable to take flight without using the alula. Recent research has shown that this feature dates from the Cretaceous period, following the discovery of a fossil the size of a goldfinch, 115 million years old. This reveals that perfect mastery of flight had already been achieved in the remote past.

Opposite

Surfbird

Aphriza virgata

Paracas Peninsula, Peru

These birds are specialists in taking flight simultaneously. Flying perfectly together, the flock circles in close formation and, after wheeling around a few times, comes to rest once again. So perfectly are the birds coordinated that they never collide, as if they were really one individual comprising a myriad entities.

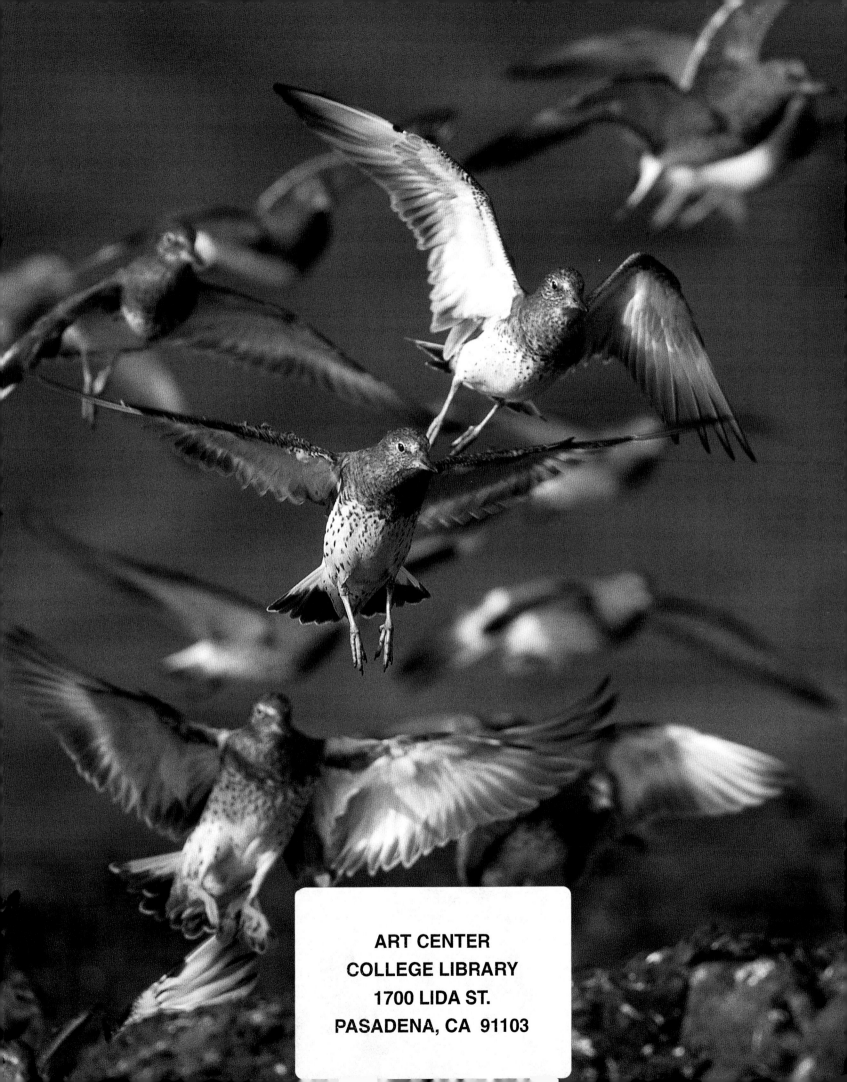

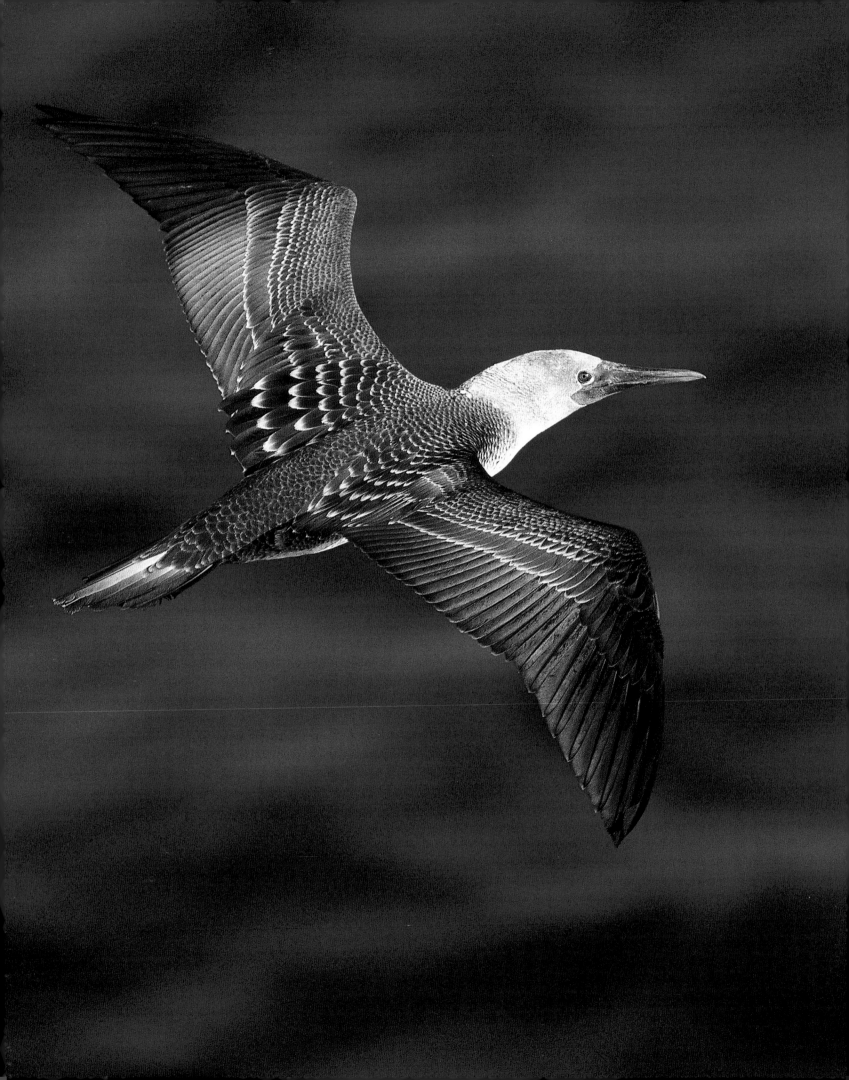

Peruvian booby

Sula variegata

Paracas Peninsula, Peru

Compared to flapping flight, gliding is an excellent way to save energy. Seabirds use the rising air currents produced by enormous cliffs. Big ships also create whirling air currents for birds to glide upon.

White tern

Gygis alba

Amirantes Islands, Indian Ocean

The overall shape of a bird's wing can be analyzed according to the three elements essential to its function: the degree of curvature, the ratio of length to width, and the presence (or absence) of openings.

Common pochard

Aythya ferina

Brenne, France

For a bird to take flight, air must be circulating rapidly enough along its wings to produce lift. This duck runs across the surface of the water while beating its wings to gather sufficient wind speed to take off.

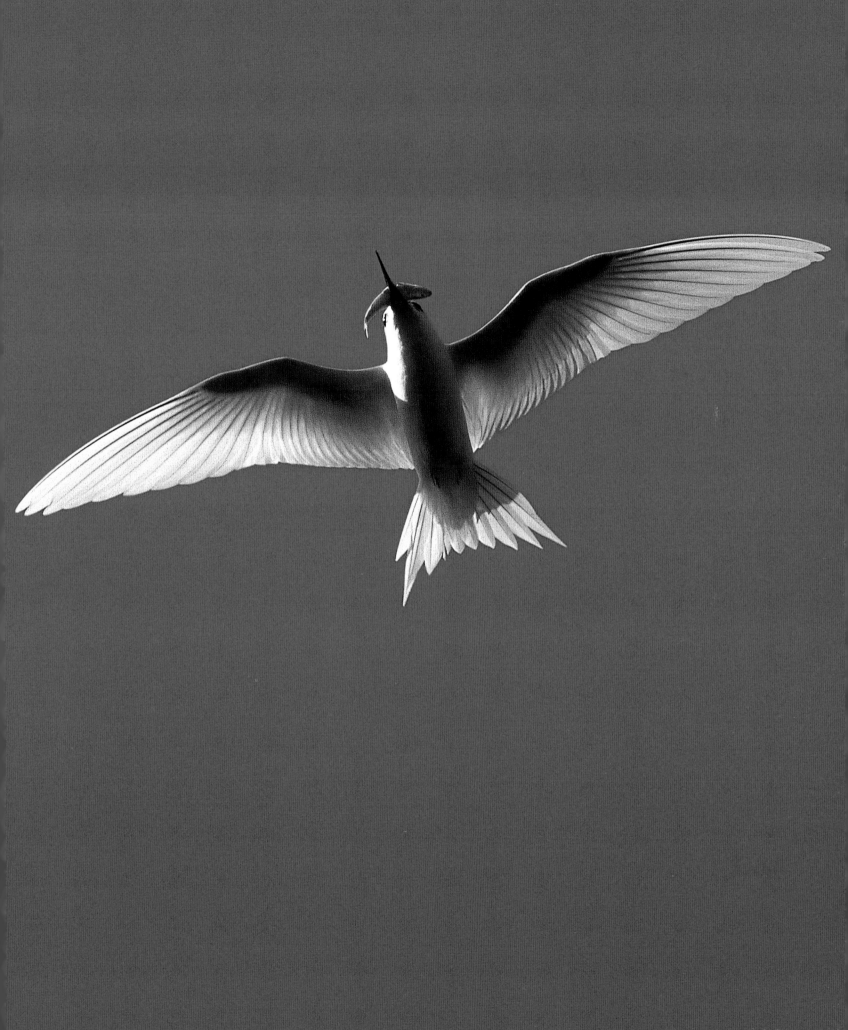

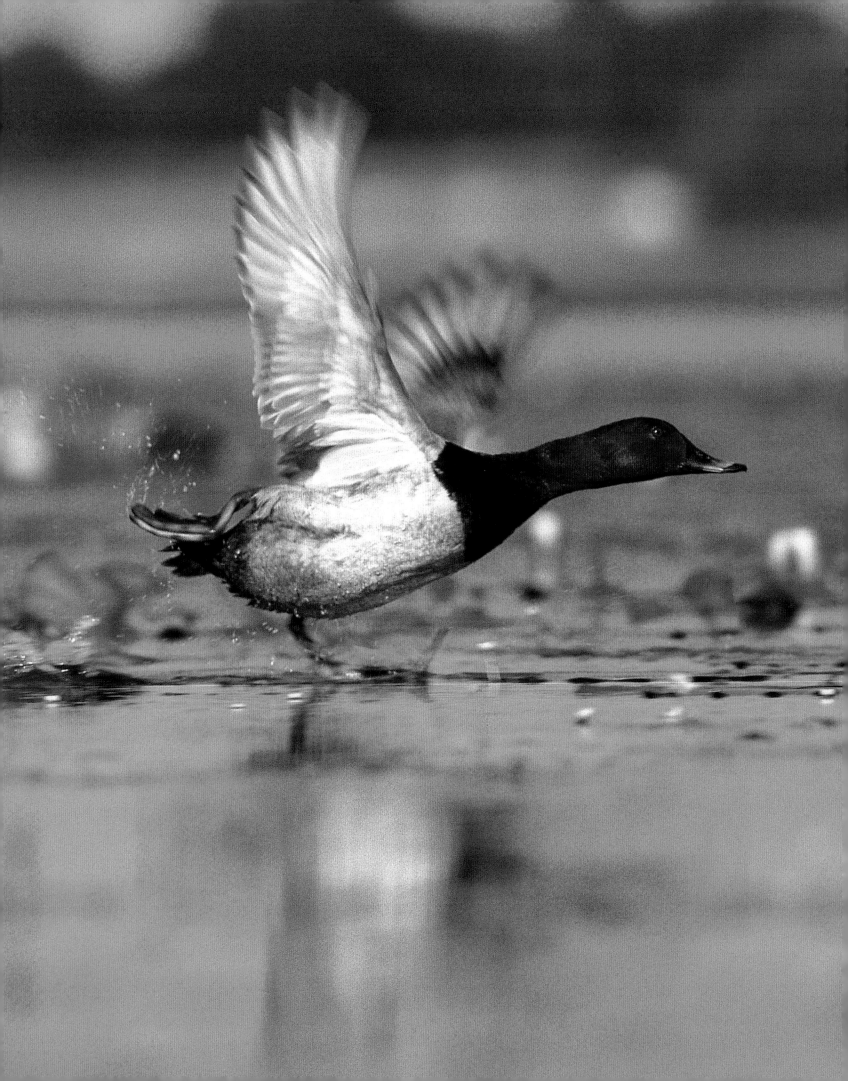

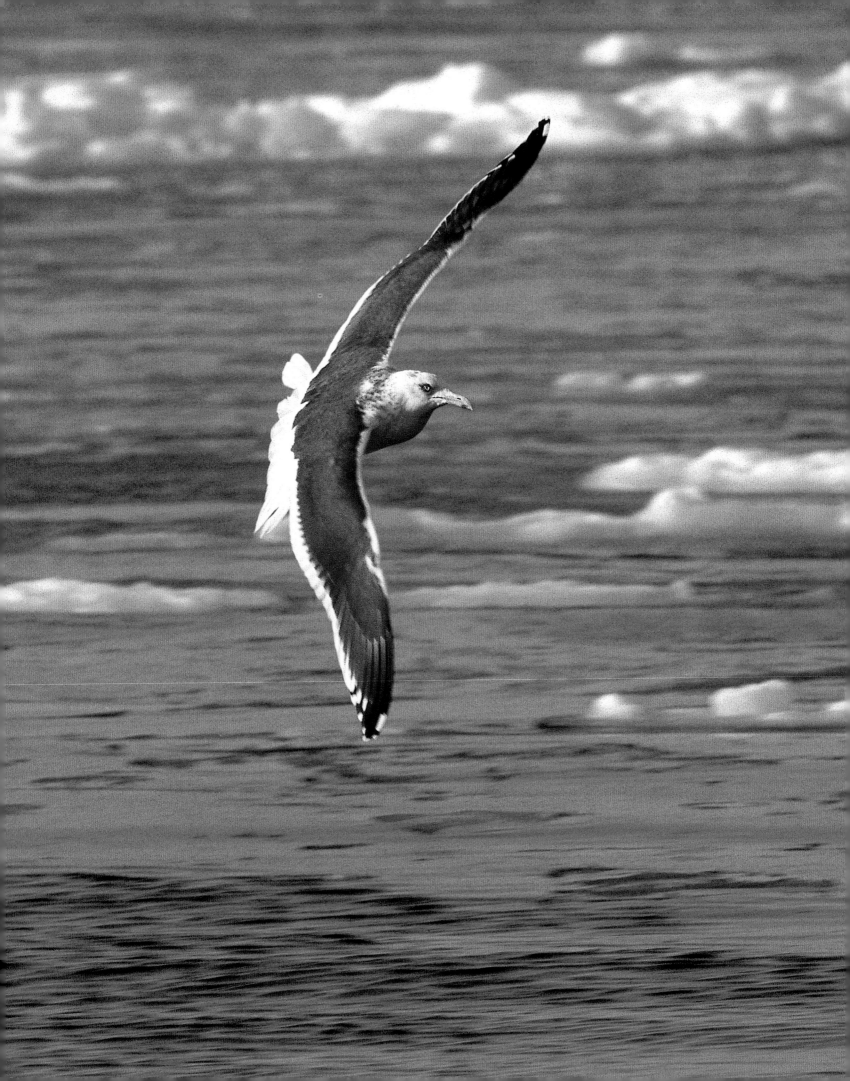

Slaty-backed gull

Larus schistisagus

Japan

Typical of seabirds, these long, narrow wings are designed for gliding. Birds with this wing shape expend considerable amounts of energy in flapping flight.

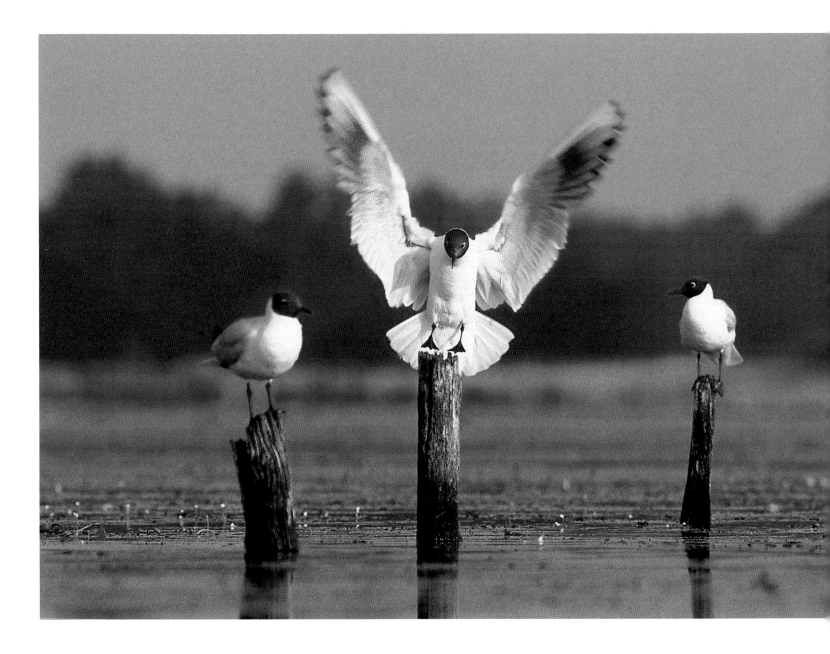

Takeoff is always exhausting for a bird. It can be done by jumping off the ground, which requires very muscular legs positioned under the bird's center of gravity, as well as a firm foothold on the ground. Swifts, whose four forward-pointing toes deprive them of such a foothold, cannot propel themselves upward and prefer to launch themselves downward off a ledge. Water birds, such as swans, have legs positioned to the rear of their bodies. They are also unable to jump upward and are forced to run along to get up enough speed to take off, like an aircraft. Wind is a precious asset that makes takeoff easier, as birds can achieve lift by moving against it. Albatrosses are almost incapable of taking off without wind.

Landing is equally problematic, as anyone knows who has watched a young bird miss its target or go rolling head over heels on hitting the ground. Practice is essential for mastering this technique, and a gentle landing requires that wings and tail be spread out, in order for the bird to slow down.

Water birds increasingly use their webbed feet to cushion their landing, although it is less important for them to master landing techniques than it is for birds landing on a branch—water attenuates many a blunder. As with takeoff, wind makes landing easier, and large birds always land into a headwind.

Above

Black-headed gull

Larus ridibundus

Brenne, France

With wings and tail spread, this gull presents a big, wide surface area in comparison with its slim profile at rest.

44

More Than One Way of Flying

There are several different types of flight: gliding flight, flapping flight, and rapidly vibrating flight. The mechanisms involved are highly complex and not fully understood.

Gliding flight is the type that most resembles that of an aircraft. It is the prerogative of the great gliding birds, which can soar and remain aloft without the slightest wingbeat. This type of flight is possible above land, where the birds are carried up to high altitudes by rising masses of warm air. Such currents are known as thermals. Over the sea there is a different phenomenon, and the great gliding birds skim the waves, imperceptibly adjusting their wings according to wind speed. The tail, which may be spread or closed, is extremely important in flight because it acts as a rudder and allows the bird to change direction. It is therefore a deciding factor in a bird's skill at executing more or less difficult maneuvers.

Although gliding flight demands an excellent mastery of air currents, flapping flight requires an extremely complex movement of the wing joint. Contrary to common belief, simply flapping the wings up and down is enough to fly. The wings sweep air backward and downward. They bend at the elbow; feathers part; and the angle of attack is adjusted depending on air turbulence, speed,

and the direction the bird wishes to take. In short, it is an action whose complexity is beyond our understanding.

The most fascinating form of flight is the vibrating flight of the hummingbird, which produces a deep buzzing like that of a bumblebee. Capable of rising vertically, hovering motionless, and even of going backward, the hummingbird is truly a helicopter among airplanes. The wing is almost rigid, like a sort of swiveling paddle that pivots around the shoulder joint. A very slowed-down film reveals how this wing describes a figure eight from the shoulder, like a boat's single oar, suspending the delicate body of the hummingbird in midair. With its wings beating about seventy-five times per second, and up to 200 times per second when nose-diving or performing a mating display, the hummingbird's flight, too fast for the human eye, can reach speeds of fifty miles (eighty kilometers) per hour. The downside is that flight like this consumes an enormous amount of energy. Hummingbirds use more energy in proportion to their body weight than any other living thing. They must eat three times their own weight each day, and their heart accounts for almost a quarter of their weight. When night falls, they lapse into a sort of lethargic state, and their temperature and metabolic rate plummet, allowing them to survive the cold and lack of food.

There are other birds that, while lacking the vigor of these little winged jewels, can still hover in the same place for a few moments, beating their wings back and forth to maintain lift without moving forward. However, this particular type of flight consumes energy so voraciously that it can be maintained for only a few seconds. Falcons and buzzards are also specialists in hovering, and they can hold their position long enough to search the ground below for prey with their sharp eyes. However, they cannot do this in still conditions because in order to hover they must exploit even the slightest breath of wind.

Wings of All Shapes

Each type of flight is associated with a particular type of wing. The hummingbird's short wings would be useless for gliding, while the long, broad wings of soaring birds such as vultures could not flutter rapidly in vibrating flight.

Apart from the hummingbird's wing, which is so short and stiff that it is almost a hand, and a penguin's wing, which has become a paddle, there are four basic types of wing. Gliding flight requires long, broad, arched wings and a broad tail. That is the typical shape of a vulture's or a stork's wing. Very fast flight requires slender, long wings, swept back and very compact, and a short tail. These scimitar-shaped wings are typical of swallows and falcons, whose normal speed is fifty miles (eighty kilometers) per hour but which can reach 105 or even 125 miles (170 or even 200 kilometers) per hour in short bursts or when swooping (diving at high speed from high altitude). Seabirds that glide, skimming the surface of the waves, have long, narrow wings, while pheasants, which are remarkable for their explosive, zigzagging flight, have broad, short, extremely arched wings in order to maximize their lift. If disturbed by a predator, a pheasant can rocket upward at the prodigious speed of sixty-two miles (100 kilometers) per hour.

Aside from a wing's shape, the ratio of its surface area to body weight is a crucial factor for flight. This ratio is extremely high in frigate birds, which are designed to glide endlessly. However, there is a ceiling to this ratio, which is set by the physical factors such as the wings' robustness and the effect of air friction.

Opposite

Gentoo penguin

Pygoscelis papua

Antarctica

Penguins are only capable of underwater "flight," thanks to their paddlelike wings that are devoid of flight feathers. They are superb swimmers, capable of achieving speeds of up to 19 miles (30 kilometers) per hour over short distances.

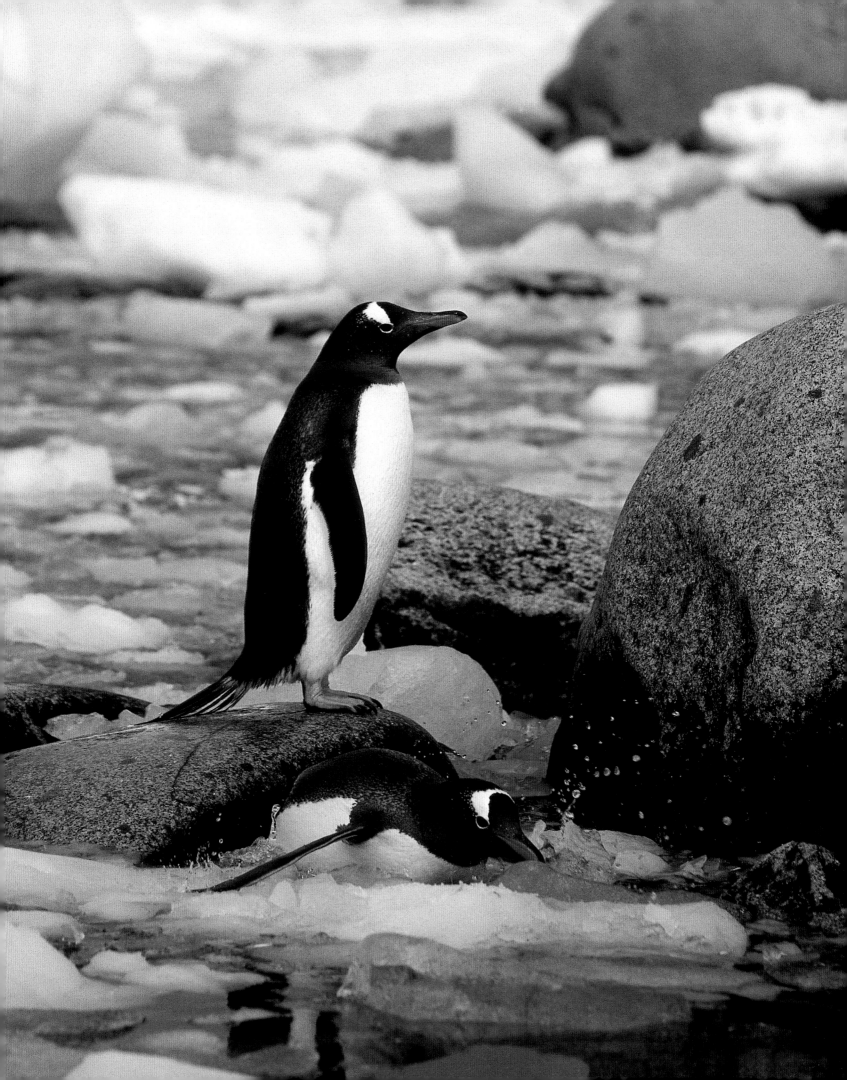

The ratio is lowest among the auks. Their wings are highly specialized for diving, resembling a penguin's paddles, and allow them to fly both through the air and under the water. However, they have great difficulty in taking off and landing, and the slightest defect in their wing flight feathers can even prevent them from doing either.

Group Flight

Many birds fly in formation when covering long distances. Geese, ducks, cranes, and gulls form a more or less perfect V shape, which can be seen crossing the sky. A flying bird produces a considerable slipstream: a downward air current is produced behind each bird, flanked on either side by a compensating rising current. Therefore, flying behind the wingtip of the bird in front allows a bird to "surf" on this current, which provides increased lift. This can save between 5 and 10 percent of a bird's energy. The bulkier a bird, the more it gains by flying in a V formation and slipping efficiently through the air. This is thus a way of optimizing energy use—as long as the lead bird is regularly relieved, that is, since flying at the front is tiring.

However, none of this explains why geese can be seen migrating over Everest at heights of 29,500 feet (9,000 meters), where there is hardly any oxygen, for we know how flying uses up large amounts of energy. But the beauty of birds and the strange fascination they have exerted over humans since the earliest times, lie partly in their mysteriousness.

Opposite

Montagu's harrier

Circus pygargus

Pinail Nature Reserve, France

A bird must sprout its first feathers before it can master flight. Beating the wings while still in the nest helps to develop the appropriate muscles.

Pages 50 and 51

Ostrich

Struthio camelus

Masai Mara, Kenya

Along with their cousins the ratites, ostriches are the only birds whose internal structure indicates that they stopped flying a very long time ago. The bones that flying muscles would be attached to have disappeared.

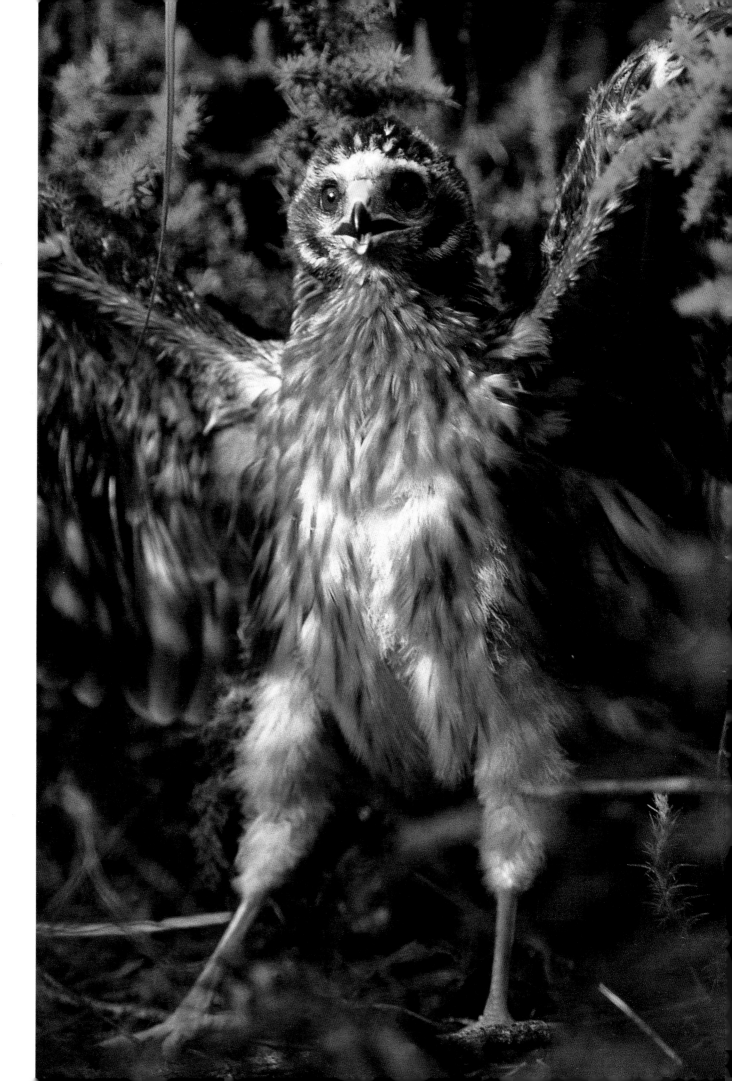

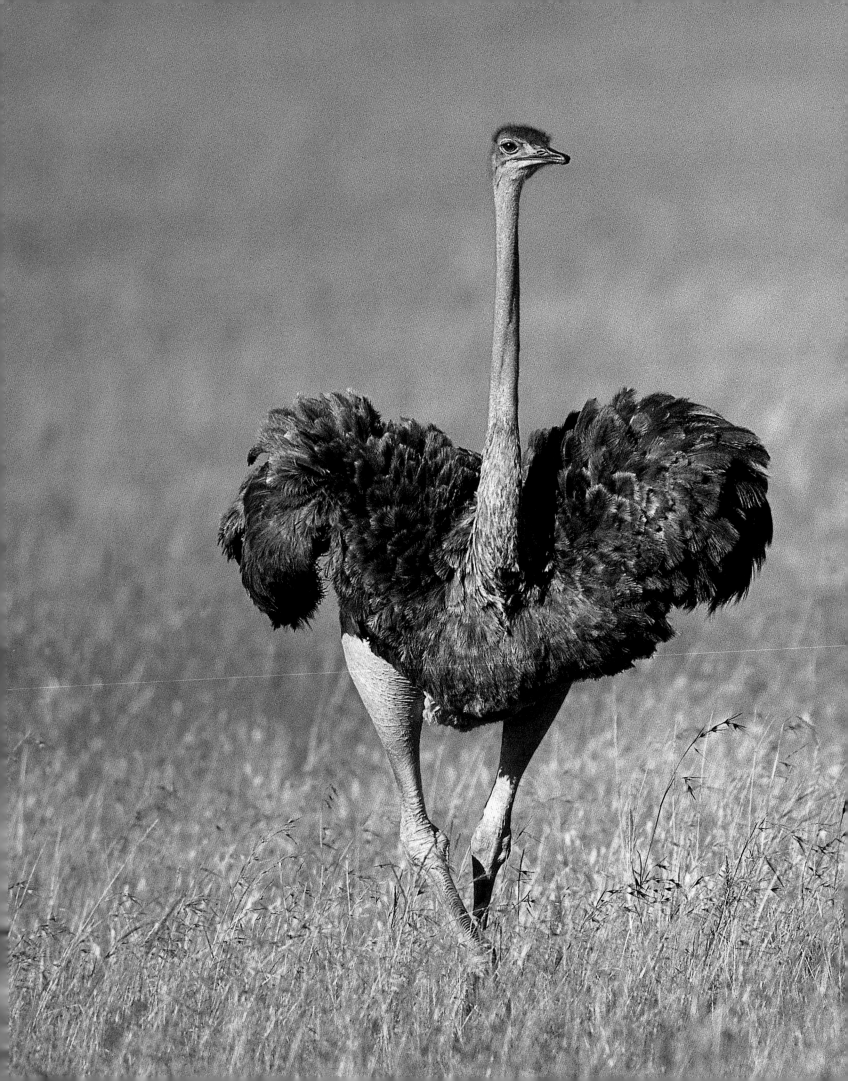

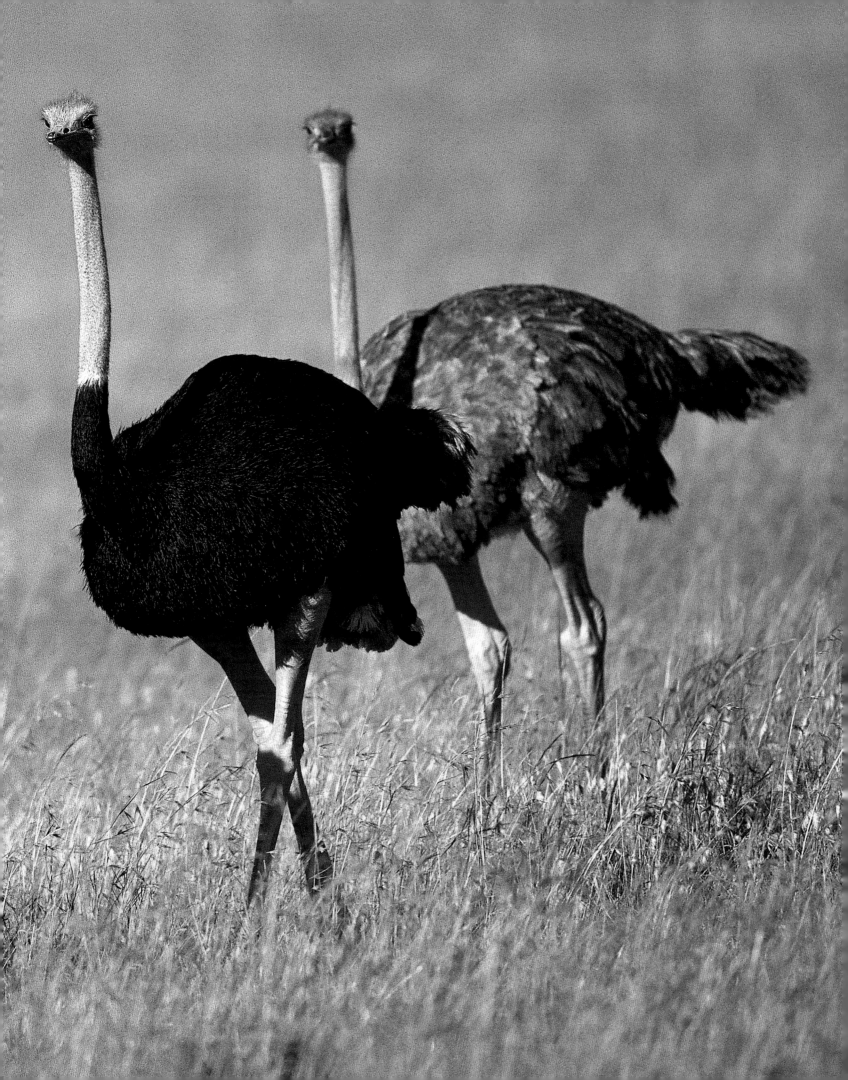

Opposite

Western marsh-harrier

Circus aeruginosus

Brenne, France

Body vertical, the bird beats its wings opposite of the way they beat in flight to reduce airspeed while maintaining lift. With feet extended before it, the bird prepares to absorb the shock of landing.

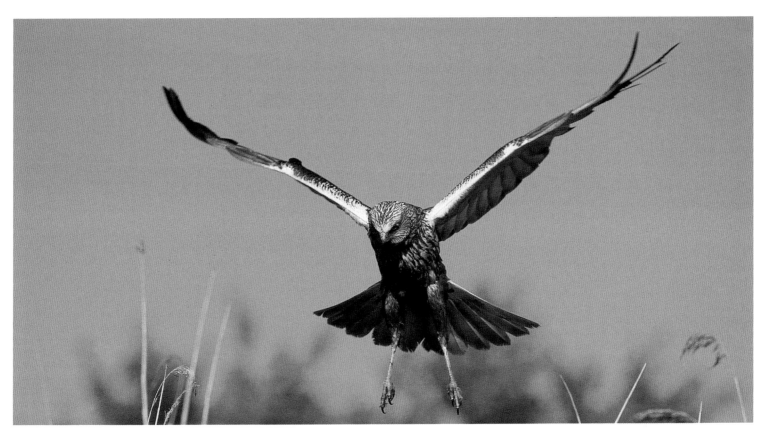
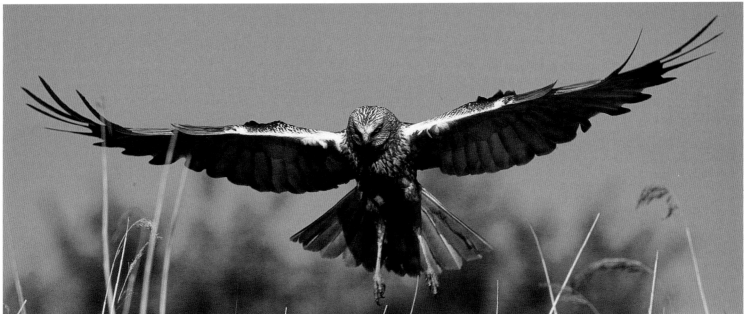
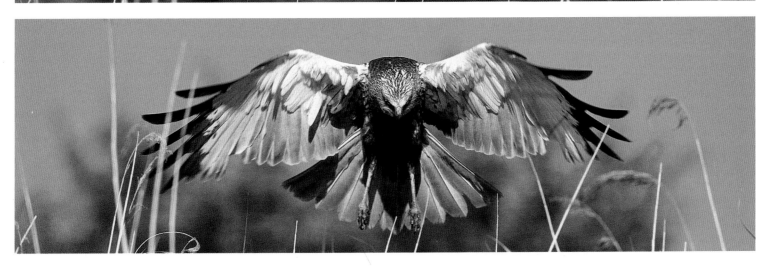

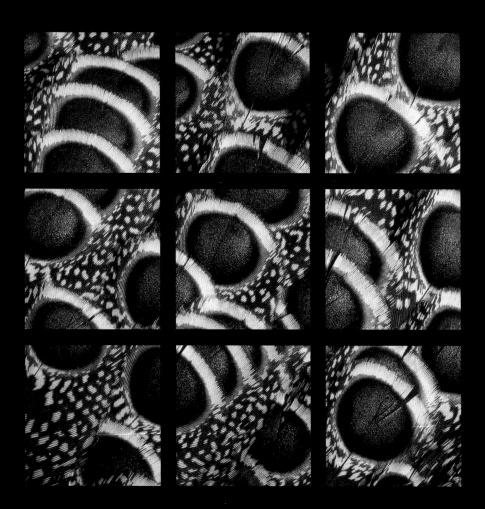

Feathers:
A Technological Marvel

Opposite

Gray peacock-pheasant

Polyplectron bicalcaratum

India

In many birds, magnificently colored plumage plays two apparently contradictory roles: it adorns and highlights the individual while also masking it from the eyes of predators. Plumage can be brilliant and camouflaging at the same time, as in the case of the many tropical birds that are almost invisible in the richness of the virgin forest.

The feather is a masterpiece. A glance at the iridescent hues of the most precious of them makes that clear. The fabulous colors that clothe the fragile bodies of birds are produced by three distinct mechanisms: pigmentation, interference, and diffusion, all of which act on light—for color is light. The greatest beauty of feathers, however, lies not in their pleasing appearance but in their structure. Light, supple, and strong, feathers are unique to birds. This small organ performs crucial functions, such as maintaining body temperature, repelling water, providing camouflage, attracting a mate, and making flight possible. However, such a highly sophisticated covering requires constant care. A bird looks after its feathers incessantly, maintaining their flexibility, exceptional strength, and water repellence by reattaching their tiny barbed hooks, called barbicels, to each other, thus making sure each feather remains seamless and intact. A bird's survival depends on the integrity of its plumage.

Feathers and flight are so intimately interconnected that when the physical function falls into disuse, feathers disappear. Penguins' feathers are so altered that they resemble scales, while large running birds such as ostriches and their relatives are covered with downy feathers which, though attractive, have become far less efficient from a technical point of view. In the case of the cassowary, that helmeted inhabitant of the deep Papuan forests, its mere three or four wing flight feathers have been reduced to horny spines at the extremity of each wing, giving a new role to this multitalented organ: that of defensive weapon.

Although the power of flight is the first characteristic that comes to mind in seeking a definition of the bird class, it is not enough on its own. Some birds are incapable of flight, while mammals such as bats, some fish, and most insects are vigorous flyers. On the other hand, birds are alone in having bodies covered with feathers, which are crucial for their survival.

An Architectural Wonder

A feather's basic structure consists of a shaft, which comprises a calamus and a rachis. The calamus is the horny quill whose end is buried in the skin. The rachis, which is filled with white pith, bears branches known as barbs on either side, rather like the teeth of a comb. These barbs, which are miniature feathers themselves, hook themselves to each other by means of barbules, which are themselves hooked to each other by means of barbicels. The entire structure is made of ker-

atin, the molecule that forms the hair and claws of mammals, the scales of reptiles, and the hair and nails of humans. However, this chemical similarity does not explain how dinosaurs' scales were transformed into feathers. The oldest known bird, *Archaeopteryx*, already had true "modern" feathers, and no intermediate stage between scales and feathers has yet been discovered.

Feathers develop in the same way as hair and scales: from a papilla on the skin. The old feather needs to fall out before a small shaft—a tiny shred within which the structures of the feather are rolled up in a spiral—sprouts in its place. The future feather gradually emerges from this tube, whose end then fuses with it, giving the feather its final form.

Different Feathers Do Different Jobs

Feathers come in two basic forms: classic feathers, called quill feathers—the category to which all the feathers that are visible on a bird belong—and down, which consists of tiny feathers hidden underneath.

The main difference between feathers and down is that the latter has no hooks on its barbules. That is why down lacks the smooth, orderly appearance of other feathers; however, its apparent untidiness is very good for insulation. Down's primary role is to form a thick insulating coat, which allows birds to keep their body temperature at about 105.8–107.6 °F (41–42 °C). This high temperature is the result of the high metabolic rate essential for flight. The down's fluffiness allows air to be trapped between its ruffled barbules. This is why a bird fluffs up its feathers when it is cold, to trap a thicker layer of air between its body and the outer covering of feathers, which act like the tiles of a roof. This air cushion also keeps rainwater out, making it run off in droplets, and increases the buoyancy of water birds.

Although their primary function is to provide effective insulation, feathers are also indispensable for flight. Without quill feathers, birds could not fly. Long and strong, quill feathers have an aerodynamic profile ideal for traveling through the air. Apart from the feathers that cover a bird's body, quill feathers come in two forms. Rectrices (from the Latin *rector*, one that directs) form the tail, steering and stabilizing the bird in flight. As their name indicates, they act as guides. Then there are the wing flight feathers, which are divided into primaries, secondaries, and tertiaries, depending on where they are attached, and which propel the bird through the air. Their perfect upkeep is vitally important. Damaged flight feathers that have lost their cohesion can keep a bird from flying. However, so efficient is the barbicels' hooking mechanism that a bird can easily reattach them to each other with two or three strokes of its bill. Careful observation reveals that birds do this constantly.

Opposite

Northern cassowary

Casuarius unappendiculatus

Papua New Guinea

Because they are not used for flight, ratites' feathers have lost their barbules. They resemble the down of a chick and serve the sole function of maintaining a constant body temperature. Their wing flight feathers, reduced to the shaft alone, are sturdy spines that offer the bird protection as it runs through the forest and that can be used as deadly weapons.

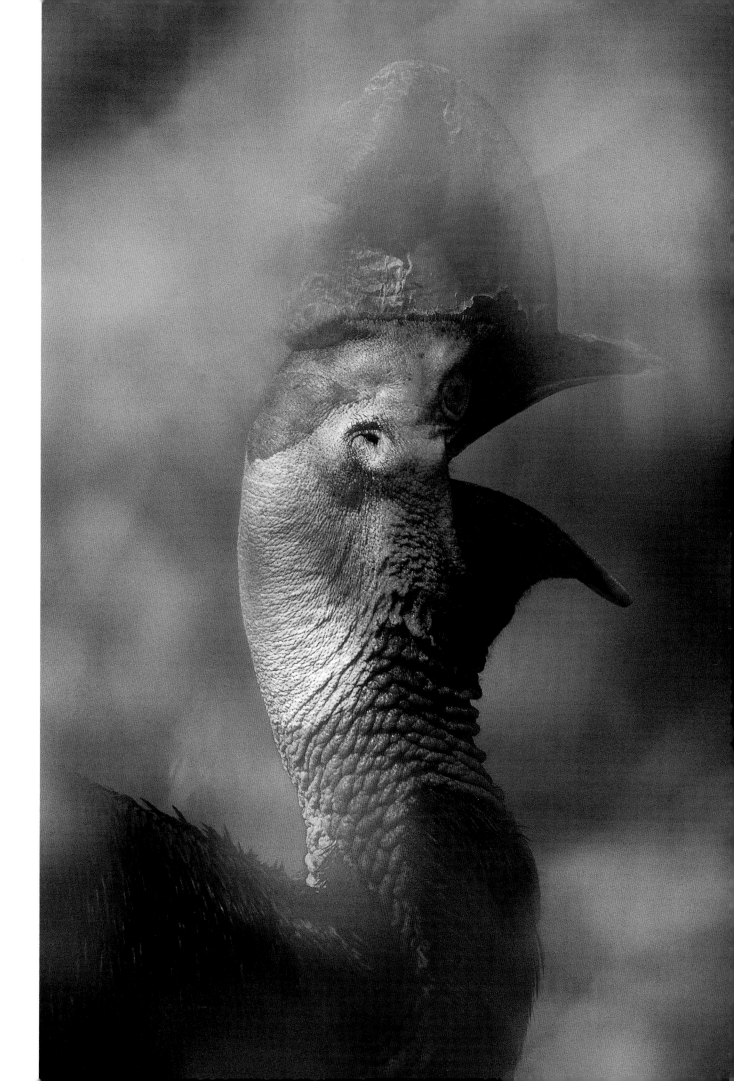

Opposite

Southern crowned pigeon

Goura scheepmakeri

Papua New Guinea

Crest feathers are used only for display. Because they are not used for flight, they have no barbules, which makes them look even more aerodynamic.

Pages 60 and 61

Barn owl

Tyto alba

Touraine, France

The disc-shaped arrangement of feathers around a nocturnal raptor's face directs sound waves to its ears, which are placed on either side of its head.

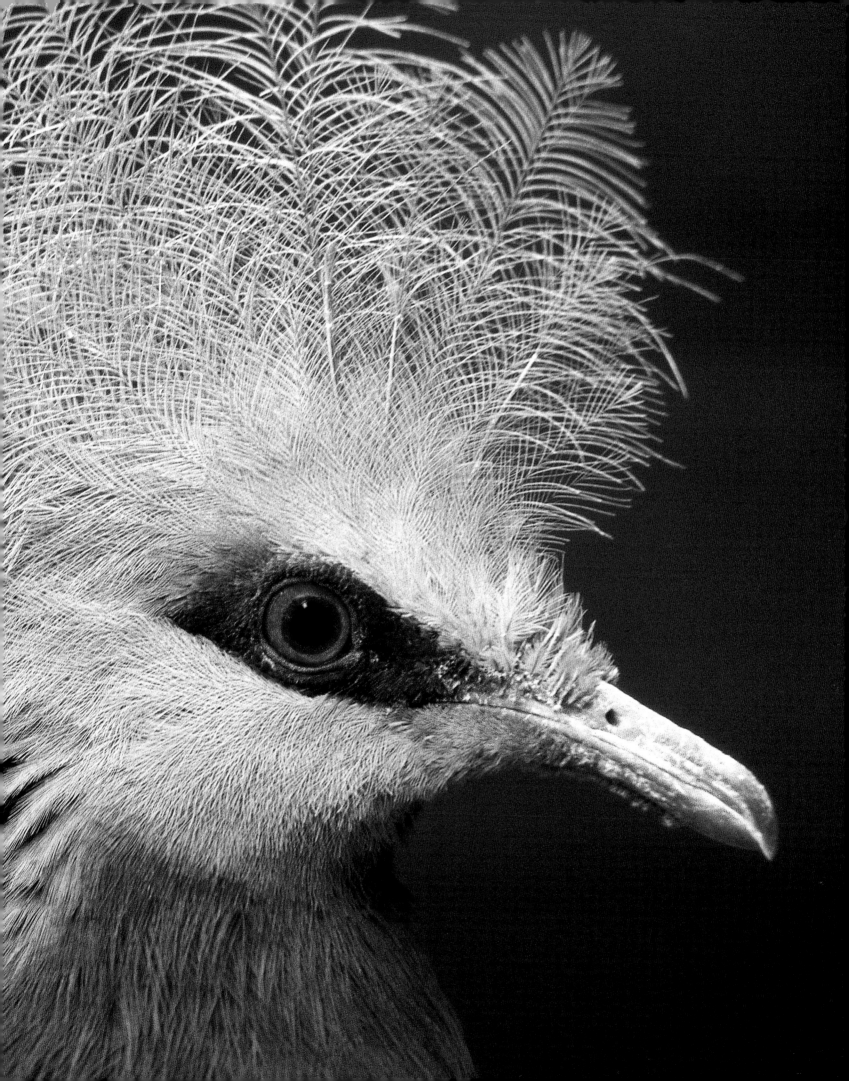

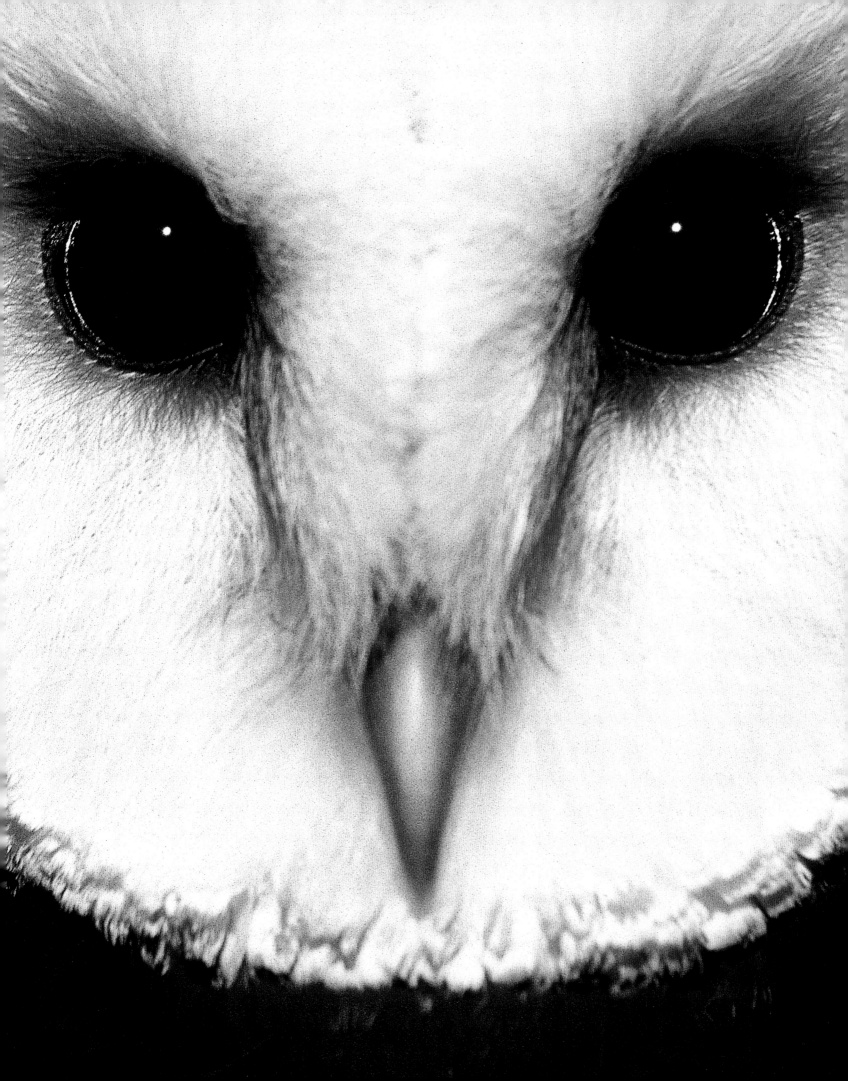

1. Pheasant coucal
2. Great argus
3. Reeves's pheasant
4. Silver pheasant
5. Satyr tragopan
6. Common pheasant
7. Lady Amherst's pheasant
8. Eurasian jay
9. Reeves's pheasant
10. Himalayan monal
11. Scarlet macaw
12. Ocellated turkey
13. Ocellated turkey
14. Blue-and-yellow macaw
15. Great argus

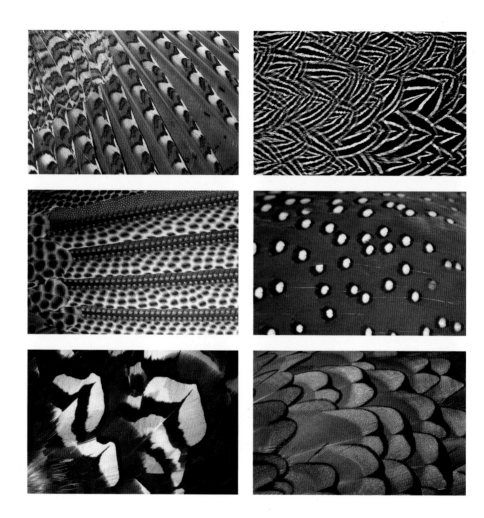

1	4
2	5
3	6

7	10	13
8	11	14
9	12	15

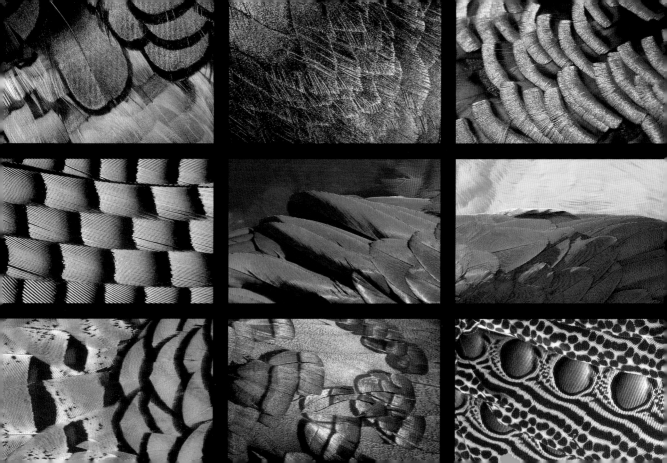

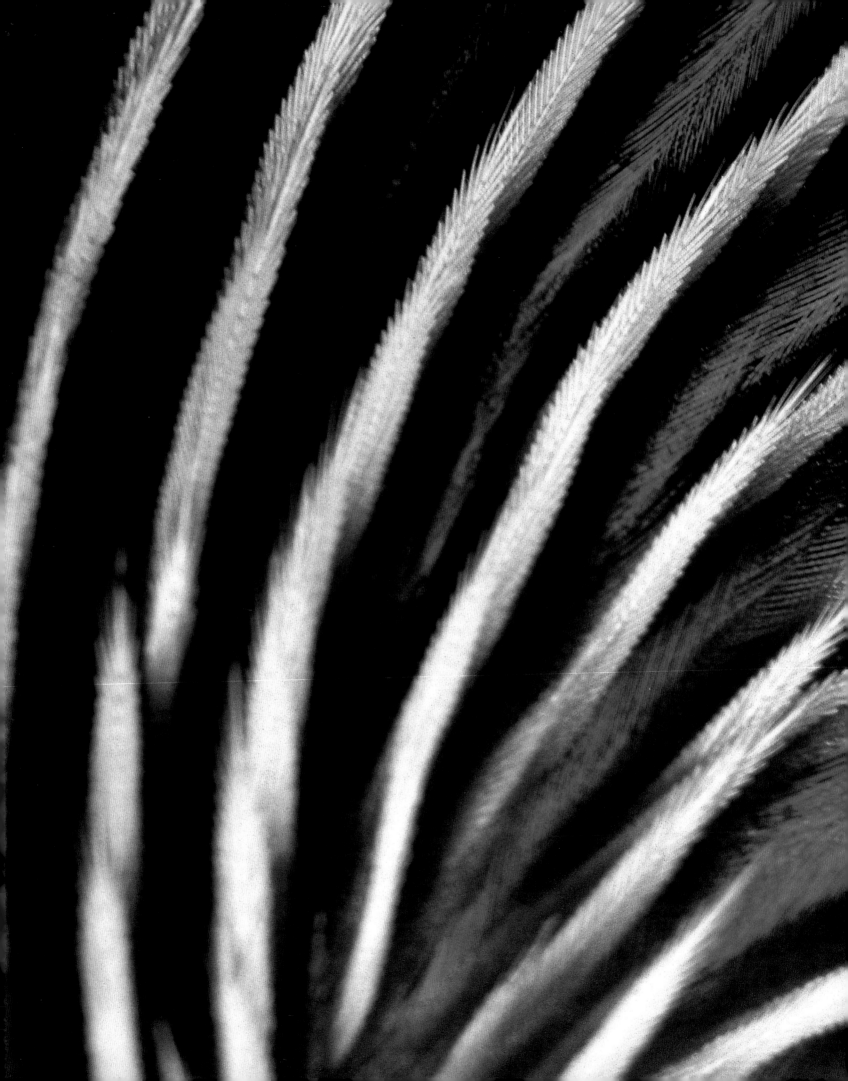

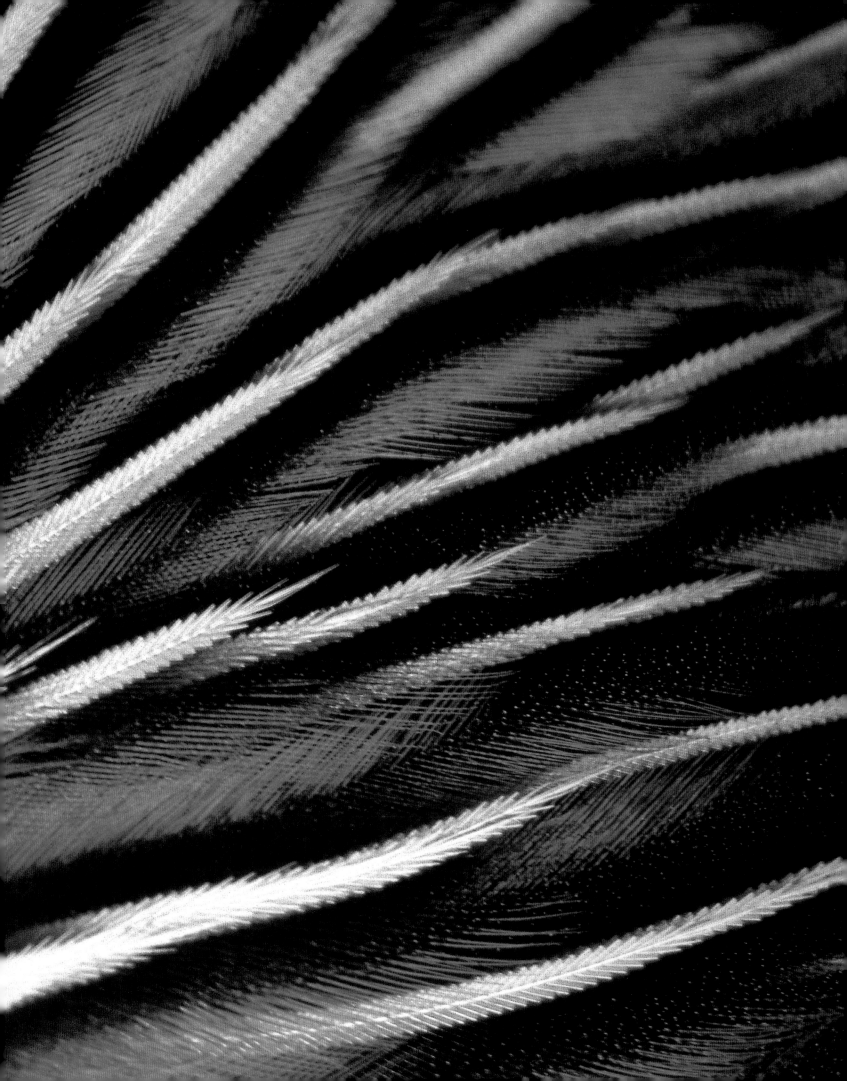

A Third Type of Feather

In addition to these two main categories of feather, there is a third type that, though extremely unobtrusive, is common to all birds. This is the filoplume. As its name suggests, the filoplume is like a thread with a tiny feather at its end. Its function remained a mystery for a long time: apparently, this feather acts as an indicator that gauges the tidiness of a bird's plumage. Because it is affected by air currents during flight, it also helps the bird adjust its plumage according to the turbulence it encounters. This feather's unobtrusiveness masks a fundamentally important role.

There are also some specialized feathers that have nothing to do with either insulation or flight. The breasts of some species of grouse are covered with highly absorbent curled feathers. These allow the bird to carry water, which it has picked up by sitting in it, back to its chicks in the nest. This is the technique used by the namaqua sand grouse, which soak their belly feathers in order to quench their chicks' thirst.

A Heavy Burden of Feathers

With penguins as the exception, birds' bodies are not entirely covered in feathers. They grow in zones: on the head, the edge of the wings and end of the tail, down the back, and on the rump on the bird's upperparts; and on the neck, sides of the belly, and around the cloaca on the underparts. Areas of bare skin are called apteria, while those with feathers are called pterylae. Despite this, the body appears to be entirely, and evenly, covered with feathers, for these lie uniformly on its surface. This economy saves some weight without impairing either flight or insulation. Indeed, it is hard to conceive that the feathers on a bird's body are so dense that they often weigh more than its skeleton—sometimes twice as much!

The feathers' size and number vary among species and according to the size of the body that needs to be covered. A hummingbird has about 1,000 feathers, while a swan has 25,000, of which 80 percent grow on its neck.

Featherless in the Nest

While incubating, most birds develop brood patches—areas of bare skin richly supplied with blood vessels—on the breast and belly. A bird transmits its body warmth by applying these patches directly to its eggs. Down has such insulating properties that if eggs were to come into contact with only the down, they would not receive the warmth they need to develop. These properties are also the reason chicks are thickly covered with down when they are born, the only exception being the chicks of species whose parents continue to brood them. In all species, down is always the first feather type to grow, covering the young birds to insulate them from the cold.

Pages 64 and 65

Vulturine guinea fowl

Acryllium vulturinum

Kenya

This magnificent dark blue, striated with black and white, is characteristic of the vulturine guinea fowl. Both males and females sport the same dazzling colors—a rarity in the family of gallinaceous birds, which comprises domestic fowl, pheasants, and peacocks, and in which the males are usually more brightly colored.

Opposite

Victoria crowned pigeon

Goura victoria

Papua New Guinea

Both sexes of this crowned pigeon have the same plumage, but only the male raises his crest to woo his partner during greeting displays.

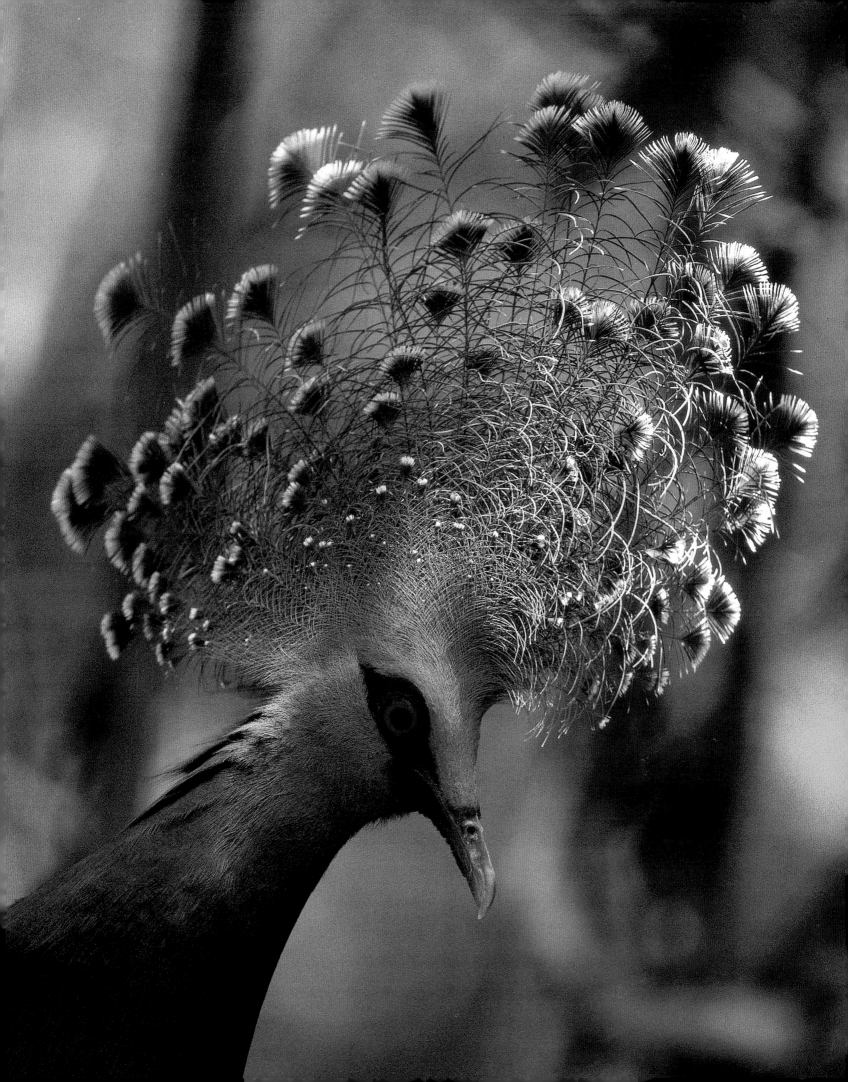

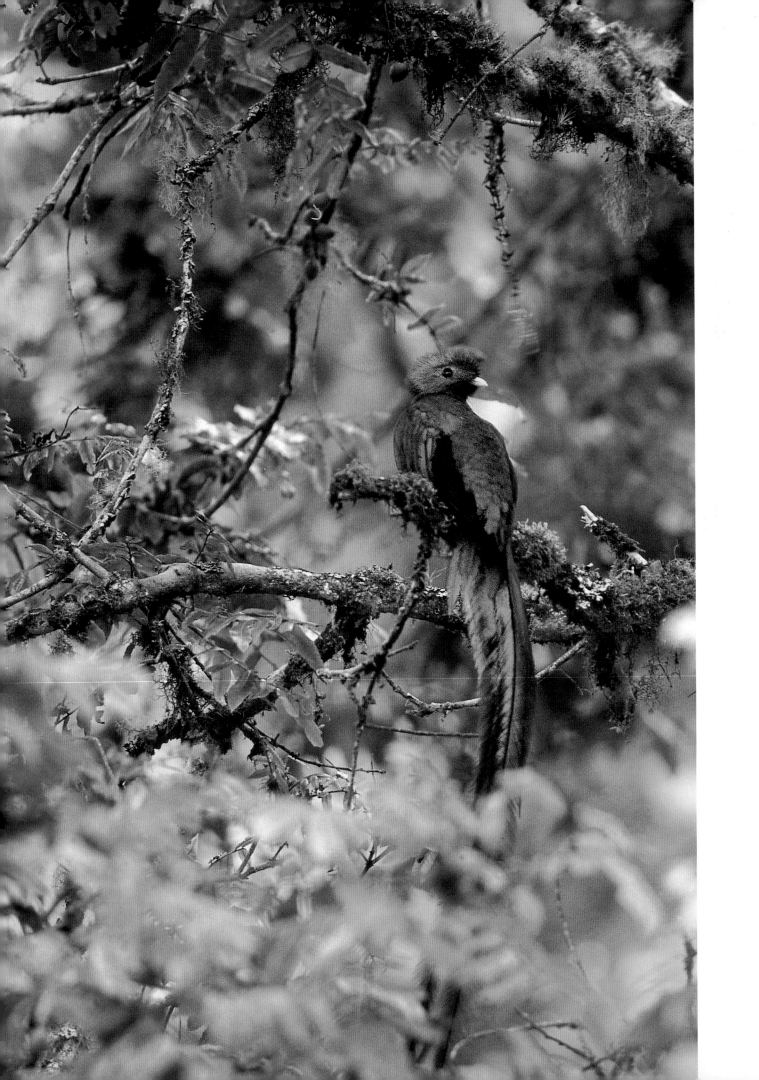

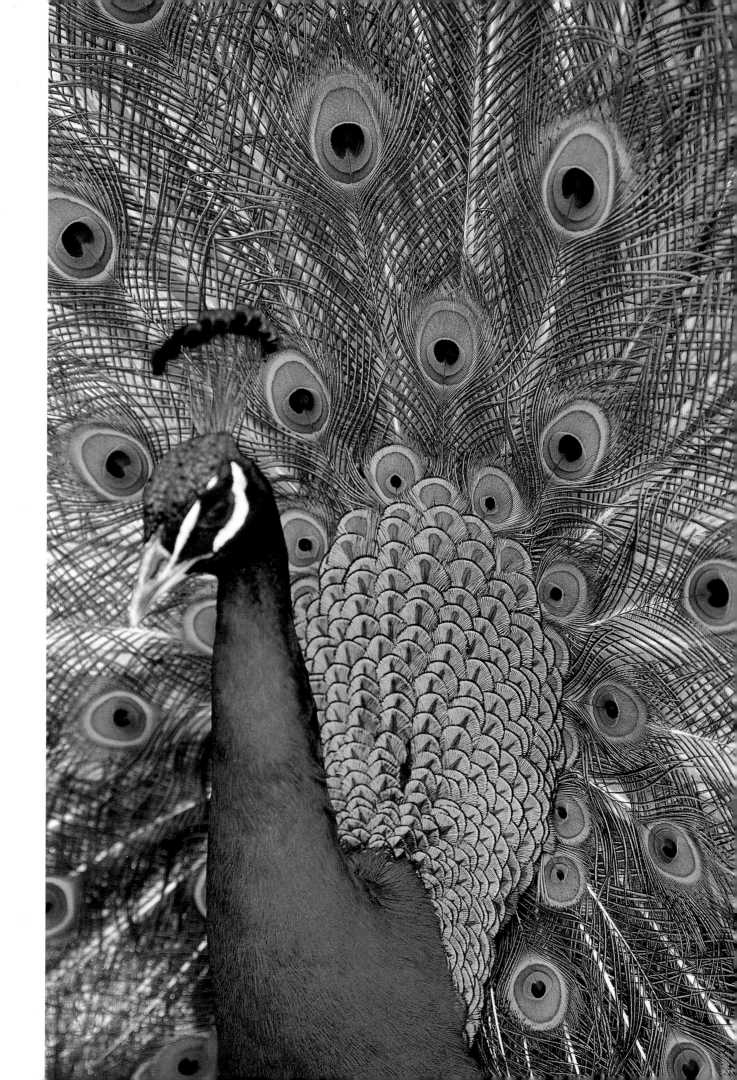

Fun at Bath Time

A beautiful suit of clothes deserves to be looked after and kept clean, and the only way to get really clean is to bathe. Bathing not only livens up the feathers, it also moistens them, making it easier to apply a bird's natural oil. Swifts, owls, kingfishers, and hummingbirds dive directly into the water and then fly to a convenient place to finish their toilet at leisure. For most small passerines, a puddle is enough, and they can often be seen in one, splashing themselves liberally. Water birds such as ducks, swans, grebes, and boobies do the same, violently flapping their wings to soak themselves more thoroughly—a process that is never discreet. They turn over on their side, dive, and perform somersaults, throwing up showers of spray. No one who has watched a bird bathing can fail to be struck by the apparent joyfulness of the scene. For bathing is not only hygienic, it is also enjoyable. When not bathing, birds also like to take a shower by spreading their wings in the rain or wetting themselves in the morning dew.

There are exceptions, however. Gallinaceous birds, which include chickens, pheasants, and peacocks, take only dust baths. Nevertheless, they wallow in dry mud or sand with the same enjoyment as those who bathe in water. Other species take dust baths too, such as diurnal and nocturnal raptors, the hoopoe, nightjars, and some passerines. Although the function of such baths has not been conclusively identified, it is thought that they help to remove parasites and reduce the itching they cause.

Among birds, the most unusual bath type is the ant bath, which is limited to a few species of passerines. There are two forms. In the passive form, the bird sits on an ants' nest and disturbs it sufficiently for the worker ants to invade its plumage and liberally douse the intruder with formic acid. The active form consists of the bird actually picking up an ant, or ants, in its beak and passing them over its wing and tail feathers.

Though there is no accepted explanation for this behavior, formic acid does have insecticidal properties, and even if it did not kill all insects, it would stun them sufficiently to make them accessible while the bird is grooming. It is also believed that formic acid acts as a treatment for the important wing and tail flight feathers, which are directly affected by the active form of bathing. Tame birds do the same with products containing sulfur, and it is not uncommon to see starlings, sparrows, or crows fly over chimneys to gulp down the smoke with their gaping breaks, and then spit it out under wings or ruffle their plumage with it as during an ant bath.

Oil or Powder? A Problem of Grooming

Birds as a whole have sacrificed a great many glands in their quest for lightness. They possess neither sebaceous nor sweat glands, but they do have a large gland, the uropygial gland, situated at the base of the tail. This produces an oily liquid that birds apply liberally to their plumage for waterproofing. Species that lack this gland, such as parrots, need to use a different technique to clean and waterproof their feathers. Their thick down, which grows continuously, crumbles into

Page 68

Resplendent quetzal

Pharomachrus mocinno

Costa Rica

The male quetzal's wonderful breeding plumage is adorned by tail feathers twice the length of its body. This bird was sacred to the Aztecs, who saw in it the incarnation of the powerful god Quetzalcoatl, the plumed serpent, and its feathers were more valuable than gold. The penalty for killing a quetzal was death.

Page 69

Blue peafowl

Pavo cristatus

India

The peacock's famous tail is in fact a train. The bird's true tail acts as a support for this magnificent adornment, which weighs only a few hundred grams. At nearly 5 feet (1.5 meters) in length, the train proudly displays 100 or so "eyes" said to have hypnotic powers.

Opposite

Souimanga sunbird

Nectarinia souimanga

Aldabra Atoll, Indian Ocean

Sunbirds are the Old World equivalent of the hummingbird. Their colors, which are as brilliant as those of their American counterparts, are due to the refraction of light on their feathers.

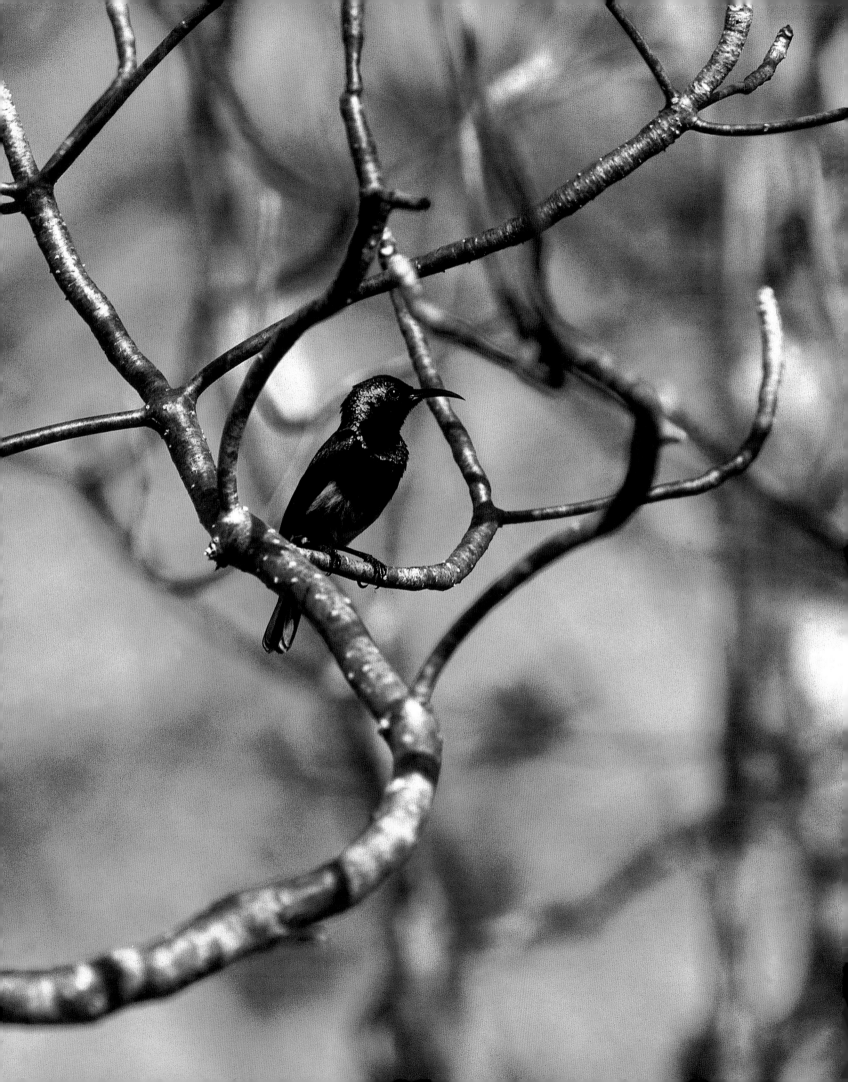

Opposite

Common pochard

Aythya ferina

Brenne, France

All birds need to bathe, even water birds, which splash about noisily. Bathing is essential to the upkeep of the feathers, which would otherwise lose their waterproof qualities.

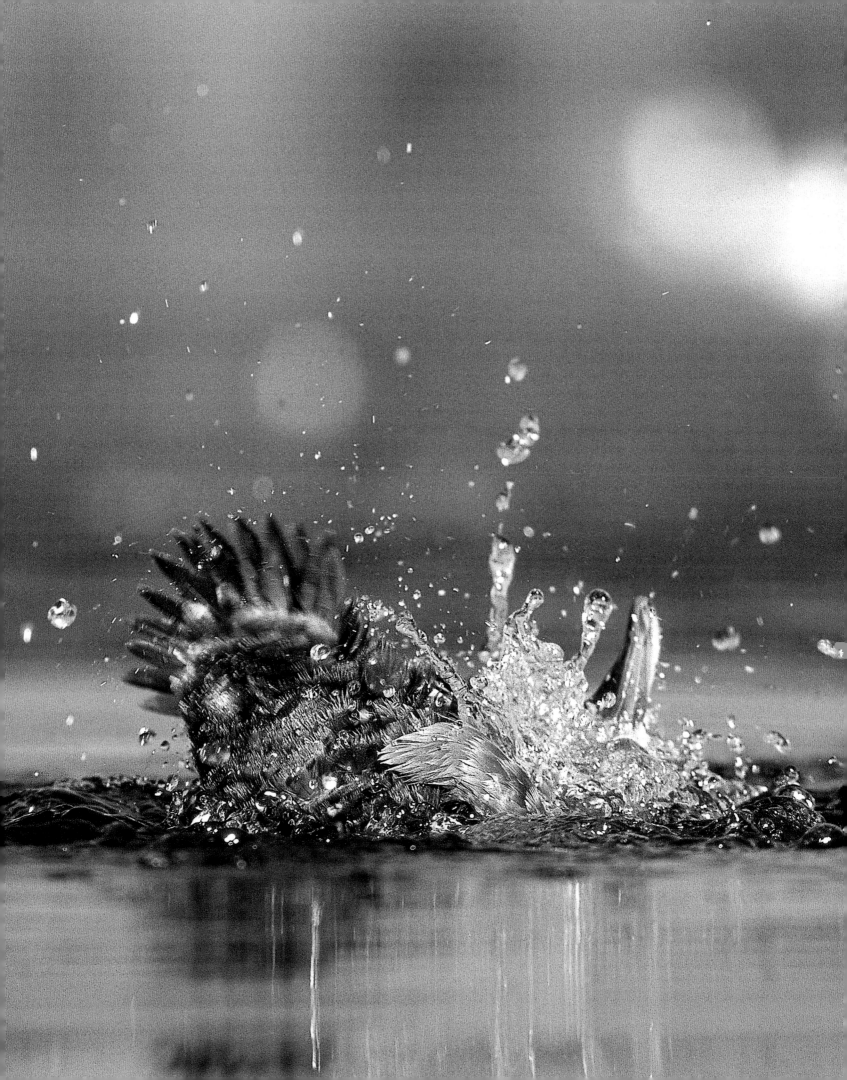

countless very fine particles, producing a dust that covers the plumage and prevents water from penetrating. Herons use the same system. They have feathers specially adapted for producing this powder. These quiver incessantly, and the powder thus produced settles on their body, where it absorbs impurities such as oil and slime from the fish they catch. The heron then smoothes its feathers with its bill, removing the powder that is now impregnated with waste.

Where grooming is impossible—for example, on the head and the upper part of the neck—a bird will scratch with its feet. Some species are equipped with a claw whose inner edge is toothed like a comb. In the case of birds that form pairs, partners often finish off each other's toilet in inaccessible places.

The sun, too, is a precious ally, for birds love sunbathing with their wings spread wide. It is not known whether they do this because it cools them down by allowing air to circulate all around the body or whether they simply find it enjoyable. It may be that ultraviolet rays have an effect on sebum or on external parasites. One thing is certain, however: large birds that glide long distances, such as vultures, pelicans, and storks, sunbathe a great deal, while those that practice flapping flight, such as herons, swans, and cranes, never do. A long period of gliding flexes, or curls, the flight feathers of the wing. It has been established that a curled-up vulture's feather will straighten in four or five minutes of exposure to the sun, as opposed to two or three hours if the bird remains in the shade. It is true that albatrosses, which are magnificent gliders, do not sunbathe—but neither do their quill feathers bend.

Molting: A Necessary Evil

With the exception of the powdery down that grows continuously, feathers are dead tissue and are regularly replaced. New feathers push the old ones out from the follicle from which they sprouted. In general, the wings and tail are the first to molt, followed by the body feathers. Penguins, whose extreme environment does not allow them to live uncovered, only molt when their new feathers have already grown in, thus keeping them permanently covered in a warm coat.

Molting of the wing's flight feathers considerably impairs a bird's flying ability. In some species this molt prevents flying altogether, and these birds must remain grounded for a few weeks while the new feathers grow. Ducks, geese, swans, grebes, rails, and loons do this, taking refuge during this time in safe places that are rich in food, such as marshes and large coastal bays. The males' plumage becomes dull during this period and resembles that of the female, which is why the process is known as "going into eclipse."

Molting uses up enormous amounts of energy, both to replace lost body heat and to produce the protein needed for new feathers to form. For this reason, most birds molt outside taxing times such as the breeding season, migration, or winter food shortages. However, some species molt precisely during the breeding season. Pelagic birds such as the storm petrel, for example, cannot afford to molt while wandering the oceans. They run fewer risks if they replace their feathers when looking after their brood and confined anyway to the land or coastal waters. Loons molt on

Opposite

Chinstrap penguin

Pygoscelis antarctica

South Shetland Islands, British Antarctic Territory

Penguins' feathers are unique—a result of the harsh climate in which these birds live. They are the only birds whose bodies are completely covered with feathers, which are thick and closely packed together. During molting, feathers drop off only after their replacements have grown, thus keeping the bird permanently covered in its warm coat.

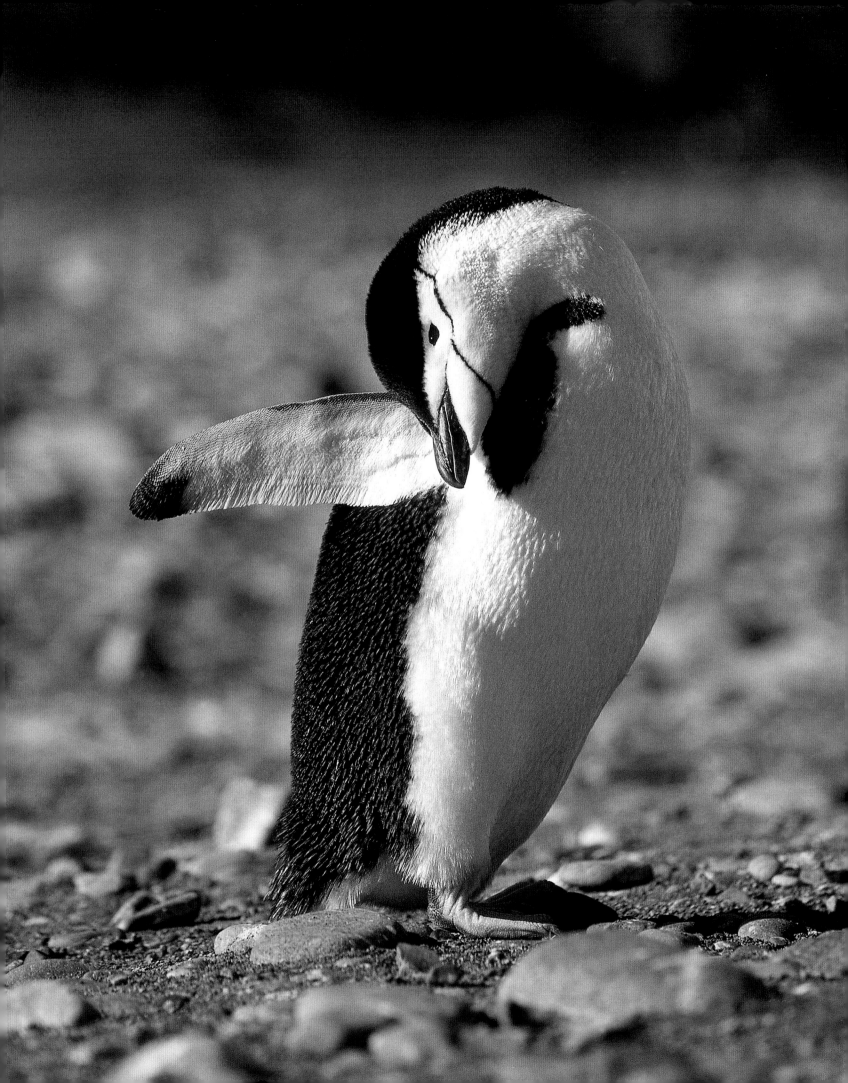

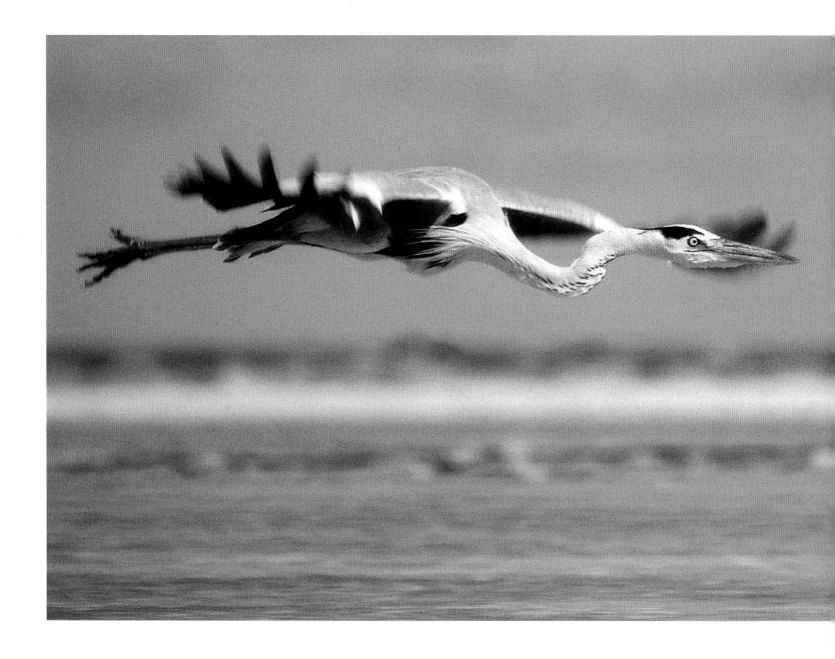

migration. Since molting deprives them of flight feathers, they are forced to migrate by swimming, which they do during the coldest months of the year. Under such conditions, meeting an oil slick clearly means certain death.

Brilliant Colors: A Mirage

Birds are adorned with the most improbable colors thanks to three distinct mechanisms: pigmentation, interference, and diffraction.

Pigments are of various kinds. Melanic pigments are produced by the skin in response to hormones. They give feathers their dark color and strengthen them. Melanin-rich feathers wear out less quickly, which is why wingtips are often black. Red, orange, and yellow are produced by carotenoids, pigments a bird obtains from food and uses unprocessed.

Above
Gray heron
Ardea cinerea
Cosmoledo Atoll, Indian Ocean

Although they frequent water and feed on fish, herons do not bathe. Instead, they have developed another technique to rid themselves of the slime that their struggling prey leaves behind on their plumage. In some areas of the heron's body, the feathers grow continuously and disintegrate at the ends, producing a fine talclike powder. The birds carefully dust their soiled feathers in this powder and then brush off the slime using a special "pectinated" claw.

Green, blue, and violet, on the other hand, are produced by the diffraction of light on the feathers, in the same way that the surface of a soap bubble gives off colors. The structure of the feathers' barbs reflects blue light waves, giving the feathers this color and an iridescent effect. If the feathers are also pigmented with melanin, the blue takes on a brown tinge, making an olive green. If they are pigmented with yellow carotenoids, the blue turns to brilliant green; if with red, violet is produced. When the barbs reflect all light frequencies, they are white; when they absorb them, the bird is black.

The magnificent colors of hummingbirds are not produced by pigments but by a phenomenon known as interference. In fact, the only color in a hummingbird's feathers is black, but it is overlaid with a layer of colorless, prismatic cells arranged in such a way that they refract and reflect light. The cells' position changes with movement, breaking up the sun's rays, and the feathers glow with countless colors that they do not actually contain.

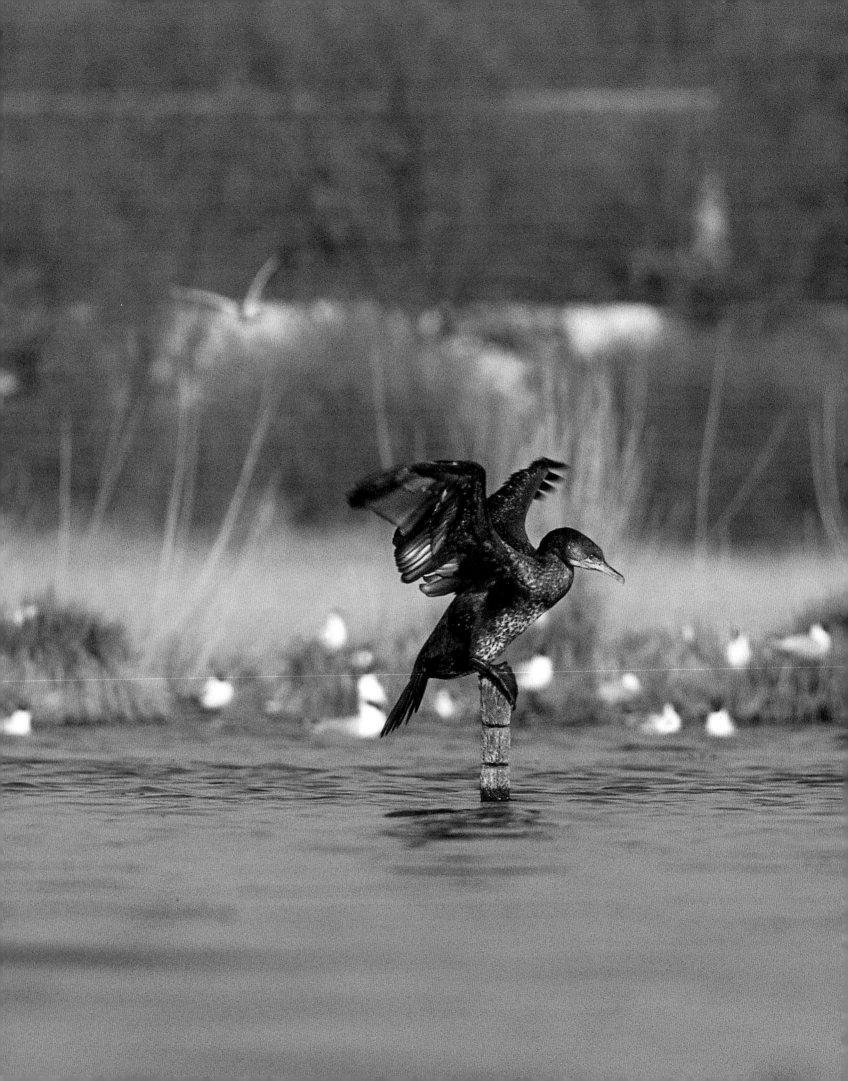

Feathers: A Technological Marvel

A bird does not acquire its adult plumage until it reaches full sexual maturity. In most cases, its first breeding coincides with the beginning of its adult plumage cycle, which then continues for the rest of its life. Some birds reach this stage after one year, while others must wait several years before they develop the plumage of an adult. Many gulls and other seabirds pass through a whole series of plumages, each indicating the bird's exact age, before they reach the stage where they have one plumage for winter and one for summer, or breeding. This is perhaps the last on the list of functions fulfilled by feathers, but it is not the least: to deck the amorous bird in a wonderful courting costume; to encourage it in its quest for seduction.

Pages 78 and 79

Cormorant

Phalacrocorax carbo

Brenne, France

Unlike those of most water birds, the cormorant's feathers are not waterproof. After a short time under water, the bird gets soaked to the skin and must dry itself off in the sun.

Opposite

King penguin

Aptenodytes patagonica

South Georgia Island, Antarctica

The thick brown down on this chick is typical of the species. Beginning at the bottom, the young birds gradually shed their down once their permanent feathers—small, stiff, and overlapping like tiles on a roof—have fully grown in. This is why immature birds can be seen in penguin colonies with brown, tousled heads and the black-and-white bodies typical of adults.

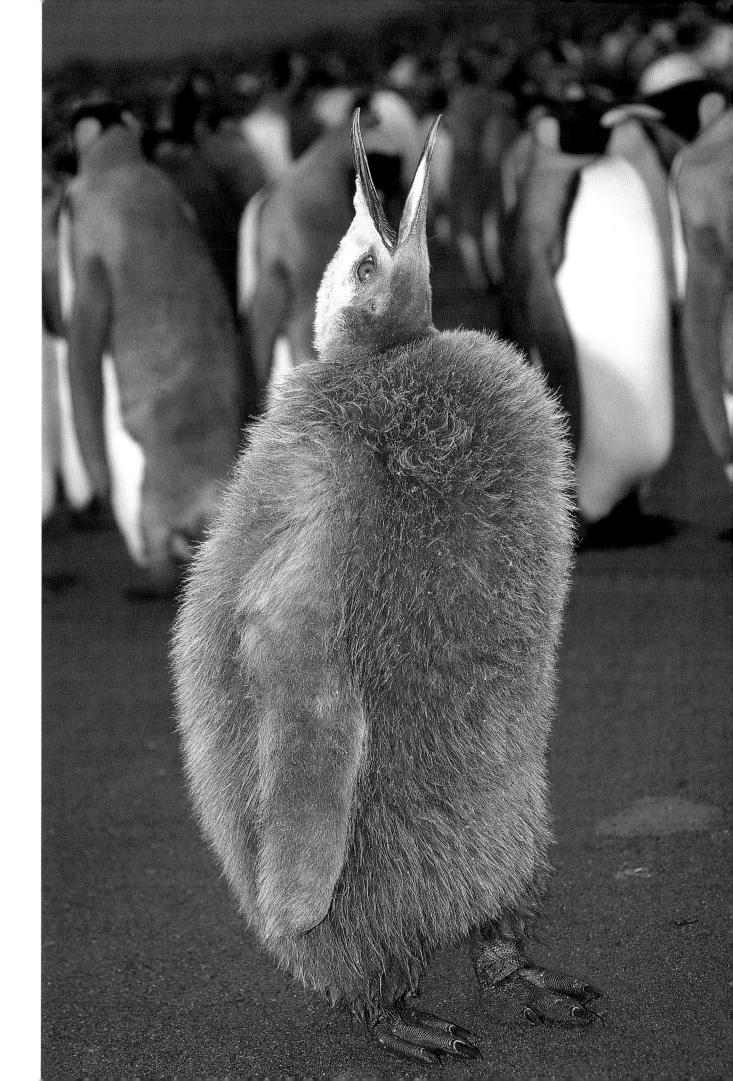

The Essence of the Senses

To survive, to grow, to exploit resources; to thrive, eat, and avoid being eaten—these are the goals of all animals on the planet, without exception. Aided by the power of flight, birds rise to this challenge armed with an arsenal of senses that, while fundamentally the same as those of mammals, do not necessarily function in the same way. With a brain designed for performing aerobatics, and vision whose perfection is unparalleled in the animal kingdom, birds hold all the trump cards to allow them to conquer the world and defeat its difficulties.

Flight alone requires four senses: balance, sight, touch (which tells the bird how air is flowing over its feathers) and proprioception (which tells it the relative position of its various organs at any given moment).

The search for food is the other intensive activity that places demands on acute senses. Sight and touch—the latter now using the tip of the bill—are those most involved, followed by hearing, taste, and smell. It is commonly believed that birds have no sense of smell. This is wrong. Some have such a keen sense of smell that they can detect a source of food within a radius of a few miles. As for their hearing, it is as sharp as their eyesight.

The list is not complete without echolocation, that rare sense developed by animals that live in dark caves, which birds share with most cetaceans and with highly specialized mammals such as bats. The echo of their own voice provides them with information on obstacles or the whereabouts of prey. The perfection of their senses is what makes all birds an inexhaustible source of amazement.

We live in a world overflowing with information. Our senses capture data, analyze them, and understand them. By telling us about our environment, they allow us to respond to it by adapting to the various situations that constantly face us. Light, sounds, smells, and warmth are just some of the factors that act on the sensory organs. The keenness with which they are perceived determines an organism's sensitivity. It goes without saying that a high level of sensitivity is an advantage; if too high, however, it can also become a true handicap. If we were completely sensitive to all the stimuli with which our environment constantly bombards us, our perception would be polluted by so much background noise that communication would be disrupted. Proportion is needed in everything. The senses of a living thing must be suited to its way of living and reacting to a given range of stimuli. In birds, all senses are geared to the ability to fly. In mastering the air, the ability to balance is fundamentally important. The seat of this sense of balance is in a bird's highly developed cerebellum. Albatrosses and other petrels, which are great gliders, have a sort of extendable pocket on either side of their nasal septum that tells them about variations in pressure. This sense, as specialized as it is acute, allows them to glide with great mastery despite the ocean turbulence around them.

Piercing Eyesight

Birds have big eyes: the bigger an eye, the more visual cells it contains, and the better it sees. A golden eagle has larger eyes than a human. Indeed, the size of a bird's eyes is limited by only one factor—weight. Because eyes are placed far forward in the head, too much weight might upset balance in flight. This is why the ostrich can afford to be the best endowed, in this area, of all members of the animal kingdom. With eyes five times the size of ours, carried at almost 8 feet (2.5 meters) above ground, it is truly the sentinel of the savannah, alerting its grazing neighbors to the slightest danger. Needless to say, such instruments of surveillance are never hidden in the sand. We can leave legend to its flights of fancy for, where the winged community is concerned, reality is often far more spectacular.

A bird's position in the food chain determines the placement of its eyes. Predators need to pinpoint their prey. Having eyes at the front of their head gives them binocular, and therefore three-dimensional, vision. Prey species need to see all around them, a task they accomplish perfectly with eyes set on either side of their head to give them a huge field of view. The Eurasian woodcock, with its field of binocular vision broader to the rear than to the front, is an extraordinary example. Situated completely to the sides, its eyes allow the woodcock to see all around itself without the slightest movement of its head. Since it feeds on worms that burrow under the forest floor, it can keep an eye on its surroundings while searching for food. So far apart are the woodcock's eyes that they occupy the place a bird's ears would normally be, and its ears have had to relocate farther down.

Lateral eye placement does have a drawback, however: since it gives only monocular vision, it does not allow three-dimensional perception. Birds solve this problem by moving their heads from side to side, thus viewing objects from different viewpoints. This is probably why chickens and pigeons are constantly nodding their heads—a type of behavior that can be observed in many similar species.

Night Vision

The tawny owl, barn owl, and eagle owl are nocturnal, and their eyes are a hundred times more sensitive to light than those of the diurnal pigeon. Their retina—the eye's sensitive membrane—contains far more photoreceptors than those of other birds. Moreover, it combines the signals from several adjacent cells, forming a broad detector. While these cells are highly specialized in the perception of light, however, they give poor visual acuity and no color perception. In other words, this heightened sensitivity is achieved at the expense of the ability to see fine detail—an effect further magnified by the fact that several groups of cells work together, merging information among them. The eyes of diurnal birds, in contrast, contain a large number of small cells that perceive light stimuli independently of each other. Acuity and sensitivity thus appear to be incompatible. Some predators get around this by means of an ingenious compromise: their retinas contain different zones with different specializations, one area being sensitive to light while another develops a high level of acuity.

Opposite

Great gray owl

Strix nebulosa

Northeast Europe

Nocturnal raptors have huge eyes that take up so much space in the eye sockets that the eye itself cannot move, forcing the birds to turn their heads. However, they can rotate their heads over 180 degrees, which gives them a very wide field of vision.

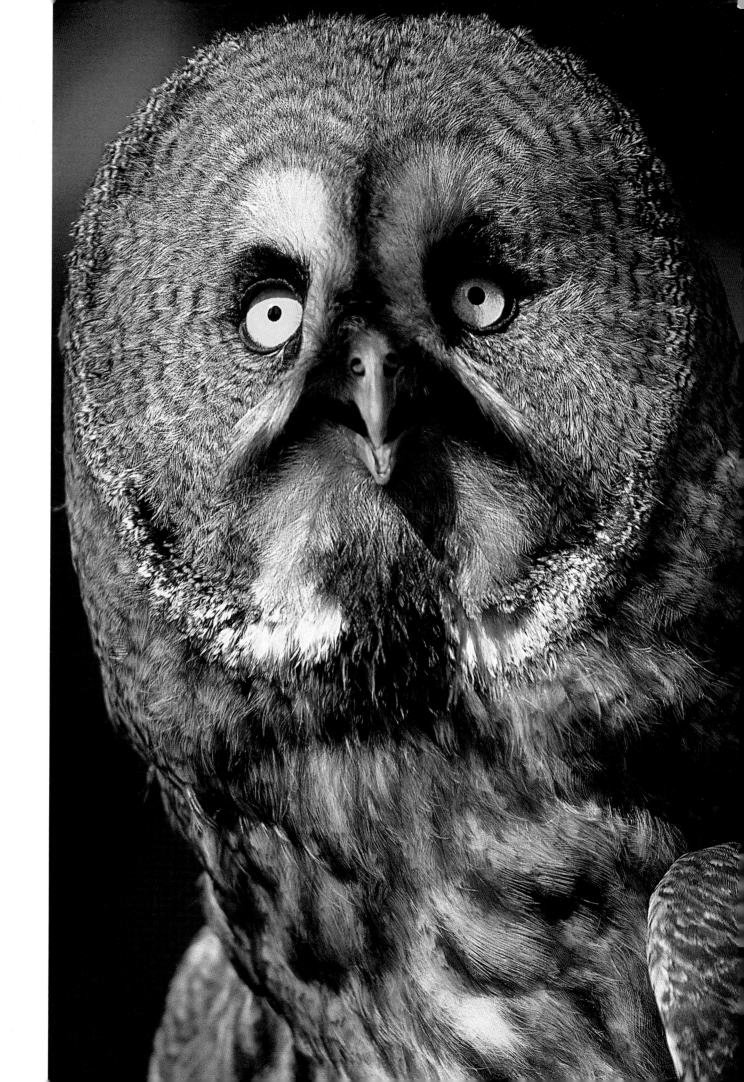

Opposite

Great crested grebe

Podiceps cristatus

Brenne, France

When under water, many diving birds improve their eyes' ability to refract light by covering them with a transparent nictitating membrane. This "third eyelid" enables them to be long-sighted and also protects the eye.

Pages 88 and 89

Green violet-ear

Colibri thalassinus

Costa Rica

Hummingbirds produce more energy in proportion to their body weight than any other warm-blooded organism. If a human used up as much energy as this winged jewel, and did not cool down by sweating, his or her body would reach a temperature of 750 °F (400 °C) and burst into flame.

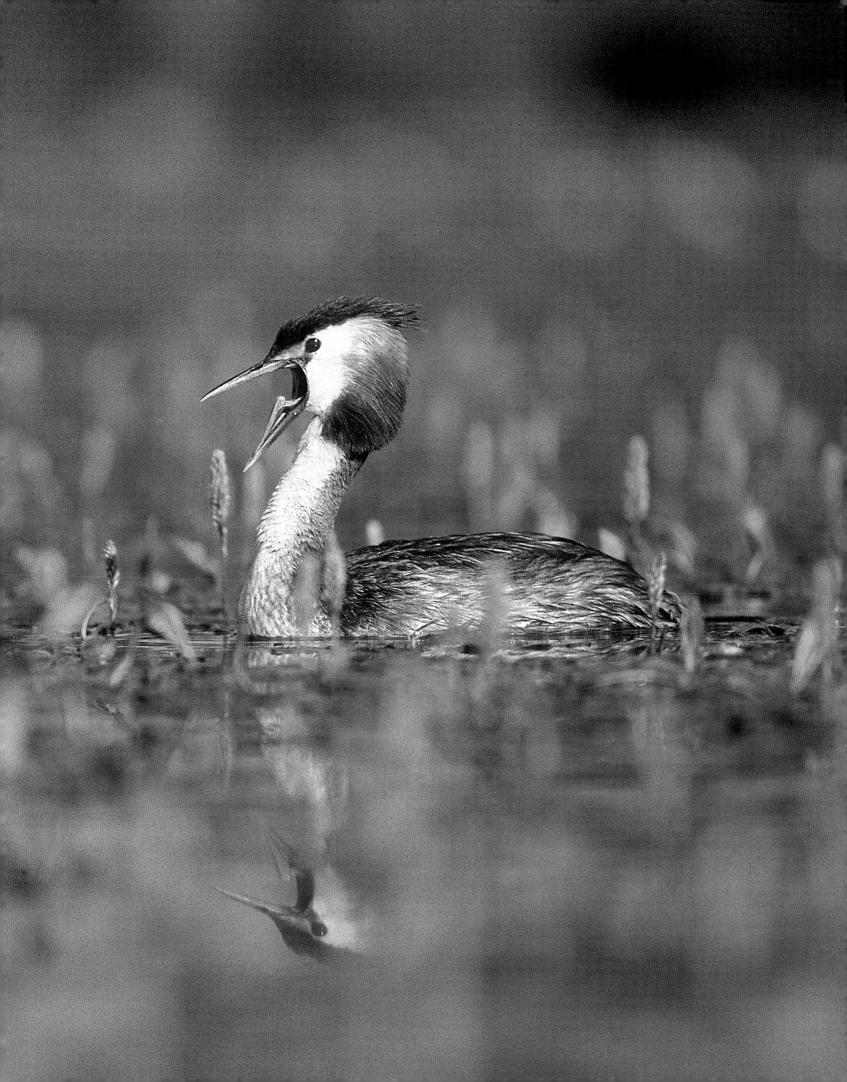

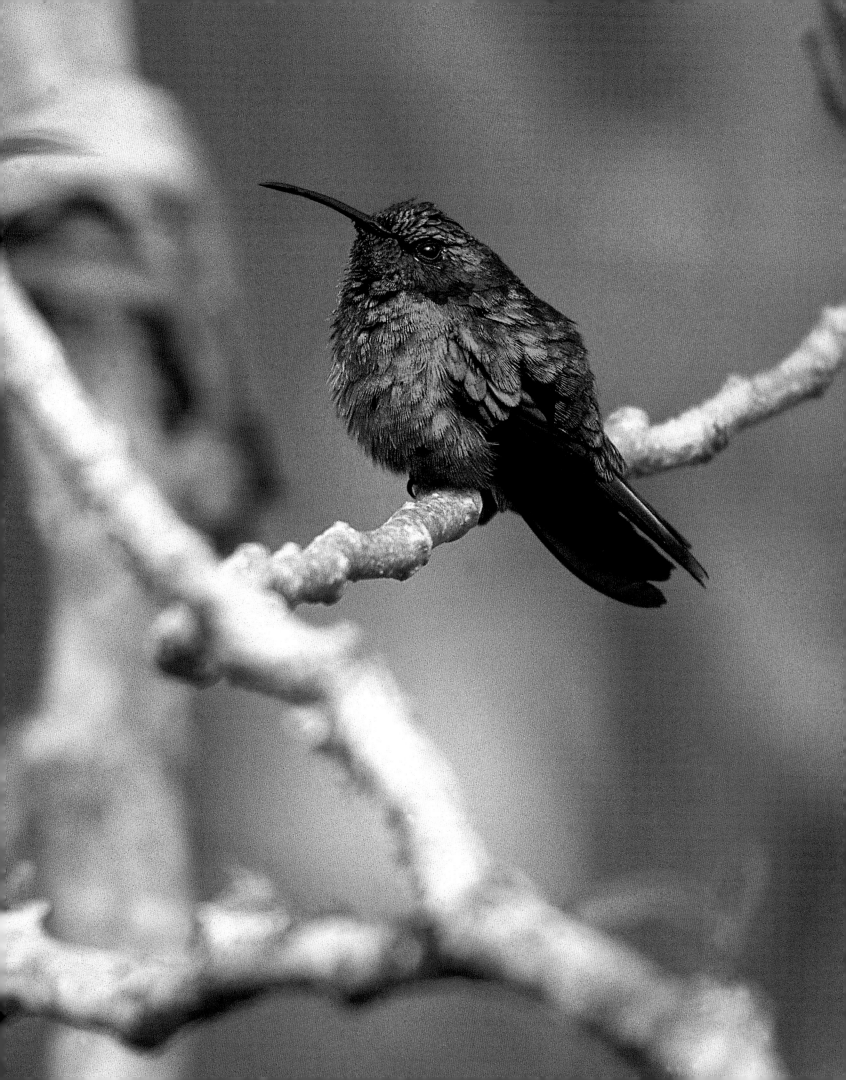

Accommodation, which allows the eye to see an object clearly whatever the distance, also demands great precision. An enveloping eye muscle makes this adjustment by modifying the curvature of the cornea, producing twice the efficiency of that in humans. Diving birds also have to compensate for the focusing problems encountered under water. They do this by using one of two systems: either they inflate part of the eye, or they cover it with a transparent third eyelid called a nictitating membrane.

Other secrets of bird retinas have been discovered recently. Most diurnal species possess cells sensitive to ultraviolet light. Scientists initially thought these might have a role in orientation, feeding, or group communication; however, it is in the very private area of sex that this type of "ultra" vision is most astonishing. To human eyes, the plumage of the blue tit shows no marked differences between male and female. This is an illusion, however. Since the birds are sensitive to ultraviolet light, they see each other very differently. Males have much more ultraviolet down their backs than females, which makes them stand out clearly. More astonishing still, females that choose males rich in ultraviolet produce more male chicks than other females. The one thing we can't say here is that love is blind.

Sense of Smell: Modest but Effective

For a long time it was thought that birds had no sense of smell. However, this sense has now been confirmed in a growing number of birds, working in such a subtle fashion that hitherto it had eluded even the closest observers.

The kiwi, that strange wingless bird of the New Zealand forests, is well known for using its sense of smell. With its nostrils positioned at the end of its bill, it can find worms buried in the earth by smell alone. Situated at the front of its brain, its highly developed olfactory bulb processes the smells perceived by the nostrils and transmitted via the olfactory nerve. Albatrosses, petrels, and shearwaters, which cruise the skies above the southern oceans, also have a highly developed olfactory bulb. These birds feed largely at night, and they return to their nests in darkness—sometimes total darkness—and always in windy conditions. This has led ornithologists to conclude that in the vast colonies of nesting birds, those returning from night hunts use their sense of smell to find their nests. Many experiments on pigeons have demonstrated that they, too, find their nests in this way. Deprived of the sense of smell, they lose their bearings. Transformed into flying rats by the dirt of large cities, these birds have still proved to be a mine of ingenuity. They possess a completely unsuspected sense, which allows them to measure and make use of the earth's magnetic field to find their way.

Other experts in smelling things out include vultures—especially the American species—which can locate a source of food exclusively by smell. However, it must be said that vultures' food generally gives off a powerful smell of decomposing flesh. The Senegal honeyguide is also talented in this department but in a rather more appetizing way. It is fond of beeswax and finds hives through their smell. This was first noticed by a sixteenth-century Portuguese missionary, whose church was invaded by honeyguides as soon as he lit candles made from natural wax. Sometimes science amounts to simple common sense.

Opposite

Secretary bird

Sagittarius serpentarius

Serengeti, Tanzania

A poor flyer but a strong runner, this cranelike raptor feeds on snakes—even the most poisonous, to whose venom it is not immune—overcoming them with its powerful bill and with wings outspread to avoid being bitten.

Page 92

Helmeted guinea fowl

Numida meleagris

Kenya

Having its eyes placed on the sides of its head gives this bird good peripheral vision, essential for prey species that need to see predators approaching from behind. However, it cannot perceive how fast approaching objects are moving. This bird's overgrown wattles are the result of genetic mutation due to captive breeding.

Page 93

Eastern rosella

Platycerus eximius

Tasmania, Australia

A parrot's tongue has ten times as many taste buds as a pigeon's. However, the sense of taste is one of the most difficult to quantify.

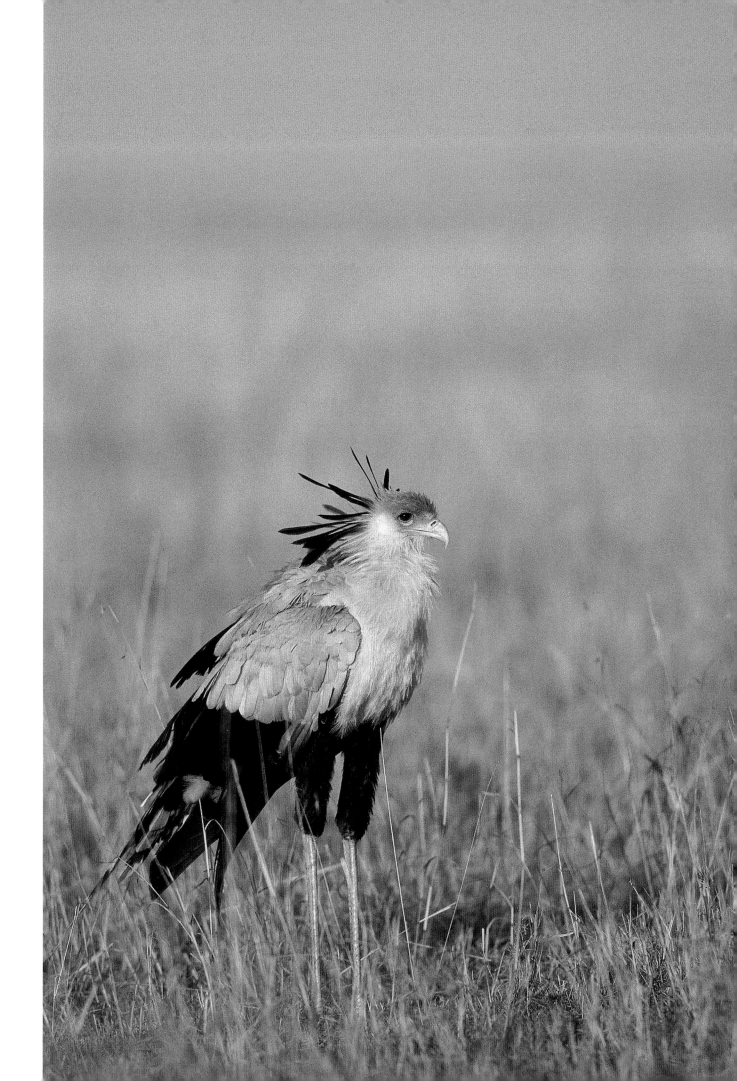

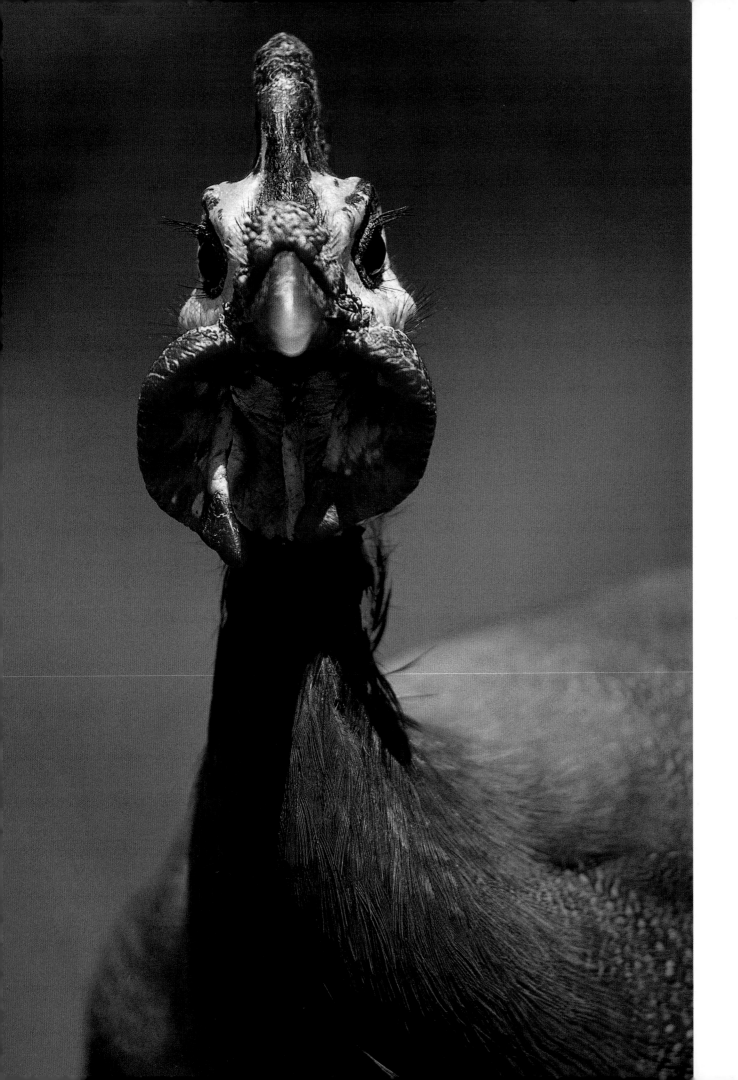

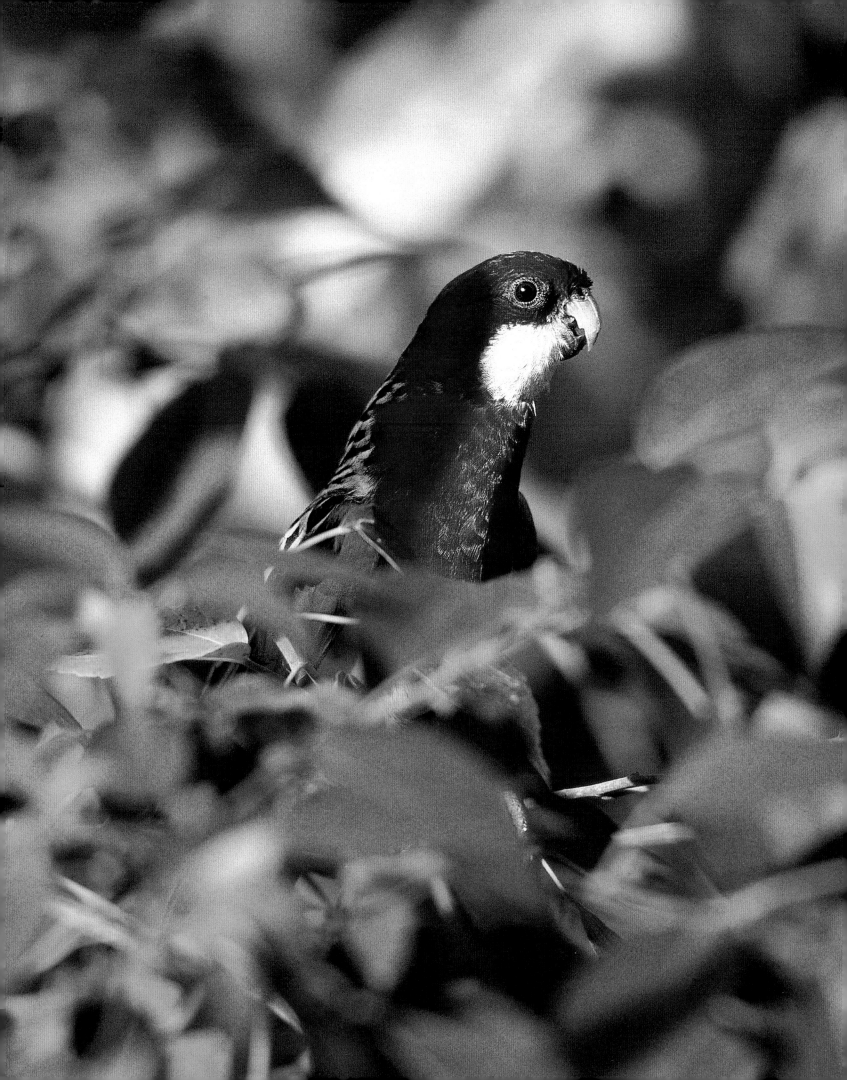

Red crowned crane

Grus japonensis

Hokkaido, Japan

Birds need to keep their heads stable in flight to help them see as well as possible. This is why their bodies oscillate while their heads remain almost motionless.

Pages 96 and 97

Chinstrap penguin

Pygoscelis antarctica

South Shetland Islands, British Antarctic Territory

From the thousands of chicks in a colony, parent penguins recognize their own almost instantly by its voice. Their extremely acute sense of hearing never fails them.

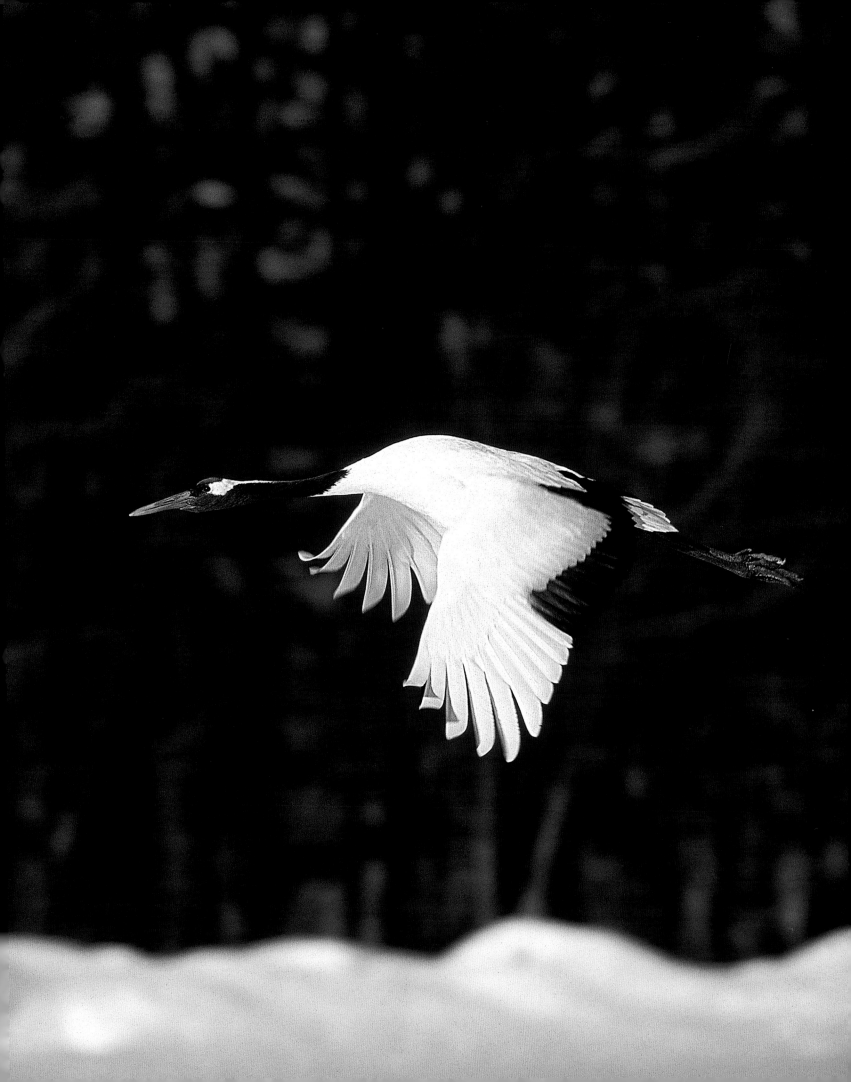

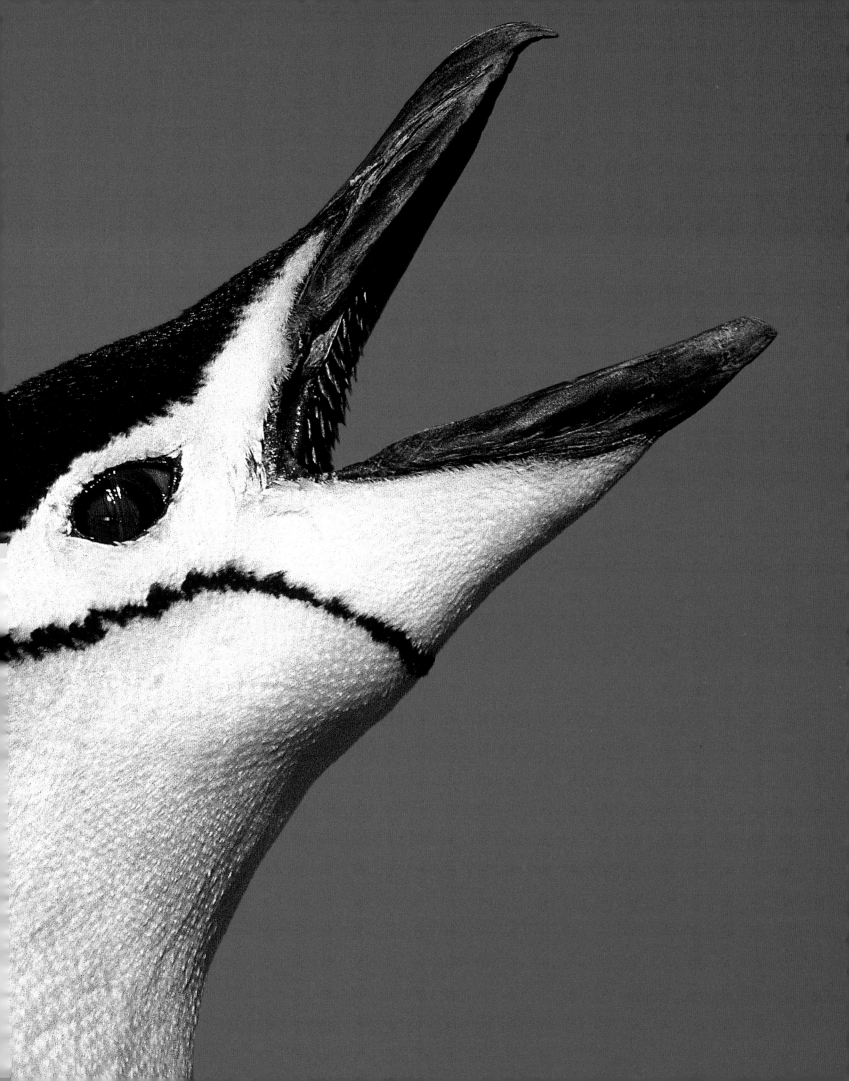

1. Short-toed eagle
2. Saddle-billed stork
3. Steppe eagle
4. Eurasian eagle owl
5. Red-and-green macaw
6. Marbled frogmouth
7. Lanner falcon
8. Chattering lory
9. Himalayan griffon
10. Blue-and-yellow macaw
11. Ostrich
12. Short-eared owl
13. Roseate spoonbill
14. Cuvier's toucan
15. Short-eared owl

1	4		7	10	13
2	5		8	11	14
3	6		9	12	15

When Geese Prick up Their Ears

Birds have no auricle. They possess just a single small bone in place of the three in a mammal's middle ear, yet their sense of hearing is comparable to ours, with an extra feature. When we hear a sound coming from one side, it goes around our head before reaching the ear on the other side. The size of our head means that our ears register a difference of a few microseconds between the times they perceive the sound, enough to tell us which direction it is coming from. The narrowness of a bird's head does not allow this; therefore, it compensates by means of an amplifier inside the skull, which allows it to pinpoint the direction of the sound with a high degree of precision.

Although most birds hunt by sight, some track their prey by hearing—woodpeckers, for instance, detect insect larvae by the sound they make while chewing wood. Naturally, nocturnal raptors take the honors for this sort of prowess. The barn owl relies on its sharp sense of hearing to seek out its prey by night. Not only can it distinguish differences among the intensity of different sounds, but it can perceive the tiny time lag between the moment they reach one ear and the moment they reach the other. Moreover, its ears are asymmetrically placed—the left is slightly higher than the right—which helps it to determine whether the sound comes from above or from below. The bird thus pinpoints sounds with such precision and acuity that it can catch prey in flight simply by using the sounds made by the prey's movement.

The final refinement is an owl's facial disc, which acts as a dish for concentrating sounds and directing them to the ear. This is probably why diurnal owls, for which acute hearing is less important, do not have a facial disc. Their "ear" tufts, on the other hand, are used purely for display or intimidation and play no part in hearing.

Hair-Trigger Sensitivity

Touch is perhaps the most diffuse sense. Beyond the sensations that can be felt on the skin, which can range as far as pain, there is also the perception of heat and cold. The nerve endings that allow these sensations to be experienced are located mostly in the areas of skin that lack feathers. Between the feathers, vibrissae tell the bird about the air that surrounds it. In compensation, birds have specific receptors placed all over their bodies. These allow them to feel vibrations and changes in pressure with such sensitivity that some writers claim to have observed birds reacting to heavy gunfire 124 miles (200 kilometers) away. On the feet, these receptors—called Herbst corpuscles—pick up vibrations from the ground or the bird's perch, alerting it to approaching danger. The Herbst corpuscles are so sophisticated that they even detect infrasound, thus allowing the bird to "hear" through its feet.

Birds' sense of touch may even give them information about atmospheric pressure, making them extremely sensitive to changes in weather. It has been established that autumn migration in the eastern United States often starts when pressure is rising, promising ideal weather conditions for the journey. However, our knowledge of this area remains much more hazy than the remarkable senses displayed by birds.

Birds' bills are just as sensitive as their feet. The bill of the mallee fowl is sensitive to heat. This allows it to probe its incubating nest to sense the temperature and adjust it to its clutch's needs.

Opposite

Magellanic penguin

Spheniscus magellanicus

Valdes Peninsula, Argentina

Penguins can swim to great depths—emperor penguins have been observed as deep as 1250 feet (382 meters). It is believed that they find their prey by echolocation, like dolphins and other cetaceans.

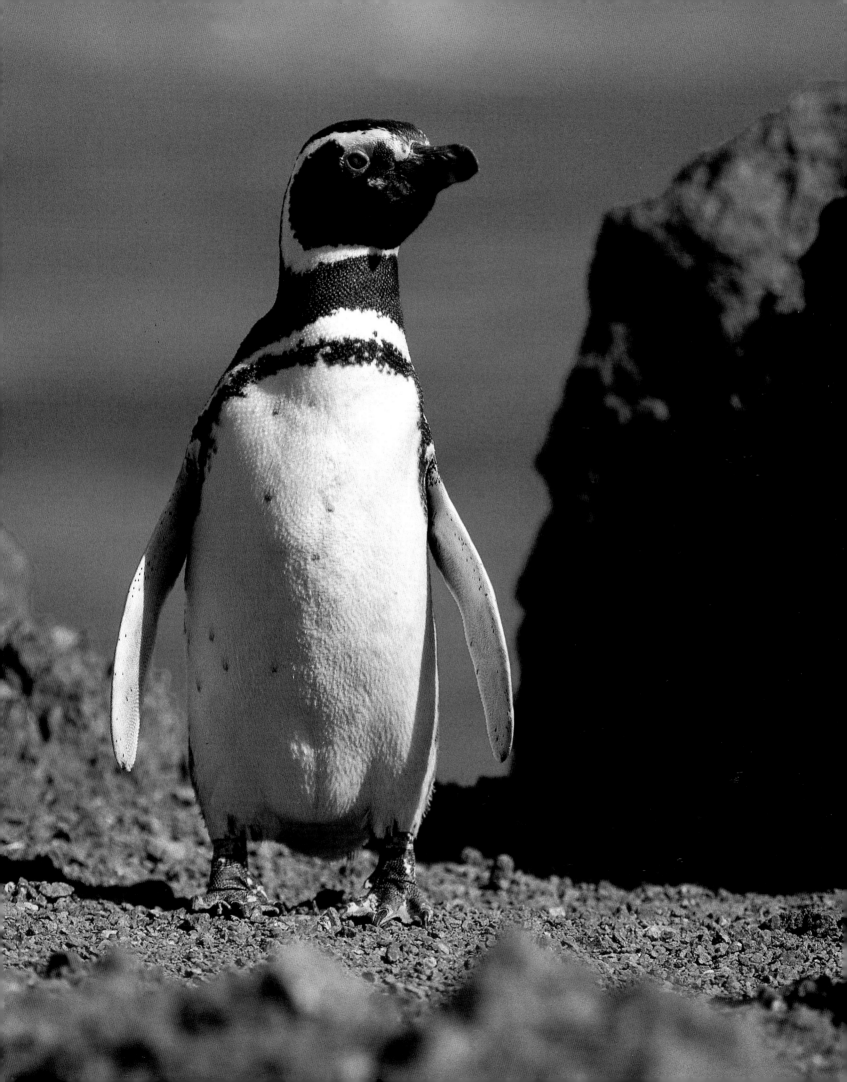

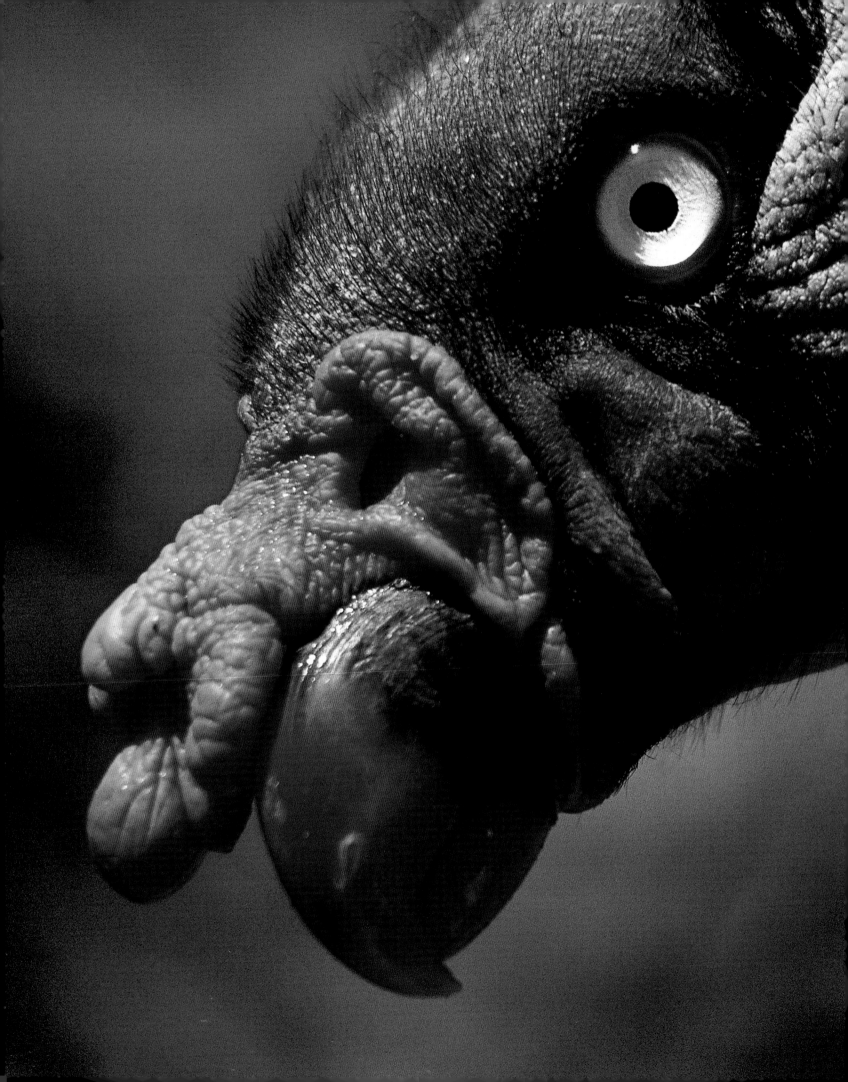

Opposite

King vulture

Sarcorhamphus papa

Peru

A vulture of Central and South America, this species is closer to the stork than to the Old World vulture. It is well known for using its sense of smell to locate the carcasses on which it feeds, but the purpose of the colored appendages on its bill remains a mystery.

Ducks sift "blind" for edible particles in silt and mud, thanks to the Herbst corpuscles in their bills. As for the unobtrusive woodcock, the end of its beak is equipped with ultrasensitive tactile buds that allow it to dig up worms and other invertebrates, on which the bird feasts hungrily, from the leaf-mold on the forest floor.

Natural Flavors

Taste involves the perception of sour, bitter, sweet, and salty flavors. This sense seems to be similar in birds and humans, although the former have far fewer taste buds, suggesting that they have a less acute sense of taste than we do. Raptors are able to swallow shrews so foul-tasting that mammals will not eat them; however, what are we to make of lories and lorikeets, which feed by licking pollen off flowers with their brush-tipped tongues?

The Strange Senses of Cave-Dwellers

The power of flight is not the only characteristic birds share with bats. Some birds have the ability to find their way using a sense completely alien to us: echolocation. The echo of their own voices warns them of obstacles to avoid or targets to aim for, allowing them to return to their nests or perches or even to catch insects. The oilbirds of Venezuela are the only New World birds to do this, while swiftlets (cave-dwelling swifts that live in Southeast Asia and southern India) also use this technique. All these birds live and nest in the depths of caves, where daylight never penetrates. Since they cannot see where they are flying, they hear where they are going by making series of sharp clicks which, unlike the squeaks of bats, are audible to the human ear. But oilbirds are not content with mere clicks: they have at their disposal a whole range of senses, honed to perfection, that are indispensable for mastering the darkness. Supported by a highly refined sense of smell, their large eyes probe the blackness. Long, tactile vibrissae surround their bills. Swiftlets, on the other hand, must always keep their bills free of obstruction so they can click. Their diurnal cousins—swifts—use their bills to carry nest-building material. Swiftlets have found a solution to the problem: they carry objects with their feet, a fine example of a behavioral adaptation to physiological demands.

Far from the darkness of caves, in temperate countries it is the length of the daylight hours that synchronizes the breeding and migration seasons with the periods of the year when conditions are best for these activities. Light filters through the feathers and the skull and activates receptor cells in the brain—the famous "third eye." We are a very long way from bringing to light all the subtleties of the senses that govern the abilities and behavior of birds. And we are further still from understanding the mechanisms that coordinate them in such a masterly manner that it all looks so simple, fluid, and clear. We can only look on in wonder.

Opposite

Papuan mountain pigeon

Gymnophaps albertisii

Papua New Guinea

The pigeon's ability to detect small changes in atmospheric pressure enables it to alter its flying altitude according to circumstances.

Pages 106 and 107

Striated heron

Butorides striatus

La Digue Island, Indian Ocean

The heron owes its lightning speed, displayed when it catches its prey, to extremely powerful muscles that are attached to a lengthened vertebra in the middle of its neck.

Above

Tufted duck

Aythia fuligula

Brenne, France

The duck's bill works like a filter. Rich in Herbst corpuscles, the bill enable these birds to trap edible particles while probing the mud of marshes and pools "blind."

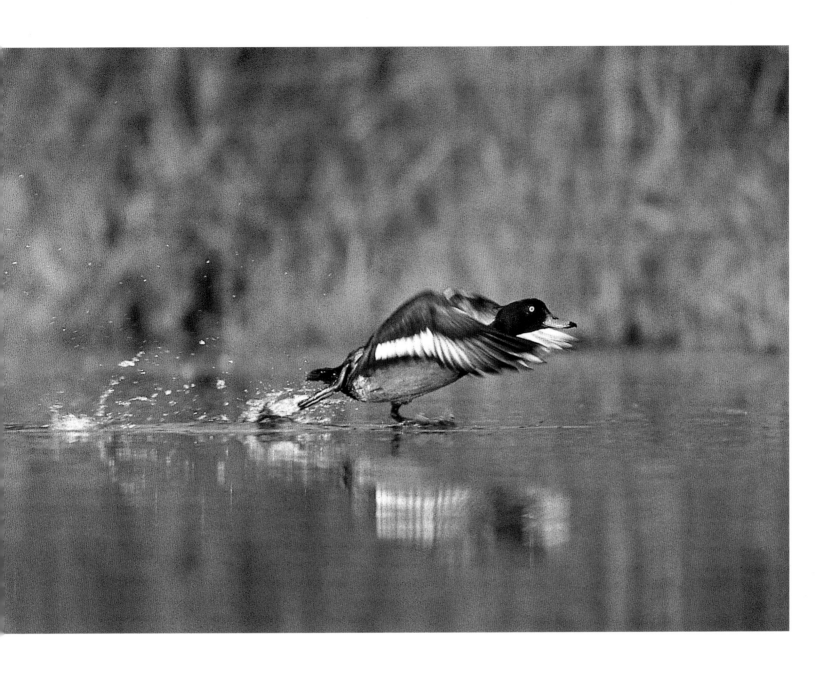

Oriental anhinga

Anhinga melanogaster

Australia

Birds have no external ears, so these organs are invisible except in species whose head is bare of feathers. Nevertheless, they have an extremely keen sense of hearing.

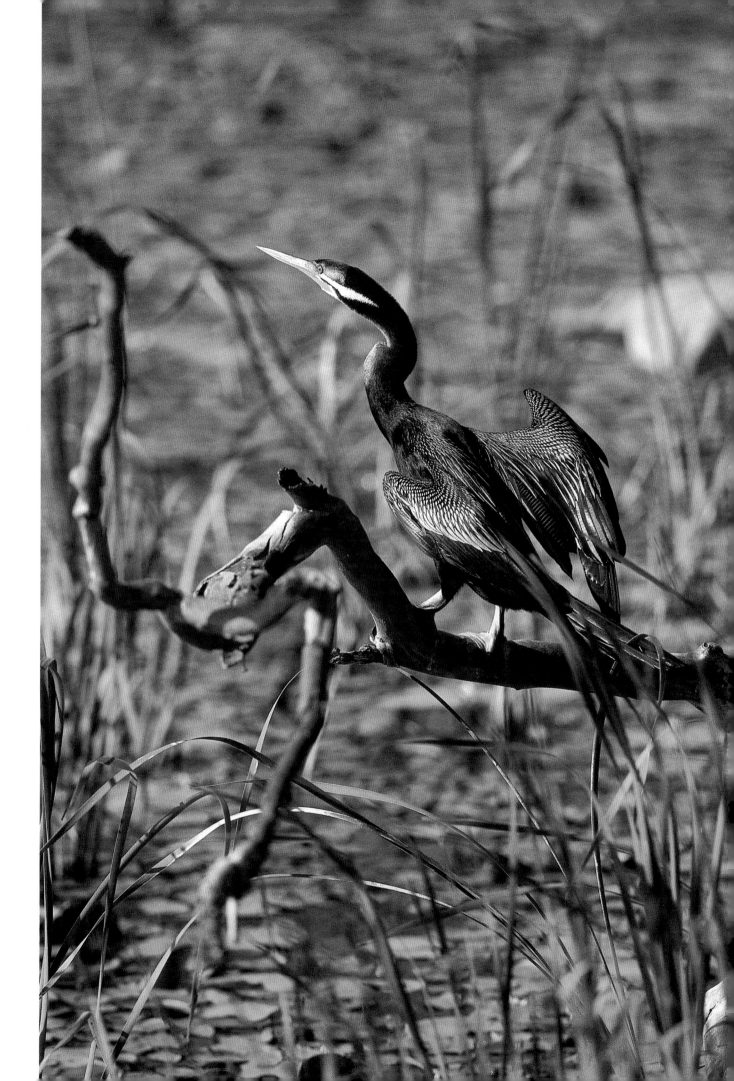

Riders on the Wind

Opposite

Opposite

Bar-tailed godwit

Limosa lapponica

Banc d'Arguin, Mauritania

This small wader nests in the tundra. The brief polar summer obliges it to breed quickly and then leave the region, whose climate is too harsh the rest of the year. Its winter haunts range from the North Sea to the tropics, and some individuals even migrate as far as Australia.

Pages 114 and 115

Pink flamingo

Phoenicopterus ruber

Camargue, France

Flamingoes take to the air as a disorganized flock, but then they gradually settle into undulating lines, flying with their necks and legs extended. On migration, these formations look like long pink and black ribbons.

Since the beginning of time, nature's great metronome has twice a year beaten the rhythm of the changing season. Wave after wave of migrating birds come and go in flocks that are sometimes so dense they darken the sky. In autumn, multitudes of birds gather and vanish into the sky, only to return with the good weather, when they bring our gardens and countrysides to life with their love songs. These population flows have so intrigued us that they have long inspired legends, such as the idea that swallows spend the winter dormant at the bottom of ponds, or the more poetic notion that birds take refuge on the moon during winter, after a journey lasting sixty days. When, finally, better-informed travelers revealed that those birds that disappeared from Europe in winter spent their time in Africa, it was believed that the smallest birds traveled as passengers, buried in the feathers of larger birds. It was thought impossible that a warbler weighing fifteen grams could cover 1,860 miles (3,000 kilometers) nonstop.

Scientific advances in areas as varied as physics, chemistry, biology, geology, and astronomy have revealed more wonders than in all our outlandish human theories. We now know that birds possess two tools indispensable to the long-distance traveler: a compass to keep on course, and a map, to know exactly where to go. Nevertheless, the mystery remains undiminished. So extraordinary are birds' abilities that migration has something prodigious about it, sometimes almost verging on the supernatural. Braving all the storms that could blow them off course, destructive pollution, and fog that could make them lose their way, birds battle on through the air, persistently, determinedly, no matter the cost.

In the fourth century B.C., Aristotle claimed that redstarts became robins in winter, while cuckoos became sparrowhawks. As romantic as the process may seem, migration can nevertheless be described precisely as the seasonal movement, in a given direction, of a given population's center of gravity. The power of flight makes this easier, but also, in part, gives rise to it in the first place. Flight uses up so much energy that it requires sufficient food supplies all year round to keep a bird's base metabolism at a sufficiently high level. Winter is a difficult time for many birds that cannot find food in the frozen ground but must nevertheless keep their body temperature above 104 °F (40 °C). By migrating periodically, birds optimize their search for food. With the spring thaw in northern regions, myriads of insect larvae and seeds are released that had been buried under the snow. This superabundance of food, and the long daylight hours, allows birds to gorge themselves during the crucial breeding season. By contrast, the extreme heat of summer in certain regions is a serious threat, as it can lead to drought and dehydration. By moving from their winter or summer quarters, birds take advantage of the best conditions all year round. However, to do this, they must endure the hardships of travel.

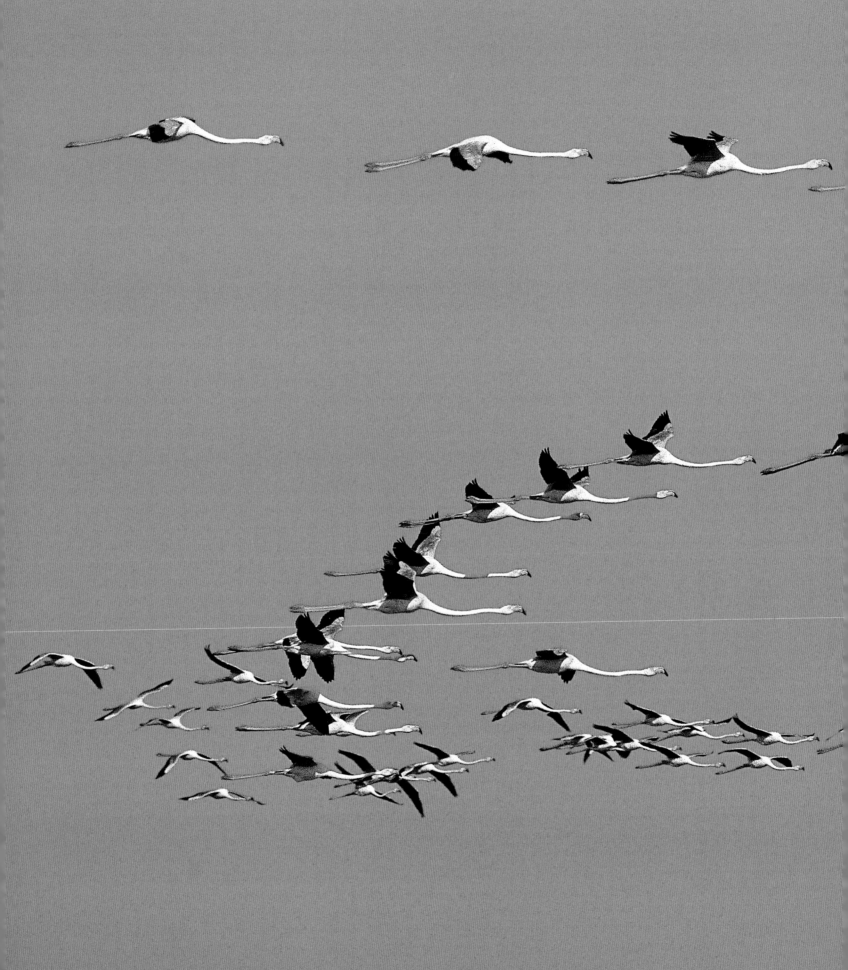

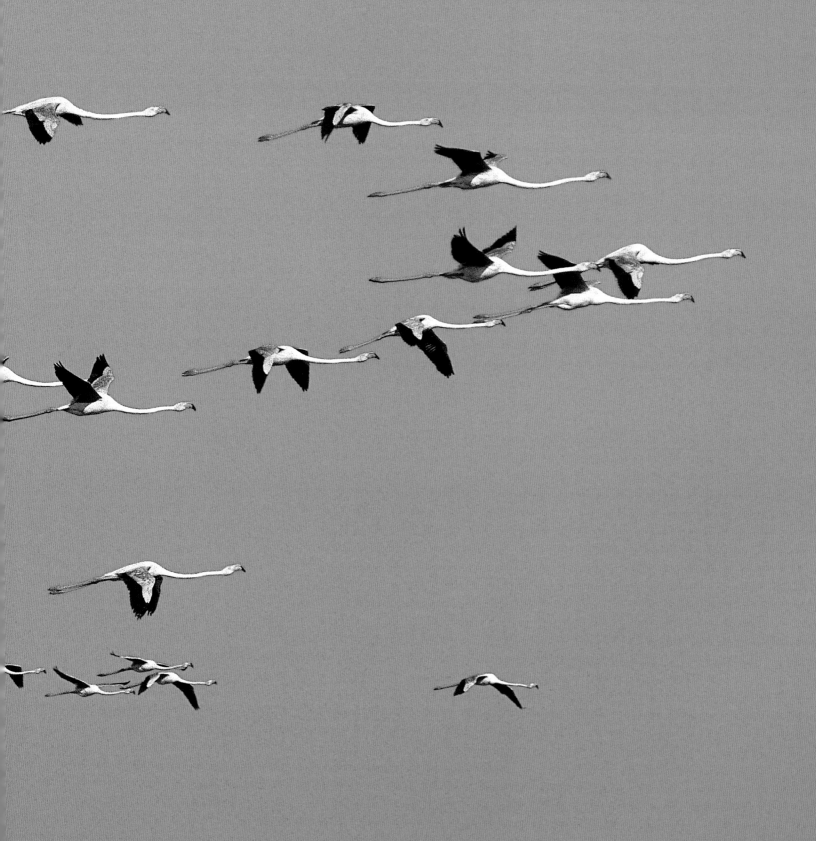

Opposite

Whooper swan

Cygnus cygnus

Hokkaido, Japan

Birds migrate to avoid starving. Their movements
are timed to come after a period of plenty, during
which they accumulate the reserves they need for
the long journey ahead. How powerfully they fly
depends on the amount of fuel—in the form of
fat—that they can carry relative to their body
weight. Large birds like swans cannot afford to
gain too much weight, as this would reduce their
flying abilities.

Pages 118 and 119

Red-billed quelea

Quelea quelea

Diawling National Park, Mauritania

Totally dependent on agriculture because they
eat only grain, queleas are not real migrants.
They travel between 621 and 932 miles (1,000
and 1,500 kilometers) to seek the places with the
best food resources.

Pages 120 and 121

Red-billed quelea

Quelea quelea

Diawling National Park, Mauritania

Considered the world's most numerous bird
species, queleas are a scourge for African farmers.
On their mini-migrations, whose timing is deter-
mined by the arrival of rains, they ravage the crops
of twenty-five of the continent's countries.

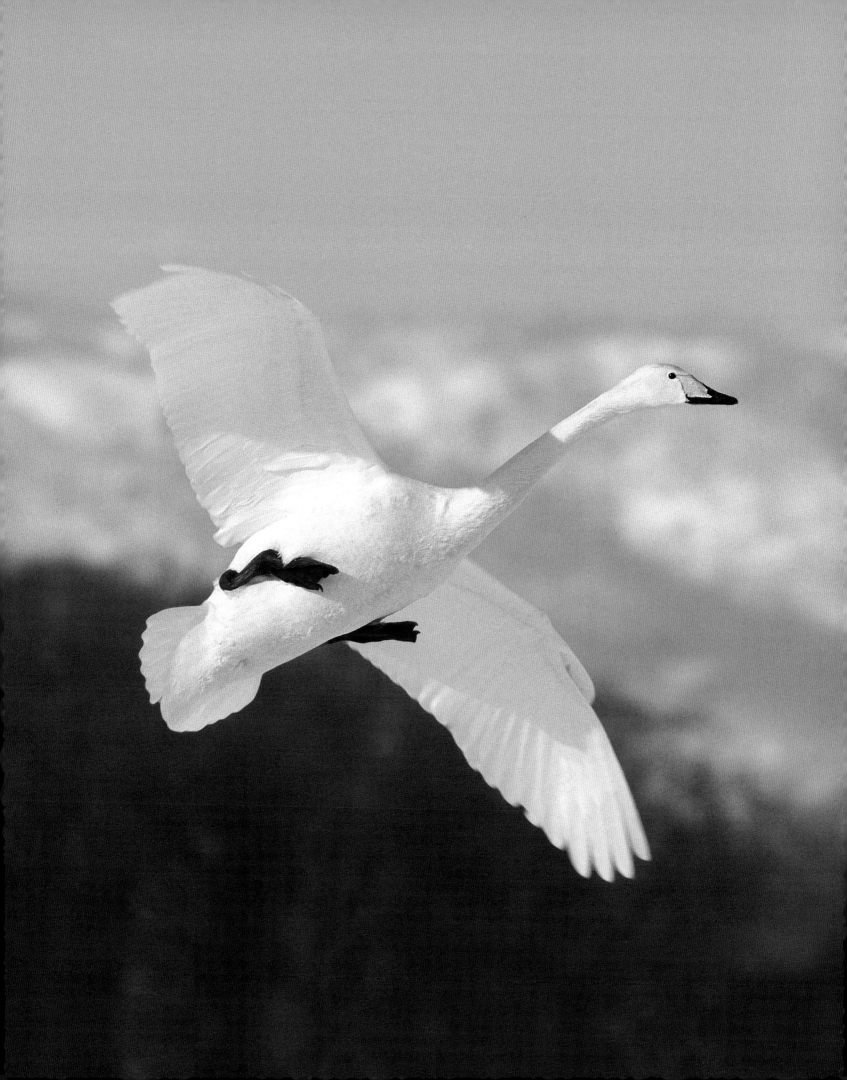

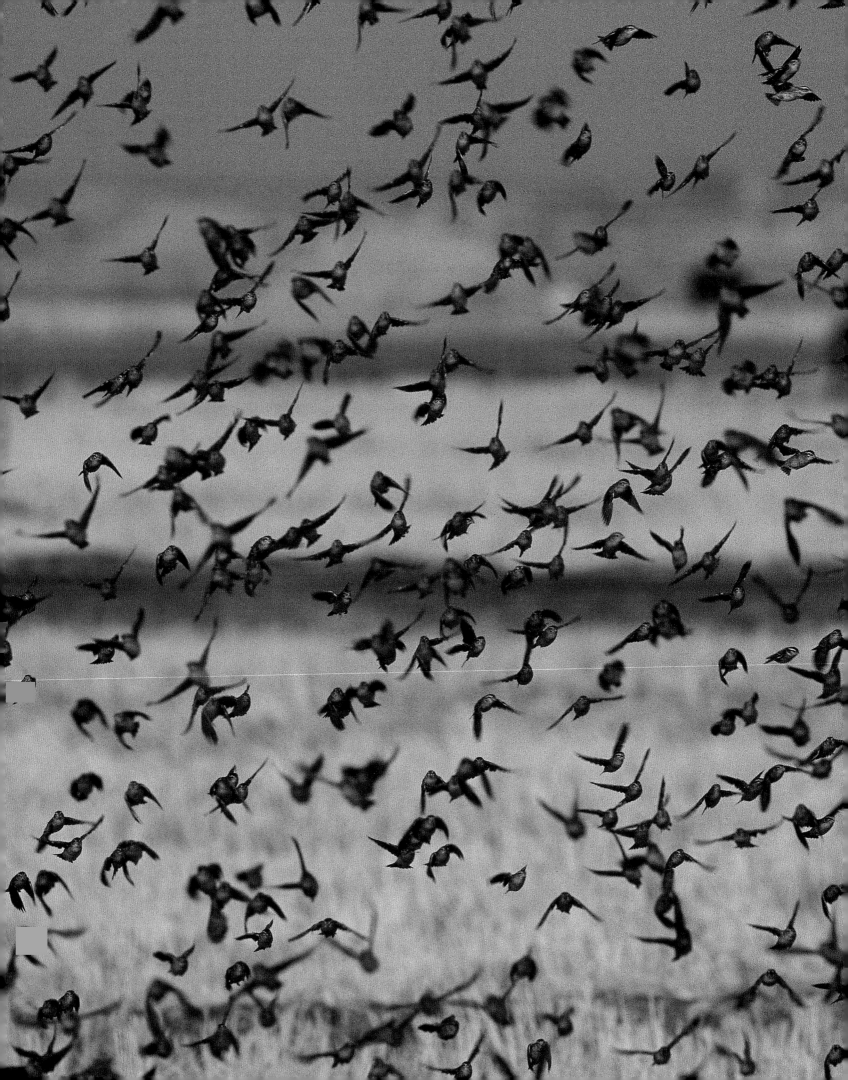

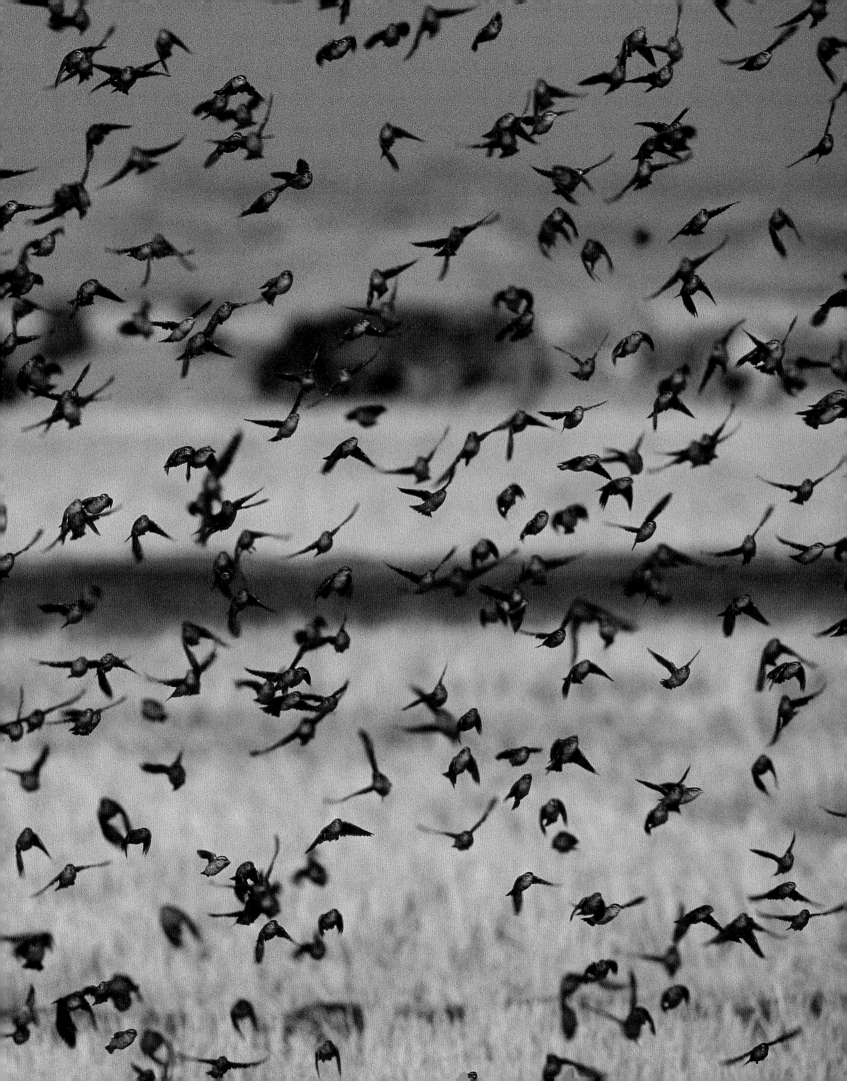

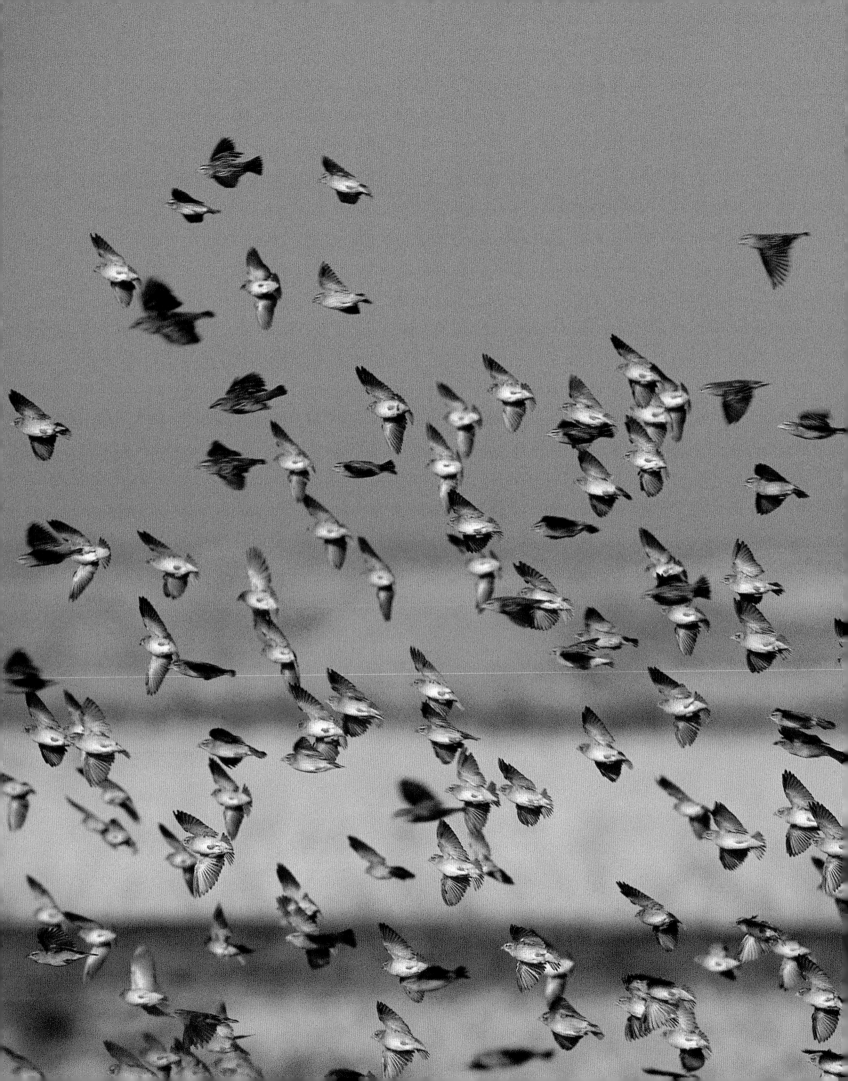

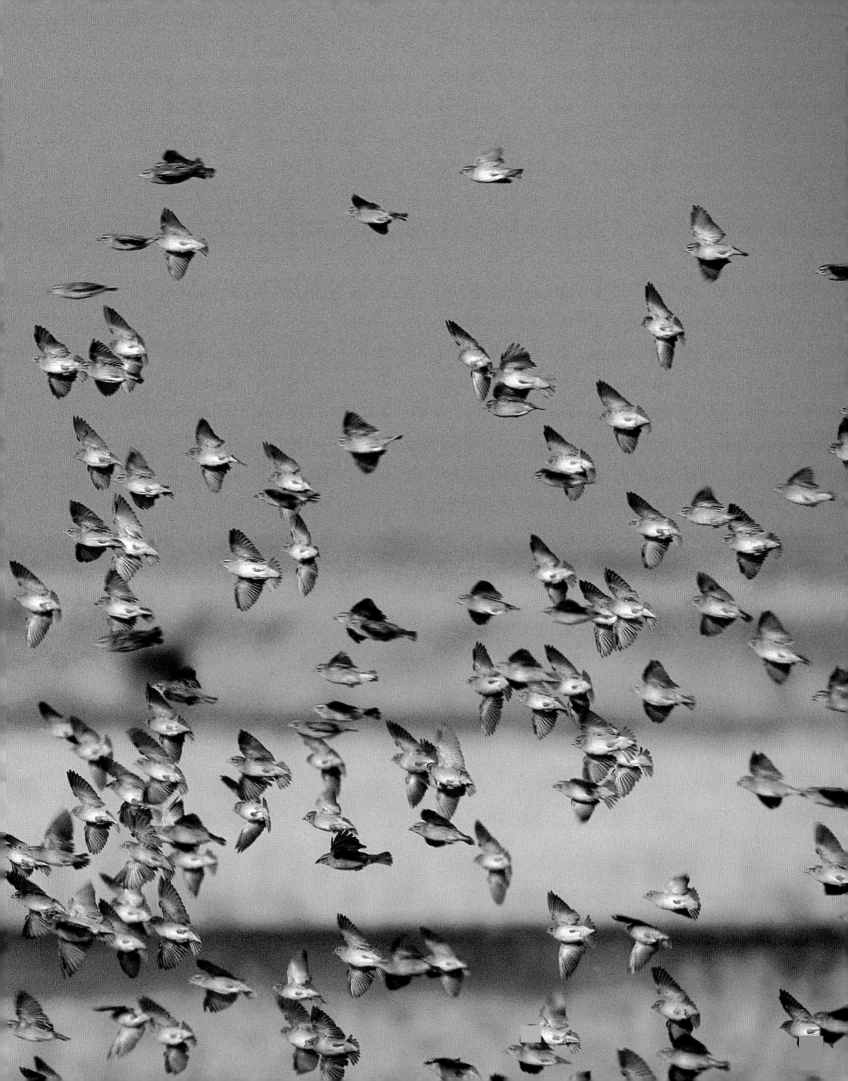

The Birth of a Quest

It is thought that birds first began to migrate during the earliest times. When the earth's axis shifted during the Tertiary period, certain regions were plunged into darkness for long stretches, forcing the birds that lived there to temporarily leave. These birds of cold latitudes acquired the habit of moving according to climatic conditions. Conversely, the progressive retreat of the glaciers at the end of the last Ice Age allowed tropical birds to extend their range toward more northerly regions, but each winter they were forced again to return to the area they originally occupied. This also explains why migration flows are more substantial in the Northern Hemisphere. Although more than three quarters of birds are migratory, this way of life is adopted only by those that live in regions where seasonal differences are marked. The farther north a bird breeds, the farther south it migrates. This phenomenon occurs even within a given species. Northern populations of robins winter in the Maghreb, while French robins remain in France, traveling no farther than the north shore of the Mediterranean.

The distances birds migrate vary from a few miles for certain seed-eaters to 12,400 miles (20,000 kilometers) for Arctic terns, which migrate twice yearly from one pole to the other in order to live in constant, albeit polar, summer. The alternation between the austral and boreal summers gives the terns the bonus of enjoying more daylight than any other bird on the planet. This migration, which covers half the planet, is spectacular for the distance traveled, but the tern, a sea bird, can feed itself on the high seas. By contrast, the tiny ruby-throated hummingbird, which leaves its wintering grounds in Mexico to breed in eastern Canada, performs an extraordinary feat. Twice a year, it crosses the 620 miles (1,000 kilometers) of the Gulf of Mexico in just twenty-four hours, with no chance to rest or feed. The bristle-thighed curlew, meanwhile, flies 6,200 miles (10,000 kilometers) across the Pacific Ocean, covering 1,860 miles (3,000 kilometers) on the longest unbroken stage, with absolutely no opportunity to feed or rest—unless, like ducks, the curlew is able to sleep with one eye open, each half of the brain resting in alternation with the other.

Leave or Face Death

Migration is the greatest danger that many species face. Only the strongest individuals survive the ordeal. For this reason, migrants must be in excellent physical condition before they begin their journey. Large gliding birds make sure their plumage is in perfect condition before they leave by molting beforehand. It is also essential to stock up with energy in order to travel for several days without food. This is why some birds literally stuff themselves with the richest possible food which, once converted into fat, produces the vast amounts of energy that will be expended during the journey. Small European passerines such as pipits and wagtails must cross the Sahara to reach their African wintering grounds. This desert crossing requires several days' flying without rest, water, or food—a terrible ordeal that they survive by almost doubling their body weight before leaving. Quails develop two bands of fat on their bellies, whose size is directly proportional to their desire to migrate. Red knots go so far as to cannibalize themselves toward the end of their odyssey, digesting their liver, kidneys, and muscles to provide the necessary fuel.

In each species, the females travel farther. There are also geographical variations: a given

Opposite

Sooty tern

Sterna fuscata

Cosmoledo Atoll, Indian Ocean

Terns disperse very quickly after the breeding season. Starting with their first migration, young birds are able to cross the Atlantic Ocean, traveling 6,835 miles (11,000 kilometers) from America to Africa without touching down because their plumage cannot get wet. They do not return to the colony where they were born until they are three years old.

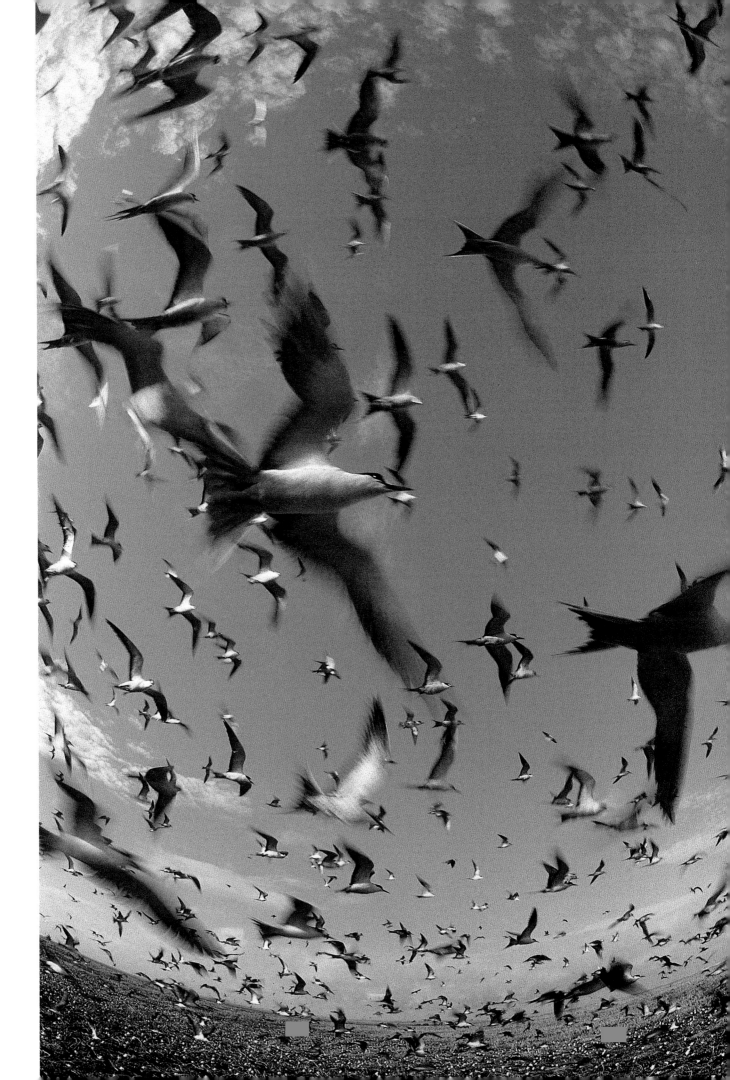

Opposite

Sanderling

Calidris alba

Banc d'Arguin, Mauritania

This small, feverishly active shore wader nests in the Arctic tundra and winters on sandy shores, reaching all the way to the Southern Hemisphere. It changes its plumage when it moves to a different region, swapping its pale gray winter garb for a pretty red coat in summer.

Below

Cape petrel

Daption capense

Drake Passage, Antarctica

The common Cape petrel is more a Southern Hemisphere nomad than a true migrant. It roams so far that occasionally individuals travel into the Northern Hemisphere.

population of blackbirds may be sedentary, whereas another may migrate. It is quite common, however, for just part of a population to migrate, as in the case of buzzards and tits in Europe. Sometimes, only a certain section of the population migrates, often the young birds. This may be a survival strategy. Those that migrate run the risk of being killed by hunters, dying on the way, or being blown off course. However, those that remain risk dying of starvation. For the species as a whole, though, the risks are halved—as are the possible gains.

How Birds Find Their Bearings

What is most astonishing about migration is the accuracy with which birds find their way over thousands of miles. How do they return to their nests after spending months on a different continent?

Large migrants such as cranes, geese, and swans guide their offspring on their first migration. The youngsters follow their elders, flying in their slipstream in V formations over long distances, thus both saving energy and learning the way. They memorize landmarks and are able to make the journey on their own after one or two trips. Geese, which have been studied in detail, do not migrate by instinct. They must learn from their parents, and in order to memorize places more effectively, they always circle before landing at the end of each stage and after taking to the air at the start of the next. Small birds, however, make the round trip without guidance, finding their way on their own by instinct. Perhaps the most surprising is the European cuckoo, which, although it has never known its parents, migrates to Africa.

Opposite

Whooper swan

Cygnus cygnus

Hokkaido, Japan

This magnificent northern bird migrates at an altitude of 27,880 feet (8,500 meters) to take advantage of the winds at that height. Its immaculate coat protects it from the rigors of the climate and the extreme temperatures at high altitude, which it shares only with geese and some airline pilots.

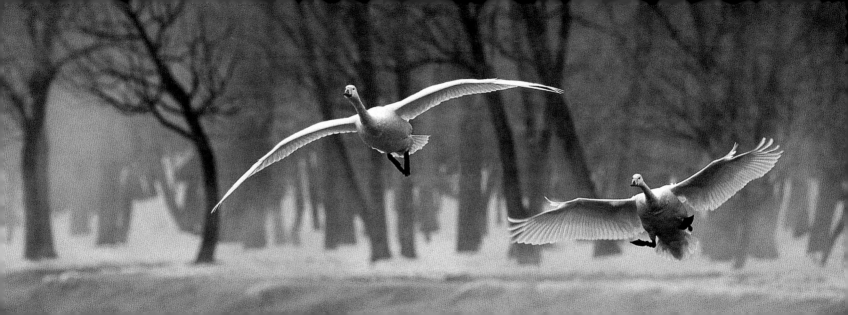

Unfailing Senses

Birds have access to a mass of information that our blunted senses cannot detect. The earth's magnetic field, a wide range of sound frequencies, polarized light, ultraviolet, and infrared—all these elude us, but migrant birds can interpret them. Waterfalls, the roar of waves on the shore, and wind in a forest all produce infrasound waves that can carry great distances. It is known that birds such as pigeons can perceive these and compare them to a sort of personal auditory map that they can use to navigate. A large number of experiments conducted on starlings and blackcaps have demonstrated that, thanks to their sensitivity to polarized light, these birds can take their bearings from the position of the sun, which they can pinpoint even when it is masked by clouds or has sunk below the horizon. Nevertheless, this still requires knowledge of the relative position of the sun at different times of day, otherwise a bearing would be constantly corrected and the birds would go round in circles. Birds have an internal biological clock, set by the sun's course, which adjusts their bearings according the time of day. By night, they can get their bearings from the pole star—the only fixed star, around which all the others rotate. This ability depends however on a perfect knowledge of the night sky (of which few humans are capable) and on being able to detect extremely slow movements, since birds must distinguish the fixed star from those that are moving. This has been confirmed by experiments conducted in a planetarium, in which the sky was made to rotate artificially around Betelgeuse, a star in the constellation Orion. The buntings—a type of small passerine—used in the experiment flew toward that star. In other experiments, it has been conclusively shown that robins use the earth's magnetic field to find their bearings. This field changes considerably over time, sometimes undergoing rapid local changes and even reversing itself several times every million years. These small passerines must therefore adjust their magnetic detectors, constantly updating their settings. Autopsies on pigeons have revealed particles of magnetite in their brains. Acting as a real internal compass, these would have allowed the birds to steer using the earth's magnetic field. Moreover, if a magnet is fixed to a pigeon's body, it becomes incapable of finding its bearings.

Experts and Apprentices

Young, inexperienced birds migrate instinctively. This happens as if the direction they take and the distance they need to cover—expressed as a given number of days' journey—were acquired through heredity. Captive birds fling themselves against the bars of their cages exactly in the same direction that their free contemporaries fly, and they do this throughout the period for which migration would normally last. Similarly, young starlings that have been set on the wrong course in experiments merely fly in the same direction as their migration route, for the length of time it would take them to reach their destination. By contrast, adult starlings subjected to the same experiment correct their course and arrive at the correct destination. Having migrated once, a bird will cover the same route as before regardless of the conditions it encounters, such as strong winds that blow it off course, for example. In other words, a bird's first migration teaches it to master precision navigation through a combination of various methods. If the information

Opposite

Northern gannet

Morus bassanus

Canada

This migrant, which nests on the North Atlantic coasts all the way up to the Antarctic, travels south when winter approaches. Immature birds travel as far as Senegal—much farther south than the adults, which become increasingly sedentary as they grow older.

Page 130

Black crowned crane

Balearica pavonina

Masai Mara, Kenya

A large, handsome bird, the black crowned crane guides its young on their first migration to the southern wintering grounds. Among longer-lived birds, memory plays an important part in learning migration routes. The oldest individuals guide the youngest, giving them the benefit of their experience.

Page 131

Demoiselle crane

Anthropoides virgo

Keoladeo National Park, India

Also known as Numidian cranes, demoiselle cranes fly in groups at an altitude of 9,840 feet (3,000 meters). They winter in India and nest on the steppes at the border of Europe and Asia.

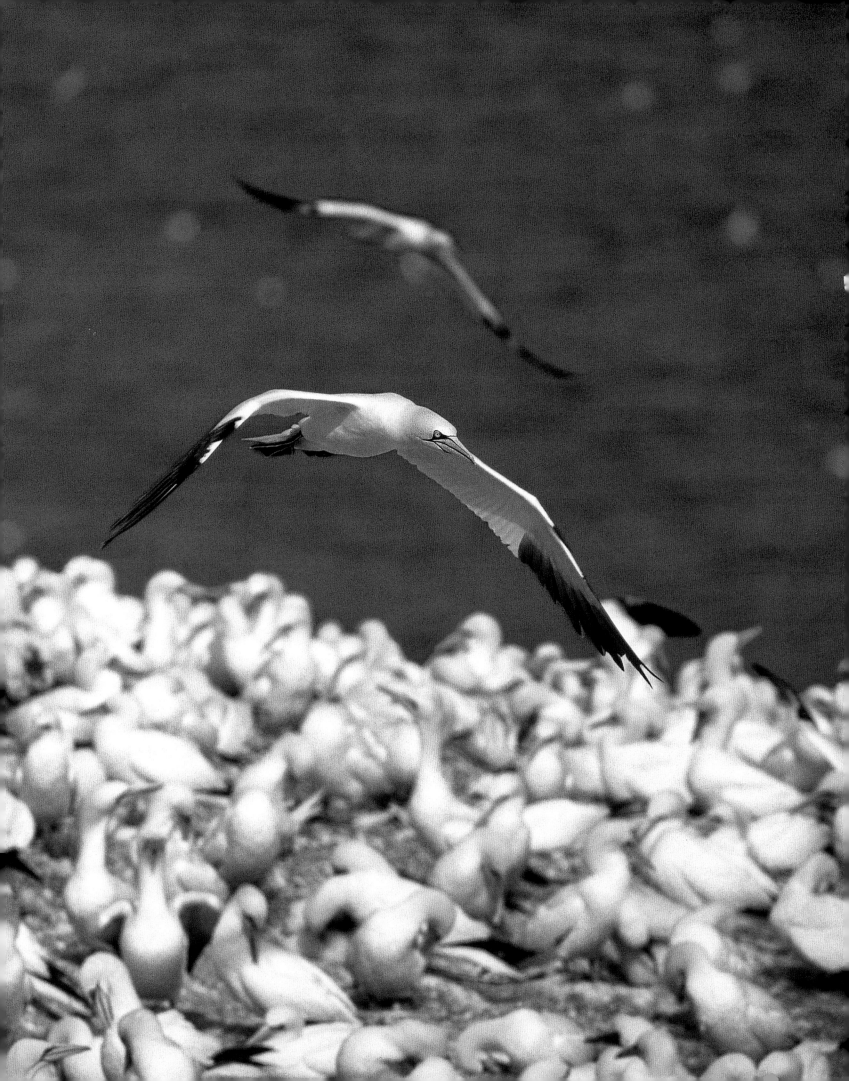

is contradictory, as in this last experiment, they are able to make the correct choice and, despite everything, regain the right route. No theory advanced so far has succeeded in solving this mystery.

Migration Highways

Most migrants travel a north-south route that is driven by the alternating seasons. East-west routes are far less common. There is also a third type of migration, in which birds go from sea level to mountaintops. North American grouse thus spend the winter in mountain pine forests and descend in summer to breed in deciduous forests, which are then rich in seeds.

In general, long-distance migrants avoid obstacles such as the sea. For this reason, European birds on their way to Africa pass around the Mediterranean via the Straits of Gibraltar in the west, or by traveling farther east down the Italian peninsula to Malta and Tunisia. The white stork, probably the most popular migrant in the European region, does this. Long sea crossings devoid of rising columns of warm air are not favorable to gliding flight.

Over land, the storks have a strategy for finding thermals. Several hundred of them fly side by side, across a front up to 1,640 feet (500 meters) wide. As soon as one encounters a column of rising air, it circles upward in what is really a thermal elevator, taking the rest of the flock with it. Bar-headed geese go so far as to clear apparently insurmountable obstacles. Overflying the Himalayas at an altitude where there is virtually no oxygen and where the temperature approaches 104 °F (40 °C) below zero, they are able to breathe where most mammals, humans included, would be utterly unable. This ability is due to their hemoglobin, which is adapted to cope with extremely high altitudes.

Opposite

White-tailed eagle

Haliaeetus albicilla

Hokkaido, Japan

In the Sea of Okhotsk, north of Japan, the island of Hokkaido is the favorite wintering spot of the great sea eagles that breed in Siberia.

Adaptations for Travel

Comparisons between the anatomies of migratory and sedentary species reveal adaptations to make long journeys easier. For instance, the wings of migratory warblers are longer and narrower than those of their sedentary cousins.

These adaptations are not merely morphological. For example, migration routes can change as a result of disturbance, often due to human activity. The grain fields that used to lie alongside the Caspian Sea were a refuge for red-necked stints, which used to winter there. The cotton that has replaced them provides no food for these birds, so the stints have changed their course and now frequent the shores of the Black Sea. In the same way, the marshy coasts of Peru were abandoned by thousands of migrants after they were drained.

Sadly, birds cannot avoid the greatest danger on migration, which has brought an astonishing number of species close to extinction, or even wiped them out altogether: shooting. Migration corridors have been known from time immemorial, and certain crossing points that the birds cannot avoid are a godsend for unscrupulous hunters, who seem more interested in clay-pigeon shooting with live targets than in true hunting. Some claim to shoot only at the front of the migrating flocks, apparently unaware that this is made up entirely of adult males. The result is a massacre that damages a species' breeding prospects.

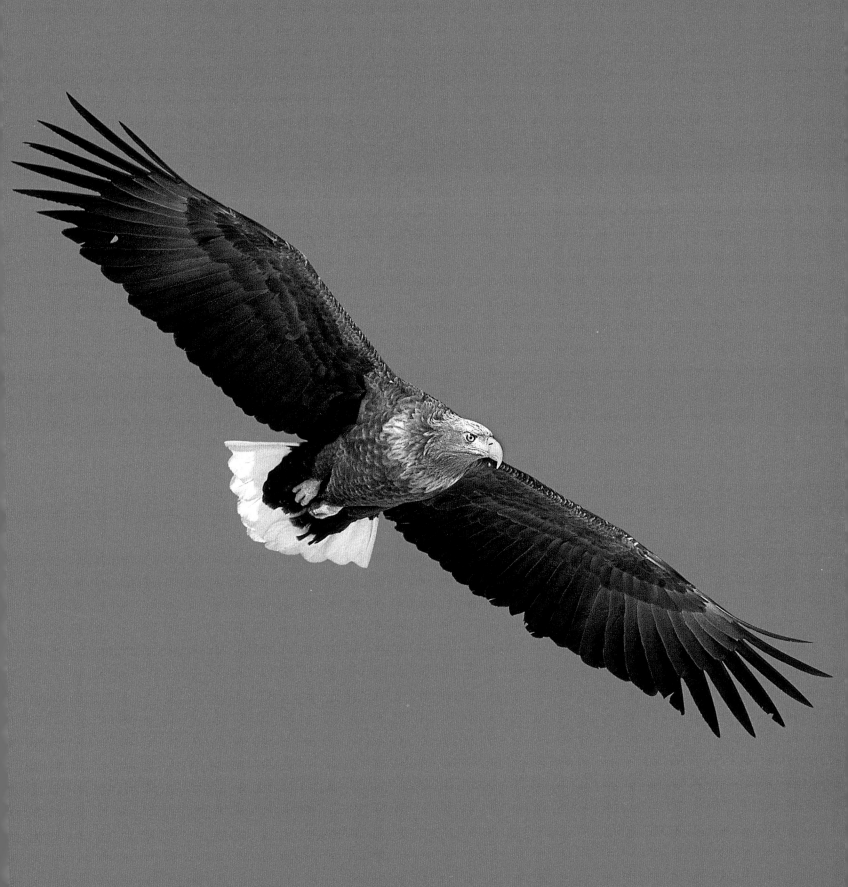

Off on Honeymoon

Seen from the Northern Hemisphere, migration looks like a flight from the unfavorable conditions of winter. Seen from the other, tropical, end of the journey, it becomes apparent that our migratory birds spend much more time in their winter quarters than their summer residence. Swallows and warblers are predominantly African species, of which only a small proportion migrates to Europe. The same is true in America, where only a small minority of flycatchers, hummingbirds, and warblers migrates from the tropics to the north of the continent. The swift, for example, spends only two months in some summer regions, long enough to hatch its brood, before returning to Africa. It seems therefore that most birds that pass the summer in our regions should be considered tropical opportunists, coming and spending their honeymoon in our latitudes, which are pleasant only during the warm season. The serin is a good example of a bird species experiencing current change in migration patterns. This sedentary Mediterranean bird began to extend its range northward less than a century ago. Today, some populations can be found as far north as southern Sweden, from where they migrate because they cannot withstand the northern winter. Migration can therefore be seen as an illustration of birds' magnificent adaptability to the conditions in which they live. Their global success can be explained by this constant willingness to explore new worlds. In view of the above, it would be more accurate to speak of pre- and post-breeding, rather than spring and autumn, migrations—especially because, taken together, the migrations of all the species in our regions continue virtually throughout the year, pausing only in December.

The mysteries of bird migration underline just how little we understand of natural phenomena and of the sensory abilities of beings we consider inferior to ourselves. Scientific advances will probably fill the gaps in our knowledge, revealing more marvels where before we could only be fascinated but baffled.

Opposite

Black-browed albatross

Diomedea melanophrys

Weddell Sea, Antarctica

Albatrosses do not migrate; they wander the Southern Hemisphere, only rarely crossing the equator. At that latitude, the strong winds that they need to remain airborne are lacking.

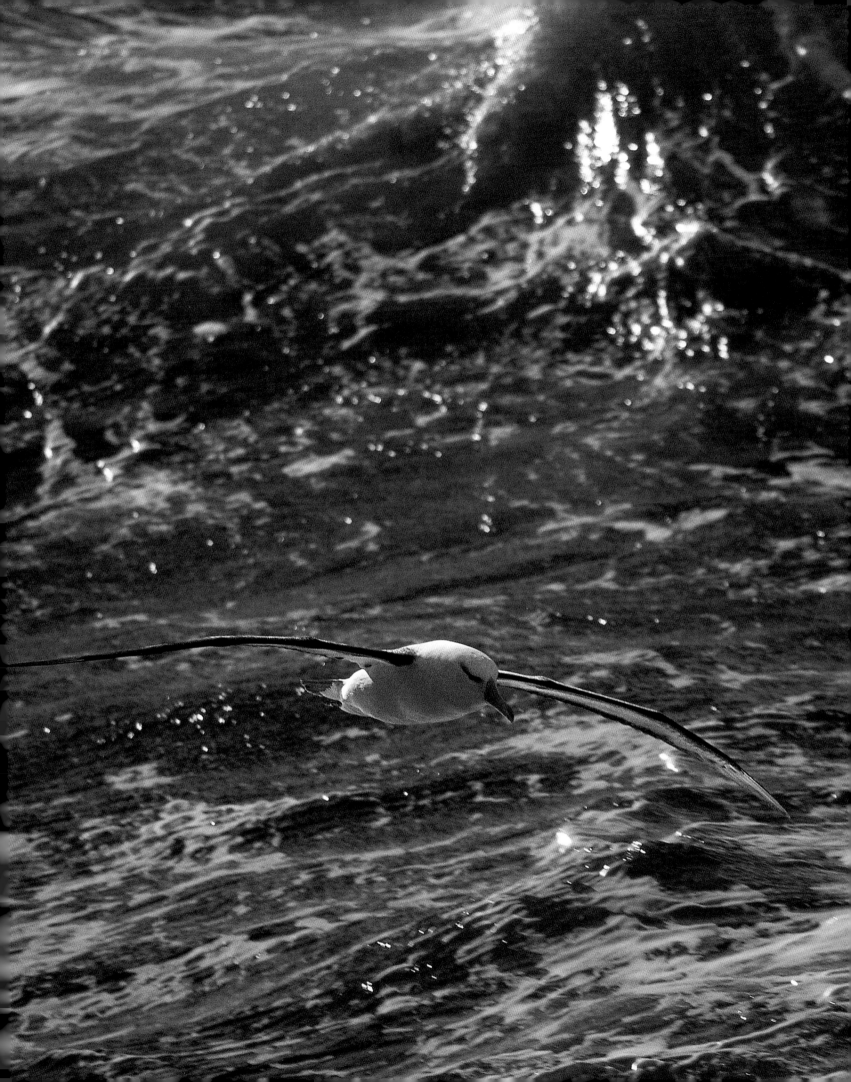

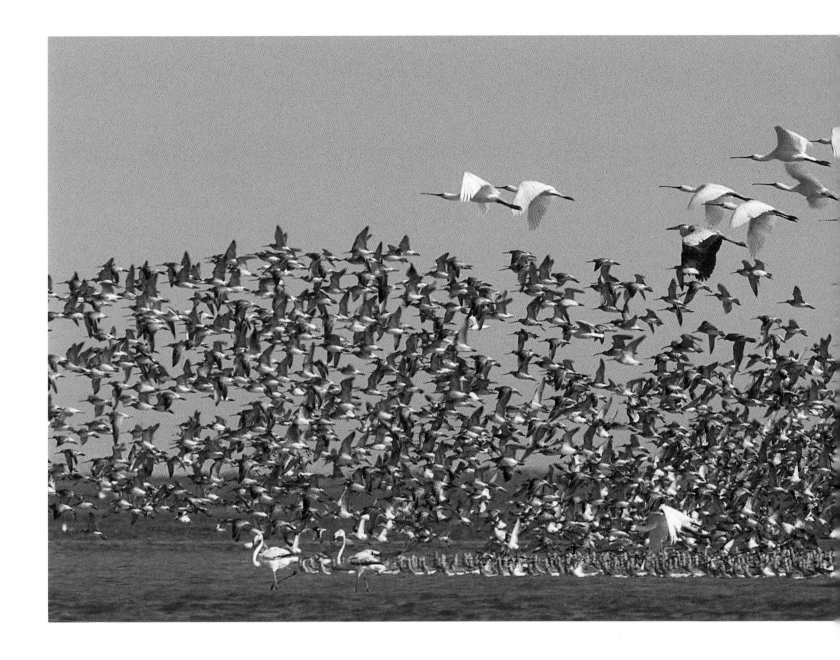

Above

Bar-tailed godwit

Limosa lapponica

Banc d'Arguin, Mauritania

Banc d'Arguin is a crossroads where thousands of birds of many species meet on migration. Apart from bar-tailed godwits, Eurasian spoonbills, gray herons, and pink flamingoes can be seen in this photograph. The reason for these gatherings is the cold currents passing offshore that favor the growth of plankton, the first link in a rich food chain.

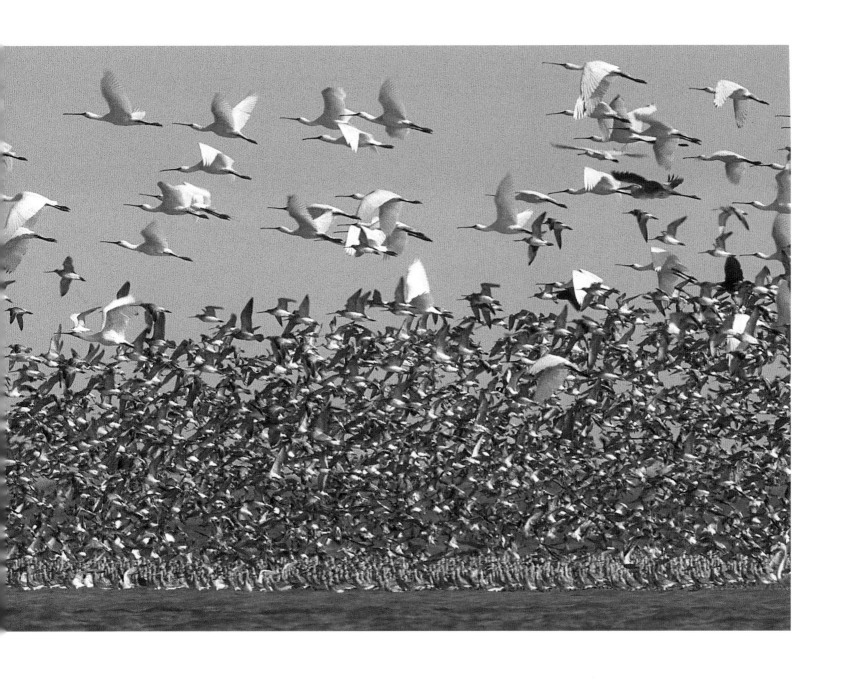

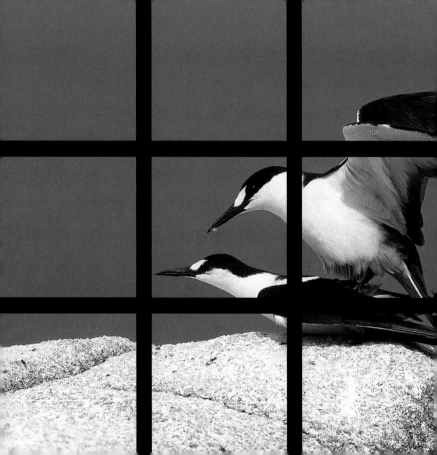

The Laws of Reproduction

Sooty tern

Sterna fuscata

Aride Island, Indian Ocean

Mating is extremely brief for most birds because the male is perched precariously on the female's back.

Birds are masters in the art of love, displaying their prowess by the diversity and sophistication of their behavior in all areas of reproduction. The splendor of courting males surpasses the most fertile imagination: their song has been echoed by classical masters such as Vivaldi, and their dances are lessons in grace and elegance.

Courtship behavior serves to establish contact between individuals that, outside the breeding season, live in loose groups or even singly. Sexual partners are attracted initially by song; later, the two individuals' emotional states gradually coincide as mating displays develop, finally culminating in mating itself.

Birds have evolved an infinite range of types of partnership. Some are firmly committed to life as a couple, remaining permanently widowed or even dying if their partner passes away. Others, while still strictly monogamous, change partners every spring. In many species, males display to attract a harem; what is less well known is that some females will not consider mating unless surrounded by a horde of suitors.

Peacocks are certainly the species most emblematic of mating displays. Everyone knows this blue bird's sumptuous, many-eyed wheel of plumes, to which hypnotic properties have been attributed. Can it be said that—like this large chicken deified by many religions, whose name has even produced the verb "to peacock"—all courting males parade themselves under the critical eye of potential sweethearts?

Birds' propensity for developing extravagant displays, verging on caricature, may be explained by the fact that almost all lack a penis. This orgy of colors, songs, and dances, which makes even the most sophisticated mammals look like meager seducers, serves one purpose: the perpetuation of the species. During the breeding season, male birds' testicles swell up to 500 times their usual size, accounting for almost 10 percent of their body weight and turning them into veritable containers of sex hormones.

Temporary Liaisons

Birds tend to be monogamous, for both parents are often needed to look after the offspring. However, most change their partners with each breeding season, and if the same pair happens to re-form the following spring, this is because they occupy the same territory rather than the result of deliberate choice. Meat-, insect-, and fish-eaters are more likely to be monogamous than grain-eaters or vegetarians, which tend to opt for polygamy. Nidicolous species, whose young complete

their development in the nest, are also chiefly monogamous because raising the young requires the energy of two parents. However, nidifugous species, whose chicks leave the nest very soon after hatching, can afford to devote time to a series of sexual encounters because one parent alone is enough to look after the brood. Environment, too, may determine social structure. For example, members of a monogamous species may have encounters outside their pair when the opportunity is abundant. Conversely, a normally polygamous species may live monogamously if extra partners are not available.

The arrival of winter normally sees pairs break up and sexual tension decrease. Members of a pair will then revert to living as individuals and either join a flock or live singly.

Partners for Life

The stork, that symbol of fidelity, returns to its nest each spring. The male arrives first and awaits his partner. After having probably been apart throughout the winter, the two resume their bill-clattering and other display rituals, which allow them to renew their acquaintance before resuming life as a pair. However, the stork is clearly more faithful to its nest than to its mate: the nest, and the young, are the breeding pair's central concern. Hornbills, tropical birds with enormous bills, behave similarly. A faithful and attentive mate, the male begins each breeding season by persuading the female to mate through gifts of insects and fruit. This is an important ritual for this pair, for the female will place herself in a position of total dependence on her mate for several months. She lays her eggs in a cavity and then walls herself inside to incubate her eggs and look after her young. The family's survival is therefore the sole responsibility of the male, who devotes all his time to feeding the mother and offspring, through a narrow opening, several times per day. Fruit, insects, even lizards and frogs are on the menu until the young are completely covered in feathers, which can take up to three months.

Another champion of the breeding partnership is the albatross, which is famous for the longevity of the bonds it forms. These great ocean-gliding birds, whose size inspired Baudelaire and many other poets, live as a pair for eighty years without straying. Cranes are also paragons of fidelity, rarely surviving the early death of a mate. Crane pairs, which perform astonishing dancing displays, live together in such harmony that the male's sperm changes cyclically, according to the fertility of his mate. Its composition varies according to the two partners' hormonal cycles, which are communicated by the calls they make. This is a true love duet, in which each partner is listening to the other.

Many Mates: Life in the Harem

In marked contrast, some birds do not form pairs at all, instead establishing relationships of varying degrees of closeness with many partners. The world's biggest bird, the ostrich, is a perfect example. This giant, so admired for the elegance of its feathers, displays by spreading its wings that, in the male, are white against a completely black body. However, he has more than feathers to display for, as a flightless bird, he possesses a penis. Being brightly colored, this organ is

Opposite

Lesser frigate bird

Fregata ariel

Aldabra Atoll, Indian Ocean

Ready to breed, this male flaunts his bright red pouch, which he inflates to an enormous size when displaying in order to attract females. The pouch gradually disappears after mating and once the first egg has been laid.

Pages 142 and 143

Black-necked grebe

Podiceps nigricollis

Brenne, France

Bonds between pairs of birds that raise their young together need to be reinforced regularly. Made by moving the head and bill to the side, an exchanged greeting reduces the hostility and fear that close contact generates.

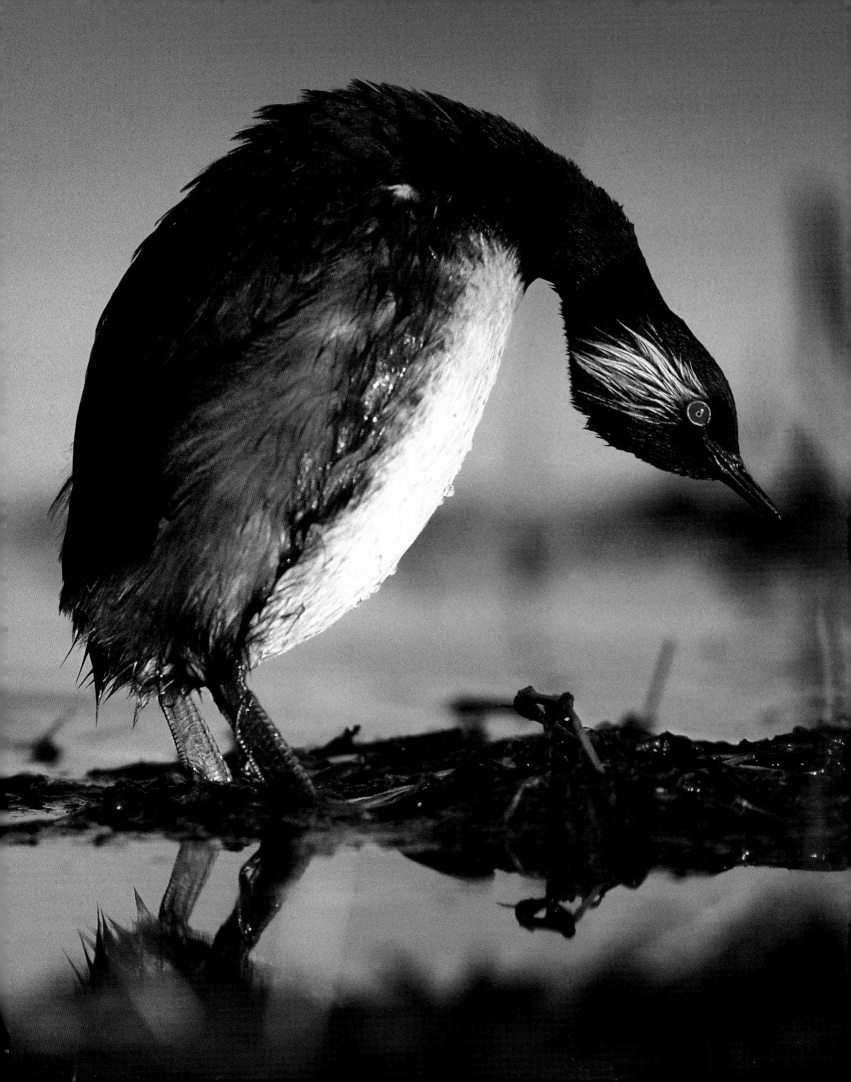

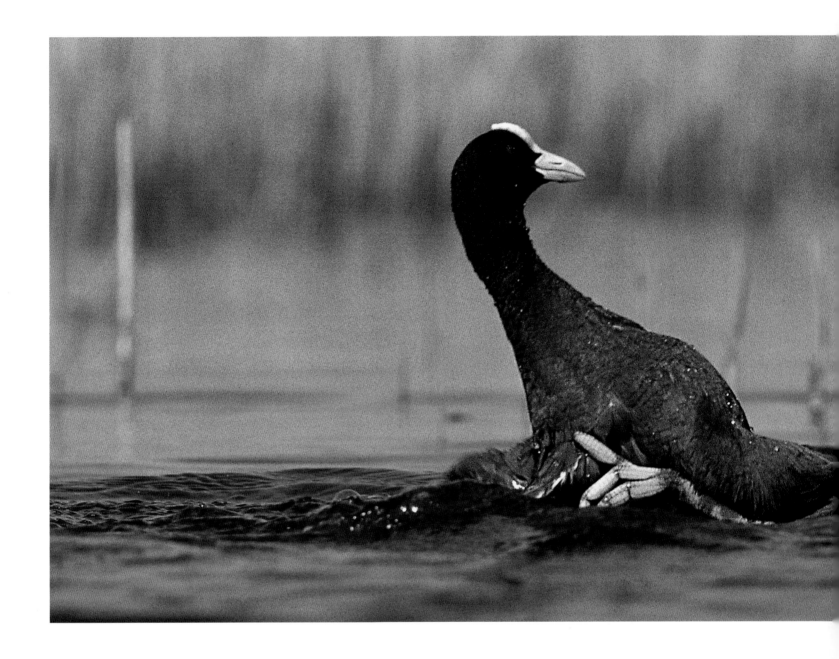

prominently displayed to show off the colors to their best advantage to the appreciative gaze of female ostriches. These indicate their chosen partner by urinating and defecating in front of him. Overcome, the male turns crimson from the base of his bald neck to the top of his head. After mating, he goes back to displaying, until he has built up a harem of up to five mates. However, this is by agreement with his first mate, whose position confers dominance. When she does not accept a lower-ranking female, she simply interposes herself between her and the male, thus ending the display.

Above

Eurasian coot

Fulica atra

Brenne, France

Before finding a mate, it is necessary to establish a territory. Territorial fights are violent among coots, which strike each other with their feet and exchange savage pecks.

Flighty Birds

Some birds do things differently. The common cuckoo, whose well-known call echoes in the woods in spring, is completely polygamous. Males and females have different partners, whose relations

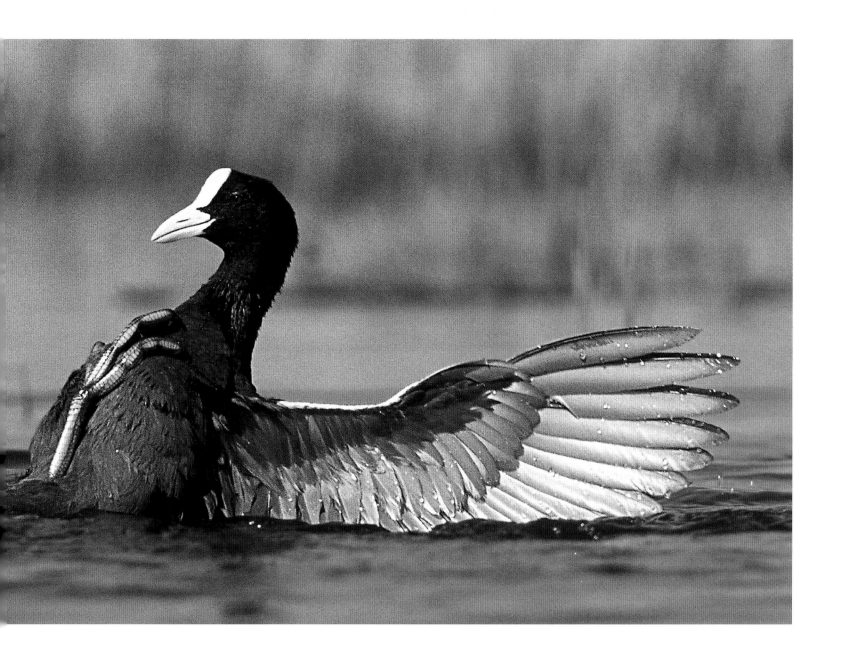

go no further that a perfunctory display followed by mating. The female, as is well known, then lays each of her eggs in the nest of a hapless host, always of the species in whose nest she was herself hatched, which must then bring up the young cuckoo on its own.

Tinamous, which live on the forest floors of South America, are also inveterate polygamists. Several females lay their eggs in a single nest, leaving the male in whose territory it lies to incubate them. They then go and lay a second clutch in another male's nest, thus shaking off all constraints.

Mating Displays

Since their sense of smell is often less keen than their other senses, birds tend to favor visual and acoustic signals in their displays, which makes them spectacular. When visibility is limited by thick

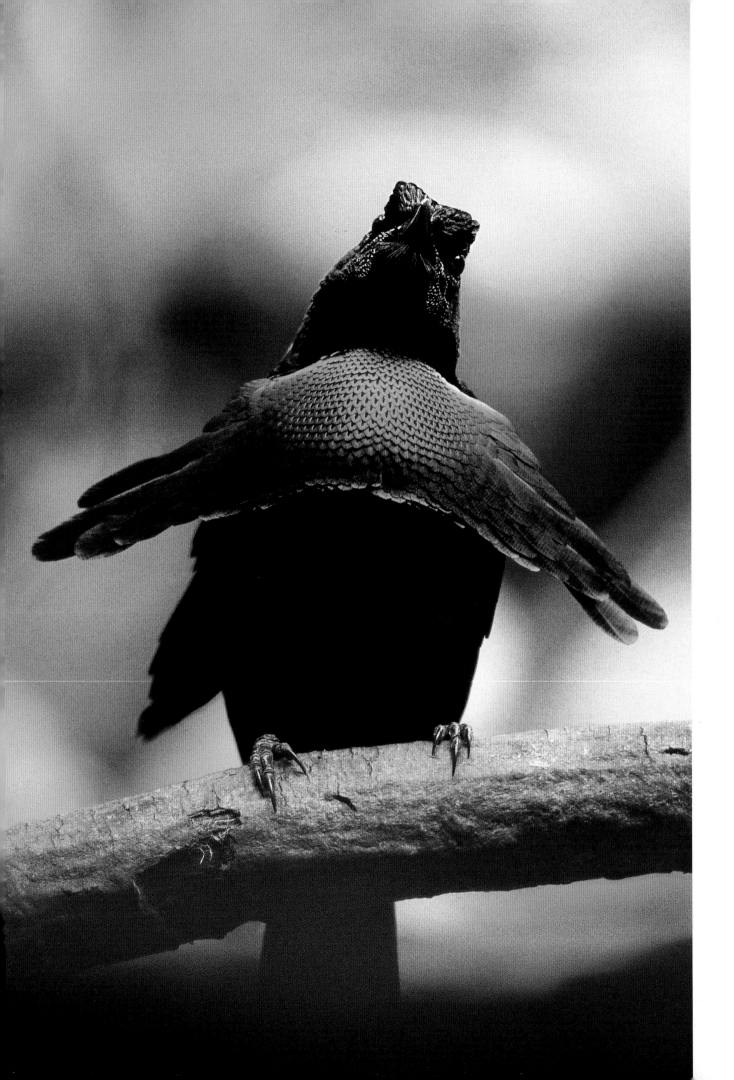

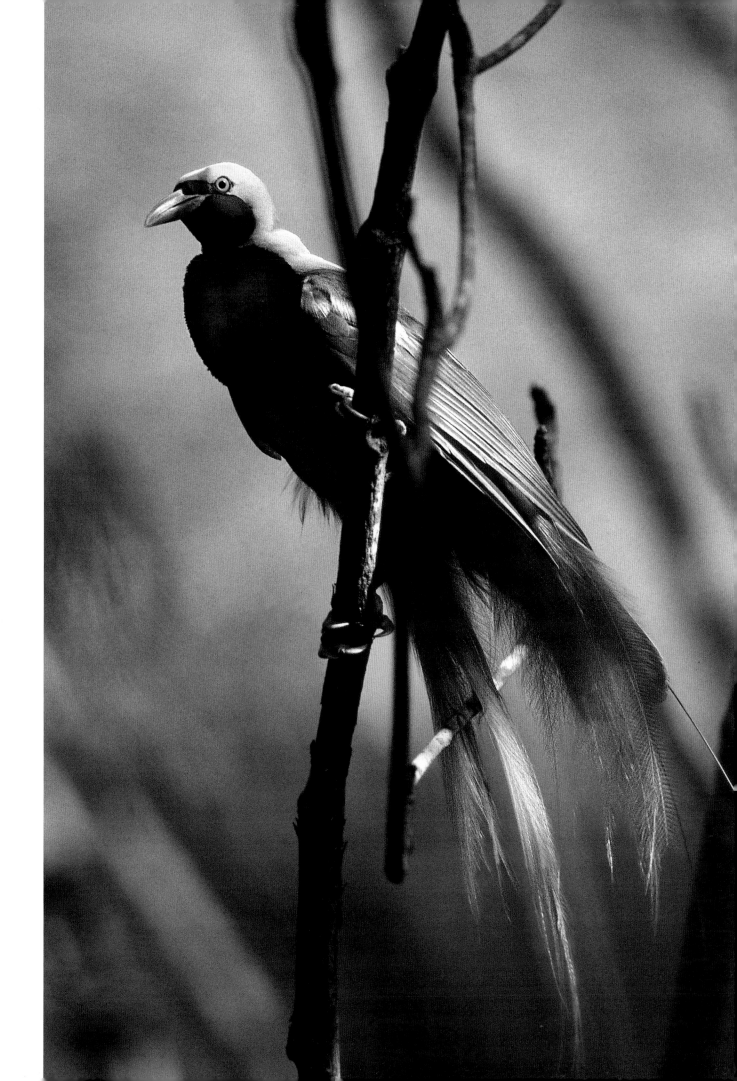

vegetation or nocturnal habits, displays take a vocal form. By contrast, species that live in open habitats, where visibility can stretch a long way, stage many visible displays, which have become ritualized over time. The male's approaches and the female's retreat have gradually evolved into a rhythmic dance whose movements are repeated and amplified.

Many mating displays, even the most sophisticated, have their origins in immature behavior, which has become ritualized. To indicate their desire to mate, some males adopt juvenile behavior—like the bearded tit, which seduces his mate by fluttering his wings like a chick begging for food. Birds of the pheasant family, especially chickens and peacocks, prefer to simulate the act of looking after chicks. The male domestic fowl and the pheasant perform the most elementary of courtship displays, scratching on the ground, retreating, pecking the ground, and clucking as if offering grain to imaginary offspring. With his wings lowered and slightly open, he even picks up small stones, dropping them immediately. The hen responds to this invitation by approaching and searching in vain. Their cousin, the Himalayan monal, a large, metallic-colored pheasant, bows deeply with his wings spread and tail fanned out, striking the ground with his bill in an ostentatious manner. As soon as a female arrives, he freezes in this ecstatic pose, only moving his fanned tail up and down slowly. The peacock's displays are so extravagant that they are hard to identify as the act of feeding chicks. Nevertheless, young males that are not yet experienced in mating dances fan their tails while actually scratching and pecking the ground, thus displaying a summary of their entire experience of life since they were chicks.

Feathered Warriors

Other members of this theatrically gifted family include male grouse, which meet in small arenas called leks and confront each other in a display that combines dances and calls. Females gather to watch, waiting until a pecking order is established before choosing the best-placed male and mating with him.

Rival males also meet in arenas and perform complex rituals, which females decipher perfectly. These small waders, related to woodcocks, are the only ones of their kind to display spectacular nuptial plumage. Like true knights bearing coats of arms, the males display the colors of their caste and thus denote their social standing. White ruff and ear-flaps indicate those with no territory to defend, and those with black or variously colored adornments square off with each other to woo females. Sometimes a particular color is enough to indicate a desire to mate, without the need to add complicated dance routines. Thus the bare skin of the male frigate bird becomes an enormous crimson sac during the breeding season. This is inflated whenever a female approaches, until the pair's single egg is laid.

Love Songs and Cooing

Birdsong is one of the greatest pleasures the natural world can offer humans. Aside from their unquestionable artistic qualities, songs have a dual function: they attract females, and they proclaim a male's presence to his rivals. For this reason they are usually delivered from a particular

Page 146

Superb bird of paradise

Lophorina superba

Papua New Guinea

Plumage for attracting a mate reaches its apotheosis in male birds of paradise, whose iridescent colors are skillfully placed in their best light during their extremely sophisticated displays.

Page 147

Raggiana bird of paradise

Paradisaea raggiana

Papua New Guinea

Male birds of paradise of almost all species play no part in raising the young, but they do spend considerable time displaying on their parade grounds, called leks. Arranged side by side, these are visited and chosen by the females, which leave as soon as mating has taken place.

Opposite

Great reed warbler

Acrocephalus arundinaceus

Brenne, France

Reed warblers are celebrated as wonderful singers that can whistle two tunes simultaneously. These are produced by the two halves of the sirynx, the bird's vocal organ.

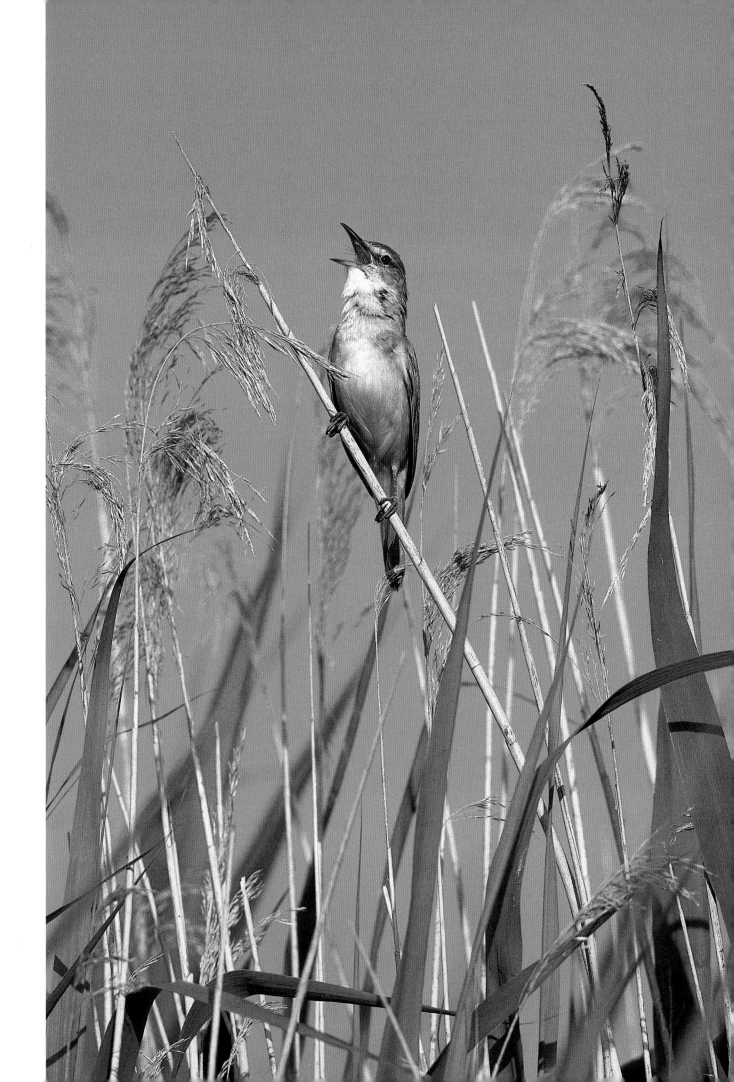

vantage point. A complex song attracts more potential mates and reduces the chances that a rival will invade the bird's territory. Complexity may indicate that the singer is in good health and of high social standing, and it sometimes gives the impression that several residents already occupy the territory. Many birds sing lustily for many months on end; others, more miserly, sing only when there is something to be gained. Thus the male of the unobtrusive European sedge warbler sings to attract a mate and stops as soon as he has found one.

In general, visual displays are the preserve of brightly colored birds, while those with duller plumage woo their mates by voice. The sweet-songed nightingale, which is grayer than a sparrow, produces its melodious warble at night. Males arrive at the end of their spring migration at night, some ten days before the females. Singing by moonlight, they attract the females' attention and thus increase their chances of mating quickly.

Although song is chiefly a male activity, sometimes two partners will sing together, as in the case of the tropical boubou (*Laniarius aethiopicus*). Each pair develops its own melody, and the partners use it to call to each other. This song is a true love duet, in which the two lovers can recognize each other without fail.

Sometimes, a singing bird develops a much wider range of pitch than is normally used by its own species. All imitators use their formidable gifts in this way to seduce females. Whydahs, handsome birds with dark plumage, do this when they parasitize the broods of finches and other similar species, using their nests to lay their own eggs. Their own territorial song is specific to their own species, whereas their amorous cooing is learned from their adoptive hosts. So perfectly do they imitate it that it is indistinguishable from the original. Similarly, the superb lyrebird, which lives in the heart of the eucalyptus and fern forests of Australia's east coast, is not content merely to be beautiful. It is a famously talented imitator, reproducing to perfection the sounds it hears in its day-to-day life. The raucous cry of the kookaburra, the more guttural call of the palm cockatoo, a soft twitter, the barking of a dog, a car horn, or a train's whistle—all these may be in its repertoire. Having attracted a female listener, the male lyrebird dances for her, setting up a stage consisting of a hillock devoid of all vegetation. His magnificent tail unfurled above his head, in a silver veil flanked by two large golden, curved feathers, gives the bird its name. Thus he dances and sings until he has lured a lover, who will bring up their single chick on her own, allowing the inveterate seducer to return to the prowl.

Accomplished Artists

Birds of paradise are not only virtuosi in nuptial dances—thanks to the surreal beauty of their plumage, they are also living jewels. They live solitary lives in the woods of New Guinea, only gathering to display on a tree that lies in the center of the territory occupied by each clan and is frequented by females and young birds. They utter loud, unmusical calls and ruffle their vividly colored feathers to various rhythms and in various positions. These vary from species to species, but all are astounding. Birds of paradise perform their display from the ground up to the topmost branches, transforming themselves into vibrating balls of feathers, their throat, wings, nape, tail, and breasts joining in their love song as they inflate themselves and curl up in their attempts to outdo each other. The blue bird of paradise ends its display hanging upside down from a branch,

Opposite

Satin bowerbird

Ptilonorynchus violaceus

Australia

The satin bowerbird uses his gifts as an architect and decorator to seduce his mate. Having braided the materials of his parade-ground walls, he paints them using pigments dissolved in his saliva. Finally, he decorates the entrance using objects collected from the surrounding area, always of different colors.

while its vibrating body produces a dull humming sound, punctuated by metronomelike movements from its long tail feathers. Even more astonishing is the dance of the emperor bird of paradise (*Paradisaea guilielmi*) a real pas de deux in which two males perform symmetrical movements. One perches on a branch while the second hangs upside down immediately under it, fusing art and geometry in perfect harmony.

Bowerbirds and catbirds are cousins of the birds of paradise, living in New Guinea and Australia. These talented architects build veritable temples of seduction, erecting towers built of woven twigs or constructing baskets that they then decorate with meticulous care, painting the walls using a shred of bark dipped into a mash of colored berries.

Gifts for Seduction

Any reluctance on the part of a possible mate is often overcome by soothing gestures. Male terns are attentive, offering their mates a fish. Kingfishers do the same, taking care to present the fish head first, making it easier to swallow. The offering of food is another ritualization of the act of looking after young, which is why such symbolic feeding is very widespread among species in which the female is solely responsible for incubation. She imitates the chick clamoring for a beakful of food. This passing of food from one partner to the other varies from species to species, ranging from the chaste kiss of the grosbeak, where no food is actually given, to the highly aerobatic movements of harriers, which pass prey to each other in mid-air.

Food is not the only gift that can be given. Nest-building material is also much appreciated, as are care and attention lavished on a partner. This takes the form of mutual grooming that usually involves only the neck and head—the parts of its own body a bird cannot reach. Nevertheless, this is enough to strengthen a pair's bond.

Once the seduction phase is complete, mating itself is usually fairly perfunctory—a simple joining of the pair's cloacae (excretory and reproductive orifices). The absence of a penis requires complete compliance on the part of the female, which must remain motionless or risk unseating her rider. The only examples of enforced copulation occur among certain ducks, which possess a penetrating organ and can force the females violently into mating.

Although males in general show great inventiveness in their displays, females are just as gifted, though their talents are more discreet. As among mammals, sex among birds is determined by sexual chromosomes. However, it is the females that determine the sex of their chicks, because they possess two different sex chromosomes: Z and W. Some species, notably Seychelles brush-warblers, can program the sex of their offspring according to environmental conditions. Thus, when food is abundant, they produce mainly females, which will help future generations to raise chicks. When food is scarce, on the other hand, they produce males, which will fly the nest to try their luck far afield.

Although we are always impressed by the physical beauty or splendid song of male birds, we forget the extraordinary decision-making powers of the females, which choose the most attractive males and then determine the sex of their chicks—a freedom of choice of which most mammals are totally unaware.

Opposite

Andean cock-of-the-rock

Rupicola peruviana

Peru

On his parade ground, the cock-of-the-rock attracts females by first uttering loud calls and then standing motionless, his superb rounded crest almost totally hiding his bill.

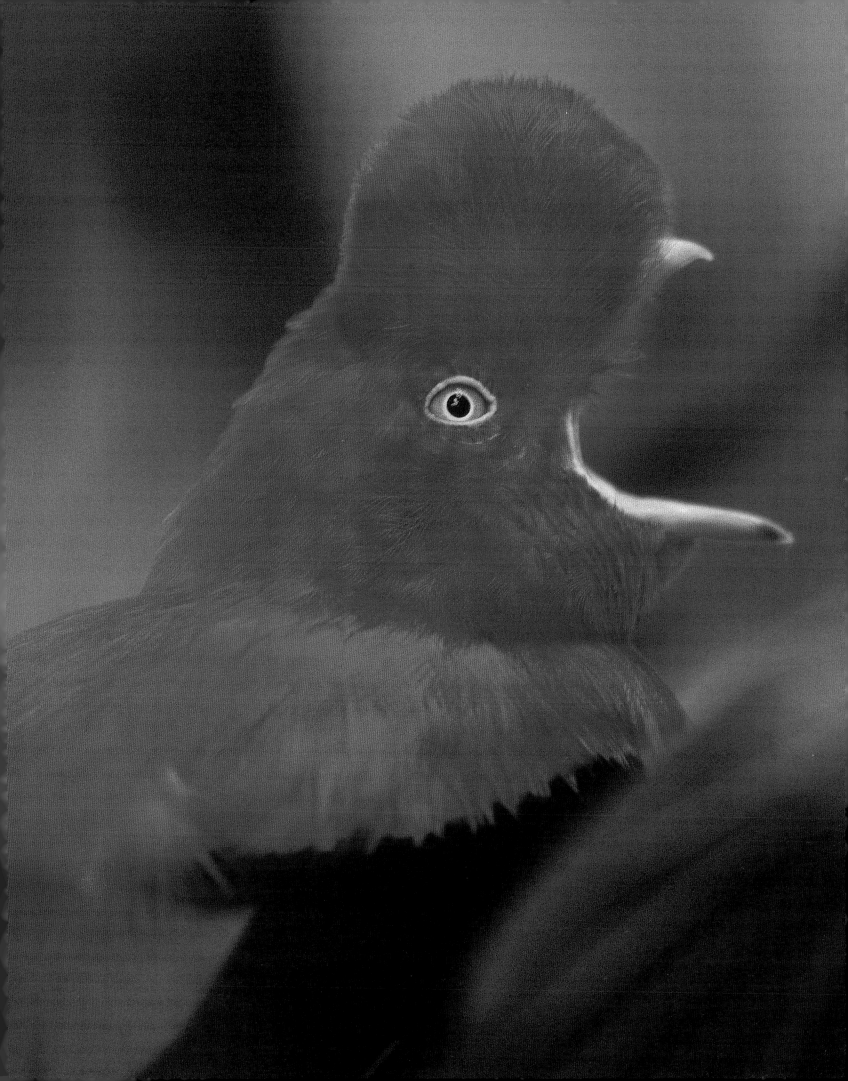

Opposite

Whiskered tern

Chlidonias hybridus

Brenne, France

After mating, a couple's bonds are reinforced by various tokens of "affection," such as offers of food by the male. The female behaves like a chick demanding to be fed.

Pages 156 and 157

Magellanic penguin

Spheniscus magellanicus

Valdes Peninsula, Argentina

These penguins emerge from the sea at the end of August to look for a suitable place to dig a burrow. The females, who do not arrive until mid-September, seek out their former partners or find new mates—in either case, always with a noisy courtship ritual.

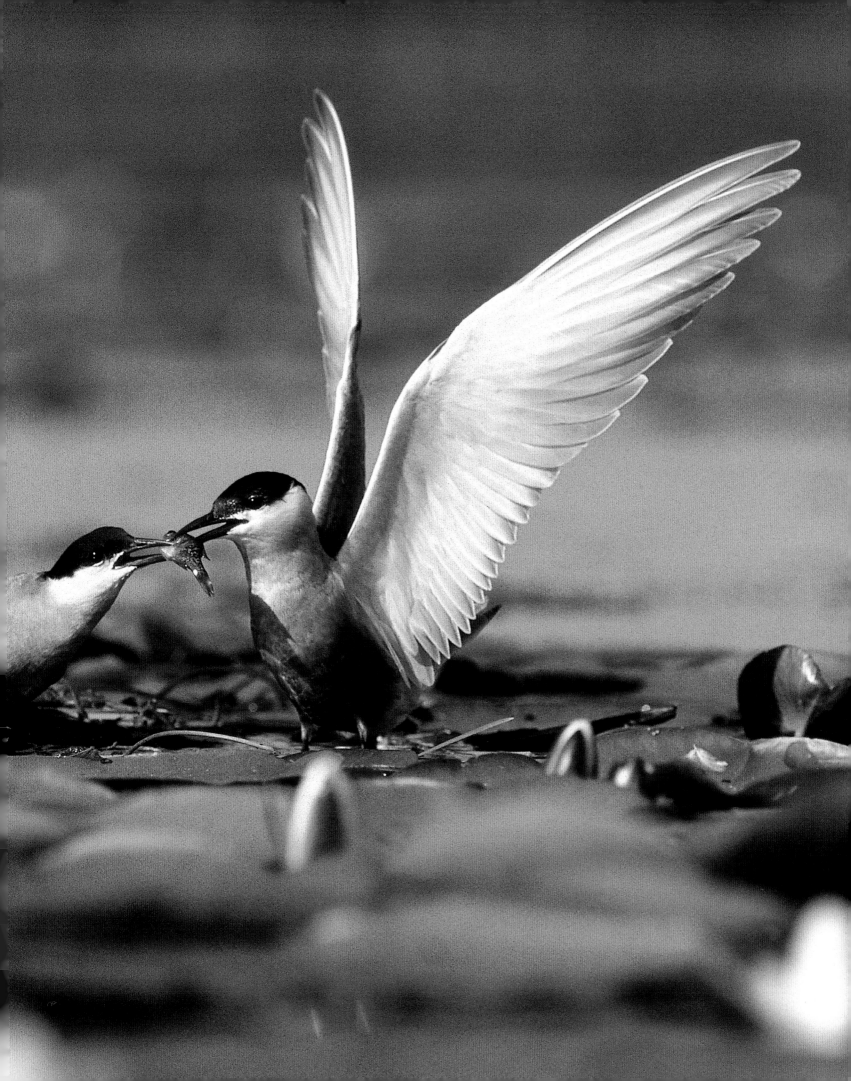

Opposite

Black-necked grebe

Podiceps nigricollis

Brenne, France

Among grebes, mating often takes place during displays, sometimes even before ovulation, and up to ten times a day in the two weeks before the eggs are laid.

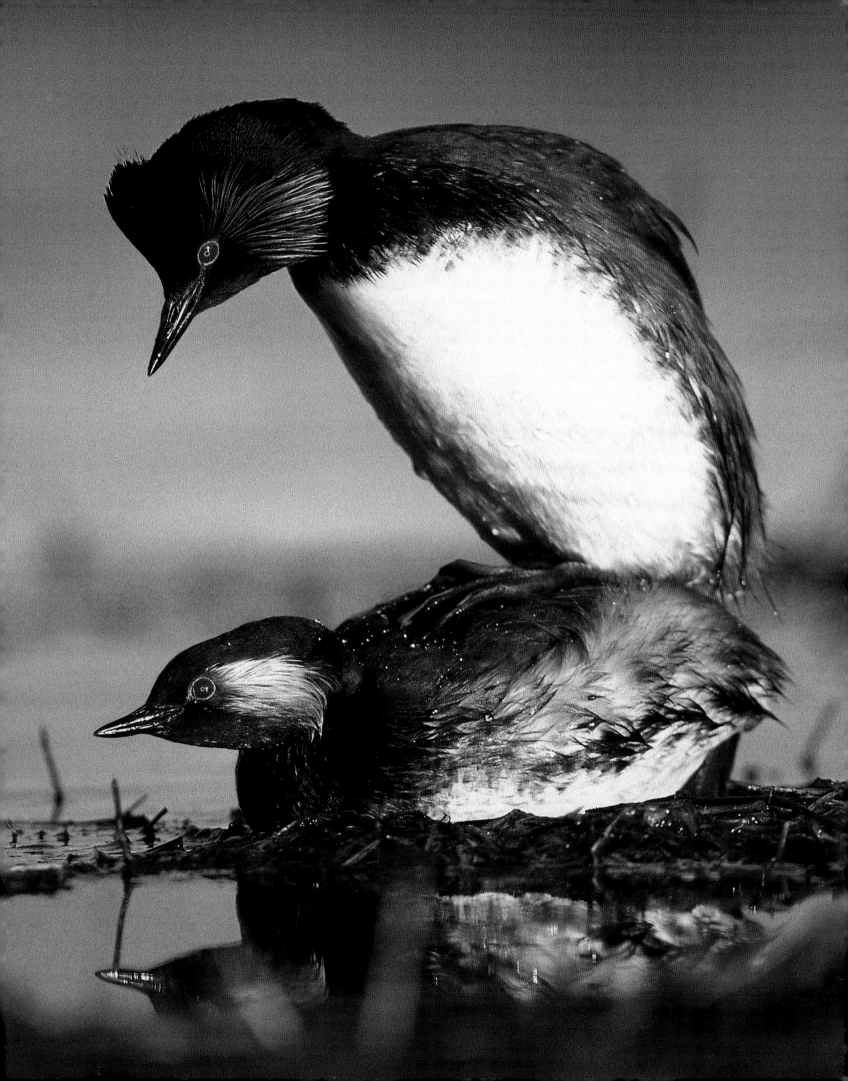

Master Builders

Common eider

Somateria mollissima

Mingan Islands, Quebec

A simple grass cup built on the ground, the eider's nest owes its fame to the precious down that lines it, the softest and warmest in the world. This nest has been parasitized by a gull, whose egg is recognizable by its speckled appearance. Such sharing of nests occurs when there is a shortage of suitable sites, but it can never succeed, because the incubation period and the time needed to raise the young differs enormously among species.

Pages 162 and 163

Black-headed gull

Larus ridibundus

Brenne, France

Both the male and the female of this species, which breeds in colonies, contribute to building the nest. This consists of a large pile of dried vegetable matter, where three eggs will be laid and incubated by both parents.

The image of a bird snuggling in a soft nest is a powerful one. Many animals build nests, but none masters the technique with the panache that birds do.

Nests are essential for birds because they lay eggs and must incubate them if they are to hatch. This is because they cannot carry their young for long, since they have had to sacrifice weight for the power of flight. The complexity of the nest varies according to the needs of each species regarding protection of the eggs and brood. From bare ground to the colonial dwellings of the sociable weaverbirds of Africa, every variation, shape, size, and material can be found in the fascinating world of birds. Some are diggers, like puffins, which scoop a hollow in the ground; others are builders, like swiftlets, which use their sticky saliva as cement; some are even tailors, like the tailorbird, which sews leaves together using blades of grass. Birds demonstrate a whole range of skills for protecting their offspring. With their hidden entrances, or perilous positions on sheer cliffs, the places where birds lay their clutches baffle both predators and the law of gravity. Paradoxical as it may seem, nests illustrate both adaptability and immutability.

The immutability lies in the fact that while each species always builds its nests along the same basic lines, they are superbly adaptable because they use whatever material is available. Moss, sheep's wool, or horsehair, scraps of cloth and other manmade items, all are sought after by these builders.

Are birds wonderful architects, genius builders, or the inventors of cocooning? Or all of these? What is a nest? On its surface, the question seems absurd. We think automatically of the small, skillfully made cups fashioned by the passerines of our own regions, such as might figure in a popular print of the return of spring or Easter. However, there are as many kinds of nest as there are birds, including "nests" that contain no eggs, and birds that have no nest. The cleverly made cradles constructed by the bowerbirds of Oceania, tastefully decorated, are not in fact nests. Despite appearances, which in this case deceive, they are actually display areas whose function is seduction, the prelude to mating. By contrast, the nightjar, a nocturnal insect-eater, is content to lay its eggs on the bare ground, even going so far as to choose the utter bareness of a flat roof—reducing the concept of a nest to its minimum: a place to lay eggs. A nest is therefore whatever a bird considers it to be.

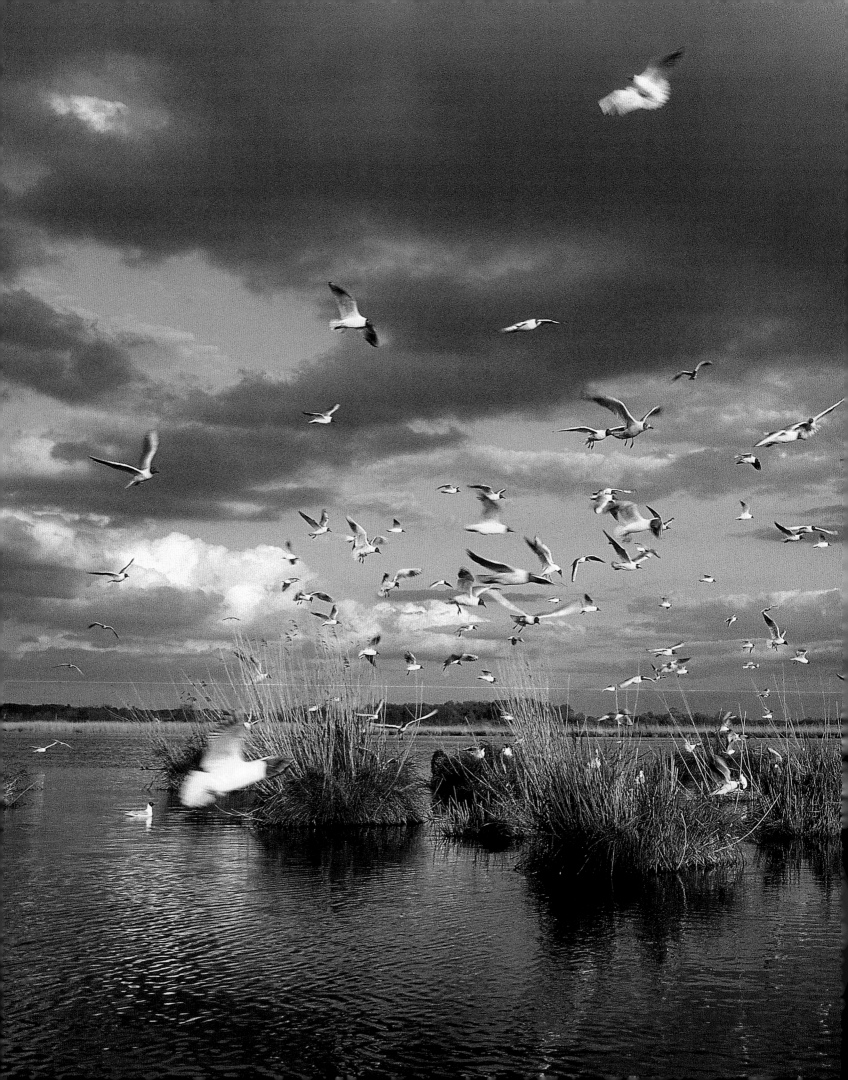

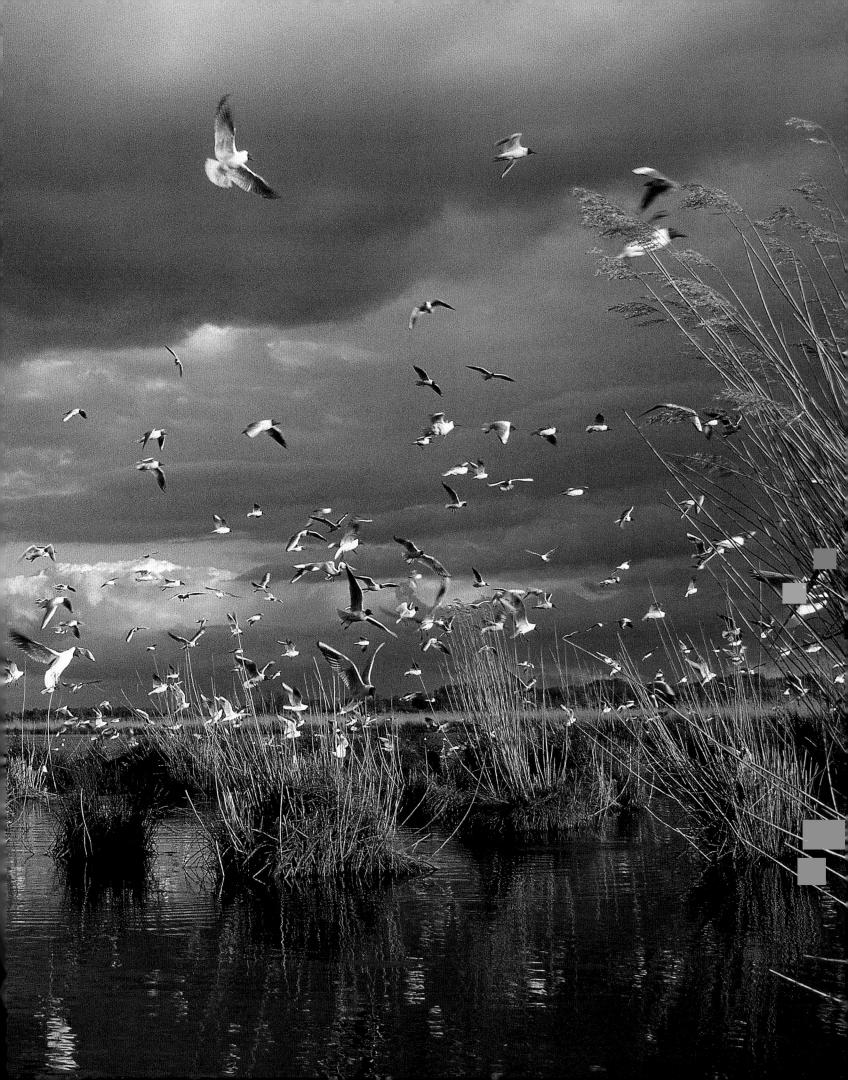

Increasing Complexity

Egg laying is something birds inherited from their reptile ancestors. Probably the earliest birds did as reptiles do: they dug a hollow in the ground, laid their eggs in it, and covered them with soil or leaves. But unlike reptiles, birds are warm-blooded and must keep their eggs at a high and constant temperature. Warmth speeds up the development of the embryo. This rapid development offers a second and considerable advantage: because they hatch more quickly, the eggs are less vulnerable because predators are given less time to find them. Nevertheless, incubation remains a vulnerable time, for they have scant protection and eggs laid on the ground may accidentally roll out of the nest. Re-placing them is a test of skill for the incubating parent, which must use its bill to roll them back without breaking them—and being ovoid, eggs do not roll straight. This is quite a feat. A nest is therefore indispensable for most birds, given their biology. They need to incubate their eggs in a safe place, at a constant temperature and humidity. It seems likely that, over long periods of time, they progressively sought to more effectively protect their young from predators. Having reached the treetops, they found there an excellent place to rear their chicks. However, laying eggs in the trees required a less exposed shelter than laying them on the ground, for both eggs and chicks needed to be protected from falling to their deaths. There were two options: either laying the eggs in an existing hole, perhaps improving and adapting it, or building a shelter from scratch.

Now, birds build an extraordinary range of nests, from the crudest to the most elaborate. This does not mean that species that build simple nests are more primitive than the others. The nest-building instinct may weaken, reappear, and disappear once more, according to the evolutionary vicissitudes of each species. The cuckoo has even lost it altogether, to the point that it lays its eggs in other species' nests and takes no interest in them whatsoever. All over the world there are similar parasites, which entrust others with the task of incubating their eggs and bringing up their young.

Opposite

Great crested grebe

Podiceps cristatus

Brenne, France

The grebe pair builds its nest on a platform of floating vegetation, preferably reeds, carefully moored to neighboring plants. The rotting plant matter inside the nest stains the eggs during incubation.

Eggs with No Nest

The extremely attractive fairy tern and white tern both lay their single egg on a bare branch, completely without protection. The newly hatched chick has powerful claws, like small talons, which allow it to cling to and even hang from the branch with ease. Equally nonexistent is the nest of the king and emperor penguins, which carry their egg, and then their chick, in a fold of abdominal skin, resting on their webbed feet, as does the waved albatross. These are the only known mobile nests. Guillemots and auks, these birds' northern equivalents, lay their eggs on the bare rock of ledges on high cliffs. The tawny owl does not modify its environment either but does take the precaution of laying its eggs in the hollow of a tree. While the Eurasian stone curlew lays its eggs in a shallow depression in the ground, its cousin the water thick-knee lays its own eggs in the droppings of hippopotamuses, while the sand grouse, a sort of pigeon that lives in the same region,

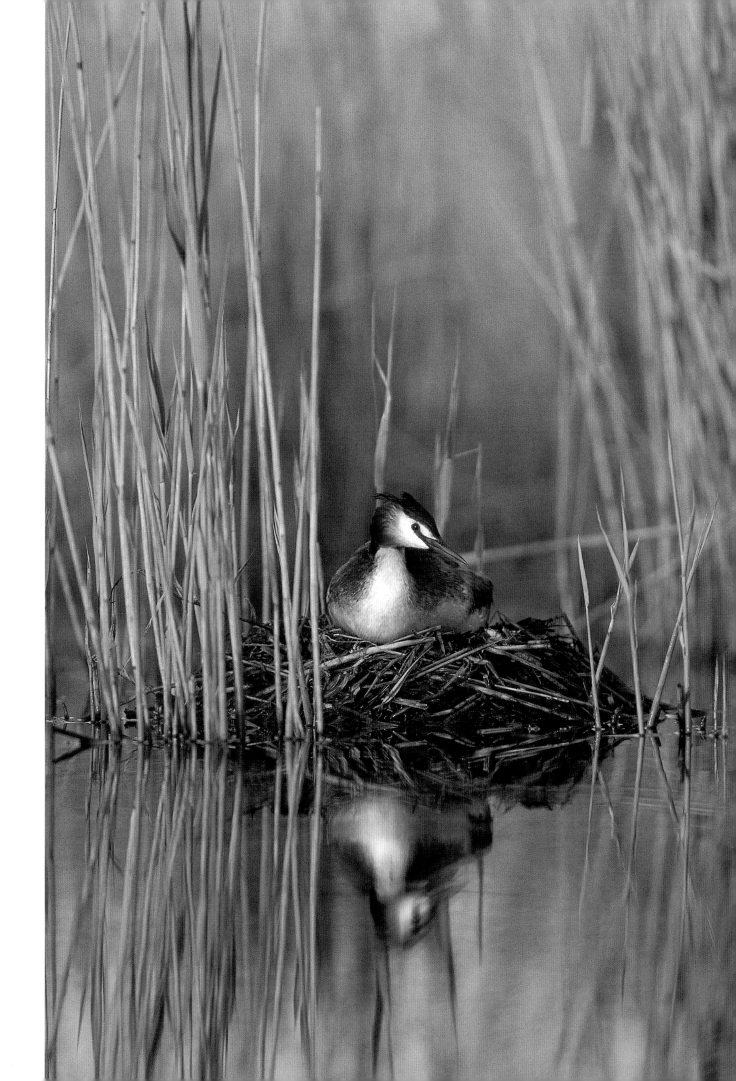

Opposite

White tern

Gygis alba

Aride Island, Indian Ocean

This handsome tropical tern lays its single egg
directly on a branch, without building even the
most rudimentary nest. This is no riskier than lay-
ing it on the side of a cliff, as many seabirds do.

is content with the broad footprints large mammals leave in the ground. Even when they build no nest, birds do not lack imagination in their quest for a place to lay their eggs.

Floating Nests

The nests built by grebes and jaçanas, water birds that live in marshes and lakes, look rather rudimentary. However, they are interesting in one singular respect: they float. This means that whatever the water level, which can vary widely in this type of habitat, they keep the clutch safe. The nest's occupants remain dry at all times. Since the nests are moored to the reeds growing by the shore, these strange rafts cannot drift away, and the reeds also screen them from the sharp eyes of predators. Flamingoes have found another way of solving the problem of fluctuating water levels: they build a chimney-shaped nest out of mud pellets in the shallows and lay their eggs at the top.

Cups and Domes

The hemispherical cup is the shape that immediately comes to mind when we think of a bird's nest. However, while this type of nest shelters the brood perfectly, it leaves the parent exposed, whose body must act as a roof and protection for its precious offspring. The advantage of such nests is that they offer the sitting bird a clear view of its surroundings. It is difficult for a marauder to approach without being spotted, and easy for the bird to take flight at the last minute. Many species add a sort of protective dome made of twigs, as do magpies, which like to build in the tops of trees, and sparrows when they nest in the open.

Dome-shaped nests, with their spherical shape and side entrances, are a little more elaborate. These are more cocooning, giving better protection against the elements and completely hiding parent and young. On the other hand, they prevent the sitting bird from seeing an approaching predator, and they make escape more problematic. Orioles of the New World have solved this problem very cleverly. They simply build their hanging nests close to those of wasps, which protect them by preventing monkeys and snakes from venturing too close. The Cape penduline tit is equally crafty. Its domed nest, hanging from a branch, looks entirely ordinary with its wide side entrance. However, this nest is designed to deceive, and is equipped with a safety system worthy of the pharaohs of ancient Egypt. In fact, the side entrance is a dummy that leads nowhere, designed to turn away undesirable visitors. The true entrance to the nest chamber is a narrow slit beneath, completely invisible from the outside. The bird makes sure to open and close it with its feet each time it enters or leaves.

The winter wren, which is equally fond of European gardens as it is of forests, has a strategy that is quite different. This tireless builder makes several nests of moss, straw, and small twigs, each equipped with a side entrance. Having finished his work, the male lets the female

Opposite

Seychelles paradise-flycatcher

Terpsiphone corvina

La Digue, Seychelles

A nest built at the end of slender branches offers the simplest form of protection: it is inaccessible to land predators because they can not venture there without risking a fall.

Page 170

White tern

Gygis alba

Aride Island, Indian Ocean

The safety of the tern chick depends entirely on its ability to stay on the branch where it was born. Fortunately, the young are equipped with powerful claws, which enable them to cling to their branches, sometimes even hanging upside down.

Page 171

Village weaver

Ploceus cucullatus

Masai Mara, Kenya

Weaverbirds are skilled builders whose materials are shreds of freshly picked vegetation. The male builds the nest alone. If he fails to attract a female before the weeds and grasses start to decompose, he discards it and builds a new one. The female's job is to line her chosen dwelling with feathers, to make it more comfortable.

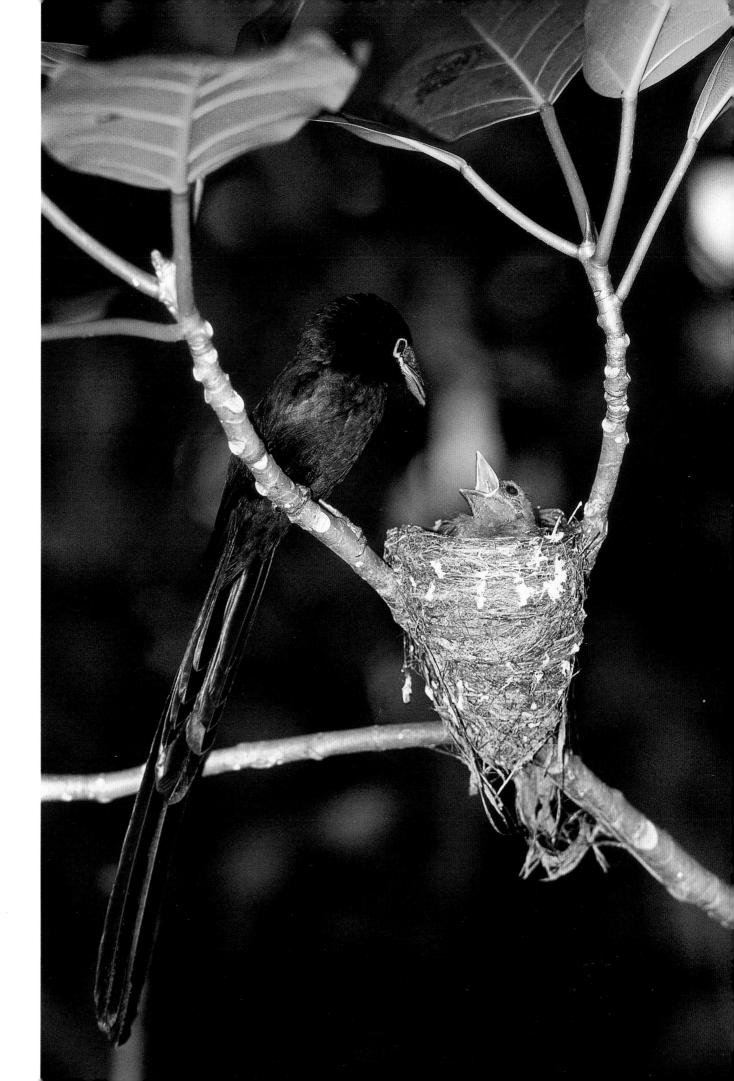

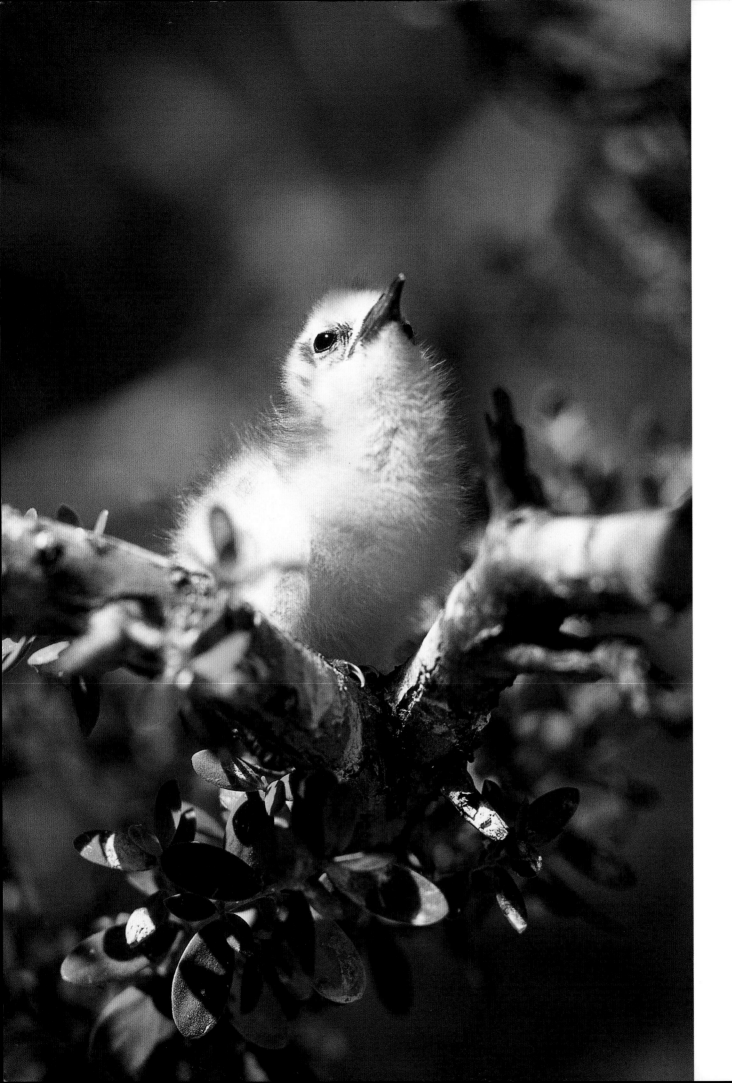

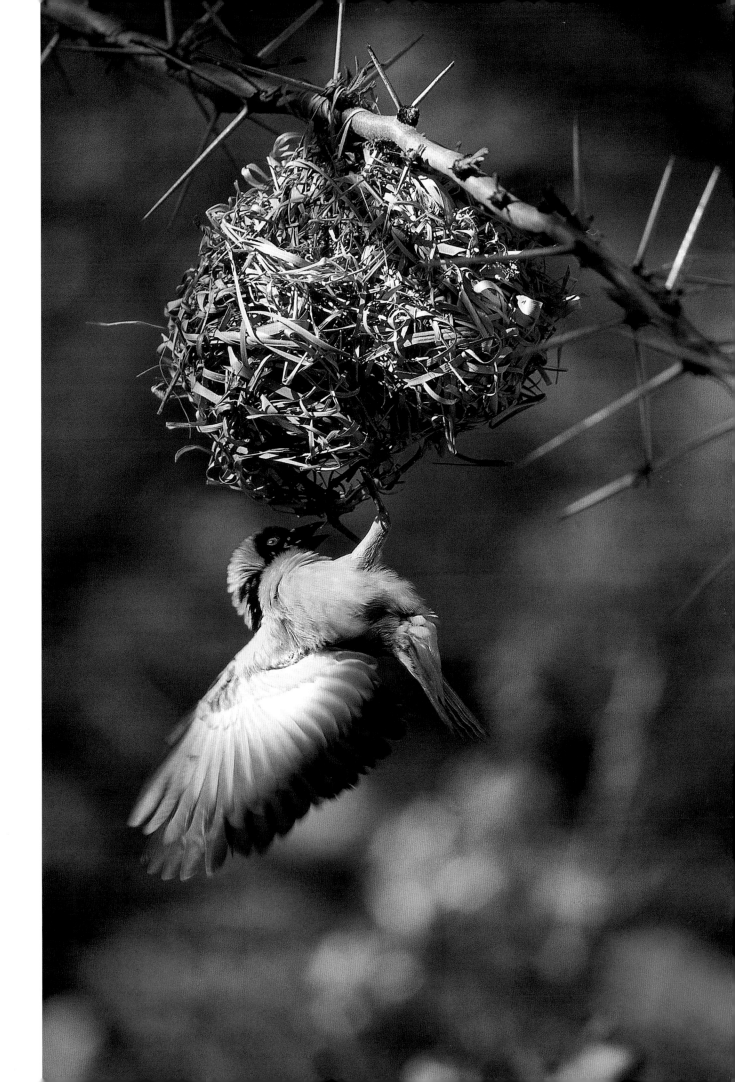

choose the nest she prefers. She then lines it with hair and feathers before laying between five and seven eggs.

Gifted Basket-Makers

The art of nest building demands that tasks be accomplished in a certain order. First, the strongest materials must be chosen to ensure the construction is robust. Weaverbirds, masters of the art as their name suggests, start by collecting several solid stems. They arrange these around the fork of a branch and fasten them together at the ends, forming a circle that will be the nest's base. They then reinforce this circle by adding other thick pieces of material. Finally, they weave all around the dome and the basket using three techniques: knotting, weaving, and braiding. Such is their dexterity that they are perfect masters of the slip-knot, the half-stitch, and the half-hitch. This, however, demands a long apprenticeship, and the nests built by young males blow down with the first gust of wind. The tailorbird is another skilled craftsman. This Asian species builds itself an inaccessible nest by sewing large leaves together with plant fibers, which it passes through holes it has previously made along the leaves' edges. It then lines this discreet casing with fibers and down, producing a soft little cocoon. Finally, the delicate hummingbird strengthens its nest with strands of silk woven by spiders or caterpillars, and even uses real silk when it can get it from human silk-manufacturing plants.

When Reality Is Beyond Our Understanding

Megapodes, the large gallinaceous birds of Oceania, have specialized in using the heat that exists naturally in their environment, and they build nests like no other. None of the twelve species of these birds incubates its eggs. The site is carefully chosen to provide constant heat, with the incubator being the sun, volcanic activity, or a hot spring. Forest-dwelling species use the heat generated by rotting vegetation and can build mounds 33 feet wide and 16 tall (10 by 5 meters), into which they insert their eggs. The mallee fowl, which lives in the Australian bush, devotes eleven months of the year to nest building. The male gathers plant waste and leaf mold from a wide radius, building a mound which then starts to ferment, raising its temperature. As soon as the incubating mound is warm enough—around 91.4 °F (33 °C)—the female lays her eggs in holes dug into its heart. It is the male's responsibility to check the temperature daily using his tongue and to keep it constant by covering or uncovering the clutch until the eggs hatch. No sooner have the chicks extricated themselves from this giant incubator than they are left to fend for themselves entirely, receiving absolutely no care from their parents. Nevertheless, they too will be able to build this high-technology nest without any training, purely by instinct.

Far less sophisticated, but far more acrobatic, is the nest of the potoo. This relative of the nightjar makes do with a notch in a tree trunk to contain its single egg. The parent bird then clings

Opposite

Painted stork

Mycteria leucocephala

Bharatpur, India

Once the nest site has been chosen, the right building materials are not necessarily close at hand. The nesting bird must collect plant stems to complete its work.

Pages 174 and 175

Brown noddy

Anous stolidus

Amirantes, Tanzania

Species that build rudimentary nests are rarely faithful to one nest site. It is difficult to find the spot again in succeeding years, and their choice of location varies according to the environment, although the colonies within which they nest tend to form again in roughly the same place.

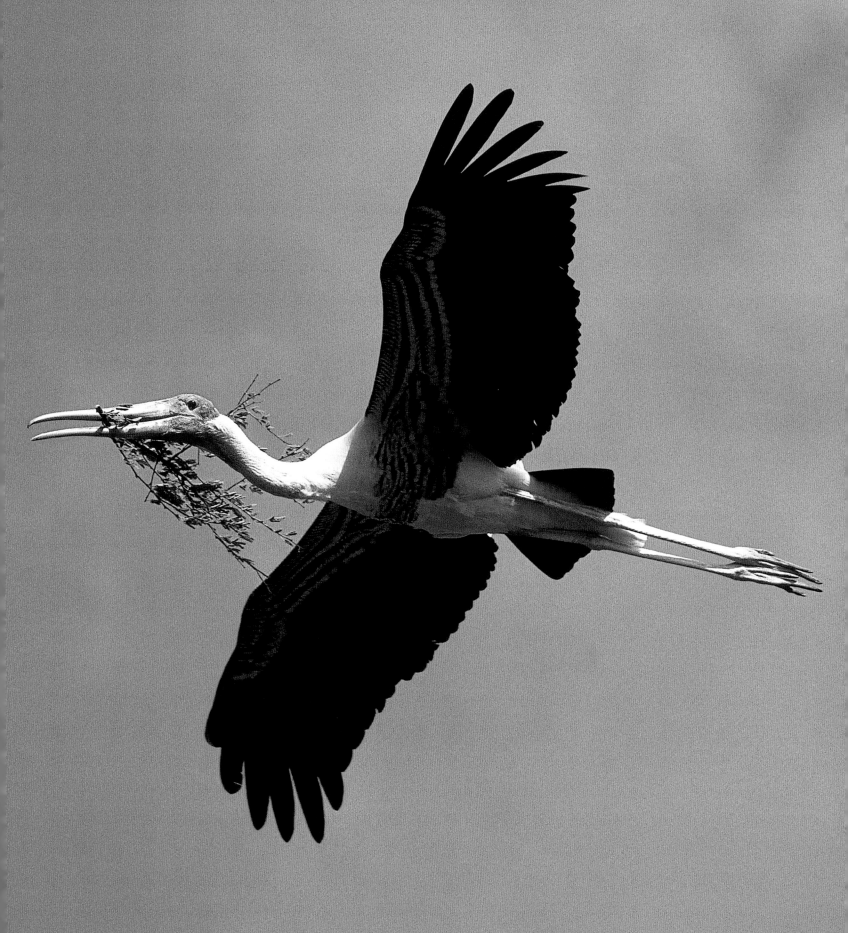

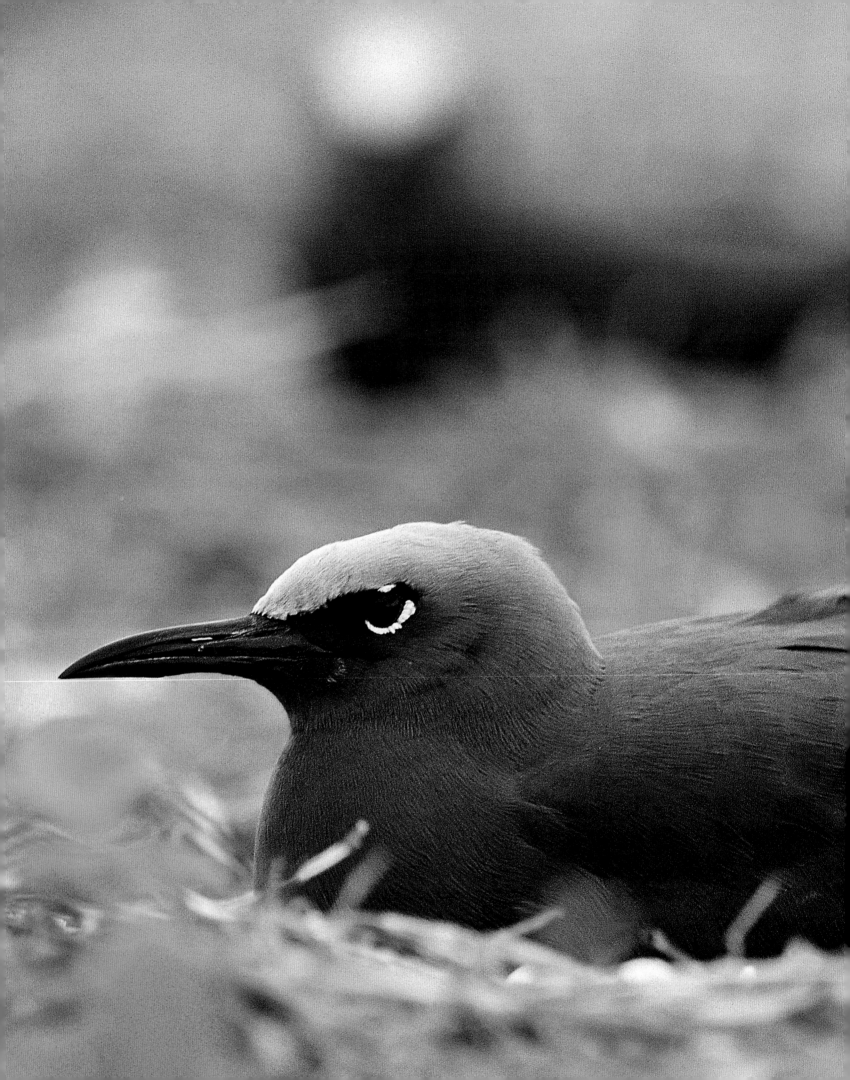

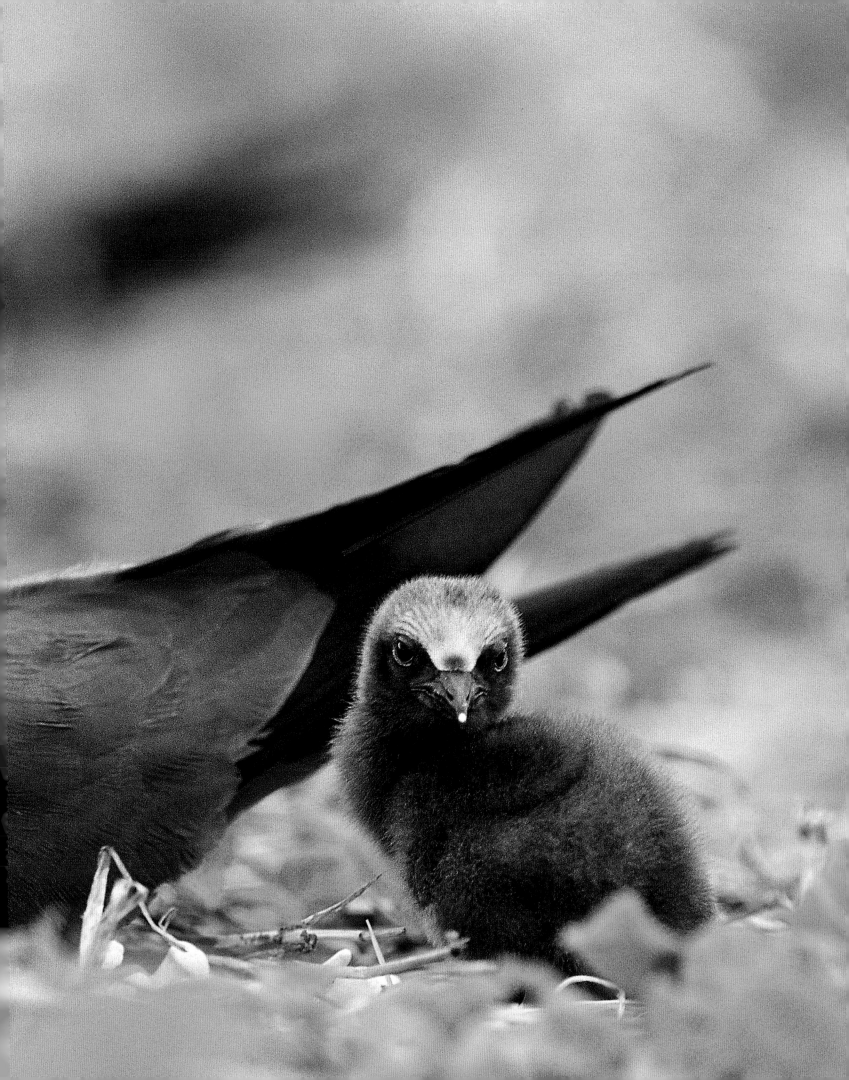

to the trunk vertically throughout the incubation period, flattening itself against the bark and relying on its superbly effective camouflage to make it look like no more than a small excrescence of the trunk. The African palm swift also behaves in a most intriguing way. This marvelous flyer, which is reluctant to come to rest anywhere but the most inaccessible of places, collects the materials for building its strange nest while in flight. It glues feathers and twigs caught in midair onto the underside of a dangling palm leaf, using its sticky saliva. This completely vertical construction acts as the cradle where the palm swift lays its clutch of eggs. Each egg must then be carefully glued to it. When the chicks hatch, they are inevitably detached from the sticky underlayer, but they are equipped with claws with which they cling firmly to the nest, and they do not fall off. Their cousins, the swiftlets, which nest in the darkest caves, use their saliva as their main building material. Some birds add a few feathers, scraps of paper, or feathers caught in flight, but Mascarene swiftlets use pure saliva, which hangs down in filaments before it dries completely. These unique nests are a delicacy in Chinese cooking, where they are used to make what is universally known as bird's nest soup. The oilbirds of South America escape this fate, even though they might be expected to meet a similar end. These cave-dwellers, which share with the swiftlets the peculiar ability of echolocation, build their nests from crushed fruit, which they glue together with their sticky saliva. Many birds use some form of mortar to hold their nests together, mixing it with the materials they have at hand. The brown noddy, a tropical seabird, uses sticky seaweed, which it glues to branches by spraying them with its droppings.

One-Ton Nests

The sociable weaverbird of southwest Africa is famous for its gigantic nest, comprising between fifty and one hundred separate dwellings built side by side under the same roof and maintained collectively by the colony's members. Each entrance is blocked with blades of grass to keep predators from entering. This enormous nest—a veritable apartment complex for birds, which can measure as much as 20 by 13 feet (6 by 4 meters)—has the advantage of maintaining a constant temperature. Warm in winter and cool in summer, such nests are found in areas poor in building materials and where suitable trees are scarce—a sort of economy of scale invented by birds that live colonially. Their advantages clearly do not pass unnoticed by other species that also make use of them; for example, the evocatively named rosy-faced lovebird or the pygmy falcon. The great disadvantage of such nests lies precisely in their gigantic size. A heavy downpour is enough to soak them completely, making them so heavy that they collapse and crash to the ground. The monk parakeet of the forests of Central America also builds a colonial nest, which rests on several thick branches of a tree. With impressive care and perseverance, these birds weave plant material into fine wands measuring up to over 8 feet (2.5 meters) long that hold together this common dwelling in which each pair of birds has its own chamber.

The nest of the hamerkop is also a gigantic affair, but it is reserved for the use of only one pair of birds. Just over 8 feet (2.5 meters) in diameter and entirely enclosed, it consists of thickly

Opposite

Whiskered tern

Chlidonias hybridus

Brenne, France

Both parents build the nest of grass and reeds on a floating platform made of plant debris.

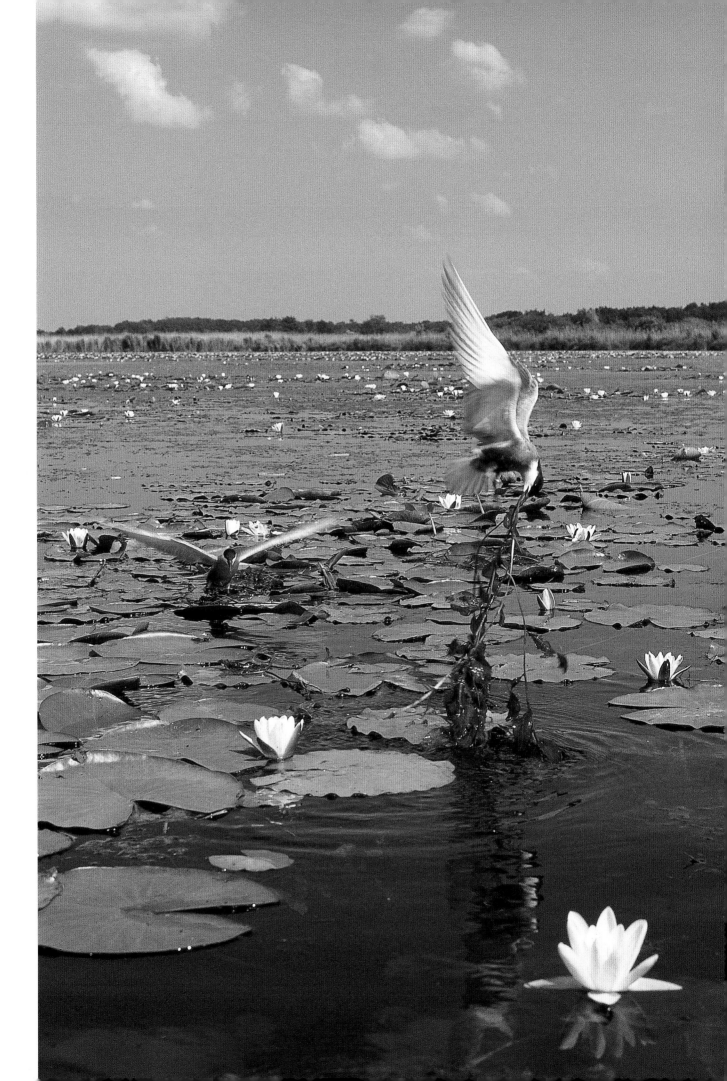

woven branches, twigs, pieces of wood, and various animal bones, all held together with mud. The entrance, on the lower part of the dome, is almost invisible. It takes between two and six months of unceasing work to build and is strong enough to bear a man's weight. No one has established the function of a nest requiring so much material and effort.

Using the Nests of Others

Woodpeckers of all species and on all continents are efficient at hollowing out trees, thanks to their powerful bills. Their nest holes are coveted by an astonishing range of other less-well-equipped species, which find in them a ready-made home. Parrots and owls are devotees, as is the myna, which is a much better imitator than builder. The wood duck, one of few ducks that does not nest on the ground, also makes use of them. The magnificent quetzal, the sacred bird of the Aztecs, is another species that occupies abandoned woodpeckers' nests, as does the king bird of paradise of New Guinea. The male of this species is breathtakingly beautiful, with blue feet and an entirely vermilion body; only about 7.8 inches (20 centimeters) long, during the breeding season it develops long tail feathers with bright-green flattened ends.

Most gallinaceous birds are content to lay their eggs in a shallow depression in the ground, which they hollow out using their breasts. The fiery-colored male satyr tragopan, however, sports multihued breast feathers and inflates his chest in front of the female and occupies the abandoned nest of a bird of prey. The crested tit of European coniferous forests takes up residence in the abandoned nest of a squirrel, which it lines with moss and mammal hairs before laying its eggs.

Soft Furnishings

Most birds use feathers or down to make their nests into cozy cocoons. The majestic Andean condor, however, chooses mammals' skins to line its enormous aerie, built on an inaccessible rocky ledge. Other raptors, such as the Old World black kite and lammergeyer, do the same. The Australian honeyguide likes horsehair, which it takes directly from the animal. The lesser road-runner, an American bird immortalized by the speedy cartoon character, lines its nest with the skins of snakes, which are also its favorite meal. The burrowing owl lives in the same semidesert habitat in the United States and Mexico, where it takes over a mammal's burrow to lay its eggs and rear its chicks. The European kingfisher, like all its kind, builds its nest on a steep bank by a pool or river, digging a tunnel up to 3 feet (1 meter) long, at the end of which is the nest chamber, carefully lined with fish scales.

Many birds like to nest in burrows. Perhaps the most astonishing is the burrow of the rhinoceros auklet, an auk of the northern Pacific, which can be up to 26 feet (8 meters) long. The sacred kingfisher does not dig deep, but it occupies a termite nest, which tends to discourage intruders. As for the violaceous trogon, it simply digs into the wax of a wasps' nest—having first devoured

Opposite

Whiskered tern

Chlidonias hybridus

Brenne, France

Birds may carry pieces of vegetation that are much longer than their own bodies. If the plants are wet, as here, they can be heavy enough to hamper flight.

Pages 180 and 181

Red-footed booby

Sula sula

Tikehau Island, French Polynesia

The most remarkable characteristic of boobies is their peculiar method of incubation: lacking brood patches, they use their feet. They sit back on their heels and alter the blood flow in the webs between their toes, thus maintaining a constant temperature throughout the forty-two- to forty-seven-day incubation period.

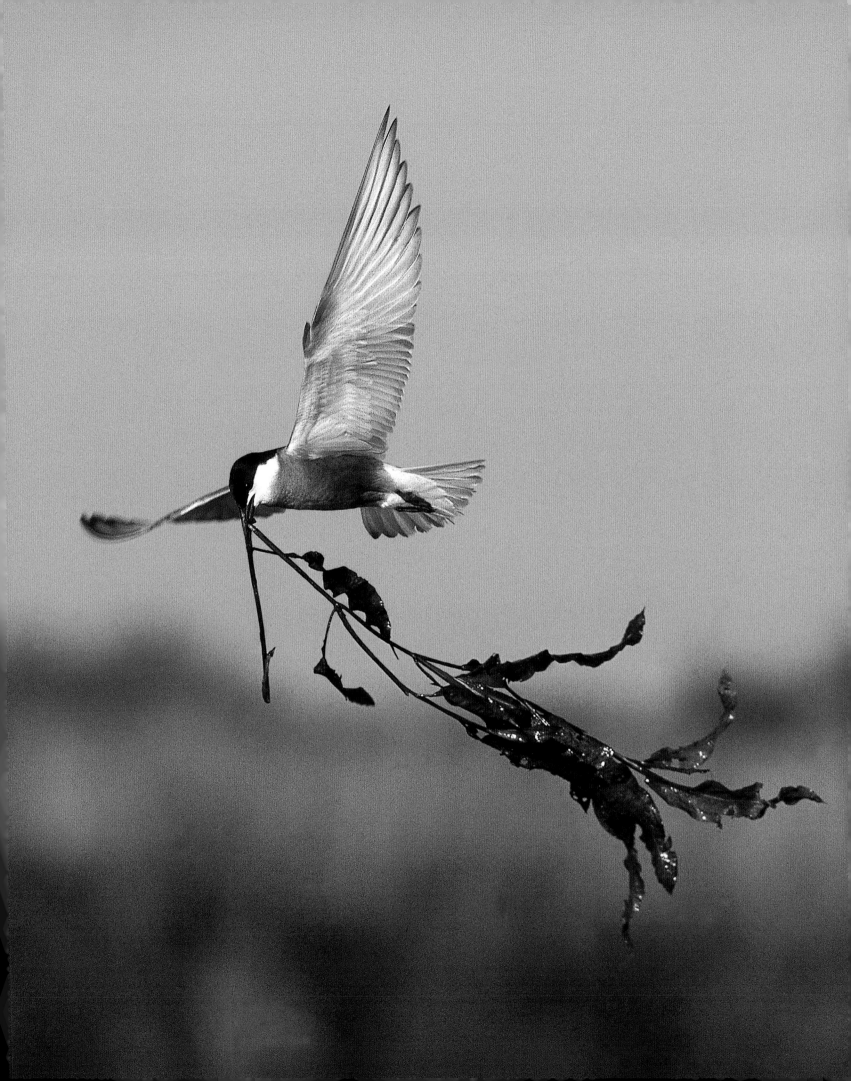

the occupants—thus getting itself both room and board. Male starlings perfume their nests with various herbs to attract females more easily, while the blue tit commonly adds shreds of aromatic plants—lavender, mint, thyme, or rosemary—which have a strong action against parasites, as well as insecticidal and disinfectant properties. Certain other tit species choose flower petals as a lining for their nests. Here, as in so many other areas, birds' habits are a constant source of astonishment; such are their remarkable talents.

Opposite

Cuckoo

Cuculus canorus

France

Cuckoo chicks often hatch before their companions in the nest. Within hours of emerging, they are driven by instinct to get rid of the other eggs by tipping them over the side.

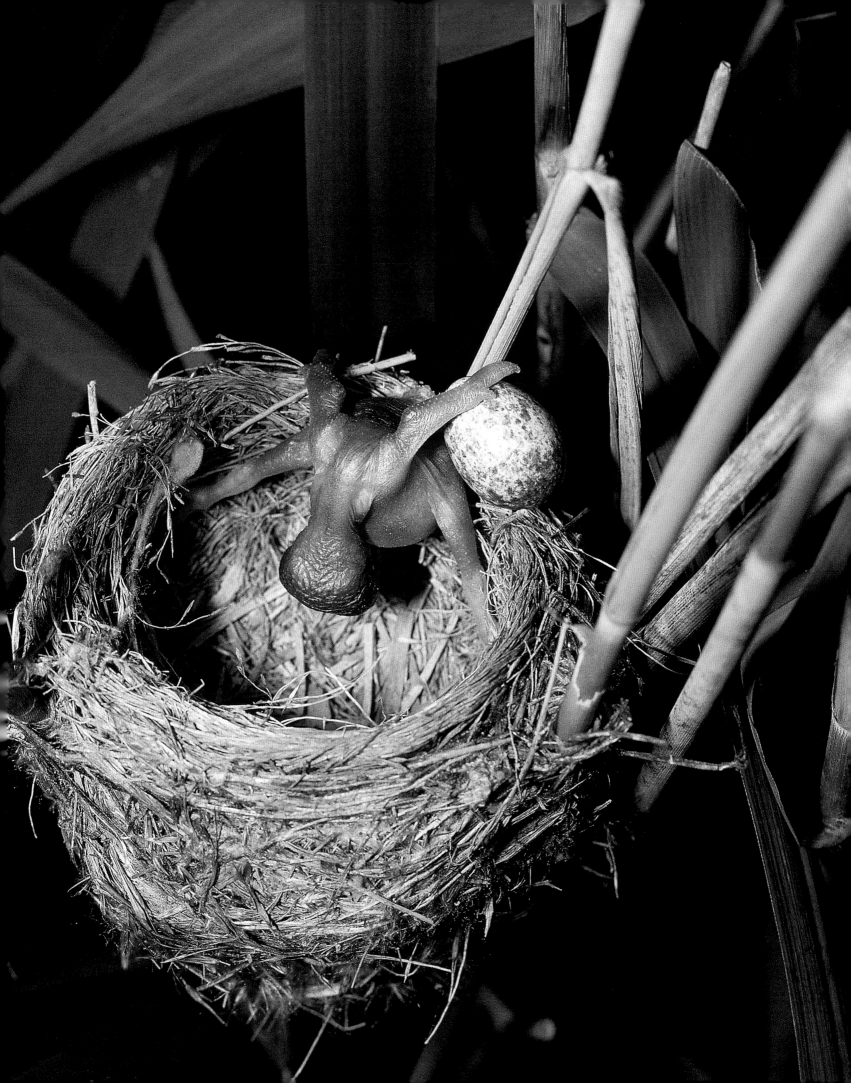

The Story Begins with an Egg

Opposite

Herring gull

Larus argentatus

Canada

When hatching, the chick has an egg tooth at the end of its bill, which enables it to break the shell. The tooth disappears after a few days.

In the beginning was the egg: a unique, magic cell, containing everything and capable of everything. This all-powerful germ of life undergoes a series of the most complex transformations to become an infinitely complex being: a bird.

The egg is another part of the bird's dinosaur heritage, and it is what allowed vertebrates to leave the sea. Many animals lay eggs, but birds' eggs are the most perfect of all. Securely sheltered inside their shells, they are a marvel of technology. The embryo is enclosed in its own reserve of water and nutritious substances—protected from the world, but not isolated from it. The shell is both hard enough to bear the weight of the incubating parent and fragile enough for the chick to break it unaided. It is also is gas permeable. Oxygen can pass through it, as can carbon dioxide and water vapor, allowing the embryo to breathe. Inside, three membranes, one within the other, protect the unborn bird, each carrying out a different function.

This perfectly organized interior is reflected in a perfect outward appearance. The eggs of ground-nesting birds are completely camouflaged in their surroundings. The shape of eggs also varies, to an extent that may appear minimal to us but which nevertheless makes them perfectly adapted to the conditions in which they are incubated. This symbol of life was given sacred status by great ancient civilizations, which saw in it the organization of the world amid primordial chaos. The Egyptians made the egg the dwelling place of Ra, the supreme god, while the Chinese, Indians, and ancient Greeks believed Creation began with a cosmic egg, whose yolk was the earth and whose white was the heavens; yin and yang—whose fusion allowed attainment of supreme harmony.

The egg is a universe in its own right, where every detail is a masterpiece. Its structure, like that of those nesting Russian dolls, protects the embryo while giving it all the nutrients necessary for its development and all the room it needs to grow. The embryo feeds on the yolk, and the white protects it from damage and infection. The shell and the three membranes are also safety barriers that allow for the exchange of gases.

Fine, yet Strong

How can it bear the weight of the adult bird for interminable hours, yet crumble under the pecks of a hatching chick? The egg meets these two challenges with a genius worthy of great architects.

The shape that offers the greatest resistance to external pressure is the sphere. Nocturnal raptors and many other birds of prey lay eggs that are more or less perfectly spherical. The problem with this shape is that an egg's diameter is limited by that of the oviduct. A sphere contains a much smaller volume than an ovoid of the same diameter, and thus offers less space for the chick to develop. Moreover, the egg must spend a long time traveling down the oviduct before it is laid, and there it is subject to pressure from muscular contractions. The stronger these are, the more pointed its front end becomes. This explains how different shapes are formed—from the classic ovoid of the chicken's egg, to the elongated one of the grebe, to the guillemot's pear-shaped egg.

The closer the egg approaches to the exit from the oviduct, the harder it becomes. Formed from crystals of mineral salts, its shell is thin yet very robust, thanks to the way the crystals are arranged. With their ends pointing to the center of the egg, and long interlocking projections, these crystals support each other like the stones in a vaulted arch. Pressure from the outside tends to wedge them together, locking the different elements and reinforcing their common structure. On the other hand, the slightest pressure from within can detach them, breaking the shell.

A Series of Semipermeable Barriers

The shell is perforated by pores that allow the embryo to breathe until it hatches. If this respiration is blocked, the chick will die in the shell. Thus unwanted clutches can be disposed of by covering the eggs with oil. Inside the egg, the amnion covers and protects the embryo, while the allantois gathers waste and acts as a respiratory organ. The chorion encloses the whole: embryo, yolk sac, and membranes. When the chick hatches, it discards its waste by leaving its coverings.

A network of blood vessels develops on the surface of the chorion, facilitating the exchange of various substances. The albumen, or egg white, comes between the chorion and the shell. The albumen consists of different layers, and is more concentrated in the center; it is both a water reservoir and a protein store. Its consistency also makes it a shock absorber for the yolk in case the egg suffers a blow. Also, thanks to its chemical properties, hardly any of the few germs that succeed in getting through the shell and the two tough membranes on its inner surface are able to multiply.

Once laid, the egg cools gradually. This temperature change triggers a contraction that separates the two membranes at the large end and forms a small air pocket. When hatching, the chick tears the inner membrane and breathes that trapped air before resuming its efforts and completing its exit from the shell. There is yet another refinement: the chorion elongates at either end and forms two spiral threads, called chalazae, which are attached to the membranes on the inside of the shell. These hold the yolk sac in position. Through their twisting and untwisting, the chalazae always keep the embryo at the top of the yolk, which is essential to its development.

Opposite

Black-necked grebe

Podiceps nigricollis

Brenne, France

An egg's diameter is limited by that of the oviduct it travels on its way to being laid. The grebe's egg has a rather cylindrical shape—like the body of the bird itself.

186

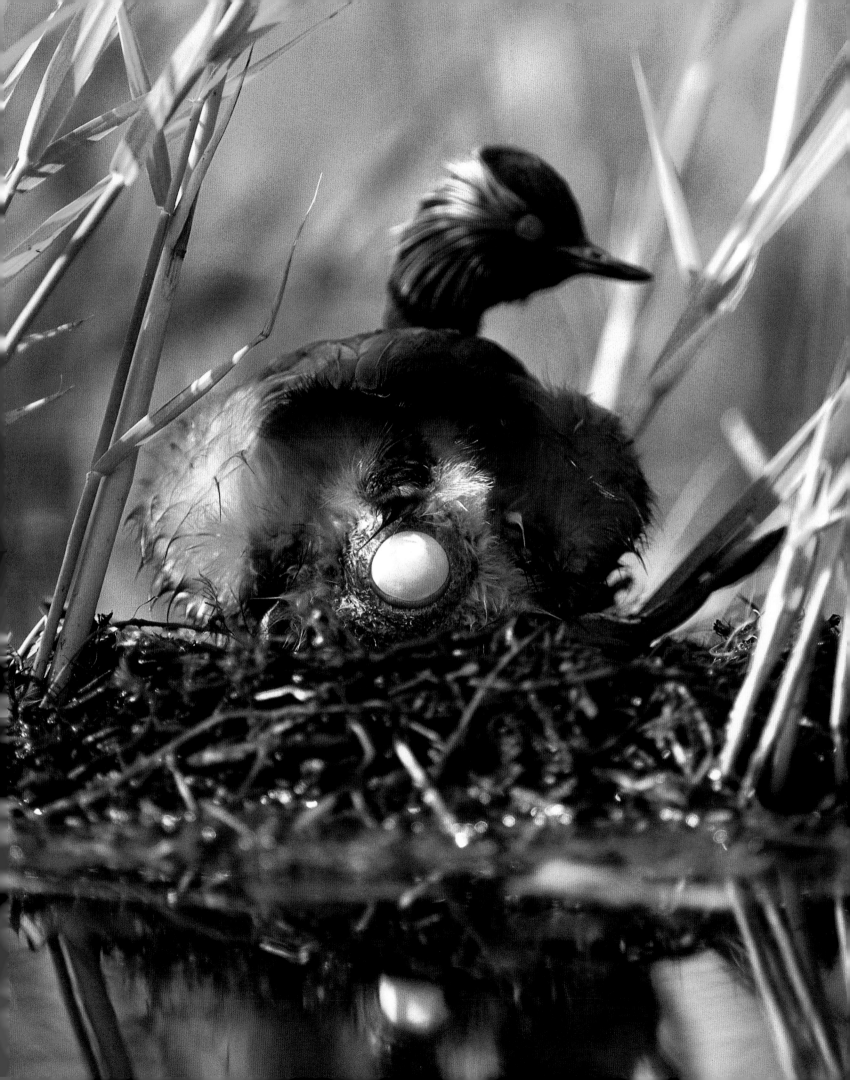

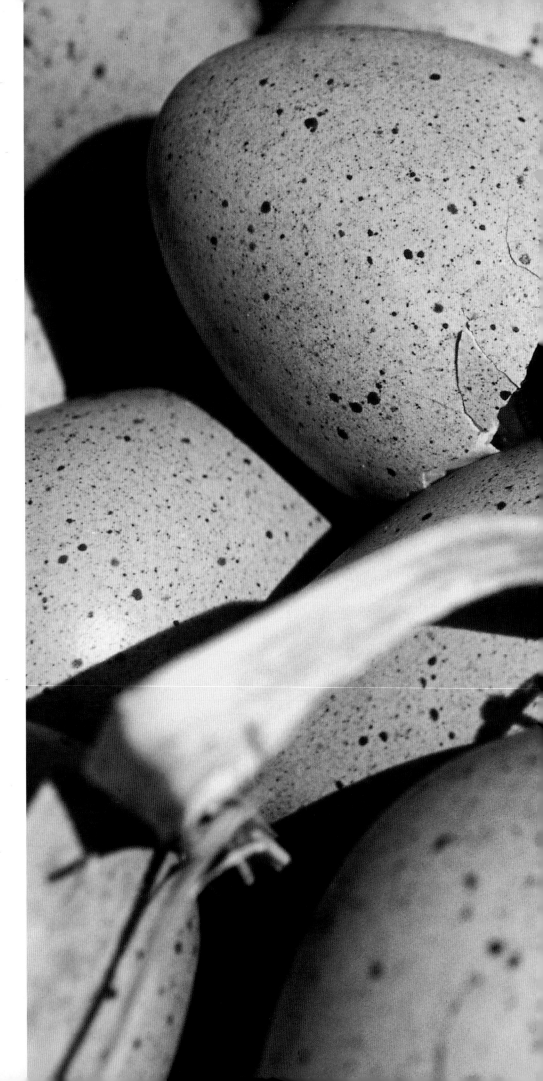

Opposite

Eurasian coot

Fulica atra

Touraine, France

The orange plumage on the head of this newly hatched coot is highly stimulating for its parents because it indicates the chick is in good health. Incubation starts as soon as the first egg is laid, and the chicks hatch in sequence some three weeks later.

188

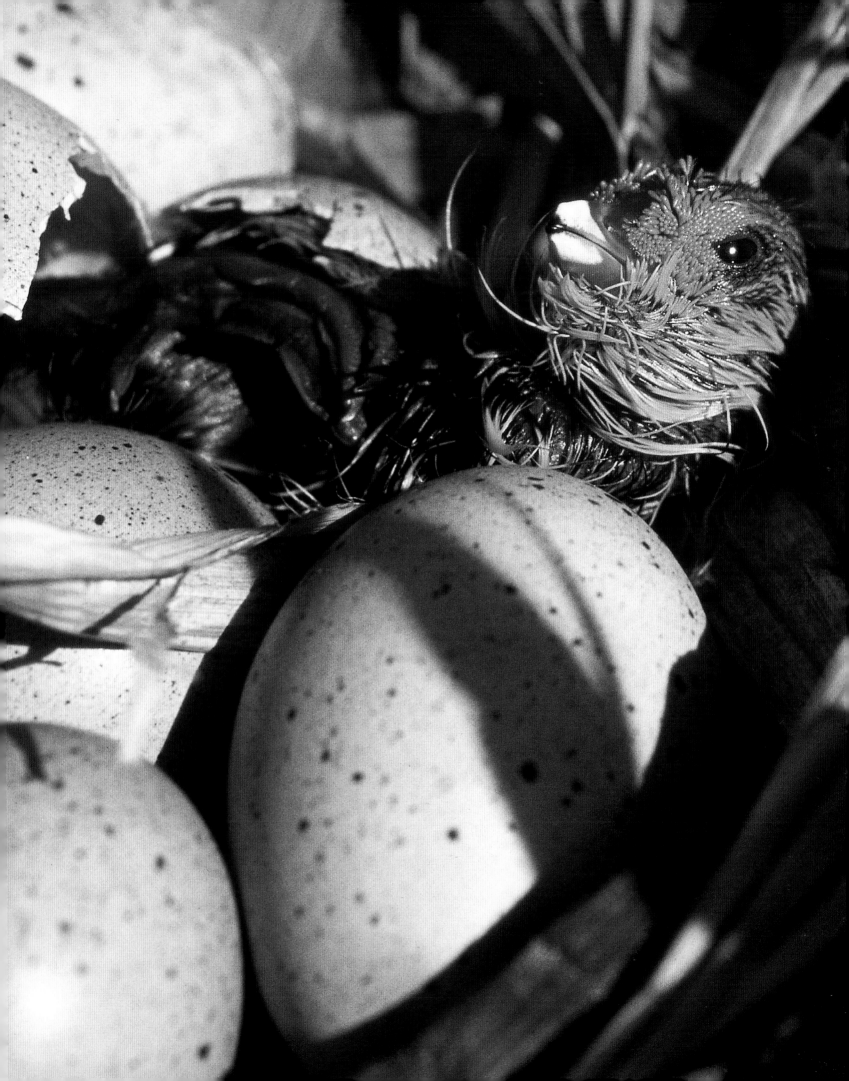

From Egg to Chick

The embryo starts to develop before the egg is laid, but it can only continue growing if it receives sufficient heat. Some species start to incubate as soon as the first egg is laid, so that the chicks hatch at intervals, but the majority start to incubate only after the last egg is laid. Since they are not heated, the first eggs laid become dormant, and they only resume development when the whole clutch is incubated. The chicks thus all hatch together, and the parents have offspring all the same age, which is often easier to manage. Only nidicolous species (whose young remain in the nest while they complete their development) can afford to raise chicks of different ages. For the most part these are raptors that need only fear shortage of food, but not predation. The few species that share this peculiarity are all either hunters or fish eaters.

For a given size of adult bird, the eggs of nidifugous species (whose young leave the nest as soon as they hatch) are markedly bigger than those of nidicolous species. Being larger, they contain more nutrients and can take the chicks inside them to a more advanced stage of development. Hatching from an egg that contains up to 35 percent yolk (compared with only 20 percent in nidicolous species), these chicks must be able to fend for themselves as soon as they come into the world. The fat contained in the yolk is stored in the liver and under the skin, which allows them, if necessary, to survive a relative food shortage.

Whether nidicolous or nidifugous, all birds incubate their eggs until they hatch—with the exception of megapodes, which build incubators. Thanks to their covering of feathers, the bodies of these birds are so well insulated that the only way they can provide enough heat for their clutch is to shed some feathers locally. Under the stimulus of incubation hormones, megapodes lose their belly feathers, and the exposed areas, called brood patches, swell with blood in order to bring the adult's body heat into direct contact with the eggs. Ducks, geese, and cormorants, which do not develop brood patches, pluck out their own breast down to make a nest lining. This phenomenon earned the eider its reputation. This large northern duck has down that is so abundant and such exceptionally good insulation that it has become highly prized for making eiderdown quilts. The northern gannet, which does not develop brood patches either, uses the broad webs of its feet for incubation.

A Multitude of Shapes and Colors

It is said that an egg's shape resembles that of the mother bird that laid it. Though totally empirical, this observation still points to a correlation that is largely correct. Owls lay spherical eggs, while grebes and loons produce very elongated ones. Small waders and auks produce pear-shaped eggs. The reason for this shape, which is like a spinning top, lies in the locations chosen by birds that build no nest. Because of its shape, the egg cannot roll far, and it turns on its own axis if it is knocked over. This is a safety measure for birds that nest on steep cliffs: Atlantic puffins, which are auks that nest in burrows, lay ovoid eggs.

Opposite

Cuckoo

Cuculus canorus

France

The reflex that drives the young cuckoo to expel everything it comes into contact within the nest appears only ten to fifteen hours after it has hatched. It disappears within three or four days, by which time the chick will have made sufficient space around itself.

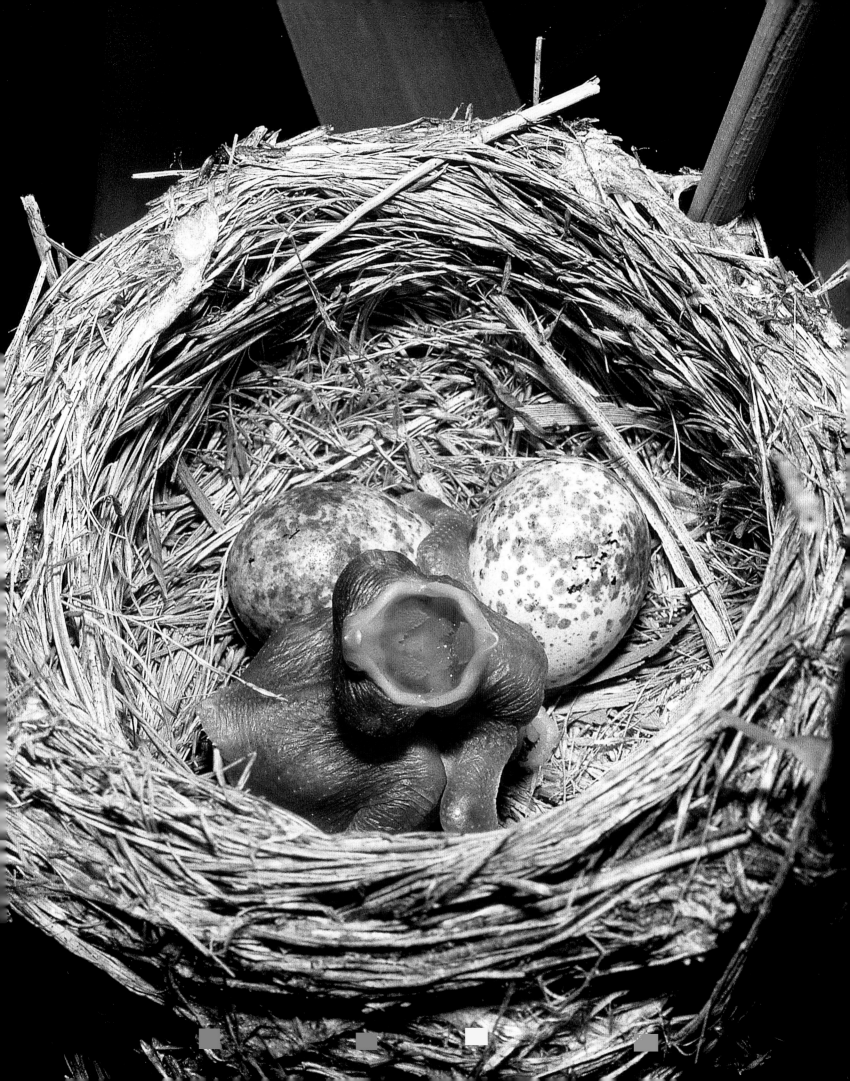

Opposite

Caspian tern

Sternia caspia

Aldabra Atoll, Indian Ocean

In the nest of sand she has hollowed out with her breast, this tern protects her chick, pulling aside the empty eggshell so that it does not hurt itself.

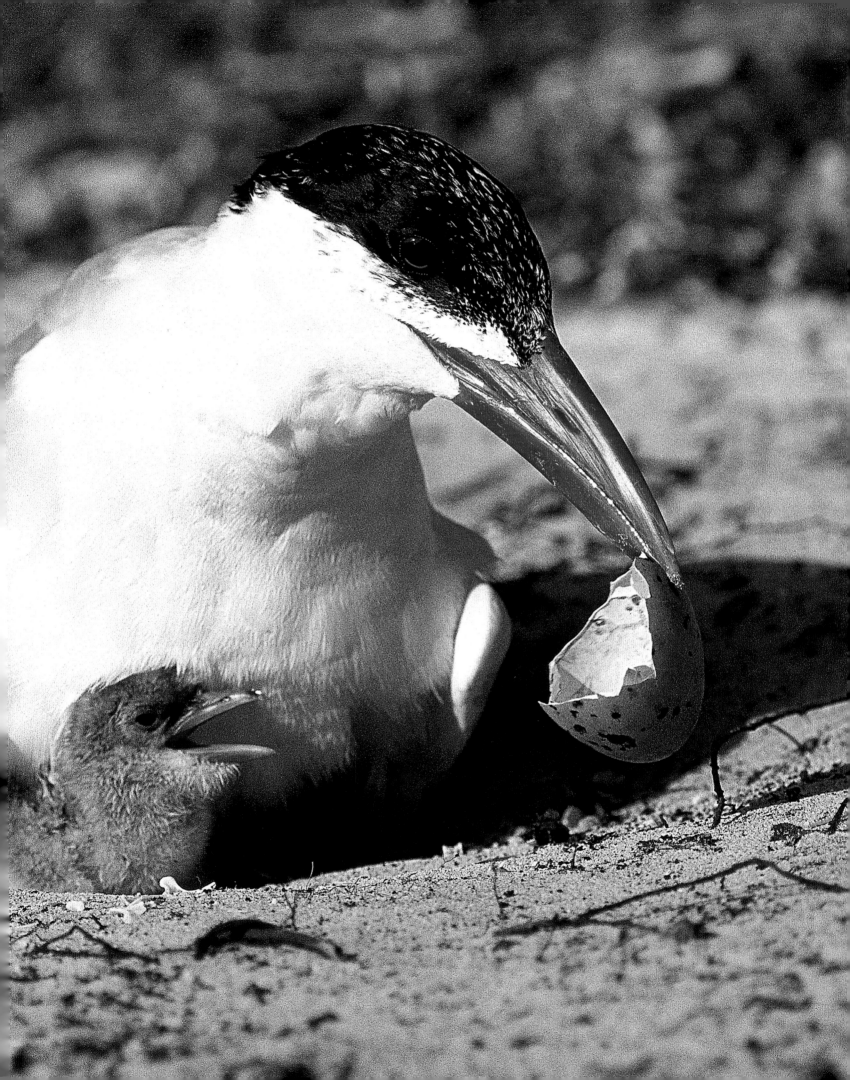

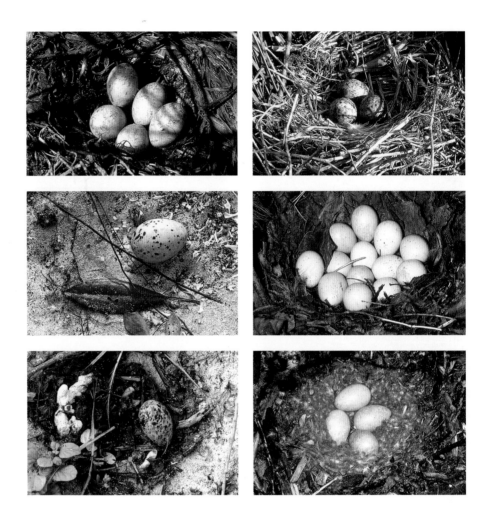

1	4	7	10	13
2	5	8	11	14
3	6	9	12	15

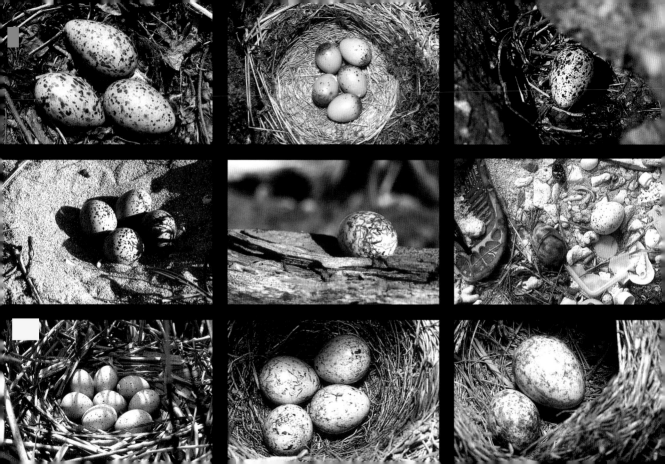

Glossy or matte, the colors of birds' eggs blend with their surroundings. The shell, originally white, becomes covered with pigments as it travels down the oviduct. These blue or brown pigments, laid down in layers in differing proportions, can produce shades from all across the color range. Birds that nest in holes generally produce white eggs, which the parents can clearly see in the dark. Those that lay their eggs in the open need to conceal their clutch from predators. The general color of the eggs and the density of their markings vary according to the type of surroundings. On the whole, blue eggs are found in dark surroundings and tawny or brown ones in open sites. Matt eggs, such as those of chickens, tend to collect dust, but most eggs have a shiny finish.

Tiny or Gigantic—But Always Closely Watched

The smallest known egg is laid by the tiny bee hummingbird of Cuba. Although no bigger than a pea, it has exactly the same structure as its giant opposite number, the ostrich's egg, which is 4,700 times bigger. Weighing .87 pounds (1.4 kilograms), the latter is not only the biggest bird's egg but also the biggest known cell. All female ostriches in a harem lay their eggs in a common nest, where the male incubates them most of the time. Only certain females contribute to incubation. Careful observers have noticed that these females can recognize their own eggs among the others. When they are incubating, they place these in the center, pushing the eggs of nonincubating females toward the edge. Warmer and better protected from the predators that a nest of such a size is certain to attract, they thus have a better chance of hatching. This probably explains why incubating females accept other females' eggs in their nest—as protection for their own. Then, if predation takes place, the other females' eggs will be devoured first.

Eccentrics

The smaller the bird, the larger its eggs are, proportionally. The biggest birds lay eggs that weigh one-twenty-fifth of their own body weight, while those of the smallest species may weigh as much as a seventh of their parents' weight. The reason for this lies in the ratio of the egg's volume to its surface area. A small egg loses more heat and moisture than a large one.

Below a certain volume, these losses would be disastrous for the embryo. The kiwi of New Zealand is an unusual bird in many respects, including in the eggs it lays, which weigh a quarter of the weight of the mother bird. These huge eggs are incubated for almost three months before producing a chick, which then continues to be nourished by the yolk sac.

Nesting in very dense colonies involves taking certain precautions, the first being that all birds should incubate at the same time to reduce the danger of eggs being broken in the bustle of birds coming and going. Penguins of the *Eudyptes* genus have found an original way of synchronizing a colony's members. Females lay an aborted egg, which is small and incompletely developed and

Opposite

Passenger pigeon's egg

Collection of the Muséum d'histoire naturelle, Paris

Carefully labeled in pen within a golden border, this piece is typical of nineteenth-century collections.

Opposite

Sooty tern

Sterna fuscata

Bird Island, Seychelles

Nesting as it does on the bare ground, the sooty tern has real problems protecting its eggs. A visit by a hermit crab is enough to destroy the entire clutch.

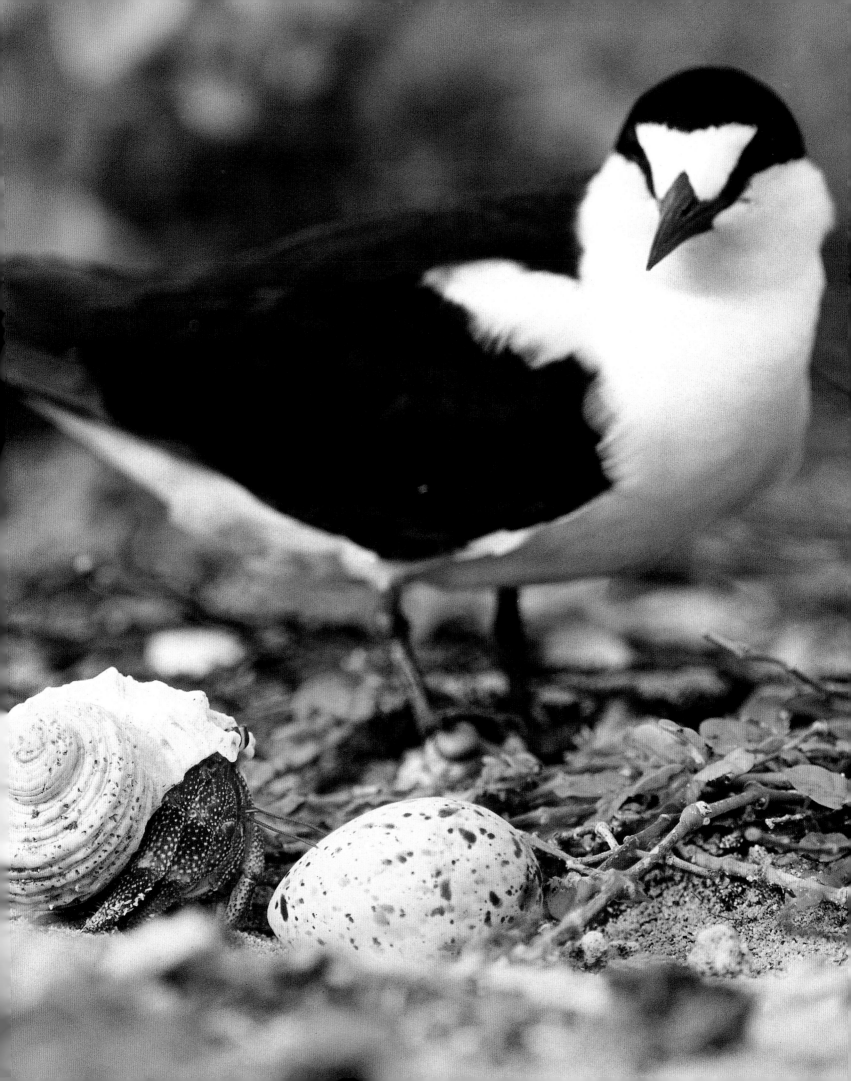

whose sole function is to stimulate neighboring females, so that all are in phase with each other and lay their true egg simultaneously. The more cohesive the colony, the safer it is for the eggs and chicks, because all parents are performing the same tasks at the same time.

Scientists have shown that large eggs are highly stimulating for parents. An oystercatcher or a gull presented with its own egg and a false one three or four times its size will incubate the larger one, even if it is far too large to cover properly. This phenomenon may be at work when host species adopt cuckoos' eggs, which they simply see as large and therefore attractive.

Imitation Eggs

Female cuckoos neither build nests nor incubate. They leave these jobs to much smaller passerines, which will be the foster parents of the single cuckoo chick. Roaming a territory of between 5 and 123 acres (2 and 50 hectares), depending on the richness of its environment the mother cuckoo locates suitable nests and waits patiently for their resident females to leave them unattended. It takes her a moment to approach her chosen nest and lay her single egg—which she does with great precision thanks to an extensible cloaca—for if by chance she were spotted, she would be furiously driven away at once. In order to make her crime as unobtrusive as possible, she steals and eats one egg from the host clutch. Cuckoos' eggs are astonishingly small relative to the parent bird, being barely larger than the host's eggs. Most remarkably, their markings and colors generally make them indistinguishable. Thus the foster parents, completely deceived, incubate them as if they were their own. Apart from being caught, the female cuckoo's biggest risk is that the host nest may give way under her weight as she is laying. Sometimes, therefore, she lays her egg on the ground close to the nest, then takes the egg in her bill and places it carefully within it. A female can lay between five and twenty-five eggs in as many host nests. These always belong to the same species of bird—the species by which she herself was fostered. This may be why her eggs imitate those of her hosts so efficiently. Experiments have shown that the hosts always reject poor copies of their eggs. Also, if the parasite's egg is laid before the host's, it is ejected from the nest, as if the bird were saying: "This can't be mine, because I haven't started laying yet."

Although each female cuckoo has her chosen host, the species as a whole can parasitize more than 120 different host species. Of the twenty species commonly parasitized, warblers, pipits, and wagtails are the most frequent victims. In order to coincide with its hosts' laying periods, the cuckoo has an extremely extended one, lasting from May to July. Sometimes, the victim discovers what has happened. The chiffchaff simply abandons its nest. The blackcap manages to throw the intruder out of the nest, while some other species simply cover their clutch with a layer of grass and lay a new one over it. The house sparrow takes a simple but radical approach: it does not feed the young cuckoo.

Opposite

Brown noddy

Anous stolidus

Farquhar Islands, Seychelles

This brown noddy seems perfectly at ease on the pile of plastic flotsam washed up by the waves, which serves as its nest.

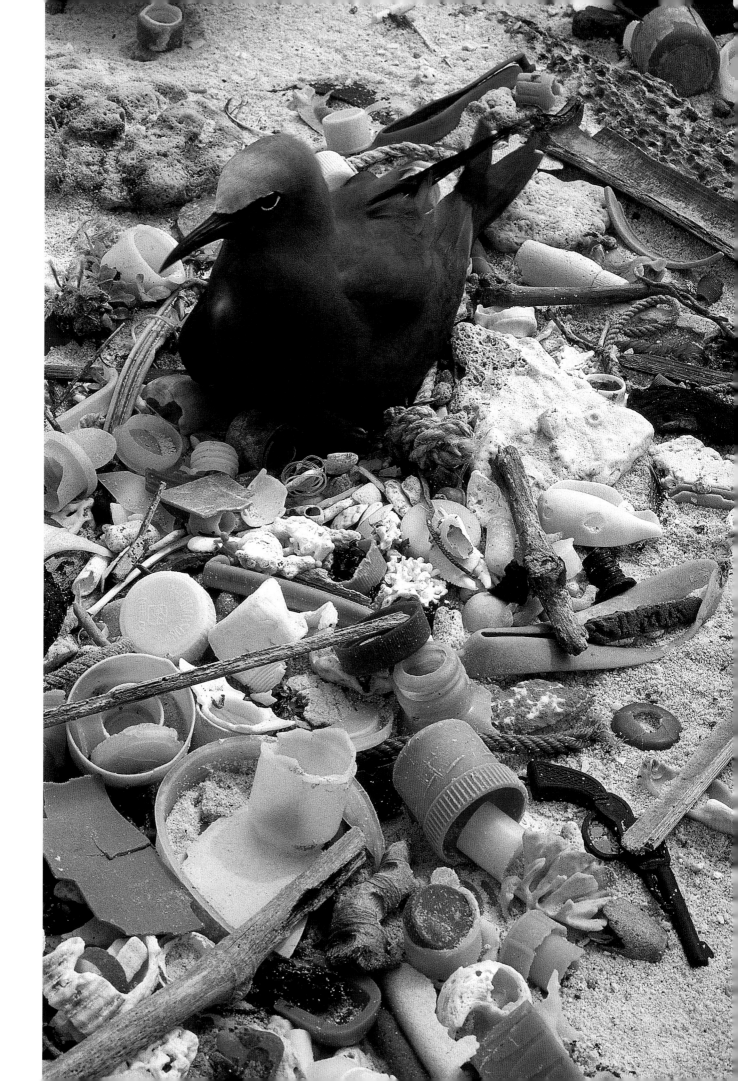

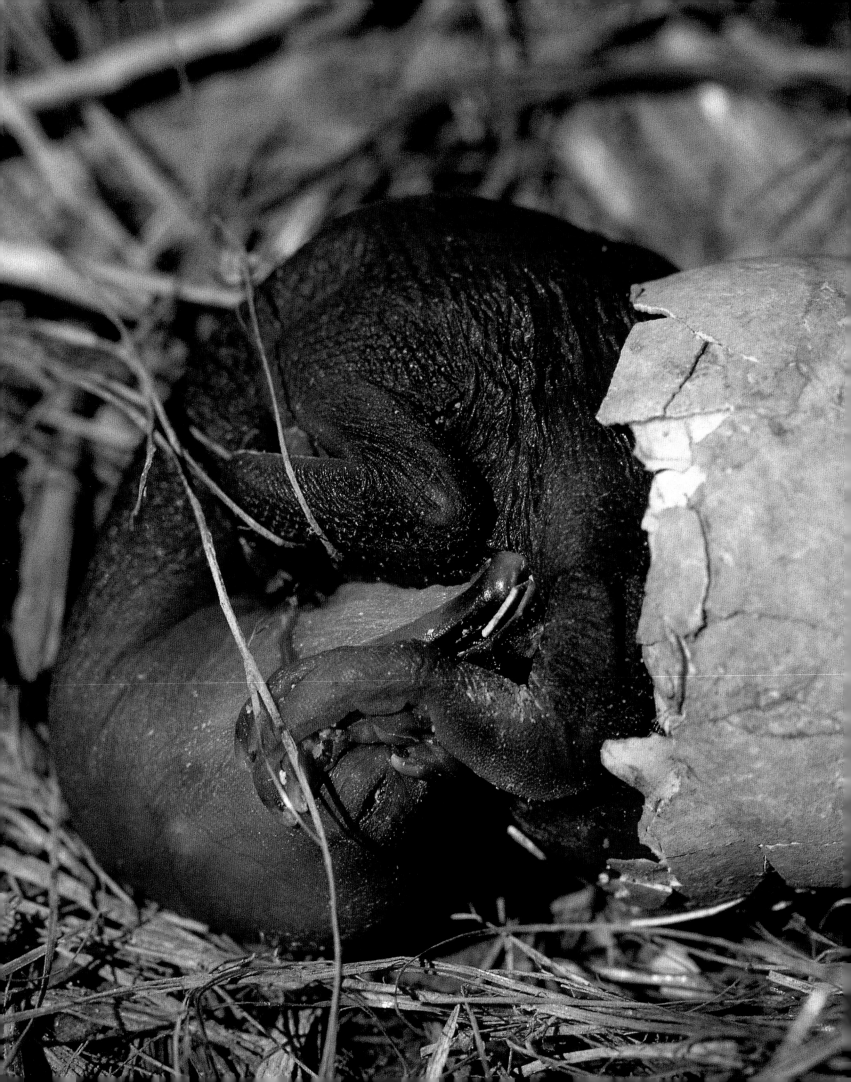

Opposite

Double-crested cormorant

Phalacrocorax auritus

Lower St. Lawrence Islands, Quebec

Only just out of the egg, this chick retains the shape it had before hatching. The powerful muscle on the nape of its neck helped it push against the shell to break it; this will disappear within a few days, as it is no longer needed.

Pages 204 and 205

Herring gull

Larus argentatus

Mingan Islands, Quebec

Having broken its shell at the large end, this down-covered chick needs only to dry its handsome plumage, which will provide camouflage and keep the chick warm while its parents are away from the nest, gathering food.

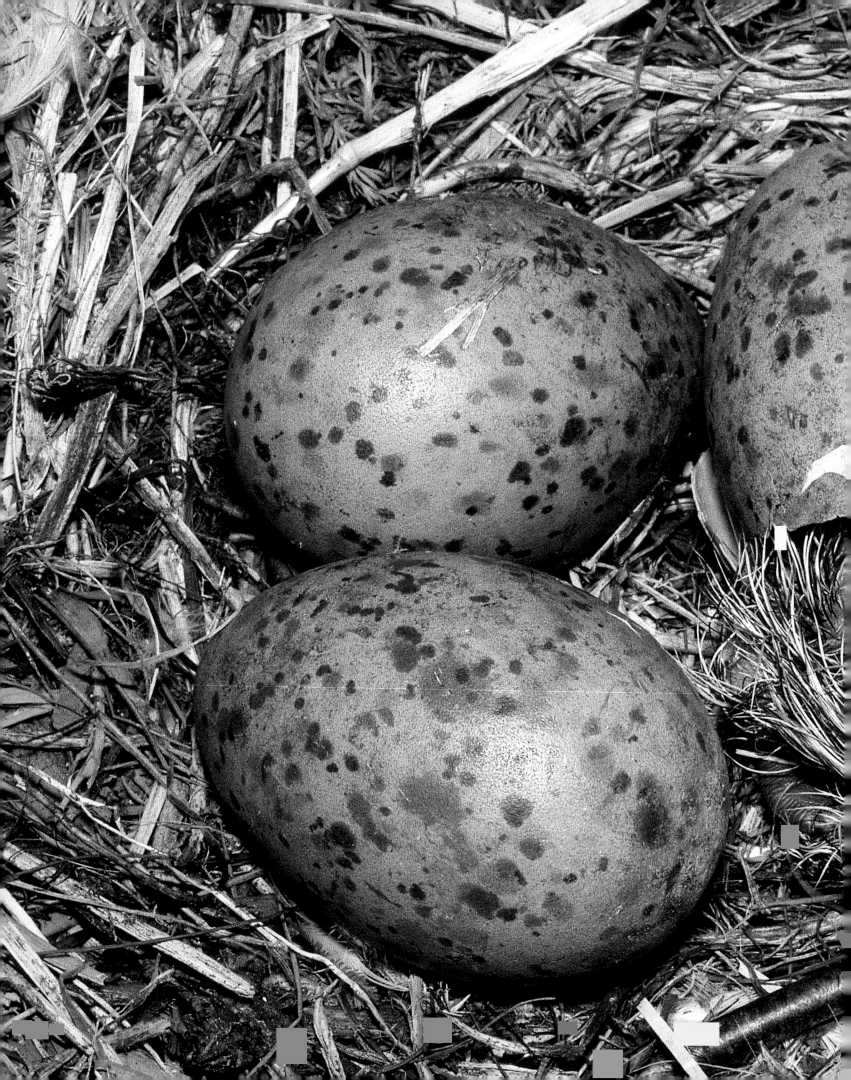

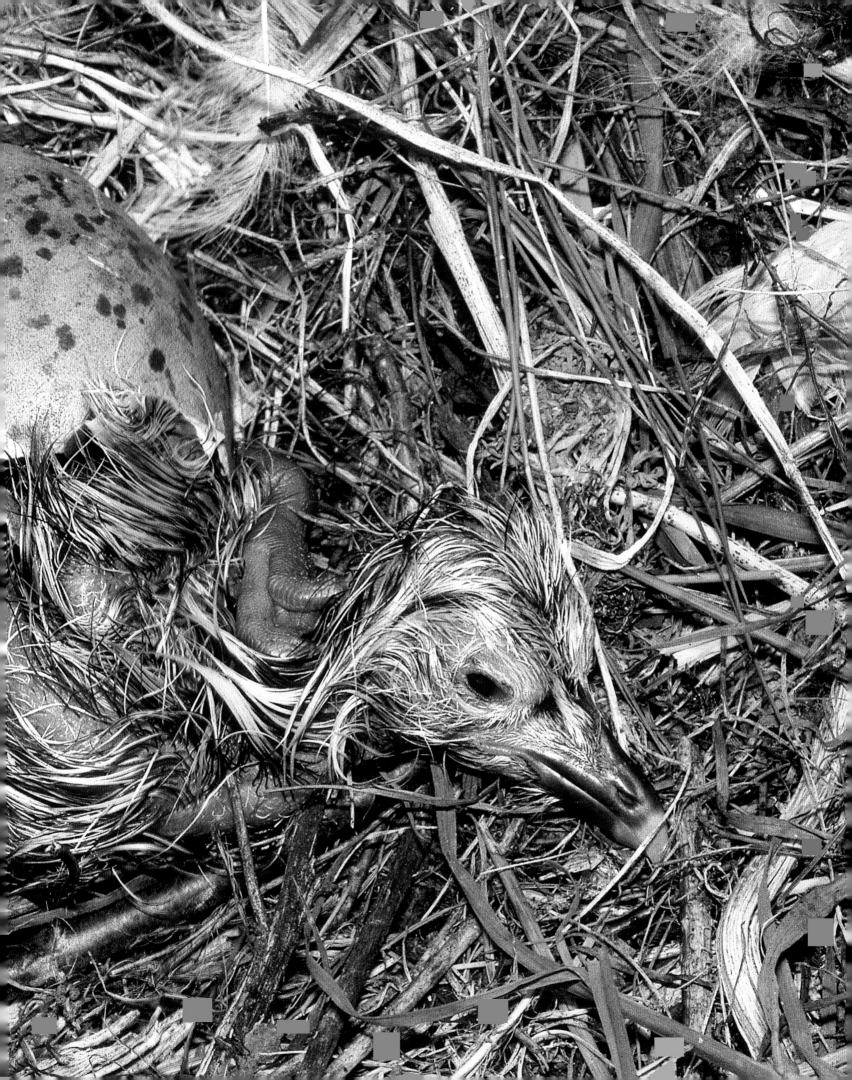

A Special Baby Tooth

A baby bird that is about to hatch has two vital attributes to help it in this laborious task. The end of its bill has a small projection, called an egg tooth, that is extremely hard—hard enough to break the shell. To wield this tool with sufficient force, the chick also has a powerful muscle that forms a large swelling on the nape of its neck. Both disappear a few days after hatching takes place, when the chick has accomplished its task. Despite these aids, hatching takes at least a few hours, and in some cases it may be several days before the chick emerges from its shell. Although the parents pay close attention when the eggs are hatching, it is rare for them to help the chicks in their labors—as if this was a ritual that must be performed when life begins. In most cases they are content to encourage it with calls, to which the chick replies, thus starting to form family ties while still in the egg. By contrast, chicks that have already hatched, barely dry from the liquid in their own eggs, often help their younger brothers and sisters. The parents hurry to dispose of the broken shells a long way from the nest, for their white interiors are clearly visible at a distance and might encourage sharp-eyed and greedy predators in search of tender meat.

The hatching process is astonishingly consistent. The chick starts by tearing the membrane inside the shell at the egg's large end, which allows it to breathe the small volume of air trapped behind it. It then makes a small hole in the shell in order to breathe air from outside, using its lungs for the first time. After regaining its strength, it chips its way around the shell in a circle and then, pushing at it from within, separates the two parts. The woodcock, which always does things its own way, also makes a small hole in the shell. However, being equipped with two egg teeth, one on each mandible, it pushes its bill through and splits the shell lengthways. Megapodes possess neither an egg tooth nor a special muscle, but they are miniature adults at birth and able to look after themselves. Breaking the shell is the least of the tasks they must manage. These exceptions aside, once the chick is hatched, the parents' next job starts, and it is far from being the least: raising their offspring to adulthood and independence.

Opposite

Private egg collection donated to the Muséum d'histoire naturelle, Paris.

Perfect in form and extraordinarily diverse in size and color, eggs have always fascinated humans.

Blood Ties

Opposite

Eurasian coot

Fulica atra

Brenne, France

Just three or four days after hatching, this young coot has left the nest. Its parents will look after it for two months, after which it will be independent.

Oh, the joys of family life! From the emperor penguin, which carries its single chick on its feet for weeks on end, to the megapodes which, having displayed wonderful ingenuity, abandon their young to the care of Mother Nature, birds display a vast range of parental behavior. There are two main groups: nidicolous species, whose chicks are naked at birth and complete their development in the nest, and nidifugous species, whose young, covered in down, are sufficiently "complete" to leave the nest very soon after hatching.

Compared to a nidifugous chick, a nidicolous one looks very poorly equipped, but it makes up for its apparent helplessness by possessing powers its parents cannot resist. As a result, they expend vast amounts of energy to ensure the chick grows rapidly, becoming less vulnerable in the process.

A nidifugous chick must immediately be able to recognize its mother, so that it can follow her during its first few days of life. This "imprinting" takes place at a certain stage of its life, even before hatching. Nidicolous chicks do not have this problem. The parents feed their brood, and family ties are progressively formed. This behavior may lie at the root of the parasitism of certain species, which take advantage of the principle that "If there is a chick cheeping in my nest, it must be mine!"

This is dangerously naïve. But the parental role goes beyond merely providing board and lodging. The parents protect their young from predators and from the weather, and they teach them how to behave in their environment as well as toward their kind. In some cases, this apprenticeship can last several years.

Even before perforating its shell, the young bird communicates with its parents and siblings by means of little cries. It also reacts to outside events, and its heart beats faster when its mother calls. These small cries serve not only to communicate with parents but to synchronize hatching. The rhea, an American cousin of the ostrich, starts to incubate as soon as the first egg has been laid, while the female lays the entire clutch in about ten days. Despite this, all the eggs hatch within two or three hours of each other. The young listen to each other while still in the egg. This very early mode of communication is found among many nidifugous species, for which hatching at the same time is important. The chicks that hatch first wait until the later hatchers have finished drying their down before leaving the nest.

Common pochard

Aythya ferina

Brenne, France

After watching over the nest while his mate incubated the eggs, the male pochard leaves his offspring in the care of the female, who becomes solely responsible for her brood's survival.

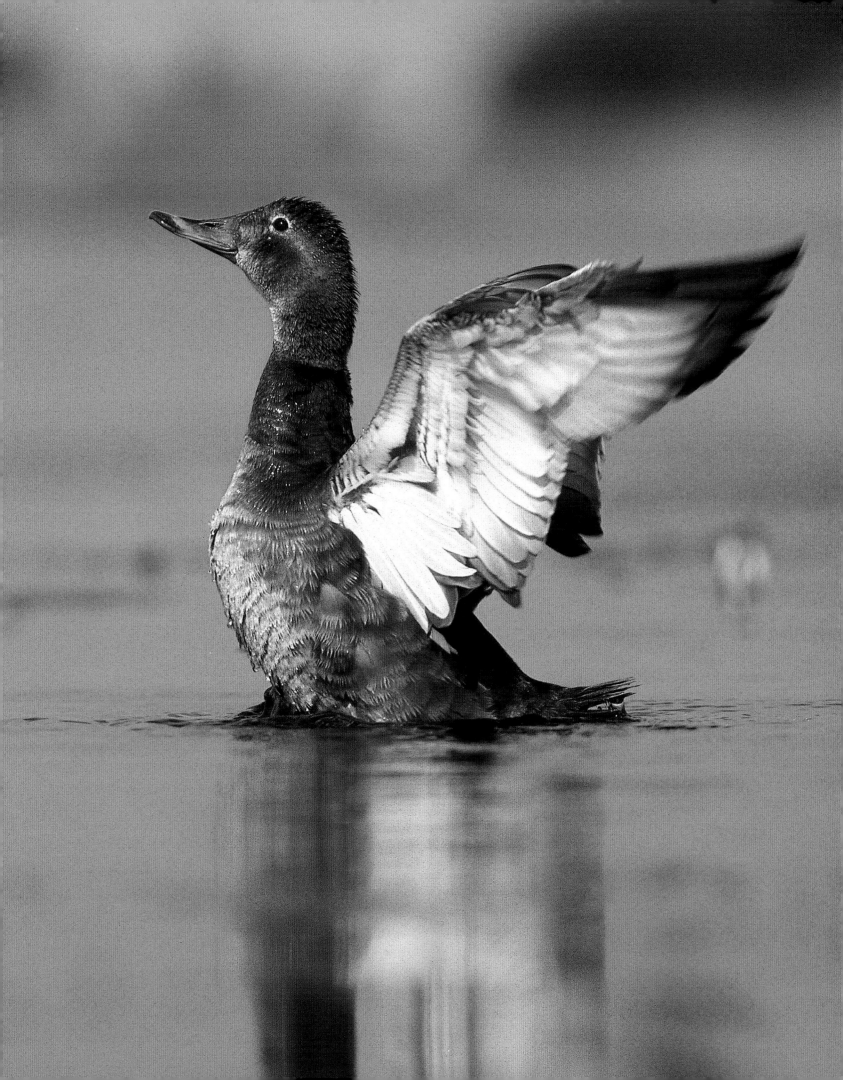

Two Different Approaches

Like their reptile ancestors, the vast majority of ground-nesting birds produce young that can look after themselves from birth. It is thought that this is a more primitive stage of development, closer to reptiles than nidicolous species are. In fact, these are two different strategies for dealing with the struggle for survival during the first, critical weeks of life.

Parents either invest their resources in the chick—via larger eggs, a longer incubation period, and the production of young that are more developed at birth—while building a poorly protected nest that offers only precarious shelter, or they invest them in the nest, which is a highly protective refuge. A shorter incubation period means that the chicks are still at the larval stage when they are born; only the digestive tract, which is remarkably well developed, is complete. Since they are well sheltered, they can receive from their parents the care necessary for them to grow, and the more exposed the nest, the faster this growth is. Because they are less exposed, birds born in burrows or holes can afford to grow more slowly than those born in simple cup nests. A young robin increases its weight from 2 grams to 15 grams in the space of twelve days; a cuckoo multiplies its weight fiftyfold in twenty-one days, growing from 2 grams to 100 grams. A remarkable feat. The biggest nidicolous species take longer, but they too grow at breakneck speed. A baby heron grows from 42 grams to 2 pounds (1.5 kilograms) in barely a month, while a gannet can increase from its birth weight of 72 grams to a hefty 2.6 pounds (4.2 kilograms) in the same time.

It goes without saying that to ensure their chicks grow at this spectacular speed, the poor parents must feed them at a rate bordering on force-feeding. Each chick consumes almost its own body weight each day. Here, too, there are two distinct approaches. The parent birds either bring smaller amounts of food but make innumerable journeys, or they feed their young less frequently but with larger quantities each time. Young passerines are in the former group. Great tits have been observed receiving 900 pieces of food per day, or one per minute. This explains why it is to birds' advantage to nest in latitudes where spring days are long, giving them more time in which to feed their brood.

Baby Food

Building a new organism requires highly nutritious food, which is often richer than that normally eaten by the parents. Seed eaters, for example, whether nidicolous or nidifugous, feed their young chiefly on insects, which are far richer in protein than seeds.

Black-capped chickadees go so far as to synchronize their first clutch with the appearance of caterpillars at the end of winter, so that their chicks can gorge on them. In recent years, global warming has led trees to come into leaf earlier in the year, and caterpillars, which live only two or three weeks, have followed suit. Birds, being more complex organisms, adapt much more slowly than insects to such rapid changes; accordingly, the chickadees still hatch at the same

Opposite

Great white pelican
Pelecanus onocrotalus
Djoudj National Park, Senegal

Pelican chicks probe deep into their parents' gular pouch, as far as the alimentary tract, to extract their food: bleeding chunks of fish. For a long time, this fueled the myth that the young fed on their parents' hearts.

Pages 214 and 215

Whiskered tern
Chlidonias hybridus
Brenne, France

The parents relieve each other while incubating and later in feeding their chicks on dragonflies, insect nymphs, tadpoles, and even small frogs.

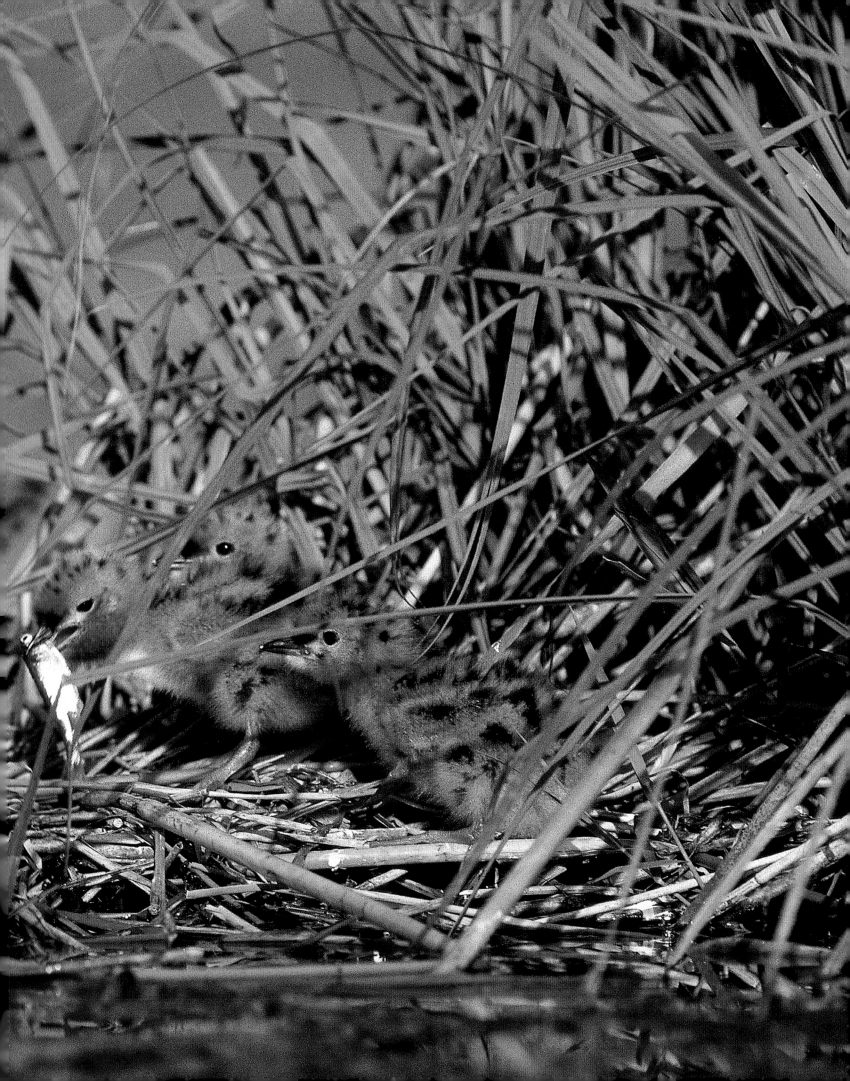

time. This apparently insignificant shift of a couple of weeks is enough to endanger the survival of the affected populations.

Parents that lack enough food supplies for their young in the crucial first few weeks of their life exhaust themselves in a fruitless search. The young are feeble, the parents unable to lay more clutches, and illness and predators finish the job. In contrast, chickadees raised in captivity fail to raise their brood because they have too much food. The overfed chicks do not open their bills and cheep—unthinkable in the wild—because they are not left to become hungry often enough. A chick that does not clamor for food is normally dead or dying, and it is better to throw it out of the nest to improve the rest of the brood's chances of survival. Overfed chickadees in captivity regularly do this.

Swifts, which feed on flying insects, are extremely sensitive to weather changes. Constant rain, for example, may prevent them from hunting. Their chicks manage to survive these enforced fasts by becoming "dormant," falling into a sort of lethargy that may last longer than a week.

Raptors carefully dismember their prey before feeding it to their chicks, though they do this more and more crudely as the chicks get older. The male kestrel catches prey and brings it to the nest, where the female dismembers it. If the female should be killed, the male continues to bring prey but will only rarely dismember it. As a result, the chicks die of hunger sitting on a pile of food that they are unable to eat.

Probably the most singular food consumed by birds is pigeon's milk. These seed eaters feed their young with a secretion from their crop. The cells in its lining break up to form a substance resembling cream cheese, which is almost as rich in protein as the milk of mammals.

However, the pelican is the bird that has long fueled the biggest myth of devotion to its young. This large bird feeds its offspring on partly digested fish, which the chicks take directly from their parent's gullet, plunging their beaks in to retrieve pieces of flesh red with blood. This has given rise to the legend that pelicans fed their young on their own hearts, a tale made enthusiastic use of by romantic writers such as Alfred de Musset.

False Nidifugous Birds

Birds that must deal with extreme conditions, such as penguins and many species that live on the high seas, produce "mixed" chicks. Physically very well developed and covered in thick down, they resemble nidifugous chicks; by behavior, however, they resemble young nidicolous ones, for they do not leave the nest and are abundantly fed by their parents. It is as if, by combining both strategies, these birds ensure that they have the best chance of surviving in a difficult environment. Were these chicks to leave the nest, they would not be able to find food and in any event would not know how to obtain it—fishing is a difficult art, requiring specific and often relatively long training.

Opposite

Intermediate egret

Egretta intermedia

Keoladeo National Park, India

Nesting in colonies of up to 1,000 individuals, intermediate egrets produce three or four chicks per pair. The chicks leave the nest at three weeks but will not be fully fledged until two weeks later.

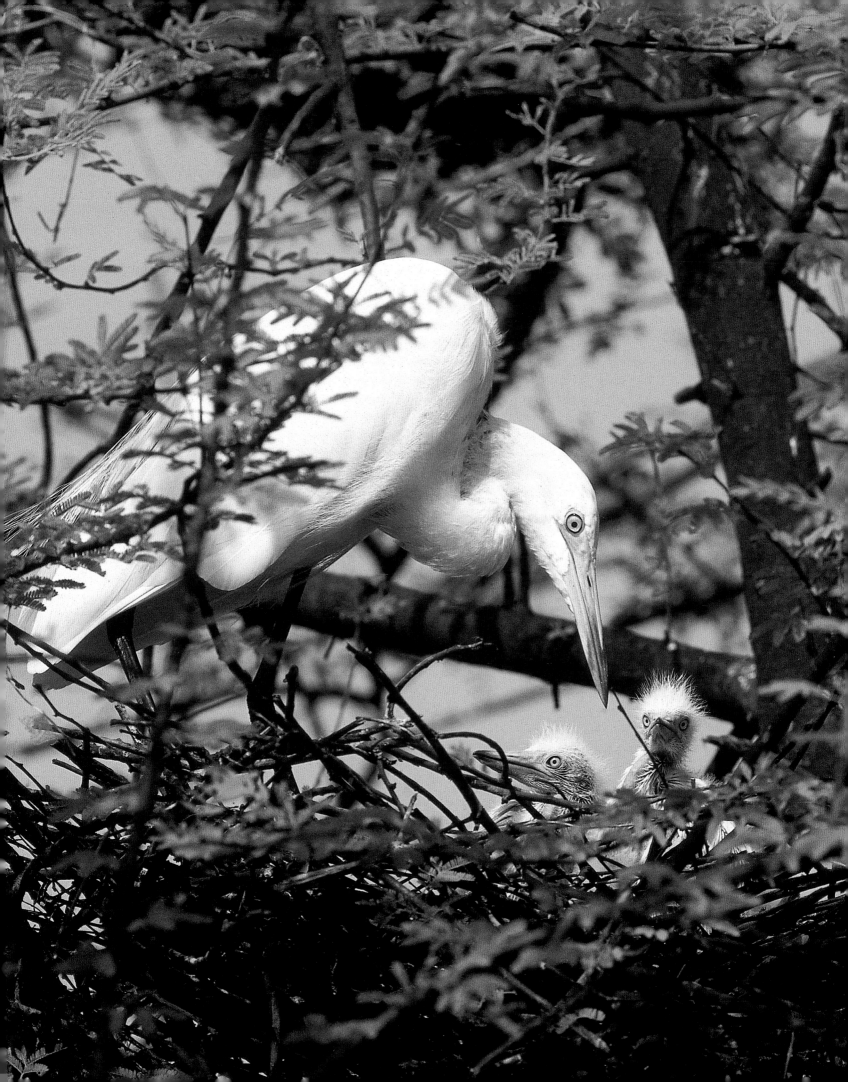

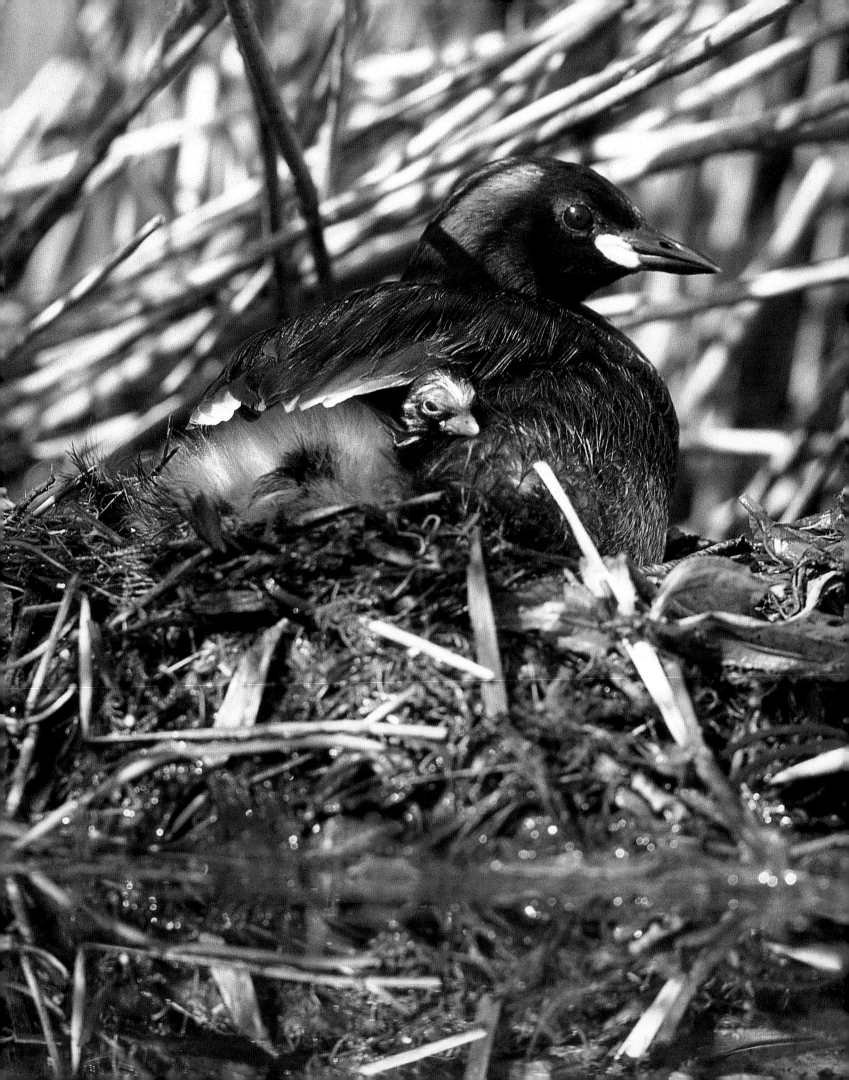

Little grebe

Tachybaptus ruficollis

Brenne, France

Well sheltered in the mother grebe's feathers, this
chick is a ball of black-and-white striped down,
looking out on the world in complete safety.

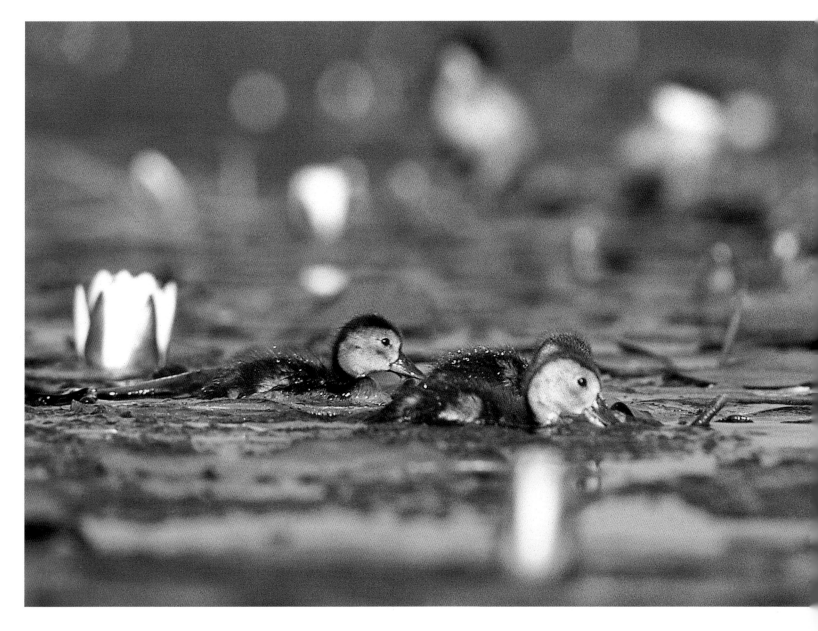

Among certain species, it is also common to find chicks so fat that they are heavier than their parents. At the age of seven weeks, a Leach's storm petrel weighs 70 grams, while an adult weighs just 45 grams. This extra weight allows the young bird to survive on its reserves until it learns how to fish well enough to feed itself.

Magnetic Markings

In general, parents feed their chicks in one of two ways: either they place food into their offspring's gaping bill, or they regurgitate food and the chick plunges its bill into the parent's to seek sustenance.

A baby gull, which is permanently hungry, vigorously pecks the red mark on its parent's bill to make it regurgitate food. In experiments where the parent's bill was replaced first by an artificial copy that lacked a red mark and then by a match with a red spot, the chick consistently chose the

Above

Common pochard

Aythya ferina

Brenne, France

A conscientious mother, the pochard raises her brood of six to twelve chicks on her own, until they can fend for themselves at the age of seven or eight weeks. Until then, she will protect them from danger and teach them how to find food.

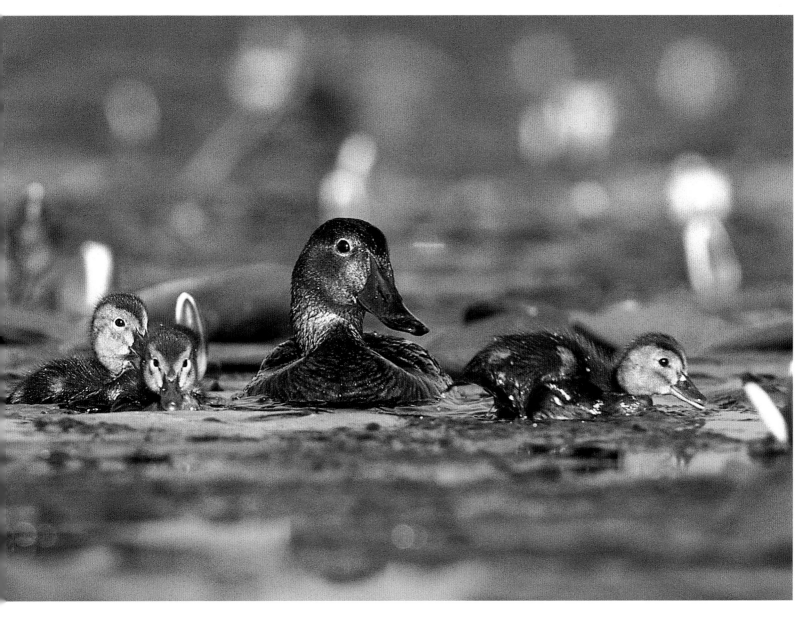

latter. This behavior led researchers to conclude that the red spot is the stimulus that triggers the baby gull's demand for food. Although sea birds generally feed by regurgitation, land birds on the whole prefer to place food in their young's bills. In these species, the bright colors of the chicks' gullets invite the parents to place food into them. Generally, the chicks' bills are also brightly colored along the borders, with various contrasting designs, especially if they are being raised in a burrow or a very dark nest. Bearded tits have white papillae on a red-and-black background, blackcaps and crows sport a bright pink gullet, and other species display all manner of brightly contrasting features. These giant, vivid beaks, and the hungry chicks' strident cries, are a powerful stimulus to the feeding parents.

The height of refinement is found in the gullet of certain parasitical birds. Thus baby whydahs, which parasitize waxbills, display exactly the same markings as their hosts' offspring, fooling the parents with the cleverest camouflage.

Black-necked grebe

Podiceps nigricollis

Brenne, France

Grebe chicks swim around their parents and often climb on their backs to rest, with only their head protruding above the feathers. Their only worry is when the parent dives: they must then either hold on tight or bob back up to the surface like little corks.

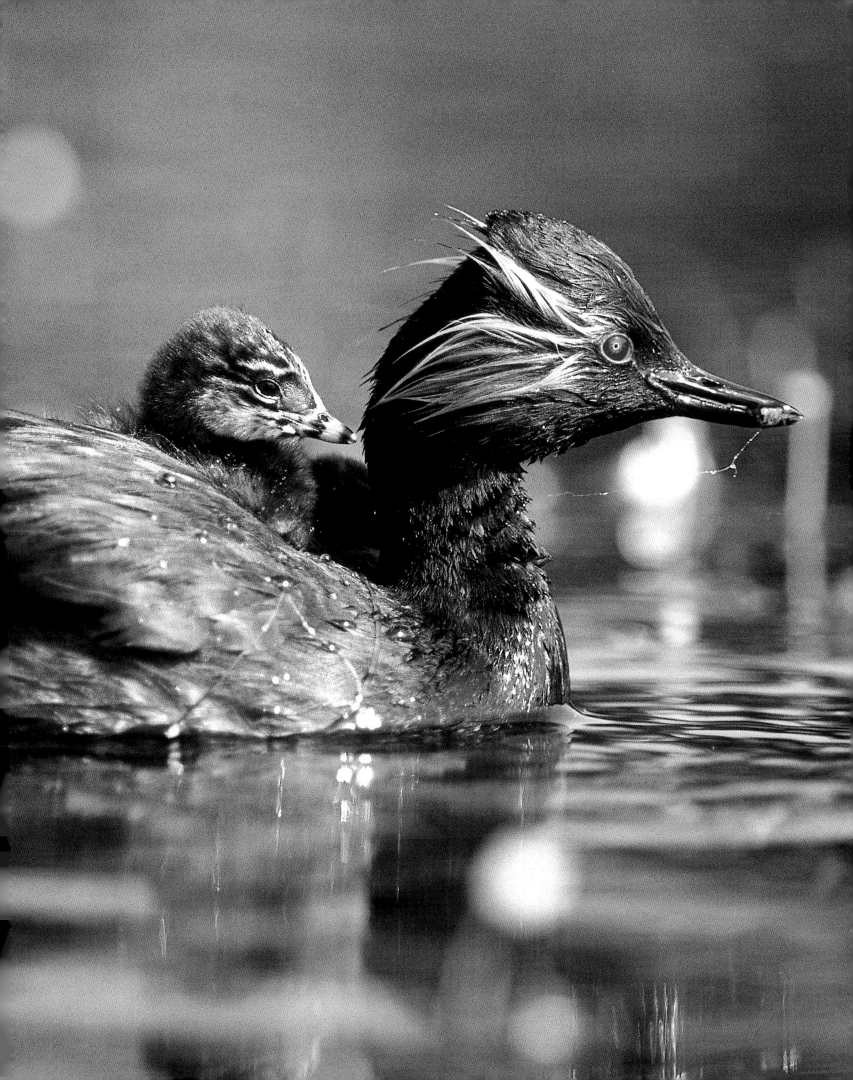

Nurses at the Nest

Although the parents of most species raise their young unaided, in some species they are helped by other birds that have not produced young of their own. The contribution of these individuals may range from providing food to fighting off predators. Some even help build the nest, keep it clean, incubate the eggs, and defend territory. This type of organization is generally found among tropical species that mate for life and occupy territory all the year round. The more intense the competition for space, the commoner this kind of association is. Helpers are usually brothers and sisters of the brood, which therefore also share the parents' genes. By helping, they gain valuable experience in reproduction. This setup therefore offers advantages to all parties. It allows the parents to raise a larger number of chicks successfully, and it teaches the nurses how to raise their own when the time comes. This type of behavior occurs among certain Central American jays and some species of African bee-eater. Sometimes, though more rarely, the helpers are not related to the brood. Among long-tailed tits, for example, the helpers are sometimes adults that have lost their own brood. In such cases, it is difficult to see what they have to gain, apart from keeping "in practice."

Parental Nurseries

Nidifugous species, chiefly those that nest colonially, quite often look after their young in groups. The biggest advantage of a nursery is that it offers a formidable defense against predators. It is easy to attack isolated chicks, and even to separate some from a small group, but it becomes dangerous to attack a whole pack of young birds that will noisily call their elders to the rescue at the slightest hint of danger. Shelducks, geese, and eiders often shepherd their broods into veritable flotillas of ducklings or goslings, entrusted to the care of a few adults. Terns, flamingoes, pelicans, and penguins, all of which nest colonially, also have nurseries that are formed as soon as the young of these seminidifugous species can control their own body temperature—which is when they have grown too big for their parents to brood them. Among flamingoes, penguins, and pelicans, parents recognize their own young in the group and come to feed them, but in most cases the chicks themselves rush toward their parents, whom they recognize instantly. The parents can thus devote their time to gathering food, knowing that their young are safer than they would be if left alone.

Nurseries are doubly advantageous for young penguins. As well as deterring predators, they also offer the best protection from the cold because the young huddle together to keep warm. This huddle is warmest in the center, and birds slowly and constantly change places, alternating between the outside and the inside.

Ostriches also raise their chicks in nurseries, comprising up to five or six different broods. When two broods meet, the little ostriches immediately run toward each other as if drawn by magnets. The adult males supervising them display to intimidate each other until one wins the battle for influence and takes charge of the group. Still, the others periodically relieve him.

Opposite

Magellanic penguin

Spheniscus magellanicus

Valdés Peninsula, Argentina

Penguins are extremely attentive parents, breeding in colonies also known as rookeries. The noise level there is high because both parents and young recognize each other by their voices.

Page 226

Mute swan

Cygnus olor

Touraine, France

Swans often carry their young on their backs and frequently show tender affection. In these close-knit families, the bonds formed between parents and young are extremely strong. Chicks learn to recognize their parents very soon after hatching during a short and crucial period—a process known as imprinting.

Page 227

Black-headed gull

Larus ridibundus

Brenne, France

Despite appearances, gull chicks are "falsely" nidifugous, and incapable of finding food unaided. Totally dependent on their parents, which travel far to satisfy their brood's growing appetites, they do not leave the nest and behave like true "nidicolous" birds, calling at the top of their voices when they are hungry.

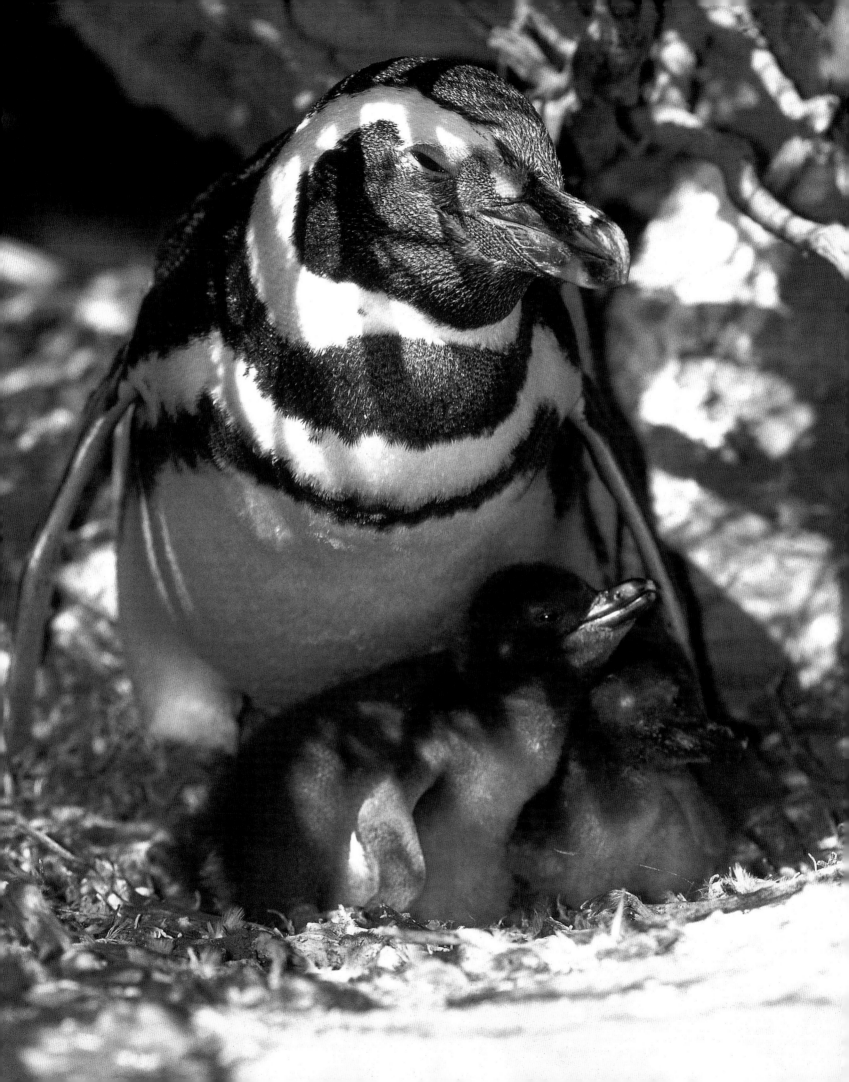

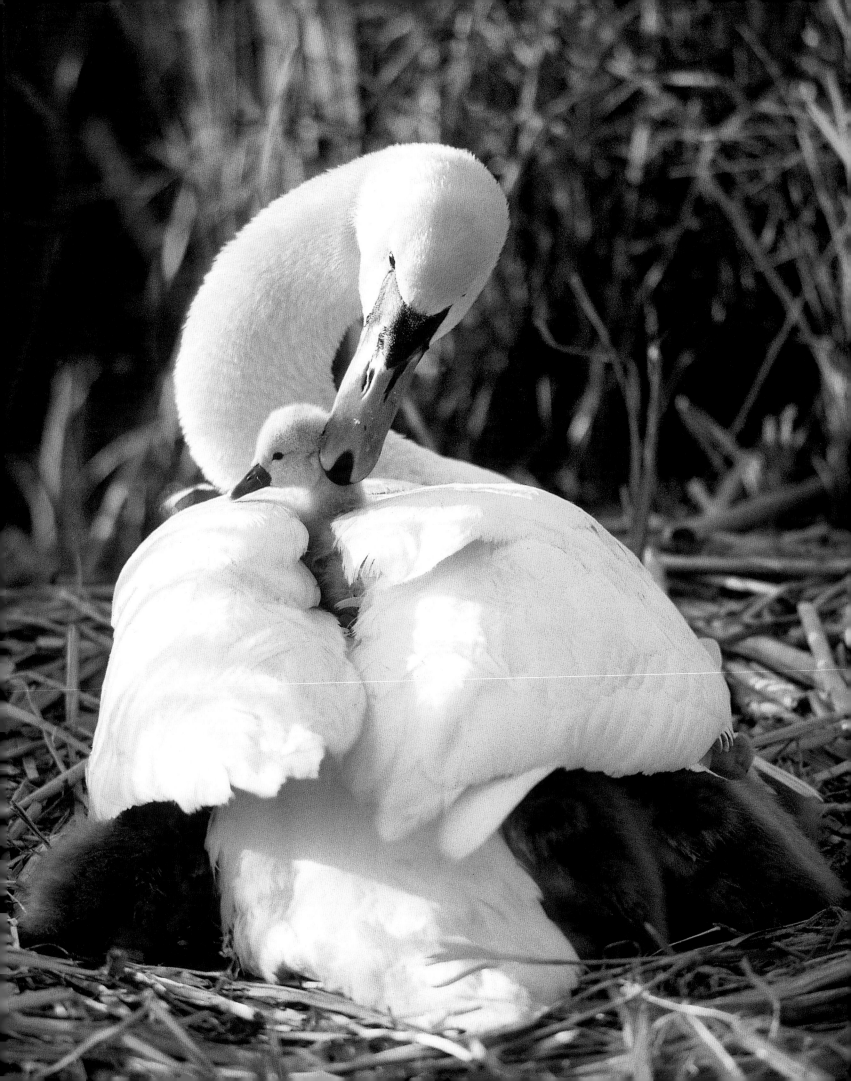

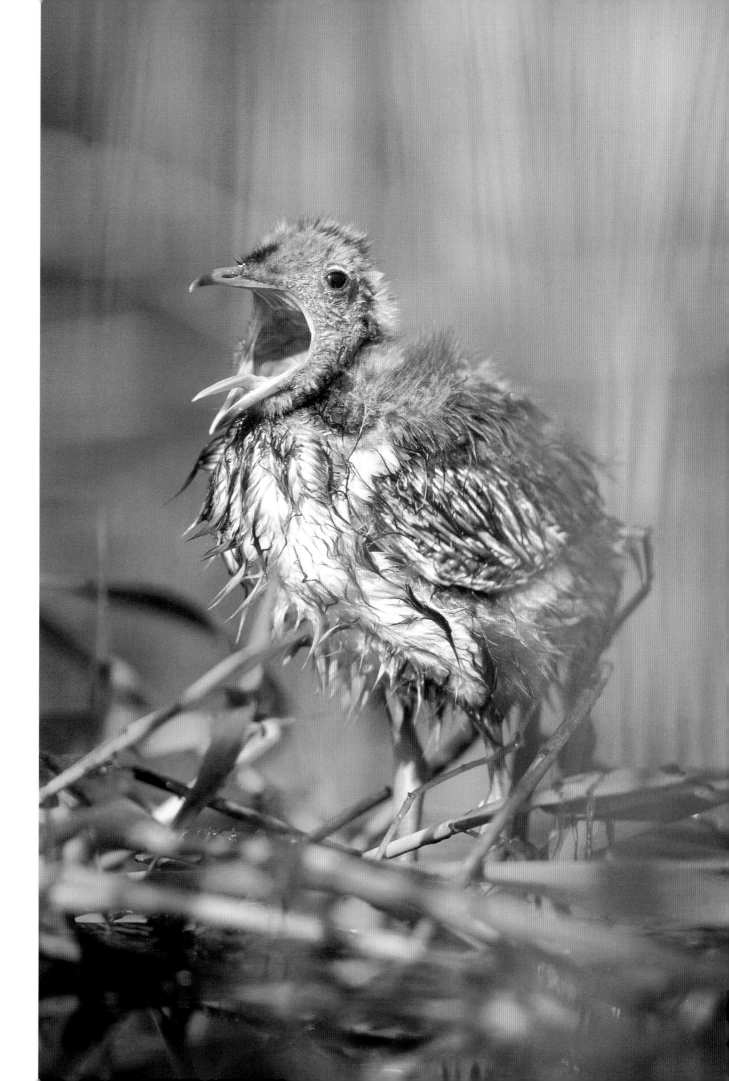

Transporting Chicks

It is not easy for a bird to carry its progeny; nevertheless, some species have developed some surprising ways of doing so. The jaçana, whose feet are so disproportionately large that it can almost walk on water, carries its young under its wing. To pick one up, it crouches, opens its wing slightly, and wedges the little bird under it. It then looks indistinguishable from any other adult bird, apart from the small, slender legs dangling below its belly. Woodcocks are also well known for carrying their offspring when a predator intrudes. They hold them between their legs and keep them in place with their bill as they fly them to safety. In this way they can carry a whole brood to refuge, one by one. Swifts, moorhens, rails, and whistling ducks use the same method. Grebes, swans, and loons are often seen swimming with chicks on their backs as if sitting in a boat, some of them so well buried in the parent's feathers that they barely protrude, only their heads poking out of the soft protective coat. Geese sometimes carry their newly hatched chicks to safety in their bills.

How to Drive Away Predators When Chicks Can't Be Moved

Raising a brood expends so much energy that when any disturbance puts the brood in danger, the parents are prepared to do anything to defend their nest or chicks. When aggressive displays have no effect, the parent birds attack the aggressor until it gives up. Thus lapwings, which nest in small groups, harass the crows that fly over their nests in search of eggs or chicks to devour. Emotions run highest when the whole group feels threatened and attacks the intruder en masse. This behavior also serves to educate the young because it teaches them which are their species' natural enemies. When neither display nor intimidation succeeds in driving away the trespasser, birds resort to trickery. A parent attracts the predator's attention by pretending to have a broken wing or leg and limps away from the nest, dragging itself zigzagging along the ground. No predator can resist the temptation of such easy meat, and the intruder invariably forsakes the nest and chicks to chase the adult. When the latter considers it has lured the threat far enough from the nest, it resumes its normal way of moving and returns to its progeny, now safe. This type of behavior is commonest among ground-nesting birds, which are much more vulnerable to predation or even to being crushed by large mammals than are birds that nest in trees. It is always astonishing to see a little ringed plover adopt this stratagem when faced with a cow in a field. Love may give humans wings; the desire to protect their broods gives birds courage and boldness that can only be admired.

Opposite

Eurasian spoonbill

Platalea leucorodia

Keoladeo National Park, India

Living in colonies that might also include herons, spoonbills are highly attentive to the needs of their young, taking turns looking after them until they fly the nest at the age of six weeks.

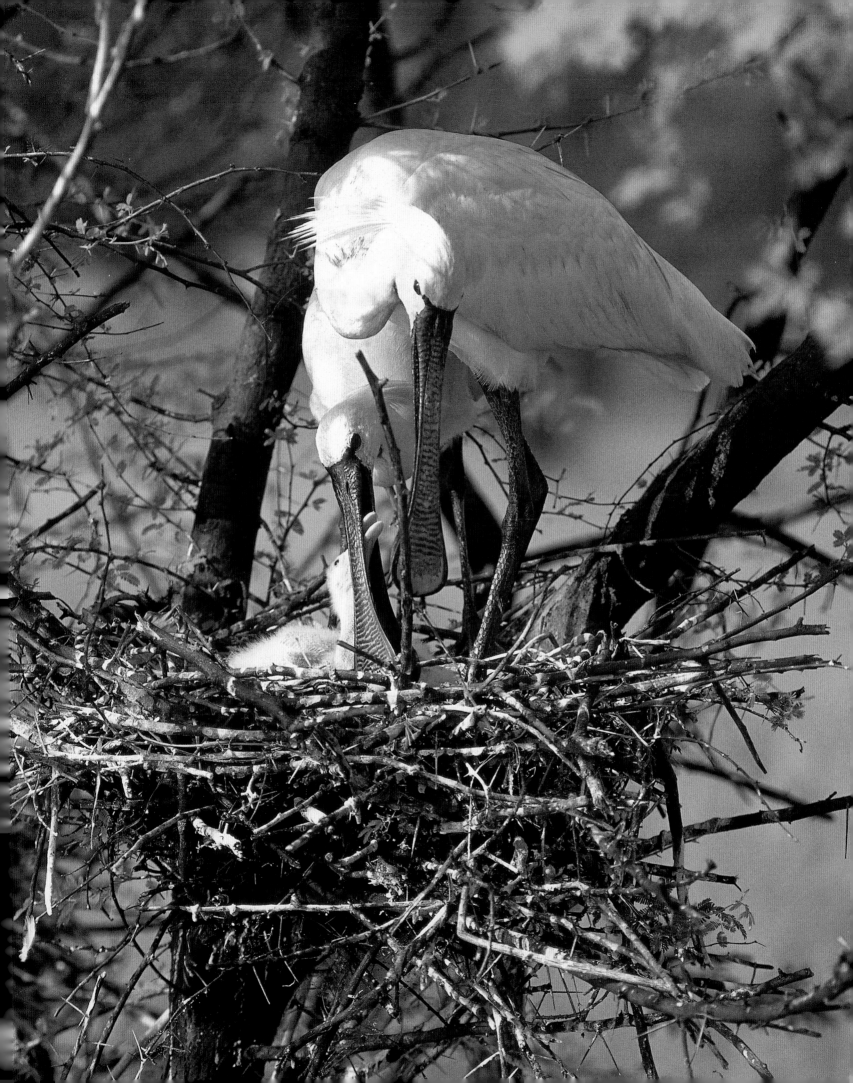

Opposite

King penguin

Aptenodytes patagonica

South Georgia Island, Antarctica

The single king penguin chick needs the care of both parents if it is to survive in the region's extreme climate. The birds huddle together in nurseries to withstand the bitter cold of the harsh winter.

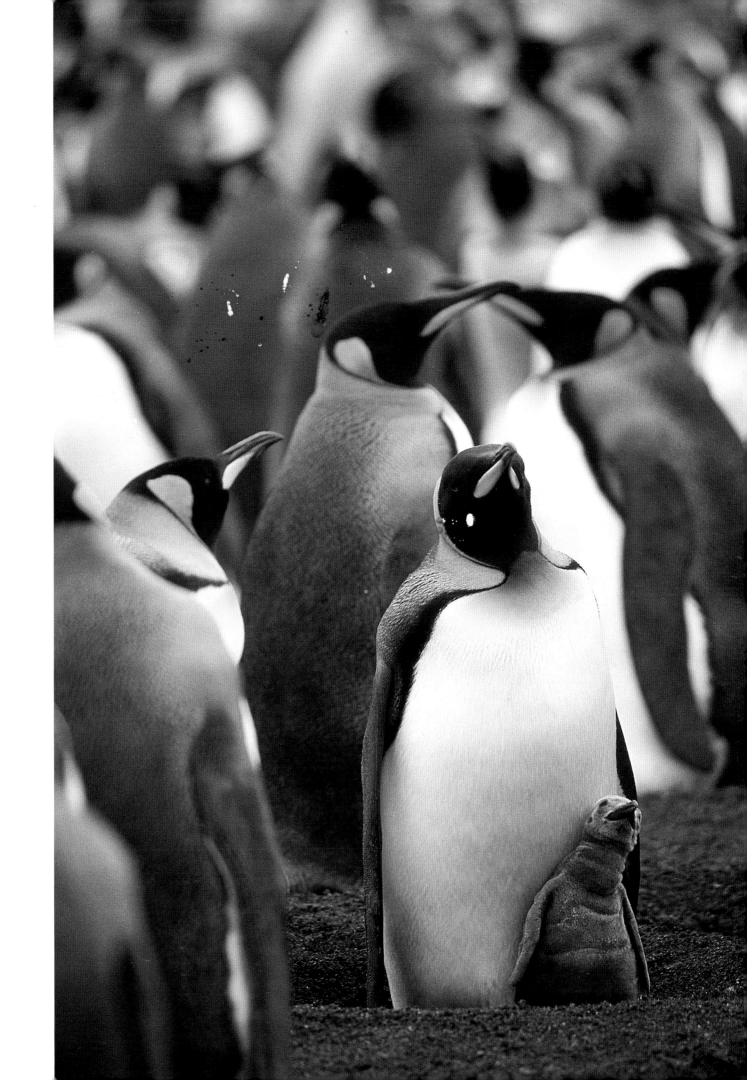

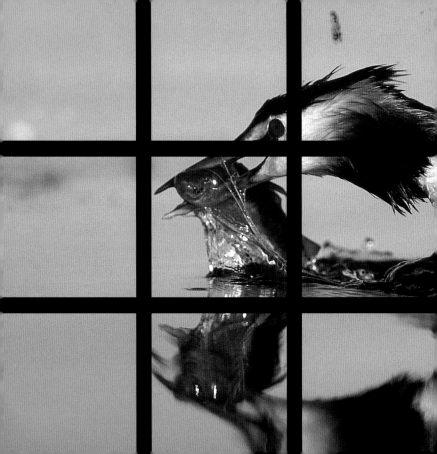

One Bill,
Infinite Possibilities

Great crested grebe

Podiceps cristatus

Brenne, France

A formidable fisherman who is able to remain under water for a minute or more, the great crested grebe chases its prey with impressive skill.

A bird's bill is a work of art—multiplicity in unity. All birds have one, but each has developed its own color, shape, and function, and these extend over such a wide range that it is difficult to catalogue them.

Every possible bill can be found in nature, one might say, and each tells its own story. As specialized as they are versatile, bills are designed to ensure their owners can cope with their environment in the best possible way. Naturally, bills are used for feeding, and they are perfectly shaped for performing this fundamental function for the survival of the species. Some birds have a dagger, others a fishing net, a filter for microorganisms, an intake for sucking in insects, or a nectar pump—bills meet all feeding needs. But they are not only for feeding: they are also used for building nests and, according to the species, may be required to weave, sew, build walls, or dig.

Bills can thus be needles, shovels, pickaxes, trowels, or power drills. They also give visual signals in the dense foliage of tropical forests, home to hornbills and toucans with bills that are remarkable as much for their size as for their coloring.

But they play their most charming role when, colored in fine hues and adorned with elaborate designs, they are important assets in the business of seduction. Thus in the breeding season the prominent bill of the puffin, which earns this bird its alternative name of sea parrot, takes on vivid colors. Red, yellow, and blue loudly convey that the bird is ready to mate; these colors disappear once this goal has been achieved.

Such is their variety that a list of all the forms bills take would be immensely long. Though they are all based on a pair of horny mandibles, they have diversified into a range of sizes and shapes that sometimes beggar belief. Some are so strange that their owners have been named after them—for example, the shoebill, a large wader of the African marshes, whose bill is disproportionately massive, or the crossbill, whose asymmetrical mandibles allow it to extract pine nuts. The diversity of forms reflects an equal diversity of diets. One could almost believe that no two species have the same diet: even though they may eat the same things, they do so in different proportions, in different settings, at different stages of their development, or simply at different times. In short, all these factors taken together mean that each bird's consumption is unique, which reduces the competition each species faces.

Form and Function

If we take the bill of a seed-eater such as the domestic canary as the bill in its basic form, we can understand each transformation as an adaptation to the demands made by diet.

The bills of canaries vary in thickness, depending on the size and toughness of the seeds each species consumes—the stoutest, belonging to the grosbeak, can crush cherry stones.

Grazing on grass, as geese do, requires a broad, flat implement resembling a cow's muzzle. The process of devouring insects demands great precision and a tool to match. Warblers, which pick insects off plants, have a fine pair of forceps, while the swift, which catches them in flight, has a gaping bill that acts like a scoop. This type of bill is even more highly developed in nightjars, where it is surrounded by bristles that direct the prey into the gaping chasm of the gullet, rather like a funnel. Woodpeckers also live on insects, which they dislodge from under the hard bark of trees; for this they use a bill like a hammer drill, which can pierce the toughest surfaces. Treecreepers are content to explore the cracks in the bark, which they do with a very slender, slightly curved bill that can easily penetrate the narrowest crevices.

Found underground, invertebrates are a very rich food source, and the woodcock's bill is perfectly suited for extracting them. They are also found in mud—requiring a long, upturned bill like that of the avocet, or a flattened one like the spoonbill's—and in open water, where dabbling ducks feed on them using their broad bills equipped with tiny hooks. Catching fish requires flawless technique and a daggerlike bill to impale them, in the manner of the heron and the kingfisher. The merganser's mandibles are covered in little hooks, ensuring a perfect grip on its slippery prey, while the pelican is universally famous for the enormous sac under its bill, which acts as a fishing net. All these bills are tools for capturing prey, but they demand that the owner swallow it whole. Only the sharp bills of raptors allow them to tear up prey and swallow it in pieces. Curiously, parrots, which are essentially fruit eaters, have similar bills; however, they too tear fruit to pieces before eating.

Flamingo's Smile, and Other Strange Bills

Leaving aside its slender build, the pink flamingo is the avian equivalent of the whale and the oyster. It is a filter that passes large quantities of water through its buccal cavity, retaining only the microorganisms that live suspended in it. This fine strainer feeds head down in shallow lakes; its hooked bill is sharply curved and thus held parallel to the muddy bottom. The flamingo is probably the only animal that can feed with its bill closed. Its lower mandible is triangular in section and fits exactly into the open tube of the upper mandible. Where the surfaces of the two meet, they bristle with lamellae that act as filters. When the bird is dredging from side to side, its tongue acts exactly like a pump, whose constant movement back and forth expels the water and sucks up the nutritive elements. Another peculiarity is that the flamingo's bill is articulated the opposite way to those of other birds, with a hinged upper mandible and a fixed lower one. The northern shoveler,

Opposite

Western capercaillie

Tetrao urogallus

Poland

This gallinaceous bird's short, thick bill is the sign of an omnivore, able to feed on seeds, fruit, buds, young shoots, and small invertebrates.

Pages 236 and 237

Whiskered tern

Chlidonias hybridus

Brenne, France

With its long, slender bill, the tern feeds in flight, skimming the water's surface and picking up insects, amphibians, and small fish.

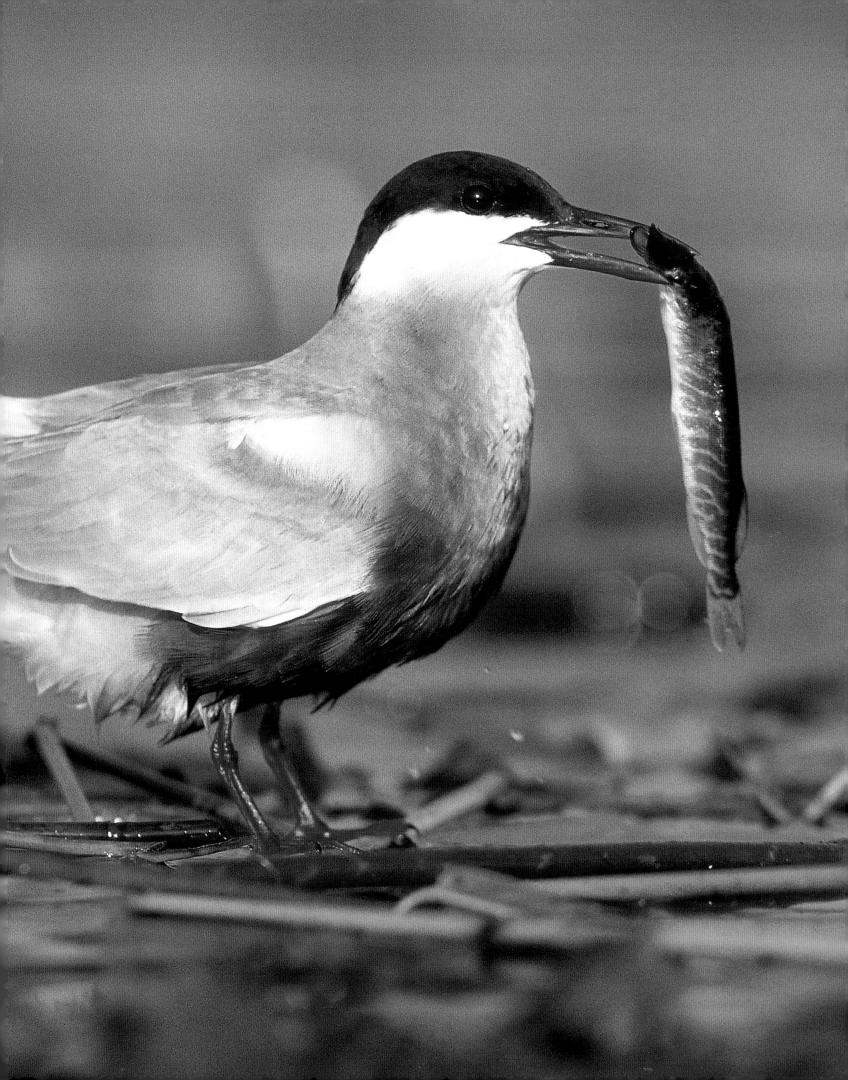

Malachite kingfisher

Alcedo cristata

Zambia

The kingfisher's harpoonlike bill is an effective weapon for spearing fish. Its similarity to that of a heron, which in all other respects is a very different bird, demonstrates the degree to which diet determines the shape of the bill.

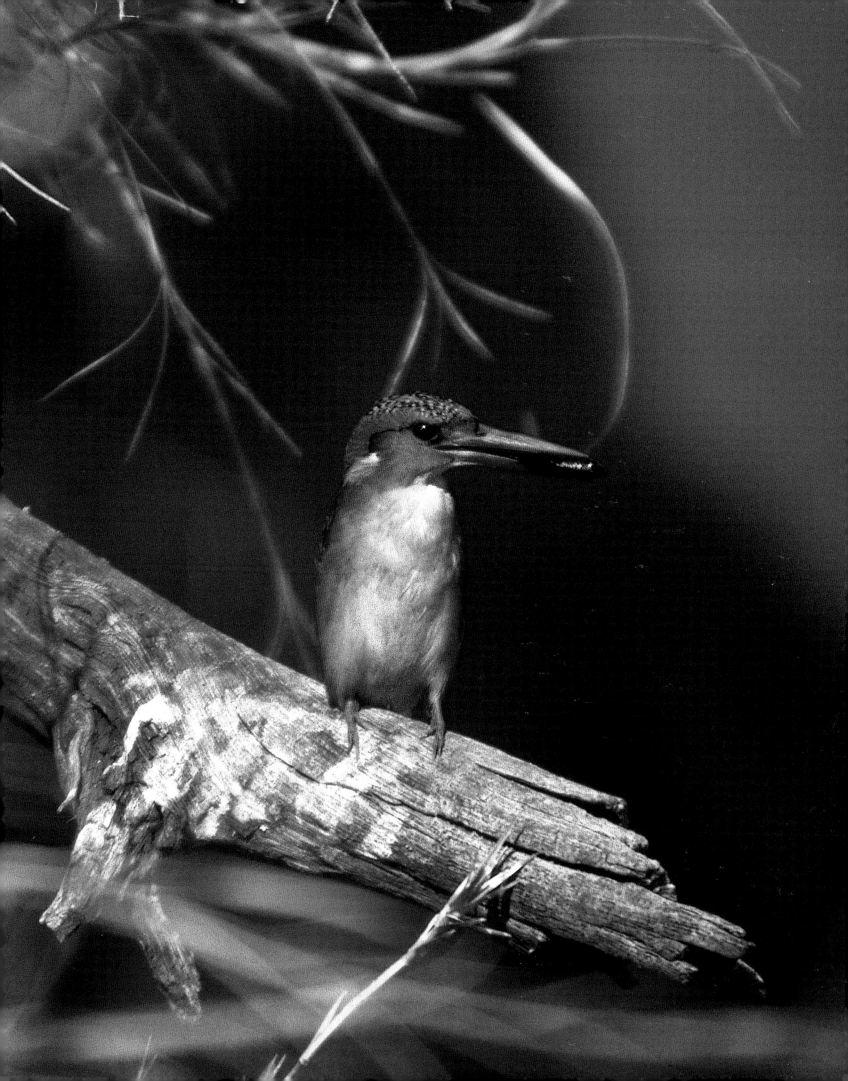

1. Short-toed eagle
2. Eclectus parrot
3. Common crane
4. Pied cormorant
5. Red-crested pochard
6. Barn swallow
7. Inca tern
8. Great white pelican
9. Great white pelican
10. Pink flamingo
11. Purple swamphen
12. Hooded vulture
13. Common raven
14. Sacred ibis
15. Curl-crested araçari

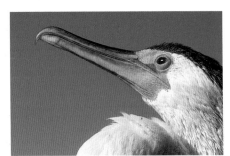

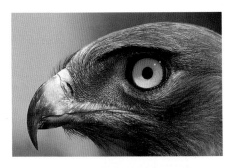

1	4
2	5
3	6

7	10	13
8	11	14
9	12	15

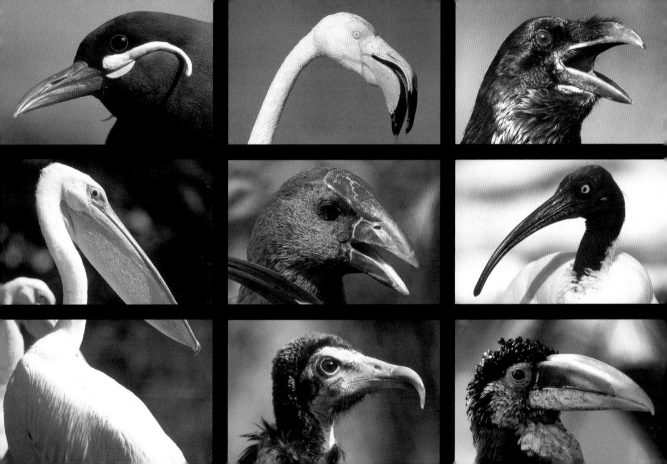

Eastern yellow-billed hornbill

Tockus flavirostris

Zimbabwe

Although they feed chiefly on fruit, hornbills also use their enormous bills to catch small prey such as insects, reptiles, and scorpions.

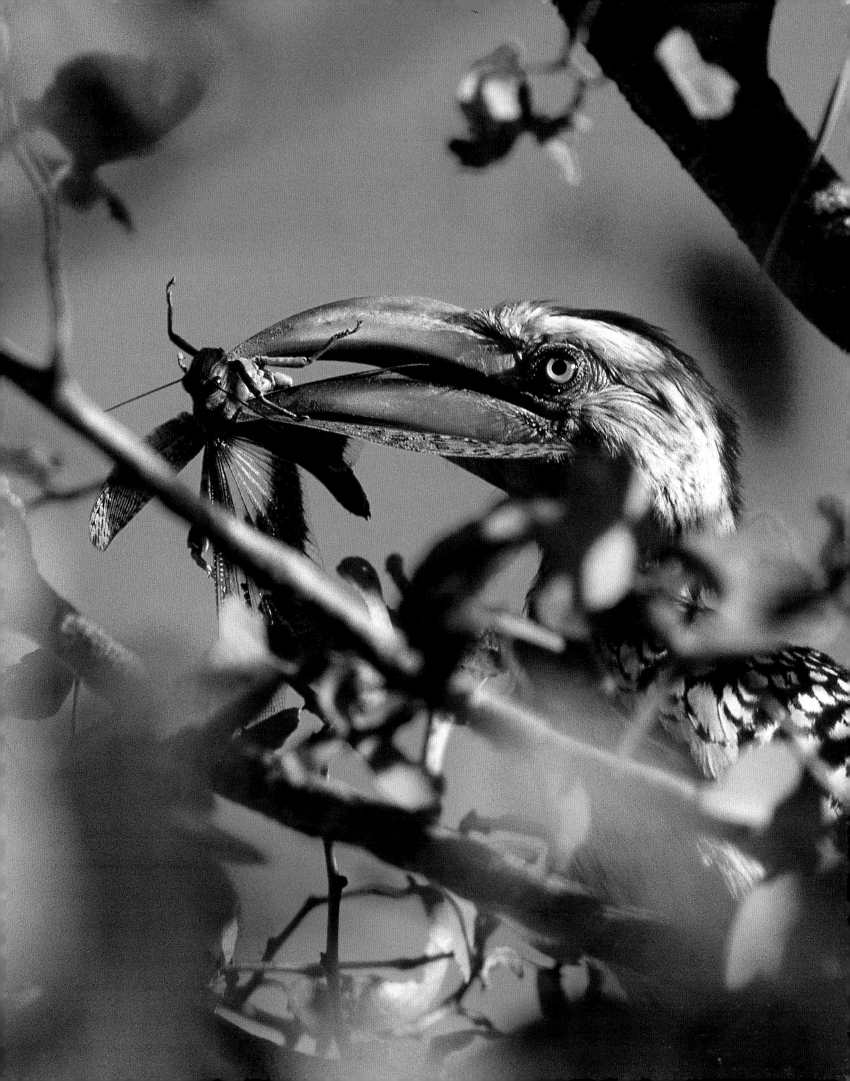

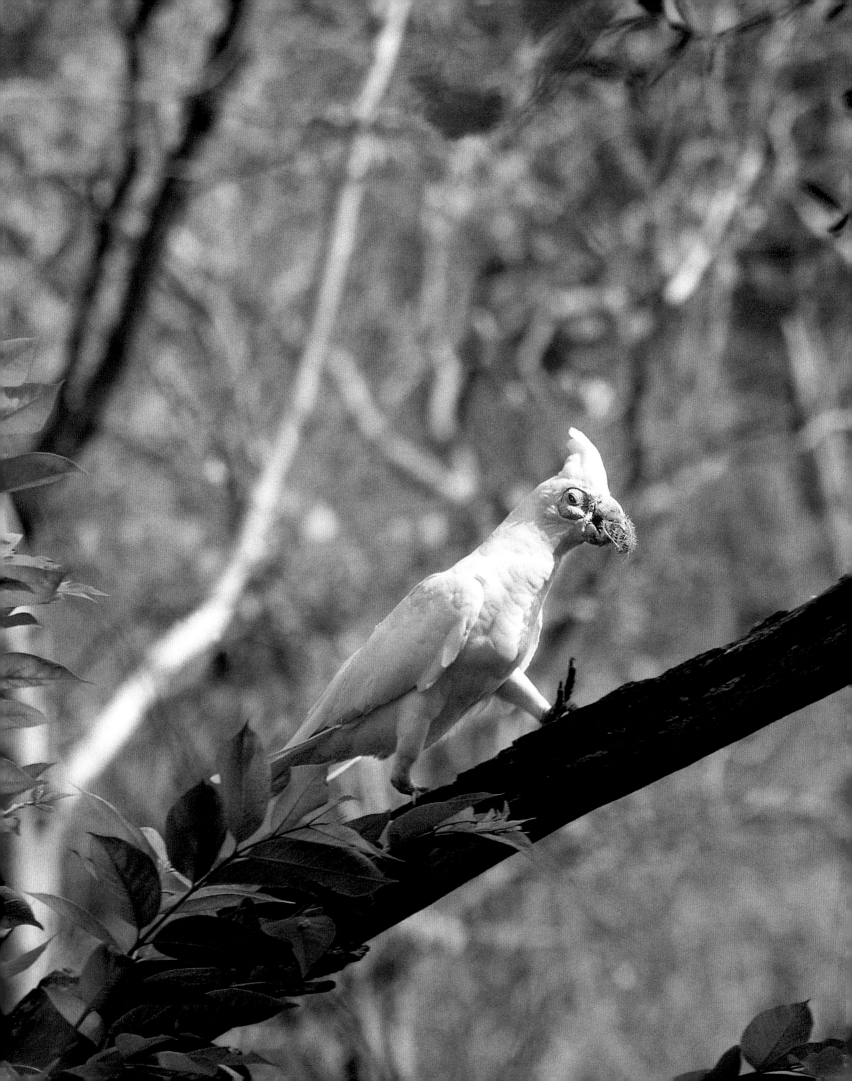

Opposite

Little corella

Cacatua sanguinea

Northern Territory, Australia

Parrots have a powerful hooked bill whose upper mandible is articulated and heavily serrated; it is a superb set of precision pincers for shelling fruit and seeds, tearing roots, bulbs, and twigs, and for extracting flesh from insects, which the parrot does not disdain.

with its enormous, broad, flat bill, feeds in the same way, by combing the mud of marshy shallows, but its bill is a less sophisticated device. Another group of astonishing fish catchers are skimmers, which feed on the surface of calm waters along tropical shores. They fly just above the surface with their bills open, their much longer lower mandible cutting through the water as the blade of a plough slices through earth. The bill snaps shut as soon as it touches a particle, and the bird swallows its prey. This specialized hunting method, which relies on the sense of touch, allows them to feed at dusk or at night, when many small fish rise to the surface.

The shoebill, with its disproportionate appendage, uses the powerful hook at its end to probe the mud of marshes in search of the small fish that live buried in it. The openbill, a large stork, possesses a bill whose two mandibles meet only at the end; this allows it to trap water snails, of which it is extremely fond.

Sights Give a More Accurate Aim

Many birds with long bills or that hunt insects have a sight placed between the end of their bill and their eyes, which helps them to strike their prey accurately. The black line that starts from the corner of the bill of the delightful blue tit and continues behind the eye is also a sight. Due to this line, the bird can accurately judge the pecks with which it catches the insects that make up its diet. The turnstone uses its bill to turn over stones and pick off the invertebrates that hide under them. Its sight allows it to align the point of its bill exactly with its fleeing prey. The long curved bill of the curlew is perfect for plunging into the tunnels dug by tubeworms in the sand and extracting them. This implement is perfected by a sight that is flawlessly aligned at its end. Exactly the opposite is the case with the heron, whose sight is out of alignment. This subtlety is due to the fact that the heron lives in the air, while its prey is under water. Light changes direction when it enters water—when we look at an underwater object, it appears to be in a different place from its true position. A marvel of adaptation, the heron's offset sight exactly compensates for the angle of refraction of light between air and water. When the sight is lined up with the heron's prey, the end of the bird's bill points exactly at the target, which it skewers without difficulty.

Bald Heads, Bare Necks, and Clean Bills

The distinction between predators and carrion-eaters is not always easy to draw. Many birds of prey do not disdain to eat a dead animal, which makes an easy meal. Among birds of prey, vultures are strictly carrion-eaters, feeding on the bodies of animals killed by others. When these are large, they have to plunge deep into the entrails to tear up their internal organs, emerging stained with blood to the base of their necks. Fortunately, having long featherless necks mean they do not soil their feathers during these banquets, and bare skin is much easier to clean than feathers or down.

Opposite

Black-capped lory

Lorius lory

Papua New Guinea

As with other parrots, the black-capped lory's bill plays an important part in its social life, where it is used for mutual removal of parasites or giving gifts of food to a mate. In its feeding role, the bill is backed up by an extremely effective tongue with a brush at its end that helps collect the nectar the bird loves.

Page 248

Great spotted woodpecker

Dendrocopos major

Shiga Kogen, Japan

The woodpecker's powerful, scissorslike bill enables it to cut through bark and make holes in tree trunks with the efficiency of a hammer drill. Among other things, this enables it to accumulate a store of food by hiding hundreds of acorns in little holes for retrieval during winter.

Page 249

Great tit

Parus major

Hokkaido, Japan

Many birds change their diet with the seasons. Tits chiefly eat seeds in winter and insects in summer. Along with this change come physiological alterations to their digestive system. In autumn, their gizzard swells up and gains muscle, resembling that of a seed-eater, and their intestines become longer to enable them to digest the proteins in vegetable matter, which are less readily available.

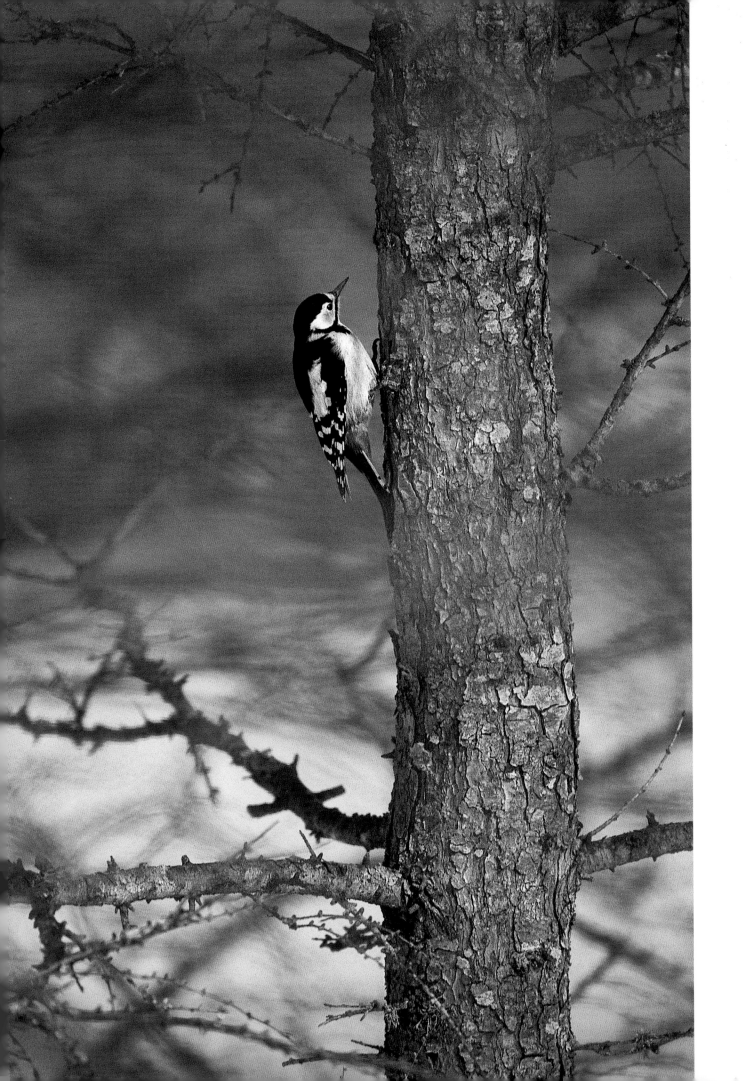

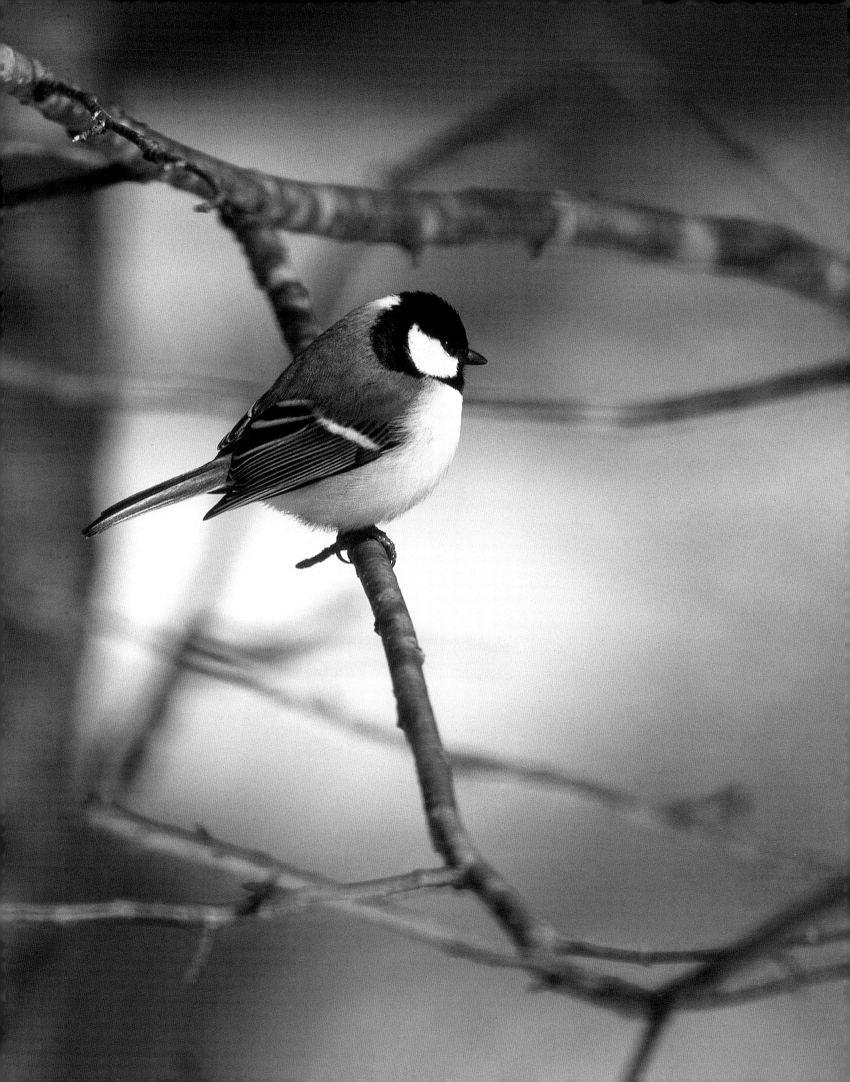

Their tongues are covered with backward-pointing barbs, allowing them to swallow large lumps of soft flesh. The white-backed vulture and Rüppell's griffon, which feed almost exclusively on dead carcasses, have the largest bare areas. Other vultures, which occasionally hunt live prey or feed on smaller carcasses, have heads and necks more or less covered with feathers. This adaptation linked to carrion-eating is not exclusive to vultures. Marabout storks—large African storks that are fond of carcasses—also have long, bare necks. To a lesser extent, but for similar reasons, the rook of western Europe is also largely devoid of feathers around the bill, which makes it instantly recognizable.

The Pelican's Trap

With a capacity of 12.5 quarts (12 liters), the white pelican's gular pouch—the sac that hangs from its bill—is a scoop that can accommodate some big catches. The hook at the end of the upper mandible allows the bird to impale the slipperiest of fish, and it is undaunted by carp weighing nearly 5 pounds (2 kilograms). Like Jonah's whale, it can scoop up a large volume of water and spit it out, swallowing only the fish. The pelican's bill may be a strange contraption, but the bird's fishing technique is no less astonishing. They gather in a flock of no more than twenty individuals and advance together in a horseshoe shape, plunging their bills underwater and pulling them out in unison. This formation, an inescapable trap for fish, increases each individual bird's catch.

A pelican's bill is more than a superb fishing net. Its gular pouch acts as a shopping basket when it builds its nest and feeds its young, but it is also an organ for controlling body temperature. Just as an elephant flaps its ears like fans to cool down in very hot weather, so the pelican spreads its gular pouch, which is richly supplied with blood vessels, and swings it from side to side periodically. The blood circulating through it is cooled and helps to keep the bird's core temperature constant. The horny protrusion at the end of the upper mandible plays a central role in feeding the bird's chicks. Colored brilliant orange or vermilion, it provides a powerful stimulus for the newborn bird, which pecks at it. The adult then regurgitates a predigested, highly nutritious pap, which trickles along this protrusion and stimulates the chick to start taking food. If it does not peck the red mark, the pelican chick does not know how to demand food.

Flower and Fruit-Eaters

To survive exclusively on a diet of fruit and flowers, a bird must find these available in sufficient quantities all the year round. For this reason, birds that do this live exclusively in tropical regions. Unlike prey animals, which develop many stratagems for escaping their gruesome fate, flowers and fruit aim to attract those that eat them by making themselves as tempting as possible. This is how plants are often fertilized and their seeds spread, which vastly increases their propagation. In general, fruit-eaters' bills, like those of seed-eaters, are in proportion to the fruit they consume.

Opposite

Shoebill

Balaeniceps rex

Africa

The shoebill's enormous, shovellike bill enables it to stir up mud, just as do the waders that feed on worms along the coastlines. The bill is also extremely useful for quenching the thirst of its chicks on hot days, when the bird uses it as a water bottle, gently trickling the contents into the open bills of its young in the nest.

Page 252

Pink flamingo

Phoenicopterus ruber ruber

Caribbean South America

A shovel and a filter at the same time, the flamingo's bill is a model of successful evolution, a small version of the enormous filtering organ of plankton-eating whales. It works in the opposite way to other birds' bills, with the upper mandible resting on the muddy bottom.

Page 253

Roseate spoonbill

Ajaia ajaja

Chacahua Lagoons, Mexico

The long, flared bill of the spoonbill—one of few birds to owe its name to this organ—is a formidable tool for probing mud in search of food.

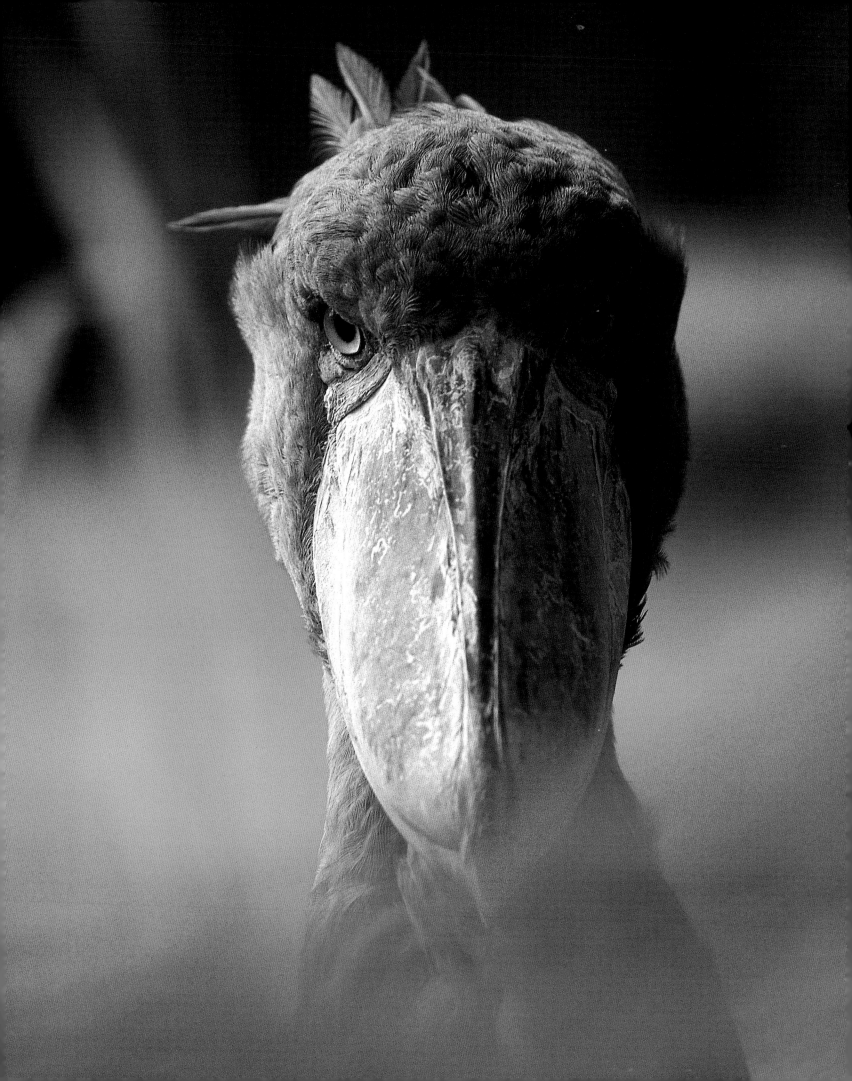

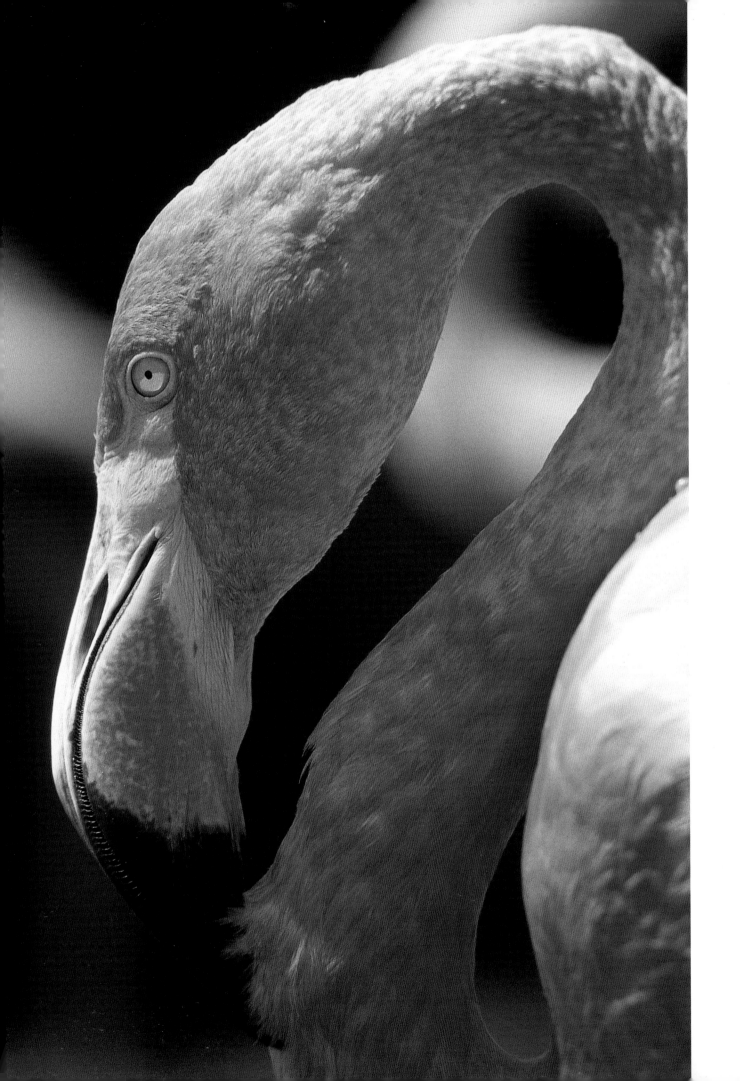

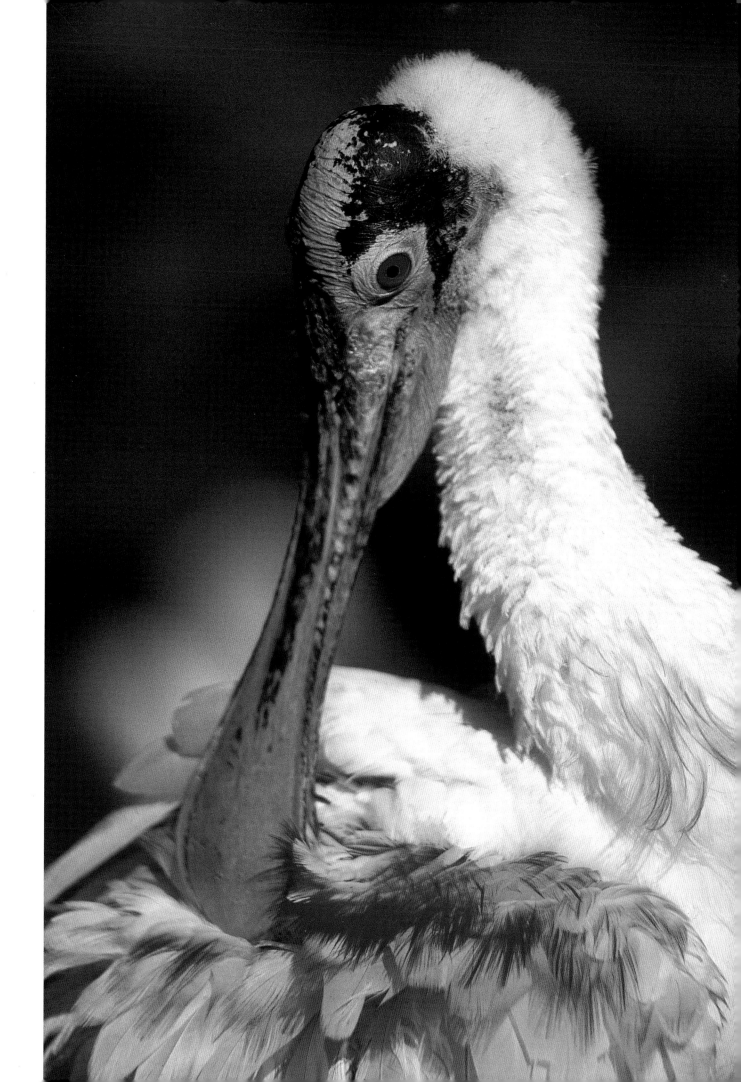

Like them, too, they feed their young on insects to boost their growth, as fruit is not sufficiently rich in protein, and gradually switch to a fruit diet when their chicks' feathers have sprouted. The oilbird feeds its young exclusively on fruit, but the complete safety of its nest in the depths of a cave means it can keep them for more than three months in this inaccessible shelter. They can thus afford to grow at an extremely slow rate, which would prove fatal to other species.

Some occasional fruit-eaters stuff themselves to such an extent that they totter and fall to the ground, completely drunk on the fermented juice. This does not happen with flowers, which many birds eat if they have the opportunity. European warblers and tits do not hesitate to suck nectar from flowers, but this is very much an optional part of their diet. By contrast, eight families of birds, all of them tropical, specialize in eating this food. The most famous of these are certainly the hummingbirds of America. Their African equivalent is the sunbird, which is also capable of rapid vibrating flight, although it prefers to perch on flowers to feed. In Australia, their place is taken by lorikeets—small, very brightly colored parrots. Nectar-eaters, too, complete their diet by eating insects, especially when raising their young.

Flowers and those that feed on them have coevolved in an extraordinary way. Lorikeets have a short tongue with a brush at its end, made up of tiny tubes that open when the bird feeds. The tongues of other nectar suckers are long, tube-shaped, and also equipped with a movable brush at the end. When they feed, the nectar is stirred and sucked up the tube by capillarity until it reaches the bird's gullet. The length and curvature of various species' bills enable each one to investigate the nectar of particular kinds of flower, producing a form of symbiosis. Thus the sword-billed hummingbird has a bill longer than its body, which enables it to probe the heart of tubulous flowers that no other bird can reach. To make themselves more accessible to birds, flowers sometimes have stems that are stiffer near the corolla, providing a convenient perch. Plants, too, use stratagems to avoid competition. Several plant species visited by the same species of bird have their male and female organs arranged differently, with the result that different species of plants deposit and collect pollen from different parts of the body or head of the visiting, and therefore pollinating, bird.

As in all things, there are cheats that take advantage of this idyllic situation. Thus the cardinal lobelia of America imitates nectar-producing flowers without producing a drop. The bird is duped, and visits the flowers anyway, pollinating the plant for no gain while the plant makes no effort to be a good host. Sunbirds, on the other hand, whose bills cannot reach the nectar in flowers whose corollas are too deep, pierce them at the base and suck it out without passing through the pollination chamber. In this case, it is the flower that is robbed without getting anything in return.

Darwin's Extraordinary Finches

The most striking example of the evolution of forms in response to environmental demands is the famous finches studied by Charles Darwin in the Galápagos Islands. These birds, all descended from the same original type, had spread to all the ecological niches in the archipelago and, in so

Opposite

Bateleur eagle

Terathopius ecaudatus

Botswana

Birds of prey have beaks designed for tearing flesh into pieces, but it is their powerful claws that kill their prey.

Page 256

Turkey vulture

Cathartes aura

Paracas Peninsula, Peru

Vultures are less heavily armed for killing than eagles, but they are just as able to tear flesh and are equipped with an abrasive tongue for detaching it from bones. Their most astonishing adaptation is their bare head, which allows them to remain clean after their feasts. The deeper a species is accustomed to plunging its neck into a carcass, the more denuded its head and neck.

Page 257

Hair-crested drongo

Dicrurus hottentottus

Cape Tribulation, Australia

This tree-dwelling insect-eater is seen here gathering its prey from flowers. It is believed that nectar-eating birds evolved from insect-eaters that fed in this way.

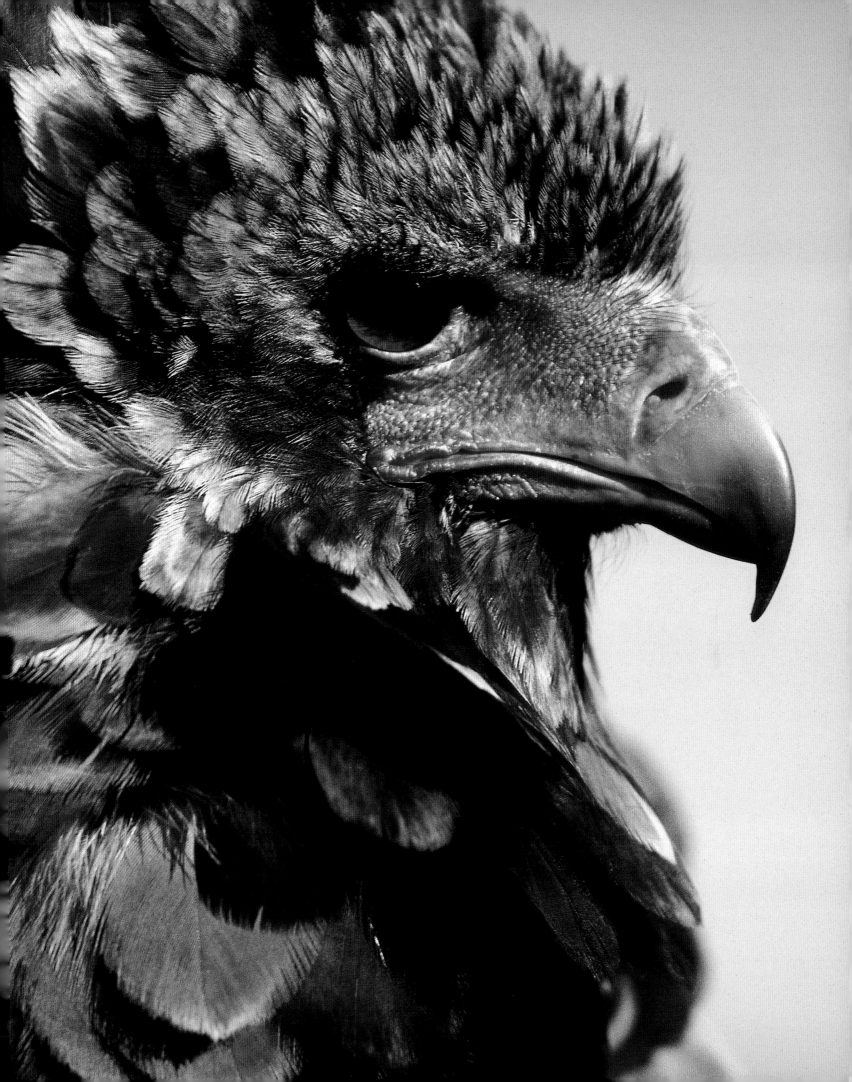

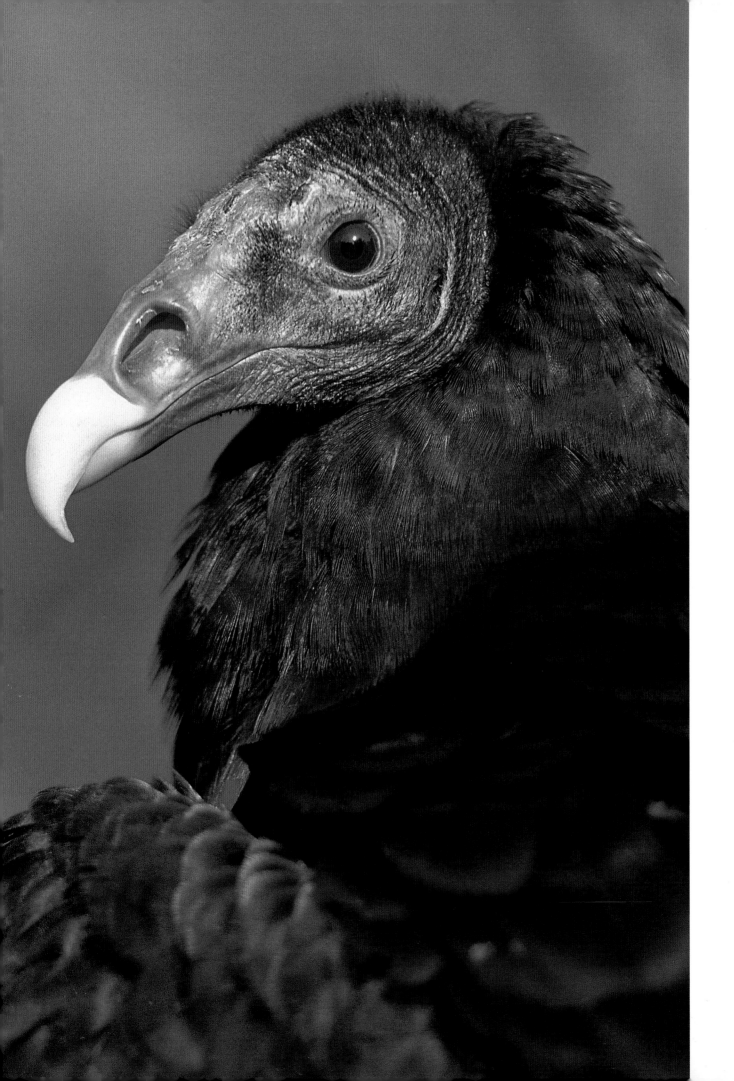

doing, had developed different forms of bill. Thus the conical bill typical of seed-eaters was transformed into a multitude of different forms depending on the demands made by the specific diet of each species. One of these had even specialized in vampirism—piercing the skin of seabird chicks to suck their blood. It was from his observation of these many types of small bird that Darwin developed his famous theory of evolution.

Less well known, but equally diversified, are the honeycreepers of Hawaii. These island dwellers are all descended from a common ancestor—a small American warbler—and have undergone an extraordinarily diverse process of evolution that has enabled them to exploit all the archipelago's food sources. Every type of bill can be found among the various species: the long, curved bill of the nectar-sucker, the fine pointed one of the insect-eater, and the short, thick one of the seed-eater.

When a bill is not up to the task demanded of it, a bird will make tools to come to its aid—like the Galápagos finch that thinks it is a woodpecker but does not have a woodpecker's strength. It first cuts into the bark of a tree with its bill, and then, using a needle-sharp cactus spine, impales the insect it has found and eats it with relish. Such ingenuity is worthy of praise indeed!

Opposite

Yellow-billed oxpecker

Buphagus africanus

Serengeti, Tanzania

Oxpeckers perform cleaning duties for the large mammals of the African savannah, chiefly relieving them of ticks. They carefully inspect all parts of the animal, from the inside of the ears to the belly, where they hang upside down. The mammals ignore them completely.

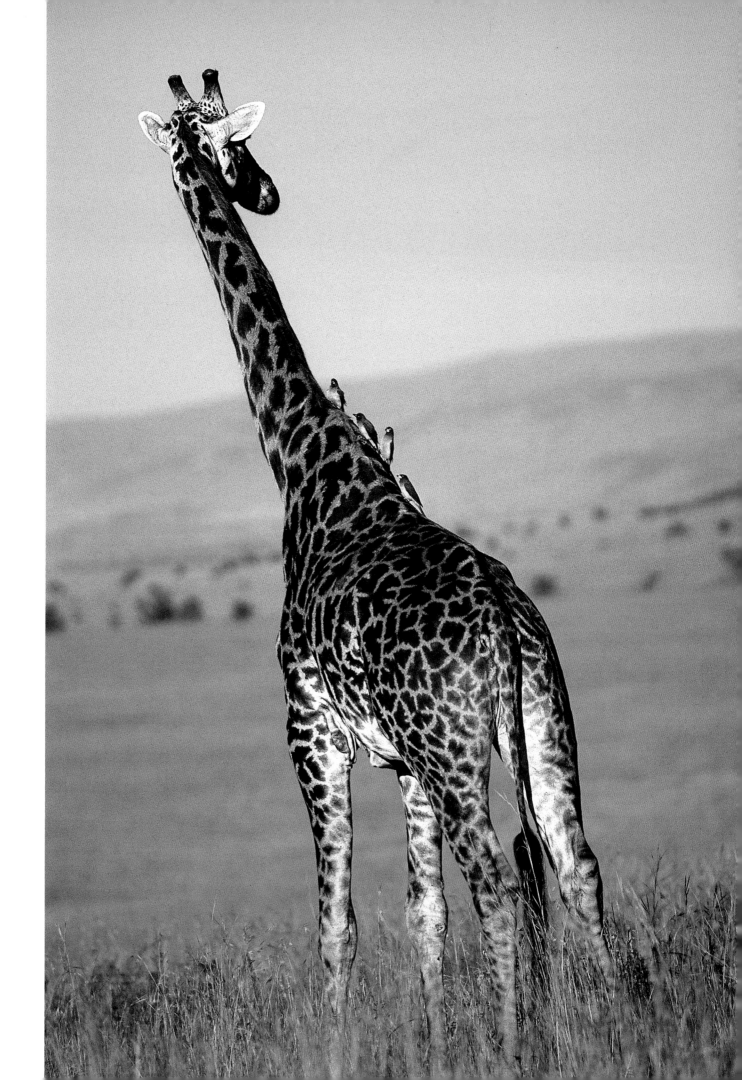

Ingenuity Conquers All

To live in harmony with the environment, to find nourishment, and to prosper in such perfect concord that it might be imagined that the organisms we observe have been put there by design, specifically to play a given role: this "adaptation" is nothing more than the most astonishing manifestation of evolution. Evolution by natural selection is the response of organisms to the problems their environment poses. Life in the eternal snow and ice of the poles does not demand the same tools as living in a tropical forest. Sand desert does not make the same demands as the vast expanses of the ocean. Birds respond to all environmental challenges, sometimes with an impudent similarity, and always with masterful skill.

When physiology is not enough to adapt to the demands of a given habitat, birds demonstrate a real ability to learn, and they develop the use of tools. Sometimes, neither tools nor specific physical attributes are required. What is needed instead is simply a highly sophisticated way of behaving that seems to suggest they are intelligent, except that such a claim on behalf of birds would bring accusations of anthropomorphism. We can thus see them as copiers or imitators, but always as observant. They demonstrate gifts that really challenge us, becoming doctors or pharmacists like those earth-eating parrots of Central America. When they are wounded and turn into surgeons, like the woodcock, birds become truly moving, and when they cannot treat themselves, they turn to one of their kind to dress wounds they cannot reach. They teach us a very important lesson.

North Pole, South Pole; auk, penguin. These two birds have perplexed us endlessly. It is difficult to conceive that they are no more closely related than a chicken and a canary. Yet auks and penguins share only their external appearance, which is dictated by the conditions in which they live—although this fact is well hidden by their black-and-white uniform. Scientists call such similarity convergent evolution. "Auk" comes from the Old Norse word *alka*. The origin of the word "penguin" is something of a mystery, however. It is thought to come possibly from the Welsh *pen*, meaning "head," and *gwyn*, meaning "white," or from the Breton *penngwenn* or Dutch *pinguyn* (though there are those who say it comes from the Latin *pinguis*, meaning "fat"). Whatever the truth of the matter, the two birds meet similar demands by means of similar adaptations: a squat body, feet at one end, vertical posture, and short wings that act as flippers under water, where both hunt their prey. Penguins have gone further than auks in their adaptation, because

they can no longer "fly" except under water, having lost the power to do so in the air—though the great auk, now extinct, was also flightless.

On a wider scale, seabirds all have plumage of similar coloring: black above, and white below. Strange as that may seem, this is probably camouflage to help them catch prey. Dark upper parts are less visible from above, because they do not stand out against the dark of the sea, and a white underside is less visible from below as it blends in better with the pale background of the sky.

A Fast Lasting Several Months

Everything about the emperor penguin is astounding. Its capacity to stay under water for almost twenty minutes at a time takes the breath away. Its ability to go to great depths, up to 1,300 feet (400 meters), is equally impressive. How can it withstand the enormous pressure of the water, and how can it catch prey at such a depth? Researchers are full of questions, but there are few answers as yet. Emperor penguins probably possess the faculty of echolocation. Among other peculiarities, they breed in the depth of the Southern winter, which is the most bitter in the world, with temperatures as low as 122 °F (50 °C) below zero and blizzards that sweep across the ice at 185 miles (300 kilometers) per hour. The breeding adult birds emerge from the open sea at the beginning of winter, gather on the ice pack, and set off to walk to their breeding grounds, which may be as much as 60 miles (100 kilometers) away, at speeds of about one mile (one or two kilometers) per hour. From this point onward, they eat nothing. Once they have paired off, a fortnight passes before the female lays a single egg, which she immediately entrusts to her mate in a highly elaborate ritual. She then leaves, returning to the sea to feed, and leaving the male the job of incubating the egg for a little over two months. By this time, neither bird has touched any food for between forty and fifty days. When the chick hatches, some sixty-five days later, the mother is supposed to return to look after the chick and allow her mate to go and satisfy his hunger at sea. However, sometimes she is delayed. If this happens, the male is still able to feed and keep the youngster warm for another ten days or so, regurgitating from its esophagus a secretion that consists of 60 percent protein and 30 percent fat. After this, it is essential that he return to the feeding grounds, which means walking the distance back to the open sea. When he arrives, he will have fasted for more than four months and lost half his body weight. The life of this large penguin is punctuated by such fasts which last, in total, half the year. To survive, it builds up enormous fat reserves; it also has phenomenal powers of recuperation, being able to gain weight twice as fast as it loses it.

Apart from the emperor penguin, whose endurance is astounding, most birds do not cope well with lack of food. They need to find the nourishment to fuel their marvelous flying machine, which uses up large amounts of energy. When environmental conditions become too unfavorable, the nightjar has a unique way of dealing with them. It is the only bird in the world that hibernates. In winter, it sleeps so soundly that it is possible to pick it up without waking it. Its heartbeat becomes so weak that it can only be detected with a stethoscope, and its body temperature plummets to 55.4 °F (13 °C). This temporary death saves it, and the return of fine weather brings resurrection.

Opposite

Comoro blue pigeon

Alectroenas sganzini

Aldabra Atoll, Indian Ocean

Isolated from the pressures of natural selection at work in the rest of the world, island animals evolve independently, producing new, "endemic" species.

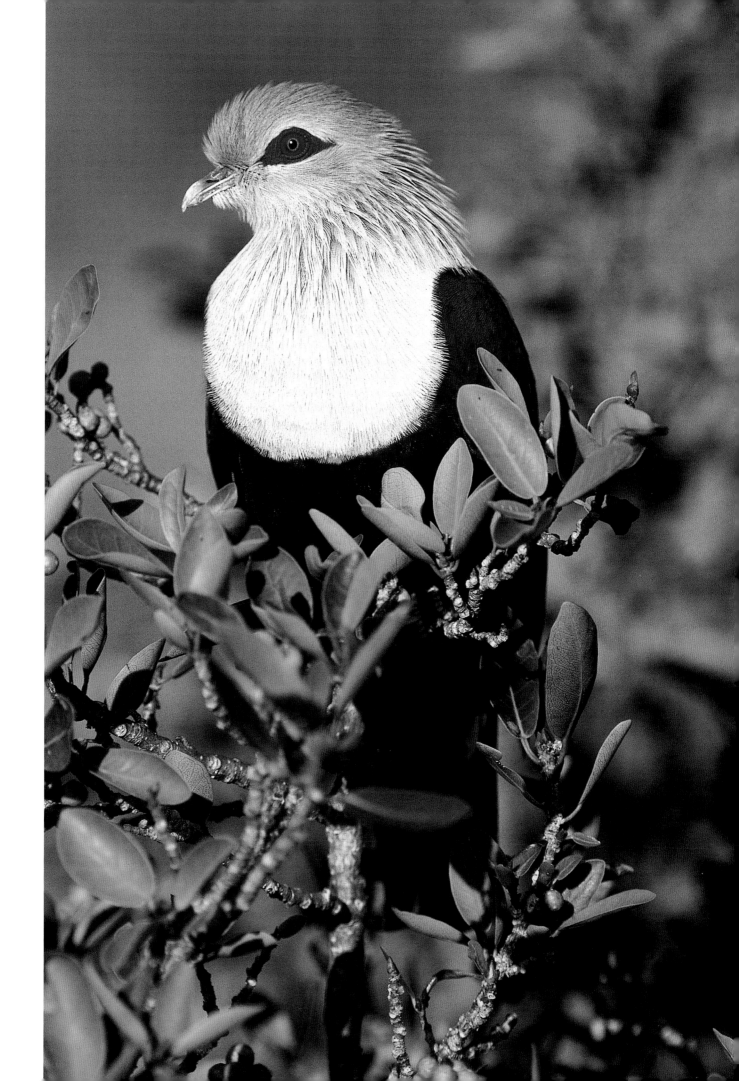

Personal Desalination Plants

From the imposing albatross to the tiny storm petrel, the members of the Order Procellariiformes all share a physical characteristic that gives them their other name of tubenoses. This refers to the two long horny tubes that sit on top of the bills of these birds. For a long time it was believed that these were the nostrils of these birds, whose sense of smell is acute. Nothing of the sort. For a start, their nostrils are inside their buccal cavity—if one of these birds were forced to keep its bill shut, it would suffocate. These tubes are involved in the removal of salt by the nasal glands. Life on the high seas requires, among other adaptations, the ability to survive without fresh water. Although sea birds do not quench their thirst by drinking salt water, they inevitably swallow it with their prey, as well as in the liquids the prey itself contains. They therefore must remove this excess salt, which is more than their kidneys are capable of handling. Therefore, they have salt glands inside the skull in front of the eyes. Their structure is similar to the kidneys of mammals: they consist of several parallel lobes, each containing thousands of microscopic tubes that absorb and excrete the salt contained in the bloodstream. They work intermittently, after salty food has been eaten, and excrete a highly concentrated liquid, which is expelled through the tubes in the bill. Birds then get rid of the liquid by vigorously shaking their heads. Many other birds that live at sea have salt glands, but only the tubenoses possess these strange horny structures, which give them their distinctive profile.

Pirates of the High Seas

The handsome frigate bird, whose anatomy does not allow it to dive in search of food, finds it more convenient to steal that of others. It shares this unpleasant habit with the jaeger, another great ocean flyer, and to a lesser extent with certain birds of prey. True acrobats of the air, frigate birds relentlessly chase birds whose stomachs are full, which they can spot precisely from their slightly slower flight. They jostle them in mid-air, sometimes grabbing the end of a wing, and do not let go of their victim until it releases its prey, whereupon they seize it with extraordinary dexterity. The poor birds thus molested will even regurgitate their food in order to be left in peace. Piracy is most profitable in the breeding season, when large numbers of birds congregate in a small area and constantly shuttle back and forth between the fishing grounds and their colonies, returning to the fold with abundant food for their chicks. In this season, many gulls also take up piracy, going so far as to bring their victims down in order to rob them.

These highly opportunistic birds adapt to all situations and develop many strategies to achieve their aims. They know how to bring to the surface worms and other organisms that burrow under sandbars, by treading on the sand at low tide. To enjoy the tender flesh of shellfish, they adopt another strategy: they carry them up aloft and drop them onto rocks to smash them open. They

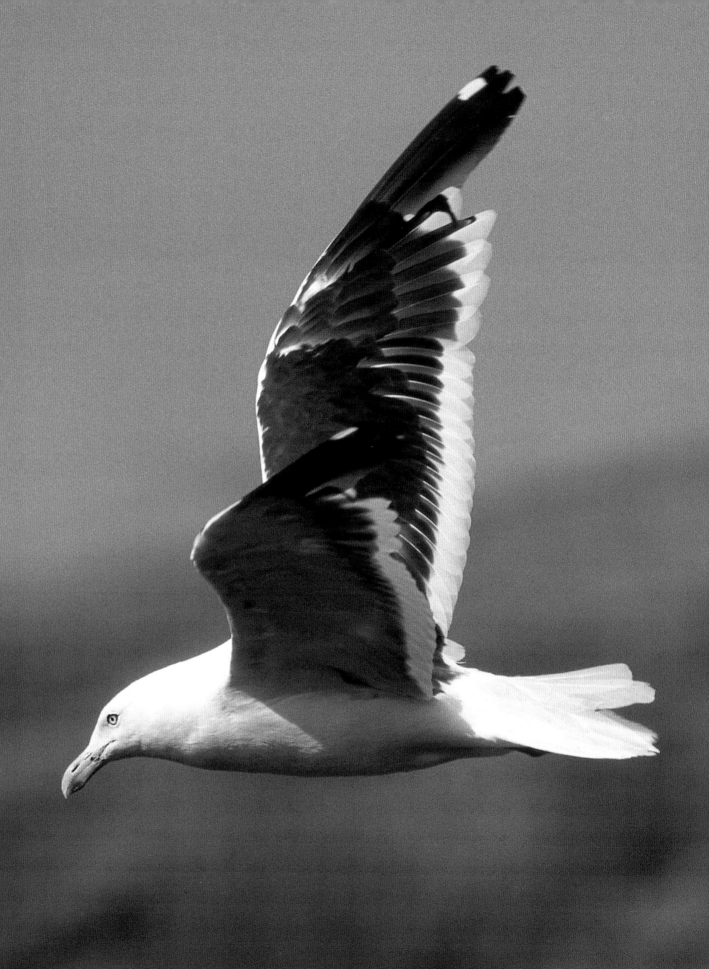

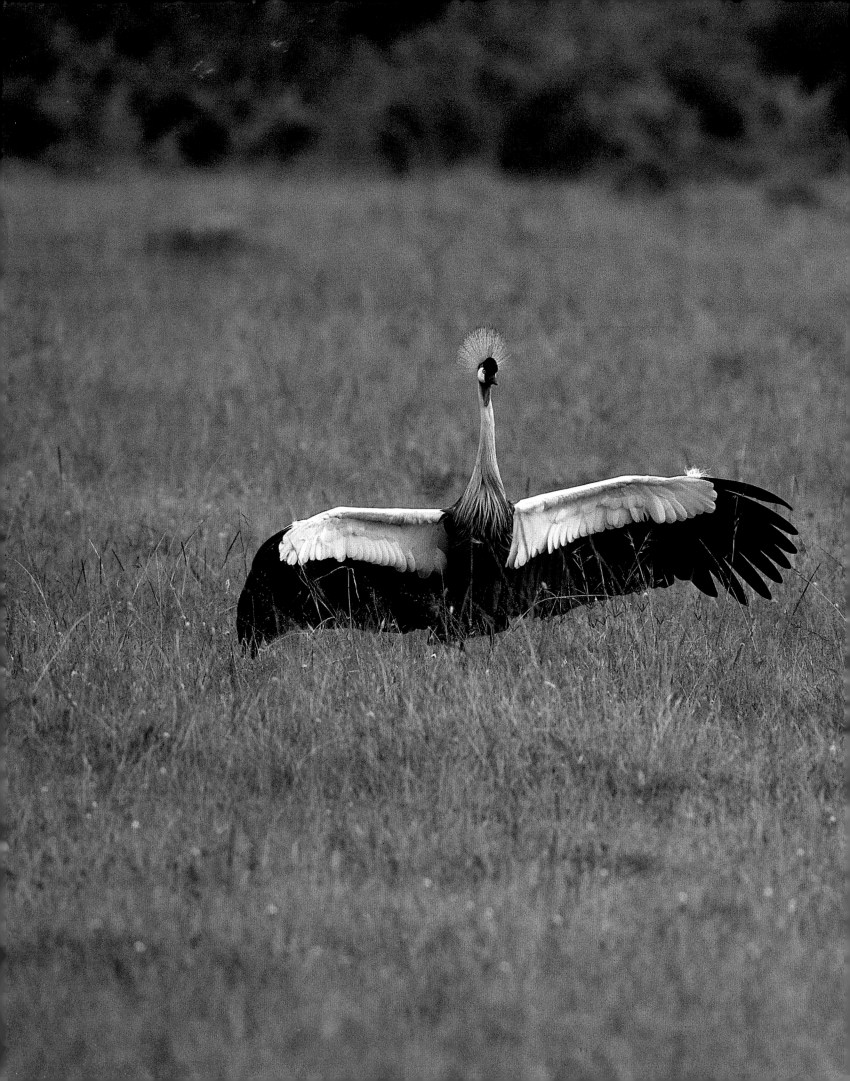

Opposite

Black crowned crane

Balearica pavonina

Masai Mara, Kenya

In a confrontation with an attacking jackal, the black crowned crane spreads its wings to frighten off the aggressor. After several fruitless attacks, the jackal will give up and leave.

267

Opposite

Northern right whale

Eubalaena glacialis

Puerto Pirámides, Argentina

This whale and airborne seabird illustrate the many interactions between species that can be observed where two zoologically rich elements meet. After removing mollusks and crustaceans from the whale's back, the bird will attack the mammal's newly exposed raw flesh.

Page 270

Razorbill

Alca torda

Lower St. Lawrence Islands, Quebec

This small auk's black back and white underparts are typical of seabirds. Several explanations have been suggested for this. One is that dark pigments reinforce feathers and protect them from the sun's ultraviolet rays. Another theory is that for birds that fly both in the air and under water, a black back is not easily visible from above, and a white belly is less obtrusive from beneath.

Page 271

Gray heron

Ardea cinerea

Brenne, France

Gray herons nest in colonies—heronries—high in tall trees, close to their fishing grounds. The oldest nests occupy the best places and are reserved for the oldest pairs of birds, whereas the new arrivals build on the outskirts. Built of branches, these enormous structures are also home to many other species that live in the "basement"—a fine example of peaceful cohabitation.

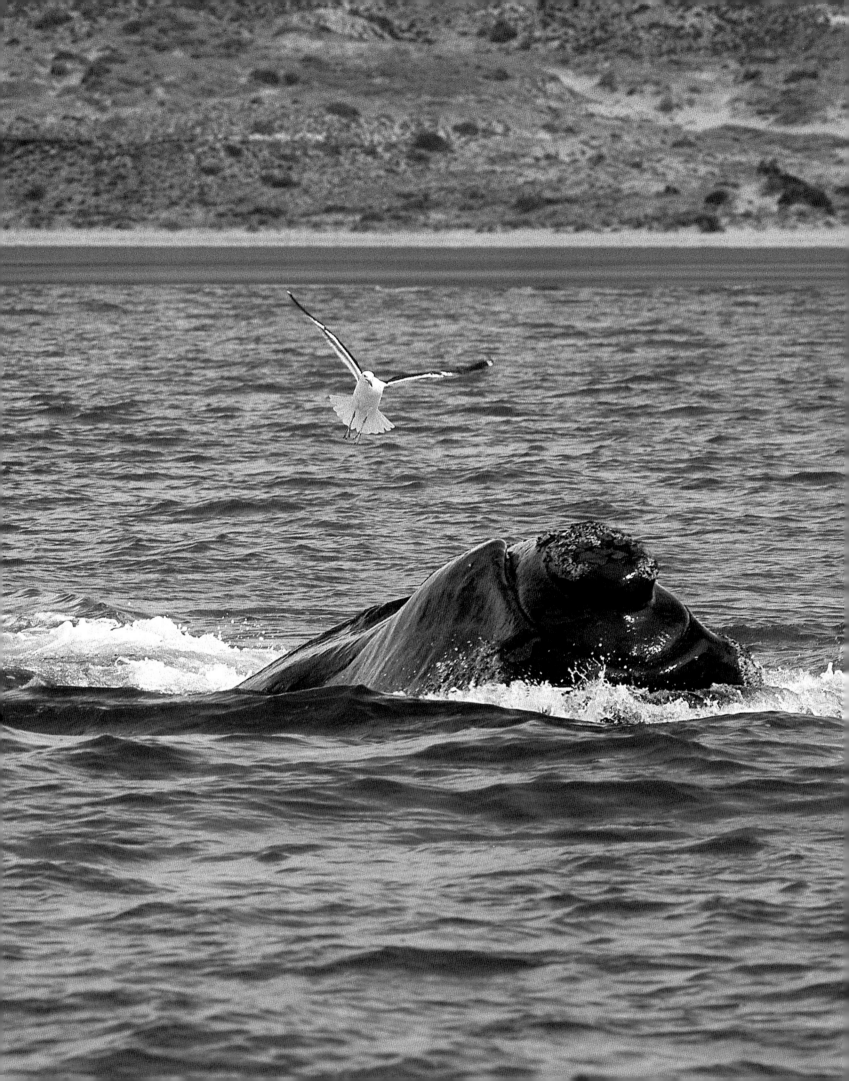

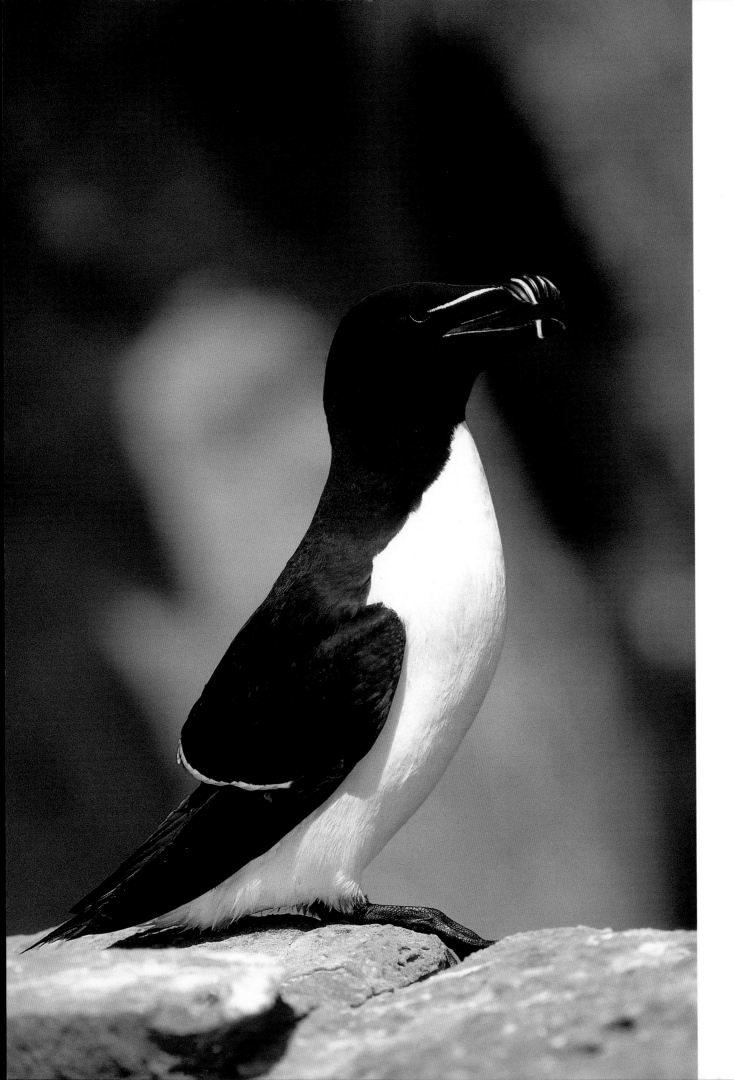

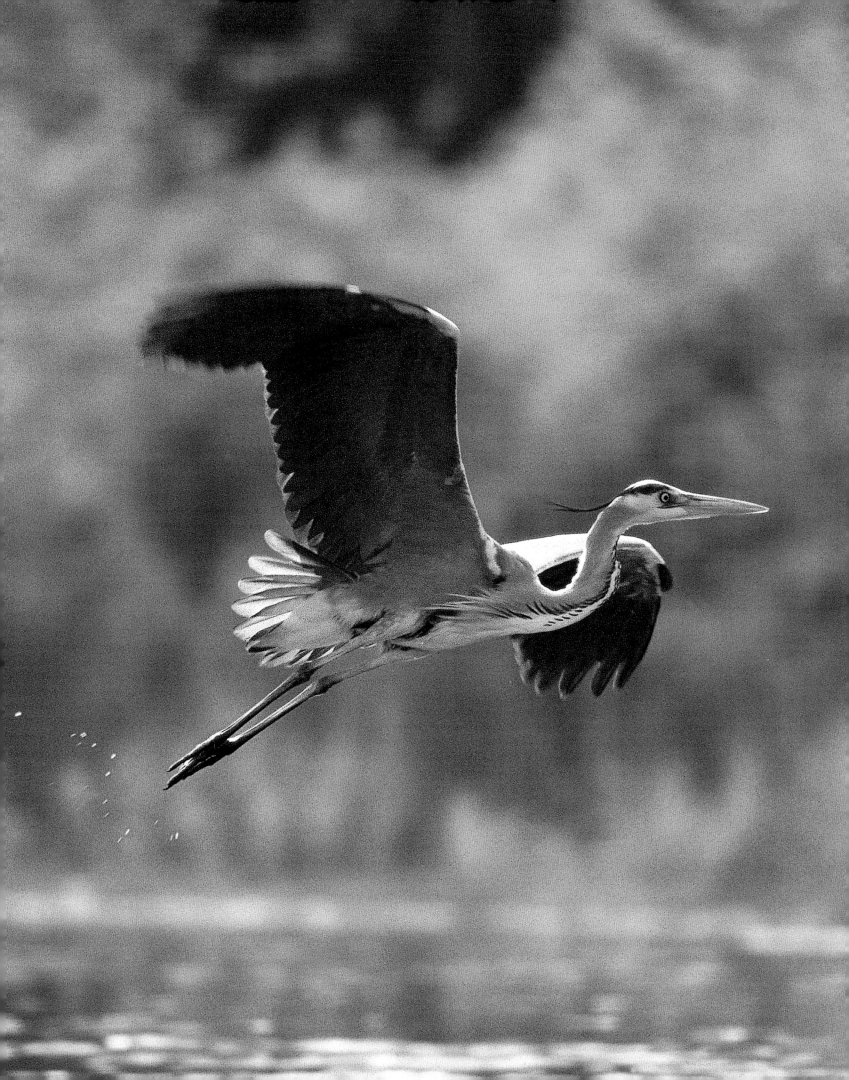

1. Egyptian vulture
2. Eurasian reed-warbler
3. Regent bowerbird
4. Atlantic puffin
5. Long-tailed cormorant
6. Yellow-billed oxpecker
7. Red-tailed black cockatoo
8. Green honeycreeper
9. Roseate spoonbill
10. Inca tern
11. Masked lapwing
12. Painted stork
13. Slaty-backed gull
14. Cape Barren goose
15. Helmeted curassow

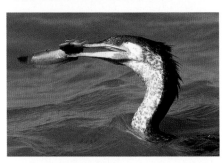

1	4
2	5
3	6

7	10	13
8	11	14
9	12	15

are also stubborn—if they fail, they repeat the operation until they succeed. This method is fairly widespread in the bird world. Song thrushes love snails. To extract the mollusks from their protective shells, the thrush drops them on rocky outcrops or holds them in its beak and strikes them on stones. Before swallowing them, however, they take care to wipe them on the grass several times to remove as much slime as possible. Vultures such as the lammergeier do the same with large mammal bones that they cannot break, dropping them on rocks until they smash. Their long tongue can then slide into the cracks in the bones to extract the succulent marrow. Small tortoises, which they also like, are treated the same way. But the Egyptian vulture has the most consummate technique. This small member of the family is inordinately fond of eggs, especially ostrich eggs. Although it can easily drop stolen eggs on the ground to break them, it cannot do this with ostrich eggs. For these, it takes the biggest stone it can find in its bill, and flings it against the shell with all its strength. If no stone is close by, it may travel up to three miles (five kilometers) to seek a suitable object, which it will bring back to strike the egg. Such resolve demonstrates both perseverance and true planning.

Using Tools: A Special Skill

The more our observations become clear, the longer the list becomes. Everyone knows of the redbacked shrike's habit of impaling its prey on sharp thorns in order to dismember it at leisure. Less well known is the fishing technique of the green heron, which uses a bait to attract fish. It plucks out a feather, or picks up any small shred of material, and drops it in the water. No fish can resist this temptation, and any fish in the vicinity immediately comes to inspect the tidbit. At once the heron spears and swallows it. If no prey approaches, it means there is none nearby; the heron retrieves its bait and tries its luck elsewhere. The hamerkop does not use a tool, but it proceeds in similar fashion. Spreading its wings wide into an umbrella shape, it produces an area of pleasant shade in the overheated waters where it fishes. Numerous small fishes collect in the shade, and the heron needs only to pick them up in its bill.

The best-known example of a bird that uses tools is the Galápagos finch. This small bird loves small wood-eating insects, as woodpeckers do, but is unable to catch them without a long retractile tongue. This does not stop it, however. The bird takes a cactus thorn, which must be slender, robust, and sharp, and probes cracks and gaps in the wood in search of its delicious prey. It holds its tool straight, as if it were an extension of its bill, and if it fails to impale an insect, it dislodges it and seizes it with its bill. This crafty finch has developed a third technique for extracting grubs from wood: it uses its needle as a lever, to bring its prey to the surface gradually. The ultimate refinement is that if the bird cannot find a suitable thorn, it makes one, by trimming a larger one to the right size. This ability to make suitable tools is found in only a tiny number of animals, which makes this small passerine a virtuoso of the animal kingdom.

Opposite

Macaroni penguin

Eudyptes chrysolophus

South Georgia Island, Antarctica

Penguins have developed a thick layer of subcutaneous fat to protect them from the cold. This complements their feathers, which lose some of their effectiveness under water.

Pages 276 and 277

White-throated kingfisher

Halcyon smyrnensis

Bharatpur, India

A lover of insects, frogs, and lizards, this kingfisher is equally fond of rodents. However, its long, daggerlike bill does not enable it to kill its prey instantly, so it stuns it by striking it on a branch and swallows it whole.

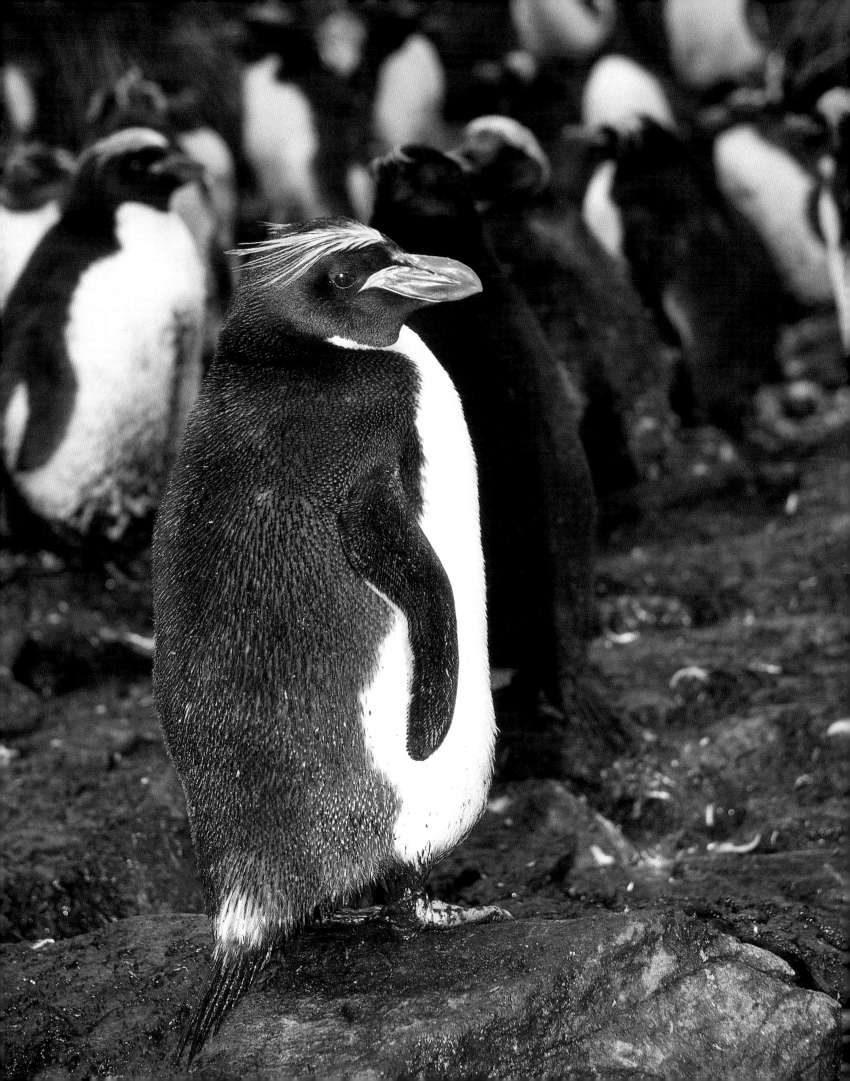

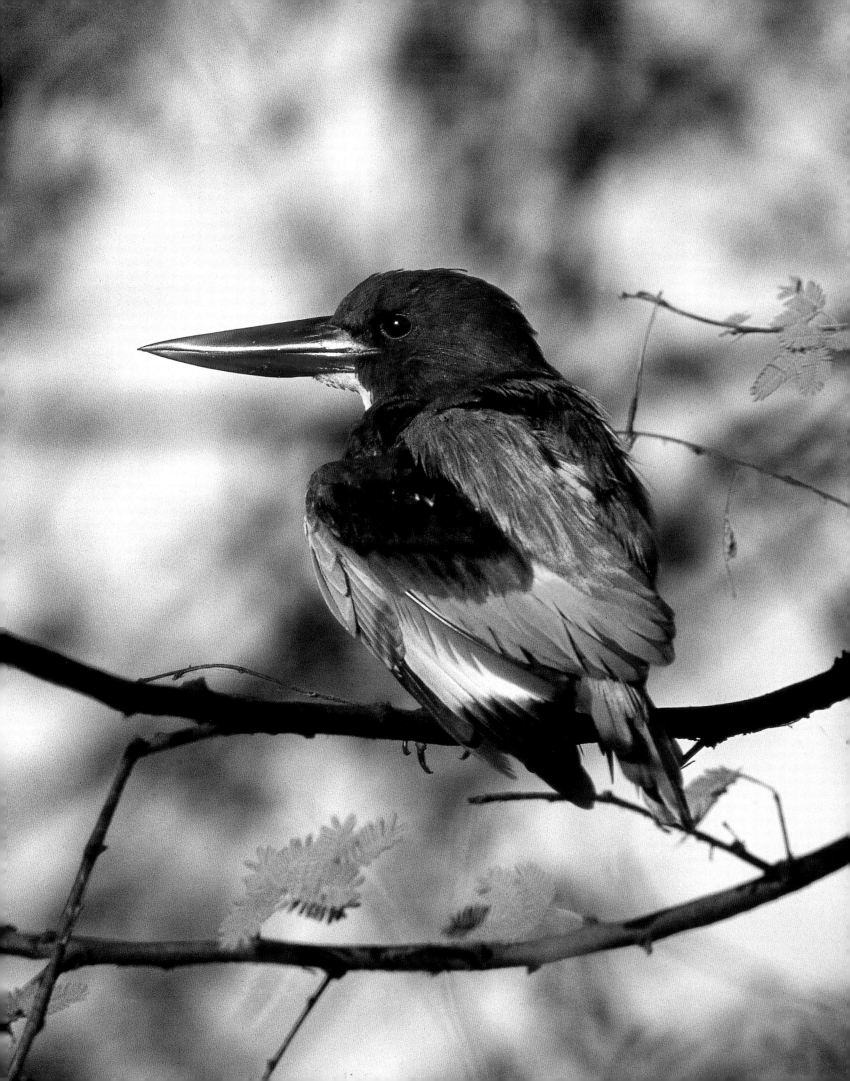

Winged Spies

The collared flycatcher raises only two broods in its short life. It therefore needs to be as efficient a parent as possible to ensure they are successful. This is why, before deciding on a nest site, it makes inquiries around the neighborhood, spying on the birds that live there already and inspecting their nests and their occupants. If these are sickly or poorly looked after, the visitor leaves at once in search of a more pleasant place. If, on the other hand, the broods look healthy and the chicks vigorous, it settles down to raise a family. This is a case of extreme caution, but the collared flycatcher is not the only species to take such care in choosing a suitable place to lay its eggs. Gulls and cormorants do the same, always preferring to nest close to robust, energetic neighbors.

How Parrots Avoid Stomachache

Earth-eating parrots are well known. Flocks of birds of different species congregate each morning along the steep banks of rivers or on cliffs where bare earth is exposed. They concentrate on a particular strip of earth, ignoring any other nearby, and eat it. Of course, many seed-eating birds swallow stones to help them grind food in their gizzards, but the earth the parrots eat is extremely fine and could not perform this task. It was long believed that this behavior provided them with essential minerals; however, the earth they are fond of contains smaller amounts of these than their staple vegetable diet. Many theories were exhaustively tested before it became apparent that the geophagy of these parrots compensated for their eating habits. They consume seeds and unripe fruit, whose richness in alkaloids and toxins renders them bitter and unpleasant to eat. The earth the parrots eat is rich in smectite, kaolin, and mica, which are highly absorbent and closely related to quinine and tannic acid. Laboratory experiments showed that the toxicity of the seeds they ate was reduced by 60 to 70 percent by the addition of the earth. Here lies the parrots' skill in adapting. In evolutionary terms, seeds and fruit have an interest in being eaten by animals only once they are ripe. Beforehand, seeds are not ready to sprout, and contain toxins to deter consumption by animals until they have matured on the tree. By counteracting the plants' toxic defenses, parrots can eat seeds and fruit before any other animal, thus getting ahead of the competition and increasing their chances of thriving when conditions become unfavorable. How the parrots identify the earth that contains such marvelous medicines remains to be established. Is it simply experience that teaches them how to relieve stomachache? This peculiarity makes parrots astonishing bird-doctors, able to treat themselves.

Opposite

Brown-eared bulbul

Hypsipetes amaurotis

Japan

Gregarious and noisy, this hyperactive bird colonizes all sorts of habitats, devouring berries, fruit, nectar-bearing flowers, and insects. It is not afraid of humans even at close quarters.

Page 280

Marbled frogmouth

Podargus ocellatus

Cape York, Australia

These large, owllike nightjars emerge at dusk and are masters of camouflage. They can remain motionless on a branch for hours on end, invisible both to predators and to their prey, on which they pounce with surprising speed.

Page 281

Red-legged seriema

Cariama cristata

South America

A strong runner but a feeble flyer, the seriema feeds on the ground, eating fruit and the small invertebrates it gathers here and there. Like the secretary bird, which it resembles in shape, the seriema's speed enables it to add lizards and snakes to its menu.

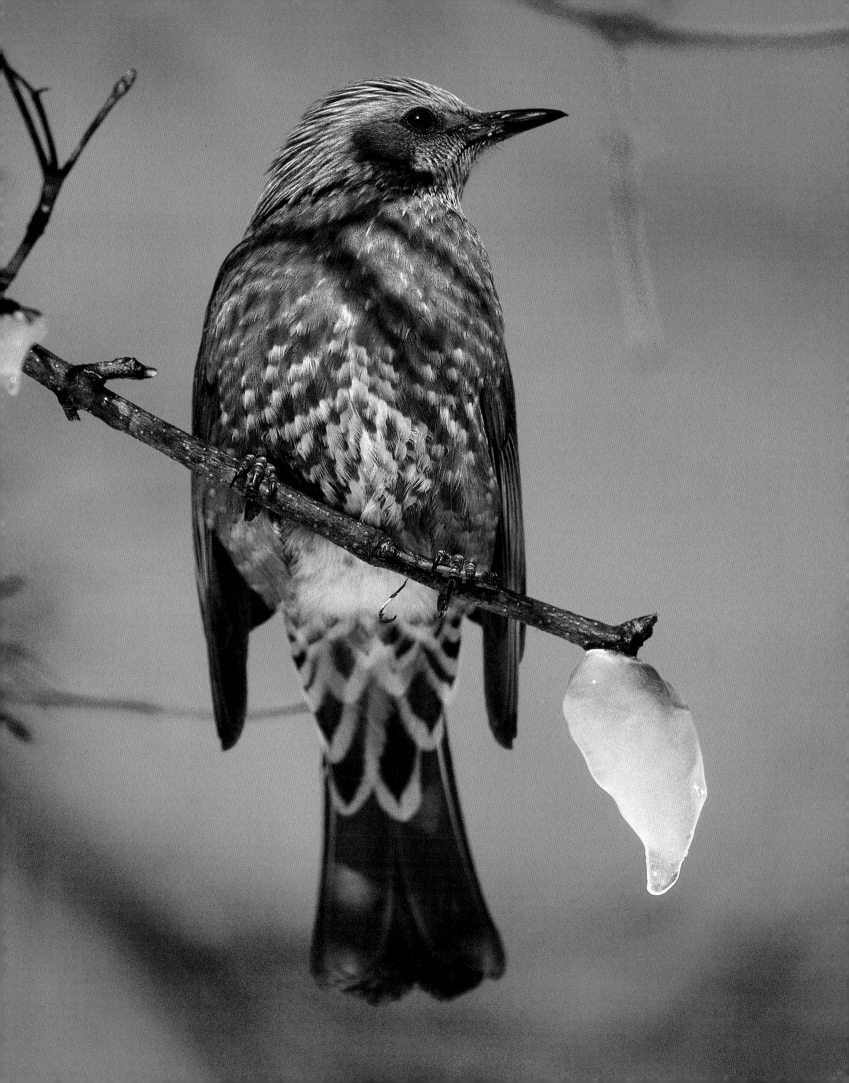

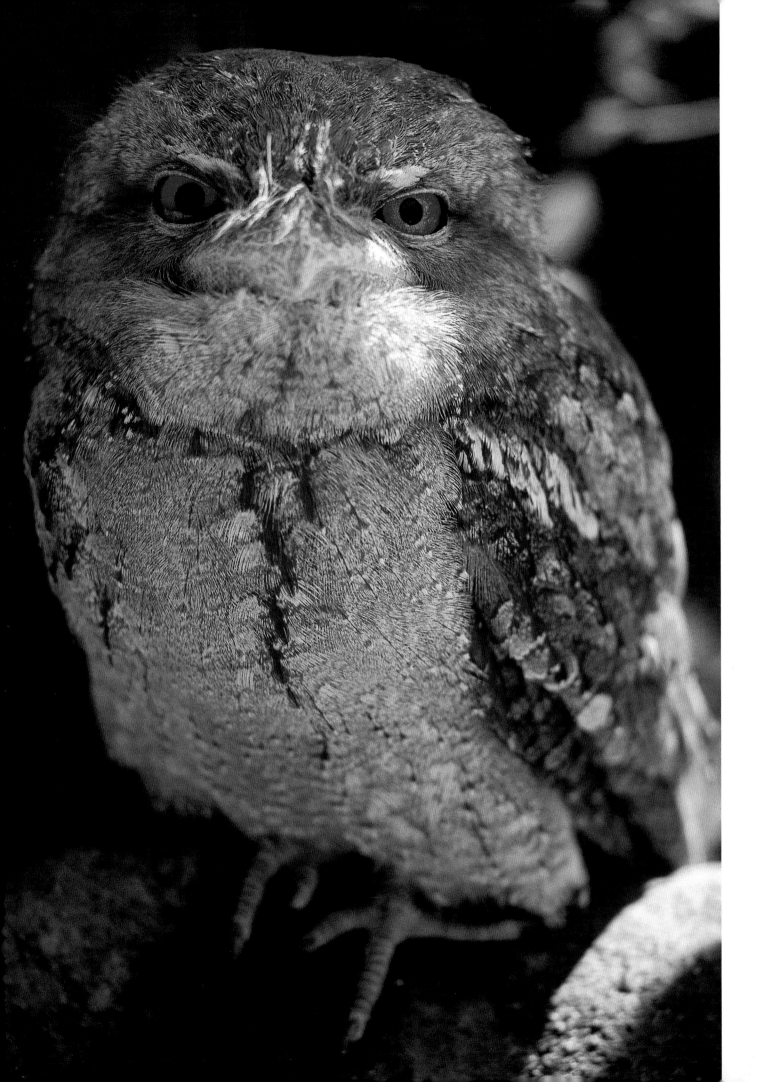

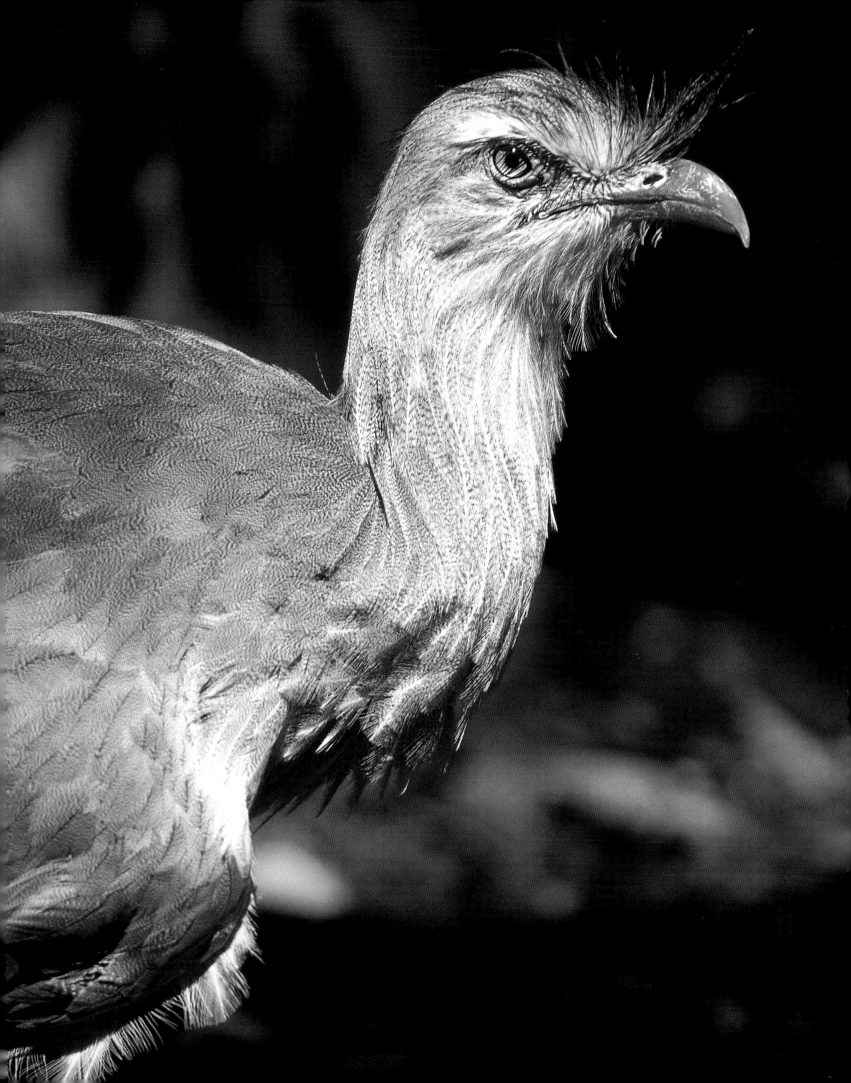

Talented Surgeons

Woodcocks—those unobtrusive woodland dwellers revered by hunters—are well known for their unique skills. No one would suspect that a small wader could be a specialist in trauma medicine and surgery, and yet there are countless stories that bear witness to this talent. Woodcocks are marvelously adept at reducing the leg fractures caused by hunters' lead shot. They fly to an area of wet clay and, using their pointed bills, apply small lumps of it to the wound. They pull up blades of grass and small roots to bind the fracture and cover it with more mud, which they carefully smooth. They only resume their normal activity when the dressing has dried, forming a plaster that can reduce the fracture. If they cannot find clay soil, woodcocks make plasters using feathers, which they pluck out of various parts of their bodies and carefully position with the shaft outward. Blood then coagulates between them, hardening the whole. In some cases woodcocks have been found that displayed nothing unusual outwardly but that, on closer inspection, revealed deep wounds to the body in places that were inaccessible to them. Despite this, they were dressed with astonishing care and skill. One Italian doctor described a bird that had been wounded in the chest, which had a supple and soft yet fairly substantial "felt" pad under its skin. Consisting of a mixture of down and various materials that even examination under the microscope failed to identify, the pad had been skillfully inserted under the skin and welded, as it were, to the wound with a whitish membrane. As well as protecting the wound, the dressing had a hemostatic effect, completely disinfecting it thanks to a drainage hole in its center.

It is a terrible pity that it was necessary to kill these lovely birds to discover their extraordinary abilities. For the majority—indeed, for all of them—the most evil being, the formidable predator that has wiped out many species, is man.

Opposite

Boat-billed heron

Cochlearius cochlearius

Chacahua Lagoons, Mexico

This inhabitant of mangrove swamps devours fish and amphibians. The boat-billed heron has a curious characteristic: its cry is similar to the croaks of the local frogs that are its staple diet.

Page 284

Red-backed shrike

Lanius collurio

Nestos Delta, Greece

Though it resembles a bird of prey in hunting technique and diet, the red-backed shrike has no such powerful bill. It makes up for this weakness by using thorn bushes, where it impales its victims in order to tear them to pieces at its leisure.

Page 285

Robin

Erithacus rubecula

Touraine, France

A small forest bird, the robin is also one of the most charming inhabitants of the garden. It is sometimes called the gardener's friend on account of the persistence with which it hovers around someone who is digging, boldly fluttering down to extract worms and snails.

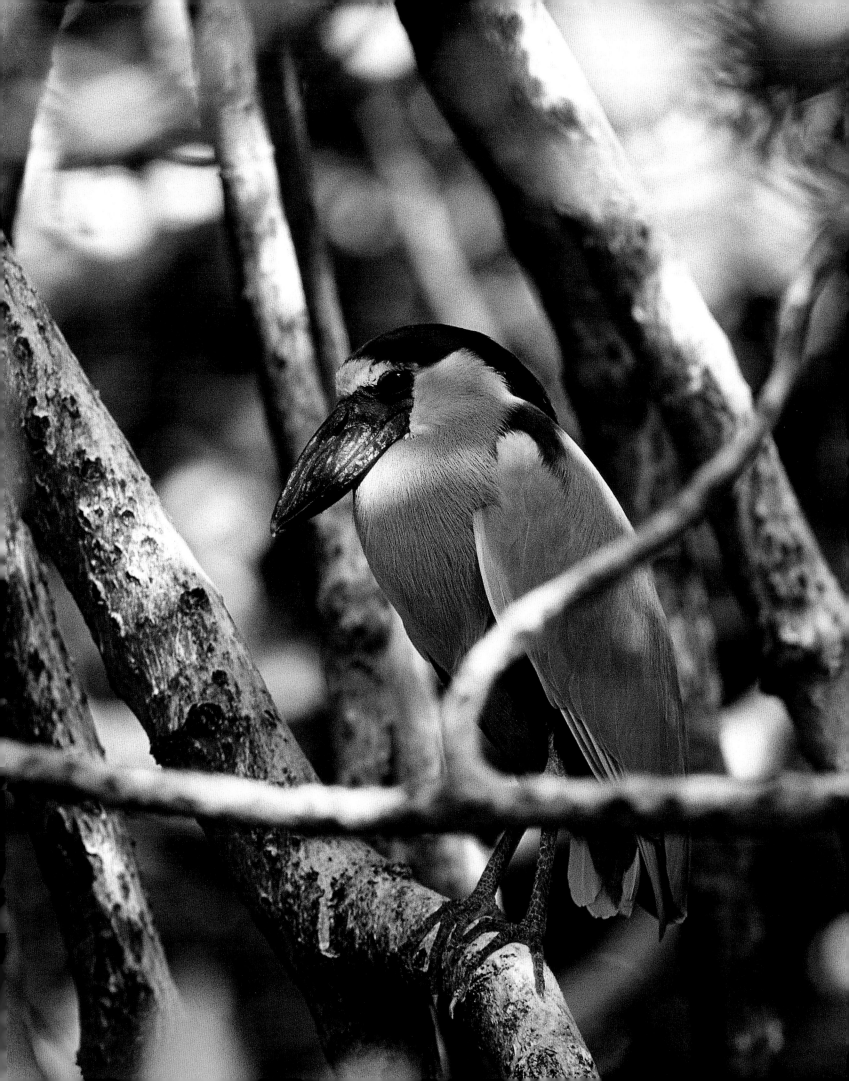

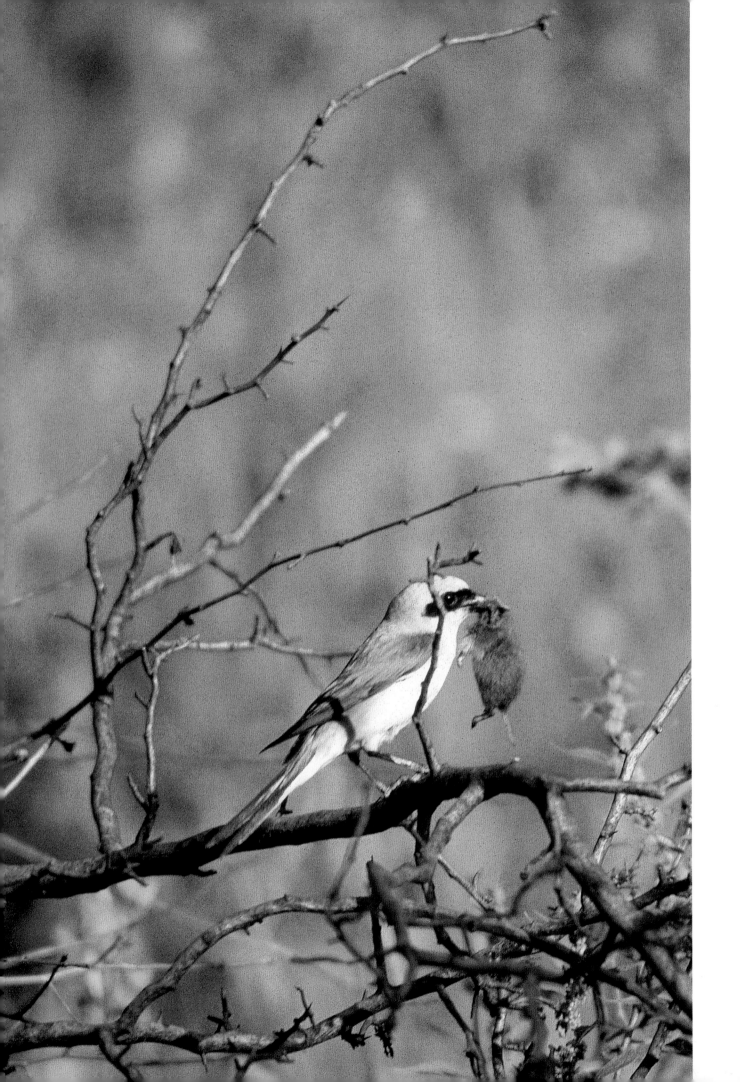

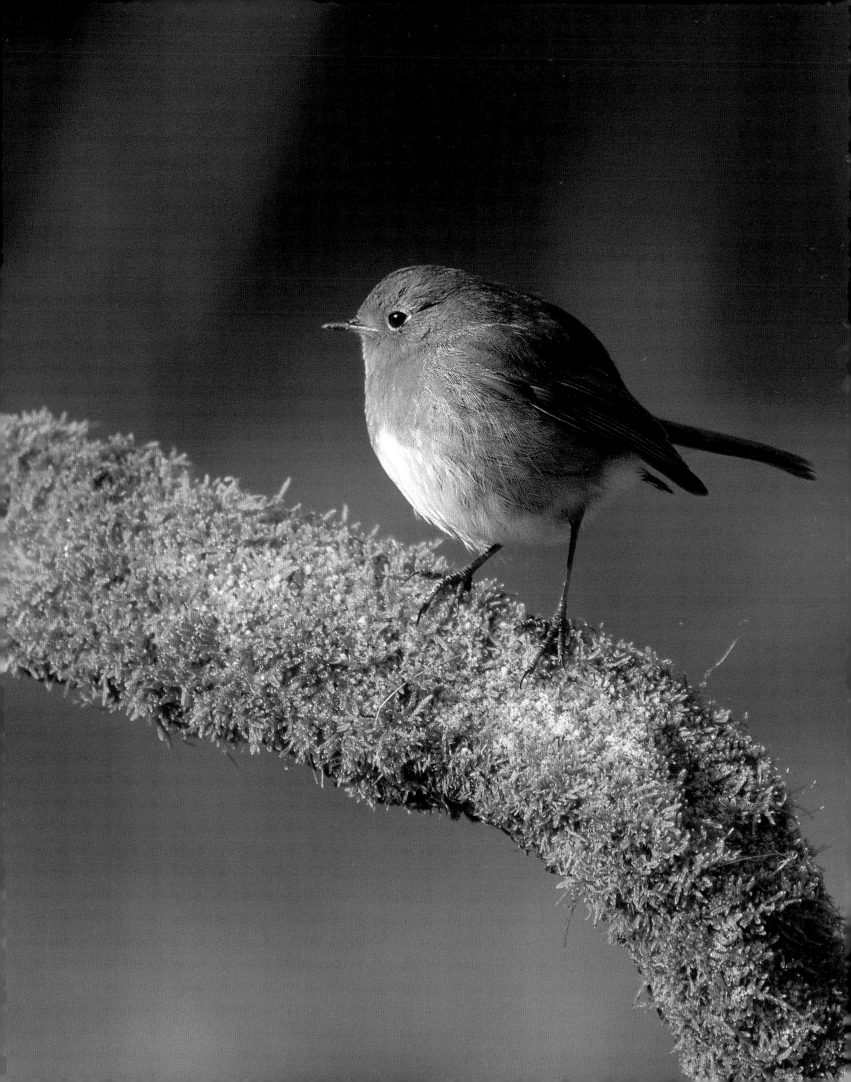

Greater blue-eared glossy starling

Lamprotornis chalybaeus

Masai Mara, Kenya

After pausing briefly on a thorn bush, the starling
takes flight, its wings making a distinctive sound.

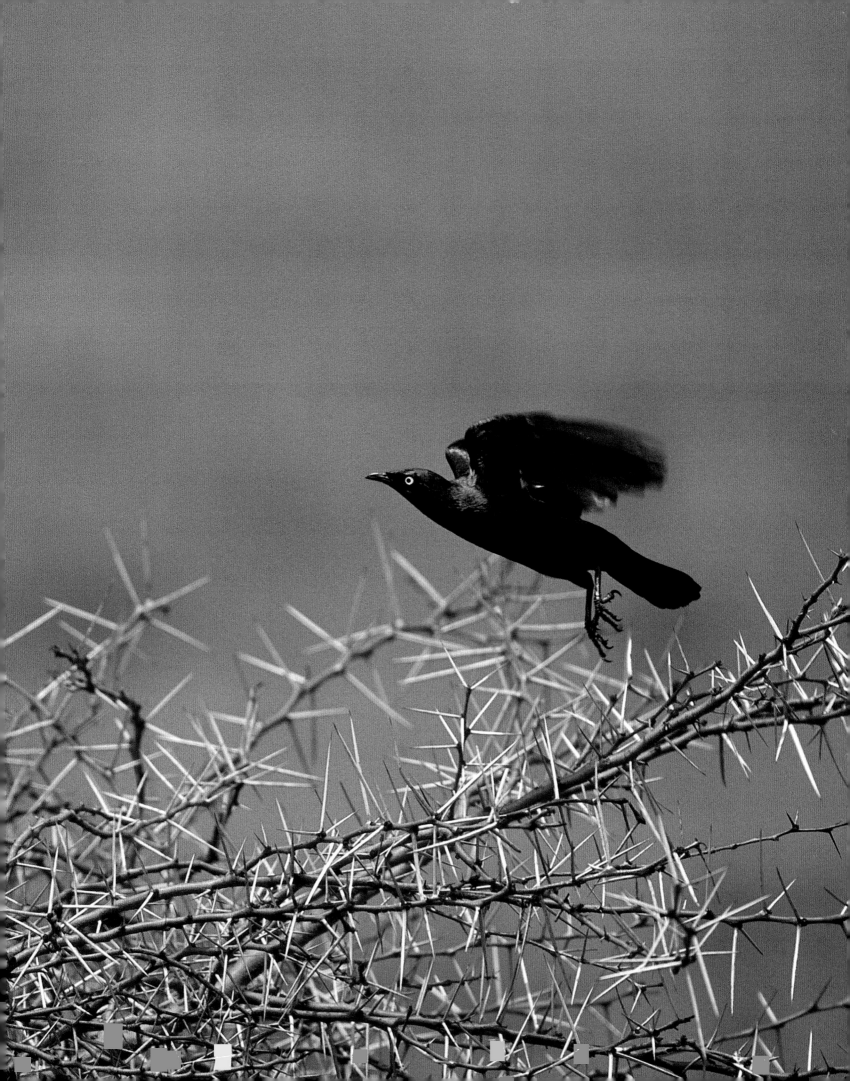

Bar-tailed godwit

Limosa lapponica

Banc d'Arguin, Mauritania

A favorite stopping place for seabirds, the extraordinarily lush Banc d'Arguin makes for a startling contrast to the barrenness of the surrounding Sahara desert.

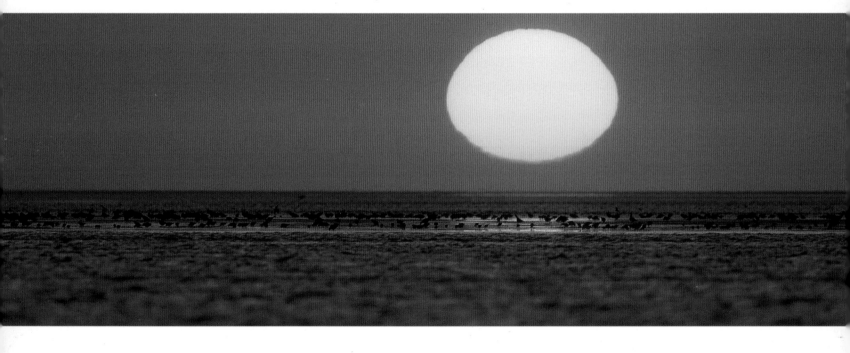

Opposite

Steller's sea eagle

Haliaeetus pelagicus

Hokkaido, Japan

Eagles generally hunt by gliding down from a height and snatching their prey in their claws. However, they do not disdain dead carcasses and readily direct their piracy at other fish-catching birds—a very easy way to get a meal for little effort.

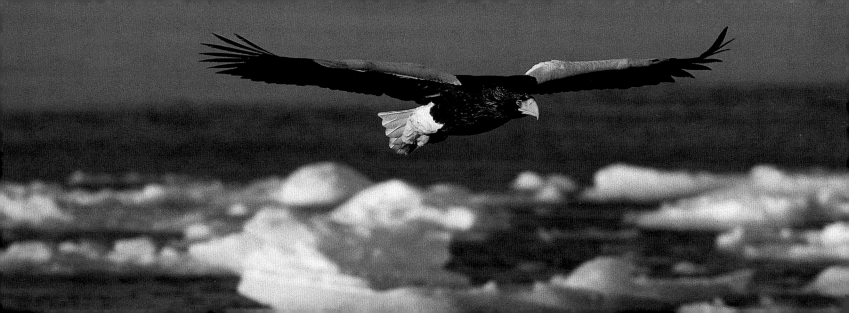

Of Birds and Men

Opposite

Barn owl

Tyto alba

Berry, France

This marvelous bird has always had a very poor reputation in some parts of the world, where it was thought to herald death. To keep death at bay, and to preserve livestock, it used to be the custom to nail the still-living bird to barn doors. Its appetite for rodents and insects actually makes the barn owl a precious ally, and fortunately today it is protected.

Pages 292 and 293

Sooty tern

Sterna fuscata

Farquhar Islands, Seychelles

Each breeding season, the people of the Farquhar Islands gather and eat eggs from the nests of the sooty tern. Although this activity is unregulated, it does not endanger the survival of the birds' vast colony.

Pollution: oil slicks, cyanide, heavy metals. Deforestation: no more shelter, no more nests, no more woodland cover. Agriculture: insecticides, pesticides, herbicides. Hunting: lead, broken wings, traps. The list of ills that man has inflicted on birds is terrible and long. Equally long is the catalogue of damage man has caused: sterility, deformities, disease, and extinction.

To their great cost, birds have always aroused human greed. Too tasty for their own good, many game birds survive only because they are artificially reared—to be shot. Too majestic, the great raptors have paid a heavy price to humans who, not content with merely admiring them, envy them. Too mysterious, nocturnal birds have long fueled superstition and needed to be destroyed to allay our fears. Too enchanting, exotic birds with splendid colors have been much prized by feather traders and others in the world of fashion who, to dress fashionable women, have not hesitated to strip the forests of their living jewels. Too good at singing, some birds are caged, so that they can brighten the icy loneliness of our urban lives with their tuneful song.

The common history of men and birds is as long and rich as that of humanity itself. There is no civilization that has not deified some species of bird, from the sacred ibis of the ancient Egyptians to the bald eagle that graces the powerful dollar, symbol of North American culture. Pursued, destroyed, made into martyrs as often as they have been regarded as sacred, birds contribute to myth according to the role that falls to them, whether of good omen or evil. Let us hope that reason will prevail over superstition, and teach us to see birds for what they are: simply wonderful living things.

It is generally agreed that primitive hunter–gatherer societies or early farmers lived in harmony with nature, in a state of ecological balance. Modern man, on the contrary, appears to be the great predator, responsible for the extinction of many species. However, if we study the bird life of isolated islands, we are forced to conclude that this is far from the case. Traditional societies did not wait for Westerners to arrive before they started destroying natural habitats and the birds that lived there. Field studies have suggested that more than a third of the bird species of Oceania disappeared with the arrival of the first humans, either as a result of hunting and egg gathering or because of habitat destruction. Moreover, the available figures are conservative. The remains of vanished species are so faint that it is almost impossible to list them properly.

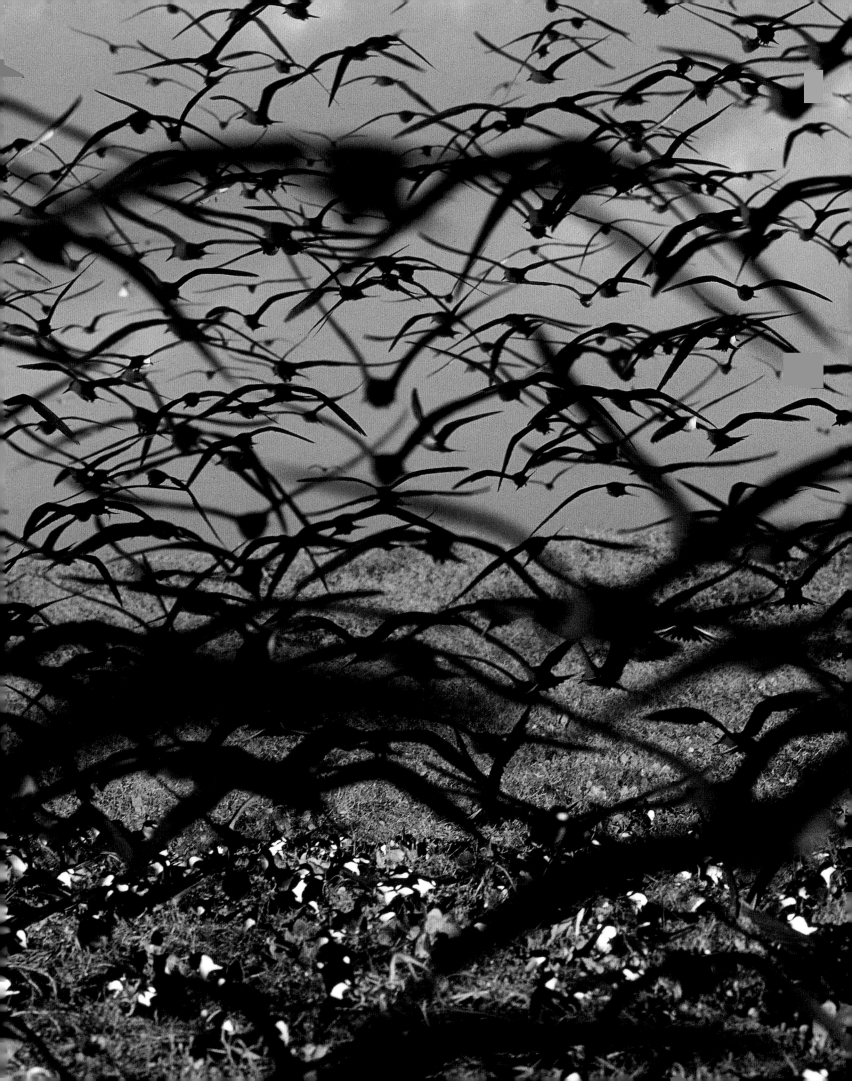

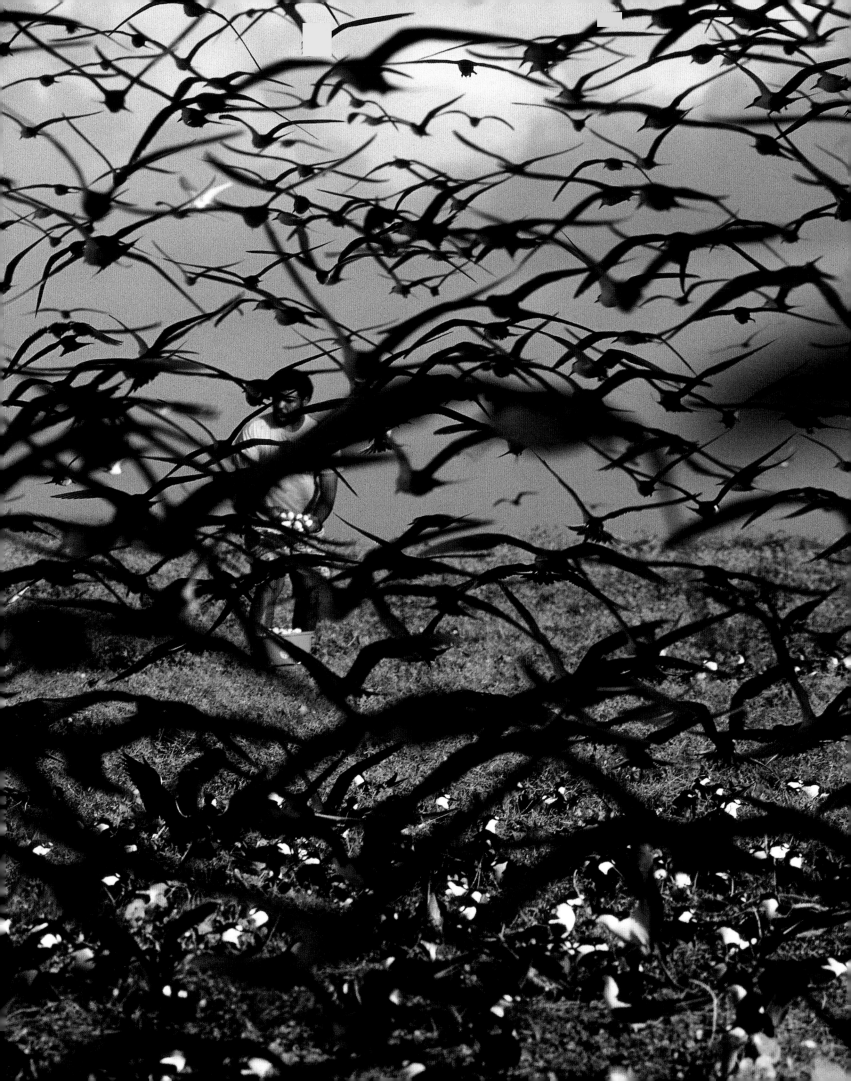

Disruptive Changes

Humans and birds have always competed for living space, for their interests have always conflicted. The first to suffer were large birds, for these need a lot of space to live and need to be undisturbed to breed. The draining of marshes and wetlands, which are so important to bird life, has deprived ducks and waders of many feeding and breeding sites, leading them to extinction in many regions. Deforestation has done the same to a wide range of woodland birds. Although in some regions the forest cover is now higher than it was during the last century, men and birds do not share the same values. Humans have a quantitative view of things, classing as "forests" both beautiful, rich woodlands and sterile plantations consisting of only one tree species, destined to produce paper or telegraph poles. Birds do not operate in quantitative terms. A woods consisting of ten different tree species offers a greater variety of cover and food sources as an identical area of single-species plantation. The changes in farming practices that led to thousands of hedges being bulldozed irreversibly destroyed the habitat of vast numbers of song birds, and exposed to wind erosion the perfectly flat surfaces of fields that stretch as far as the eye can see. On top of this, mechanization of farming and straw-burning have left no chance of survival to the game birds that nest there. If we bear in mind that a migratory bird may get its bearings from a bush where it likes to rest on each journey, always stopping at the same places during its long voyage, we can imagine the disruption caused by such habitat destruction.

The New Urban Forests

Although the physical characteristics of species change slowly, the same is not true of their behavior. Fortunately, some birds can adapt to altered environmental conditions just as fast as cities expand. The most opportunistic species can easily adjust to new situations. In our latitudes, corvids, pigeons, and gulls are extremely good at this, as are house sparrows and starlings. Cities offer two opportunities for adaptable species. The most obvious is the abundance of shelter and nesting places for cliff-nesting birds, in the form of the artificial ledges and cliffs of buildings and windows. This explains the hordes of pigeons that live in cities. Descended from the rock dove, which nests on cliffs, they have no difficulty in adapting to the verticality of cities. The second advantage is the warmth produced by the urban environment. Bricks and concrete store up the heat generated by road traffic, human activity, and central heating, releasing it at night. Temperatures are 10 °F (5 °C) higher in the city center than in the suburbs—enough to allow birds such as starlings, which were once rare, to colonize urban centers at least to seek roosting places. Moreover, the city is free of hunters, which allows game birds such as pigeons to become very tame in urban settings. Woodpigeons, cousins of the rock dove, began to colonize city centers in the early twentieth century. Nesting in trees, they gradually changed their behavior, using fewer and fewer twigs and replacing them with paper and other urban debris as building materials. This change of habits allowed them to spread throughout the city. However, the abundance of

Opposite
Andean condor
Vultur gryphus
Peru

This bird of prey—one of the world's largest—is the protagonist in ritual Peruvian festivals, in which it is first made drunk on locally brewed liquor and then tied to a bull's back. Such bloody combats make a festive occasion for the local people.

Pages 296 and 297
Bald eagle
Haliaeetus leucocephalus
North America

With its pronounced eyebrows giving it sharp-looking gaze, the bald eagle has always been a symbol of the United States. The thunderbird of the Native Americans, source of life on earth and protector of humanity, is an earlier emblem of the Americas.

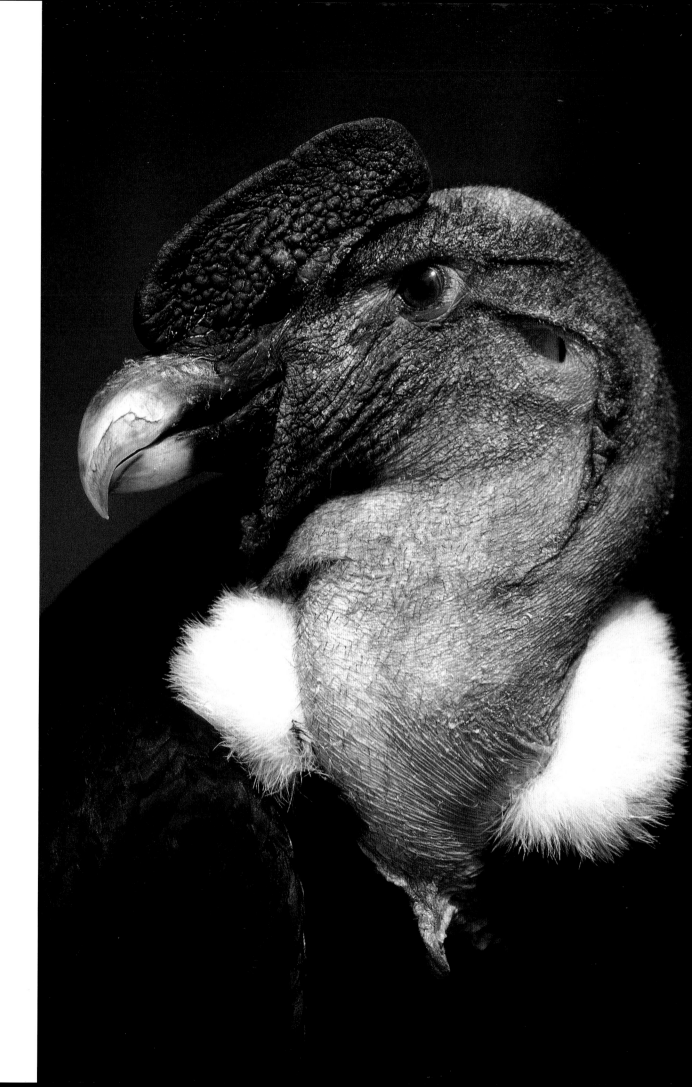

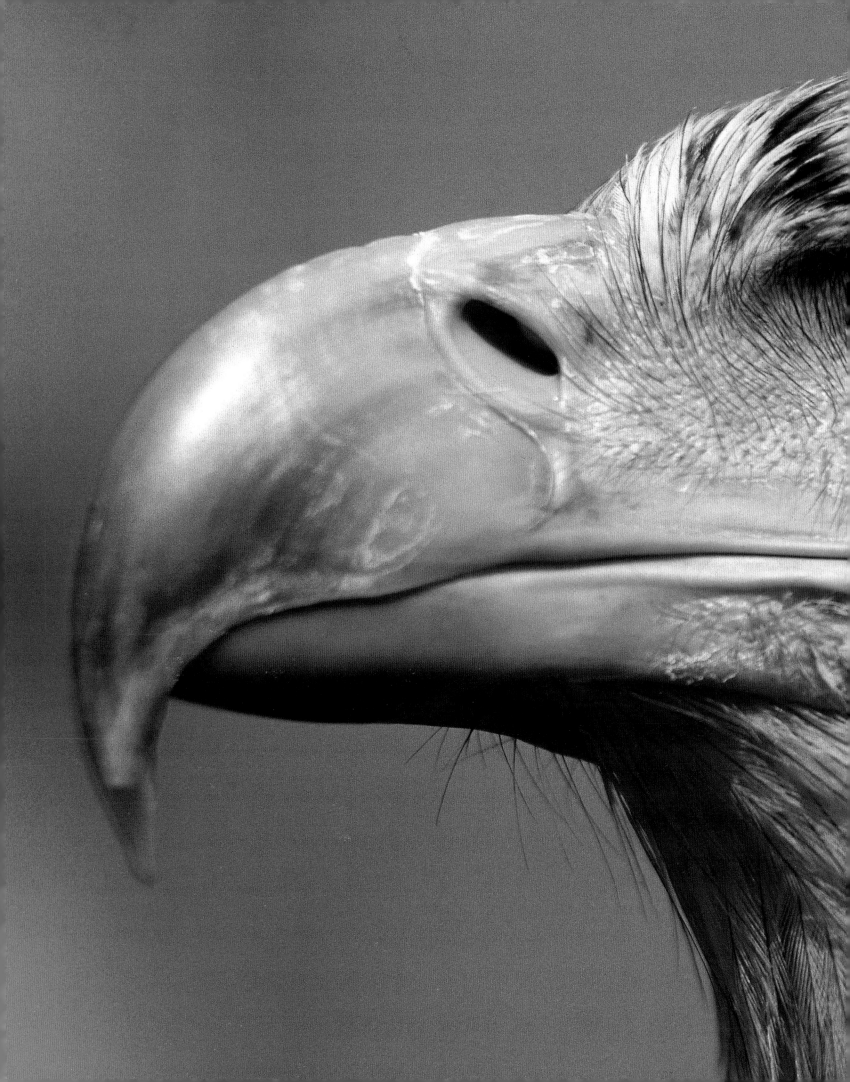

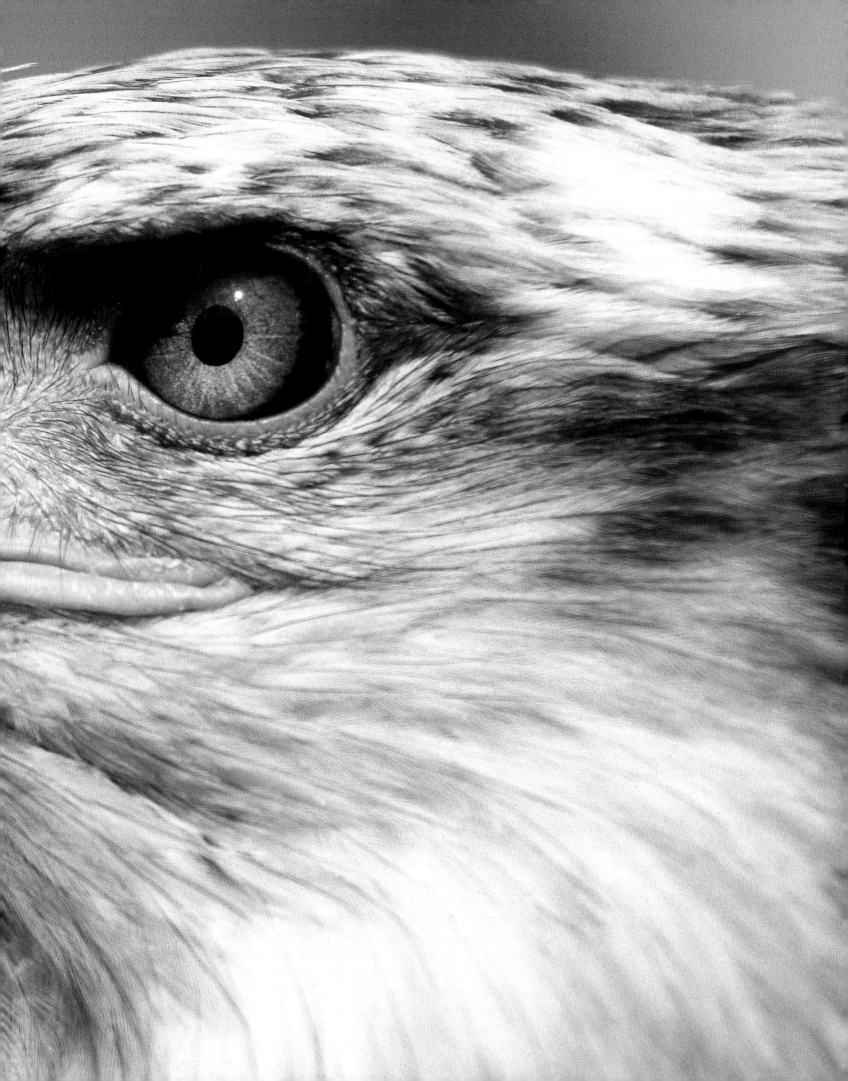

unsuspecting prey attracted predators, such as the kestrel and the tawny owl, which alternate, one hunting by day, the other by night. They have certainly had to change their eating habits: the kestrel, which is fond of invertebrates, has acquired an interest in birds, while the owl, whose diet in its natural habitat consists of 90 percent small mammals and just 10 percent birds, has also had to switch its dietary preferences. More inflexible in its habits, its cousin the barn owl has never succeeded in colonizing cities and is declining everywhere, even in the countryside.

Birds in the Service of Humans

In order better to take possession of birds, as of all things in nature, humans have domesticated them. The first attempts to do this are lost in the distant past, but the common history of birds and humans has involved the domestication of various species over the centuries. As early as 3000 B.C., the ancient Egyptians appreciated pigeons both as food and as messengers. They also noticed that wild geese that had stuffed themselves with food before leaving on migration were delicious—the Egyptians are responsible for elevating the goose to the high culinary status it still enjoys today. On all continents, wild birds have been domesticated for food: chickens in India, the guinea fowl in Africa, the turkey in North America, the Barbary duck in South America, and the goose and pigeon, which migrate between Africa and Europe. Although breeds raised for food are very different from their wild ancestors, those kept for their appearance have often remained close to the original race—for example, peacocks, ornamental pheasants and ducks, and swans. However, some have been altered so profoundly that they cannot survive without human help, such as the short-faced tumbler pigeon, which is incapable of feeding its young. Some other domestic races are so overdeveloped in certain physical characteristics that they are incapable of moving about easily. As for the innumerable types of cage and aviary birds, these have been chosen either for their beauty of their plumage or for their song. They range over an infinite palette of colors—true living jewels which, sadly, we like to admire behind the bars of a gilded cage.

Birds for Pleasure, Hunting, Sport, and Passion

Once their bellies were full, humans soon turned to the pleasures of the mind, for which they exploited the capacities of certain birds that fascinated them. Anyone who has watched a bird of prey hunting cannot but be humbled by its extraordinary mastery. As the poet Will Carleton put it in 1911: "'But you were never made, as I, /on the wings of wind to fly,' said the eagle."

Very early on, humans had the idea of using these birds' prodigious hunting abilities. This collaboration originated in Asia, thousands of years ago. Introduced to France under the Merovingian kings, falconry became over the centuries a highly sophisticated and codified art, practiced in all the courts of Europe. The Crusades allowed the Frankish knights to learn from the Saracens their

Opposite

Rock painting of flightless birds

Quinkan site

Cape York, Australia

Dating from 14,000 years ago, this painting adorns the walls of a cave sacred to Aborigines. These age-old depictions were used in magic rites meant to bring abundant reproduction in the species portrayed.

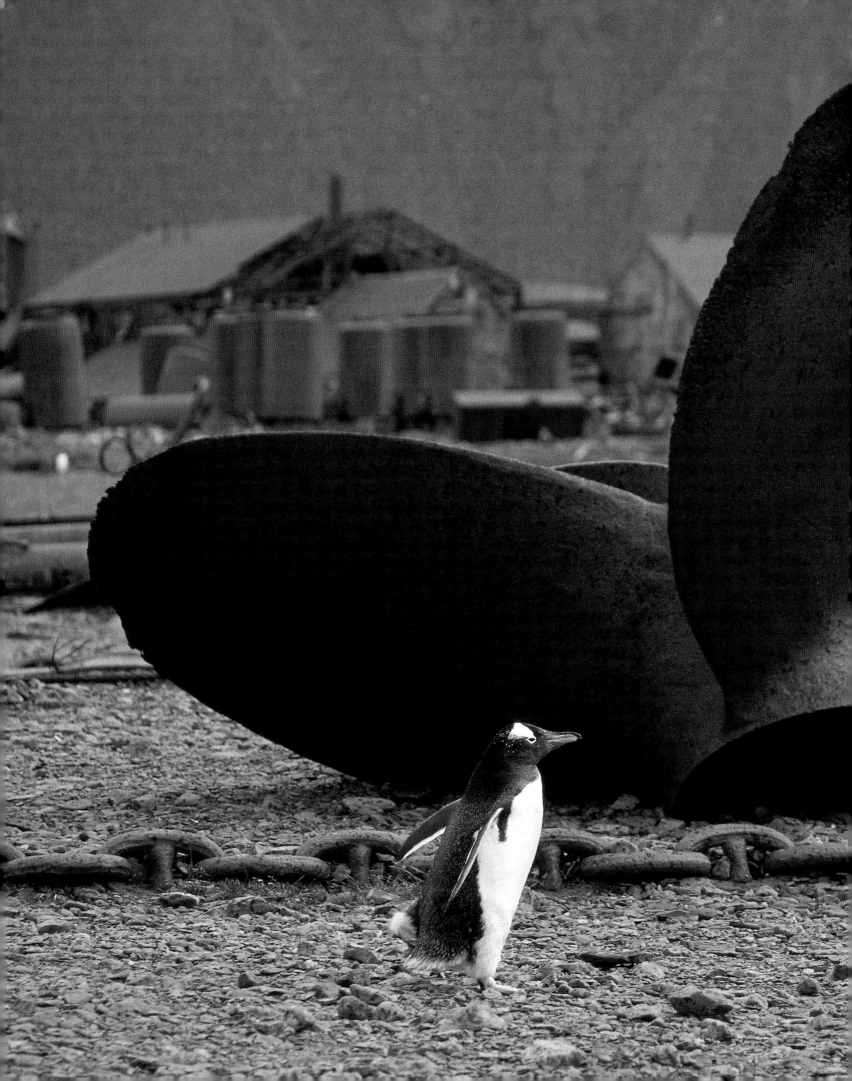

Opposite

Gentoo penguin

Pygoscelis papua

South Georgia Island, Antarctica

Penguins are the new occupants of this old whaling port, which during the last century was occupied by Norwegian whaling companies.

Page 302

Alexandrine parakeet

Psittacula eupatria

Nepal

Man's age-old fascination with birds, seen here in this child's astonished gaze, has always led to their captivity.

Page 303

Black parrot

Coracopsis nigra

Praslin Island, Seychelles

Endemic to the Vallée de Mai National Park on Praslin Island, the black parrot and the Maldive coconut tree in which it nests are both endangered species. Biologists are trying to save this bird by placing nest boxes in other trees.

extremely refined methods of training high-flying birds such as falcons, which can pursue their prey in the open and capture it by stooping, or making a high-powered high dive—in the case of the peregrine falcon, at speeds of up to 125 miles (200 kilometers) per hour. Low-flying birds of prey, such as the goshawk and sparrowhawk, are trained to pursue prey across fields and hedges.

Less noble is the cruel pastime of cockfighting, which was practiced by the ancient Greeks and Romans, and is very popular in Asia. These contests rely on the naturally pugnacious nature of these birds in the breeding season, and are also highly codified, although forbidden in most European countries. The birds, which are extremely pampered until the time comes for them to fight, are armed with steel spurs on their legs: daggers sharp enough to pierce an opponent to the heart. The tips of their feathers are sharpened to a point so that a blow with a wing can blind an adversary. Large bets are placed on the birds, which undergo quasimagical rituals and are fed secret preparations before contests, which are supposed to ensure victory.

Much more peaceful are pigeon races, which achieved notoriety during the two world wars. The races are based on pigeons' ability to return to the nest as soon as possible. It is quite normal for the birds to maintain speeds of almost 60 miles (95 kilometers) per hour over distances of between 310 and 620 miles (500 and 1,000 kilometers), and there have been cases of birds covering 186 miles (300 kilometers) at 97 miles (156 kilometers) per hour.

In Asia, some fishermen exploit the remarkable diving ability of cormorants. The birds are trained from a very young age to fish for their master, obeying his gestures and vocal commands, such as "Dive," "Fetch," "Come back," "Left," "Right," and so forth. Each bird lives in close companionship with its master, obeying no one else and even fiercely biting any intruder. If the pair are separated, the bird may even die of starvation. This collaboration lasts some fifteen years, until the bird has become too old to be productive, whereupon a highly ritualized separation takes place. After a banquet of fish, the bird is fed alcohol and rice and dies peacefully. Its body, wrapped in rice straw, is then buried with due ceremony.

Opposite

Golden eagle

Aquila chrysaetos

France

The eagle has always been a symbol of power, glory, and genius: the Romans dedicated the bird to Jupiter, and many emperors, most famously Charlemagne and Napoleon, made it their emblem.

Feathers Full of Talent

Independently of birds, certain types of feather have played an important role in human history. The goose quill is a symbol of the art of writing, to which it has made a considerable contribution. Cut into a point and dipped in ink, it has been a faithful friend to writers throughout history, and to scribes of all religions. On the American continent, the earliest example of writing was discovered recently in Mexico. The small clay cylinder, dating from 650 B.C., bears an engraved declaration of allegiance to the king: a line shaped like a bird's bill links the inscriptions. A timeless voice for this messenger of the dawn.

It is to another member of the duck family that we owe an essential item of our home comforts: the down comforter, or duvet. Lacking brood patches, ducks and geese pluck out their breast feathers, with which they line their nests before they lay their eggs. The eider, an impressive sea duck, has down so fine and abundant that humans soon got their hands on it. The male sports a

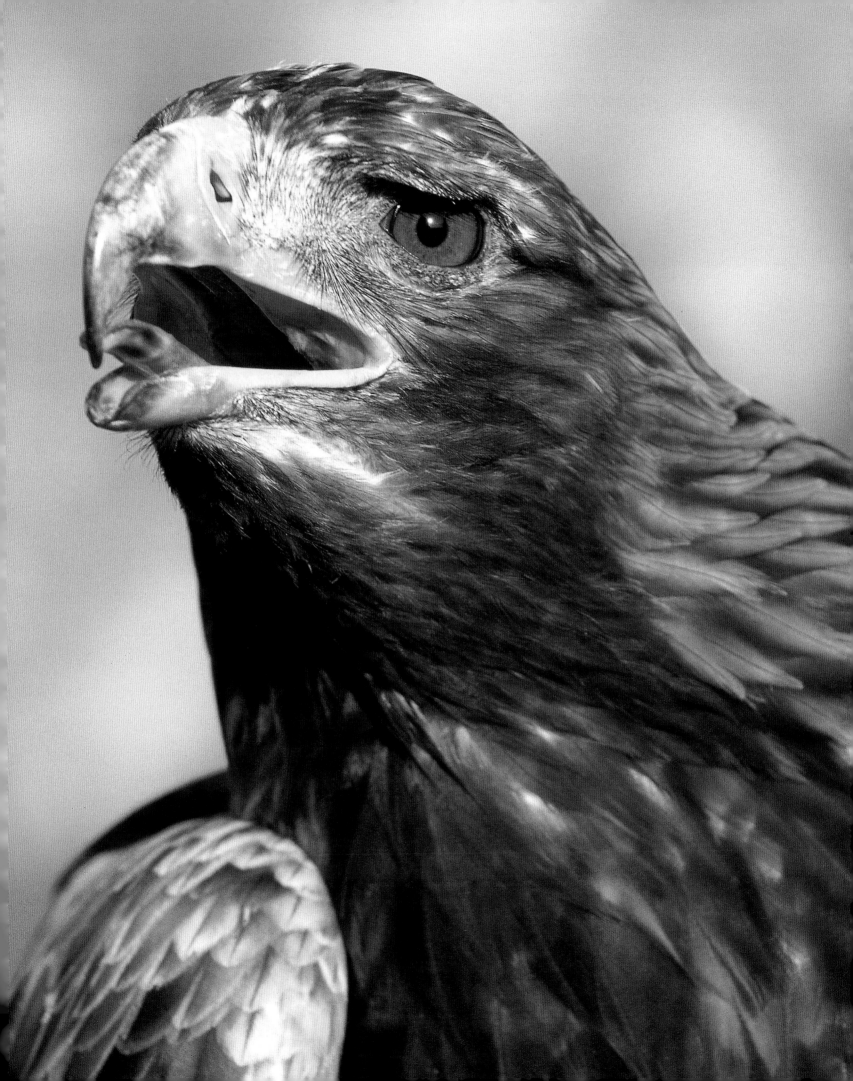

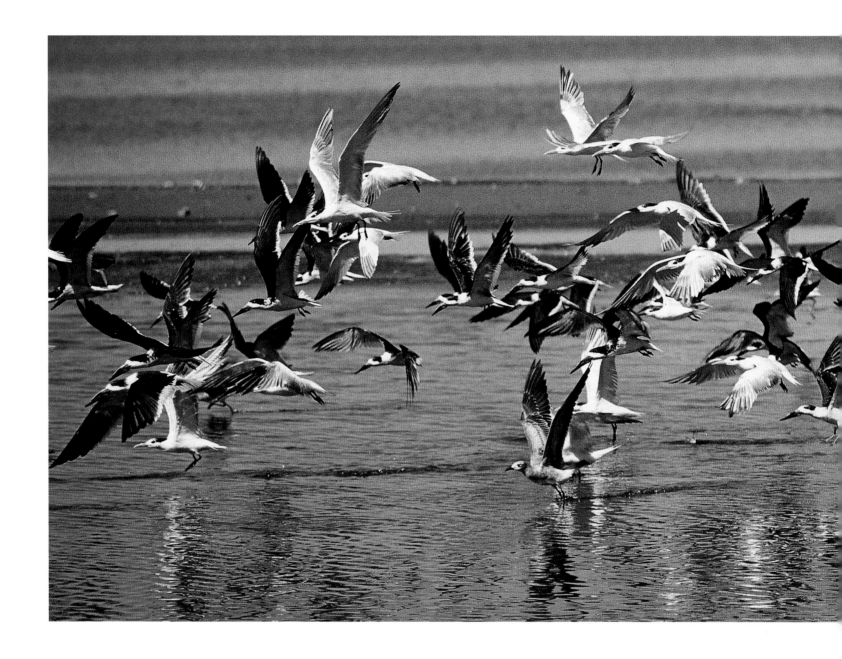

sumptuous black-and-white plumage, whereas the female is less obtrusive, being a uniform dark color that provides excellent camouflage. Eiders nest in colonies and line their nests with abundant down, which the female duck uses to cover the eggs when she leaves the nest unattended. If, however, she has to leave in a hurry, she defecates on her eggs, covering them with a thick, foul-smelling liquid that would deter the boldest predator. Thanks to some enterprising scientists, eiders in the St. Lawrence estuary, in Canada, have financed conservation measures for their own species since 1979, thanks to the sale of the precious down. When a well-hidden eider's nest is found, only 18 to 25 grams of down can be removed—in the mother duck's absence—in order not to reduce the nest's insulation. At least 100 nests must be visited to gather a little more than half a pound (1 kilogram) of saleable down. Not only that, but straw, parasites, and other undesirables need to be removed, so that at the end of the process only 20 percent of the amount originally gathered remains.

Above

Black skimmer

Rhynchops niger

Chacahua Lagoons, Mexico

Human activity can sometimes inadvertently benefit populations of seabirds. For example, they often follow in the wake of ships to feed on debris thrown overboard or on the small marine animals that become easy prey when wounded and pushed to the surface by propellers.

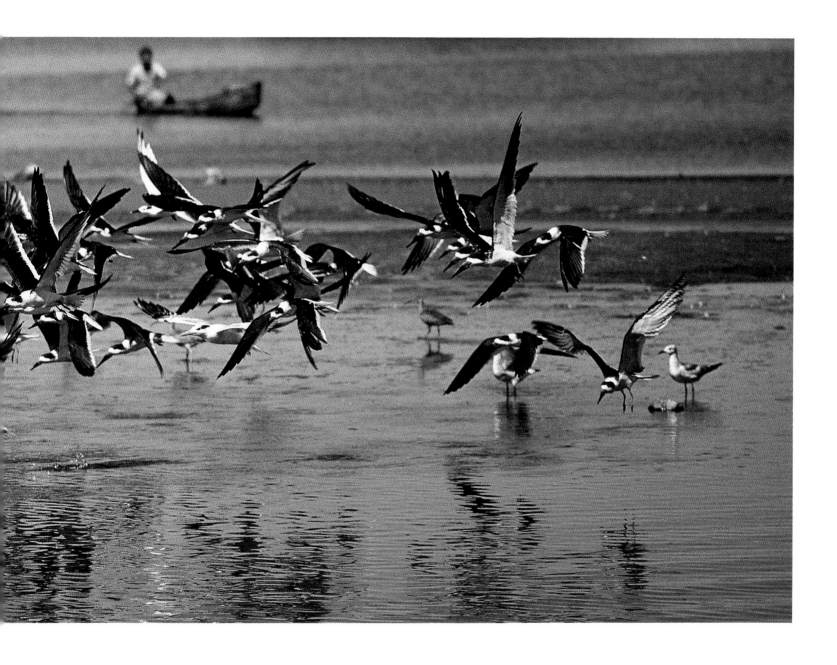

Pages 308 and 309

Papuan lorikeet

Charmosyna papou

Papua New Guinea

In times past, a thriving trade in the skins of brilliantly colored birds was plied between Mediterranean civilizations and the islands of New Guinea. The skins were covered in myrrh and dried leaves to preserve all their brilliance, giving rise to the myth of the phoenix rising from the ashes. In their native region, Papuan chiefs have always coveted the feathers of birds of paradise, wearing them for decoration.

Much less well known is the use of a unique, tiny feather found on the wing of the woodcock. Slender and stiff, this little plume is a vestigial eleventh primary feather. It is known as the painter's feather because it is the only means artists have to produce fine detail. It makes precise use so much easier that watch repairers use it to clean complex movements.

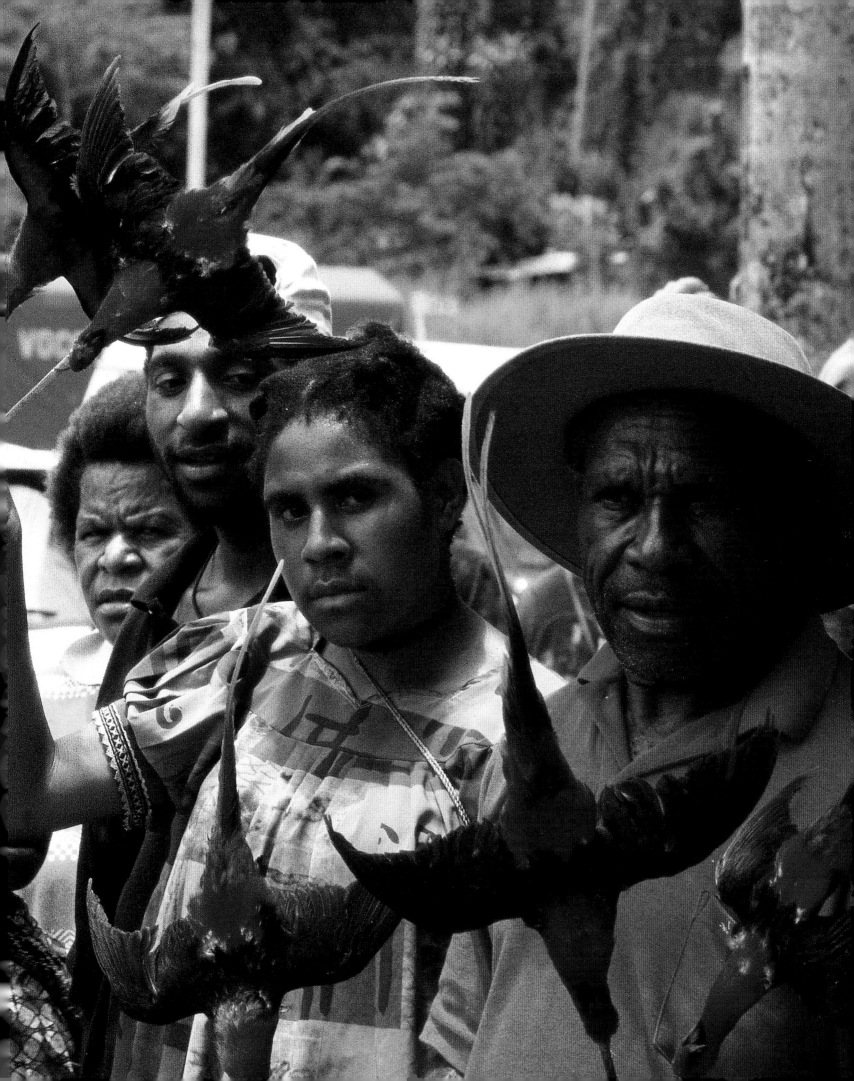

Mythical Birds, Great Civilizations

Many birds have a place, good or evil, in human pantheons, and their representations appear in all civilizations. The inhabitants of Mesopotamia had Anzû, an immense eagle with a sawlike bill, a treacherous servant of the king of gods who wanted to seize his power. Waiting on his master at his daily bath, Anzû decided to steal the insignia of his power, and take his booty to his mountaintop refuge. In consternation, the gods sent a hero to do battle with him. Armed with seven terrible winds, the hero succeeded in cutting off Anzû's wings and killing him, thus reestablishing order in the world. For the Egyptians, gods were always represented with a human body and animal head. Ra, the sun god, was incarnated in three different forms, depending on the time of day. When the sun was at its zenith, he had a falcon's head surmounted by the disk of the sun. Isis, the sorceress, transformed herself into a sparrowhawk to mate with her husband, Osiris, giving birth to Horus. This divine son, also depicted as a sparrowhawk, was protected by the ibis-headed god Thoth, possessor of all knowledge. Moon god and inventor of writing and of the sciences, Thoth replaced Ra in the night sky. He was a just and wise god, devoted to truth.

For the Greeks, heroes were demigods, with animal bodies and human heads. The sirens were bird-women who bewitched sailors with their irresistible singing. Athena, one of the most respected goddesses because she used intelligence in preference to brute force, was symbolized by an owl. Besides representing gods, birds also figure elsewhere in Greek mythology—often as malevolent beings, such as the eagle that ate Prometheus's liver every day as a punishment for giving humans the use of fire, and the iron-billed birds of the lake of Stymphalus, which ate human flesh.

Other mythologies give birds a less negative role. For Hindus, the holy bird Garuda gave humans civilization, which it carried on its wings. The Vikings, for whom death in battle was an honor, believed they were welcomed to the afterlife by Odin, king of the gods, who was kept constantly informed of events in the universe by two talking crows, Hugin ("Thought") and Munin ("Memory"). For Native American peoples, the eagle carried the Sun and the Moon up to the heavens so that they could light the world. They also give a dominant role to the thunderbird, a gigantic eagle that hides behind the clouds so that it is very difficult for humans to catch sight of it. When it flies, its wingbeats produce the sound of thunder, while its eyes give off such bolts of lightning that the earth is lit up. But the thunderbird is good for humans, whom it has saved from destruction many times, which is why its representation is often placed high up on totem poles. However, the mythology most faithful to reality is that of Central American peoples. The great civilizations of the Maya and the Aztecs believed that the gods had already created the world and destroyed it several times by means of volcanoes or deluges. Their best-known god is Quetzalcoatl, the plumed serpent—a link with the dawn of birds on our planet, when certain dinosaurs clothed themselves in a coat of feathers in order to conquer the air.

Traveling bird seller
Katmandu, Nepal

The rattan cages used in Asia to carry birds are so narrow that their occupants cannot move. To quench the birds' thirst, the sellers sometimes plunge their entire bundle into a puddle, where their hapless merchandise drinks through the bars.

Opposite

Brown noddy

Anous stolidus

Aride Island, Seychelles

Over the last fifty years, oil pollution has threatened seabirds with depressing regularity. While the thousands of metric tons of crude oil spilled into the sea condemn its inhabitants to a gruesome death, land birds suffer from other forms of pollution, which, though less glaring, are just as lethal.

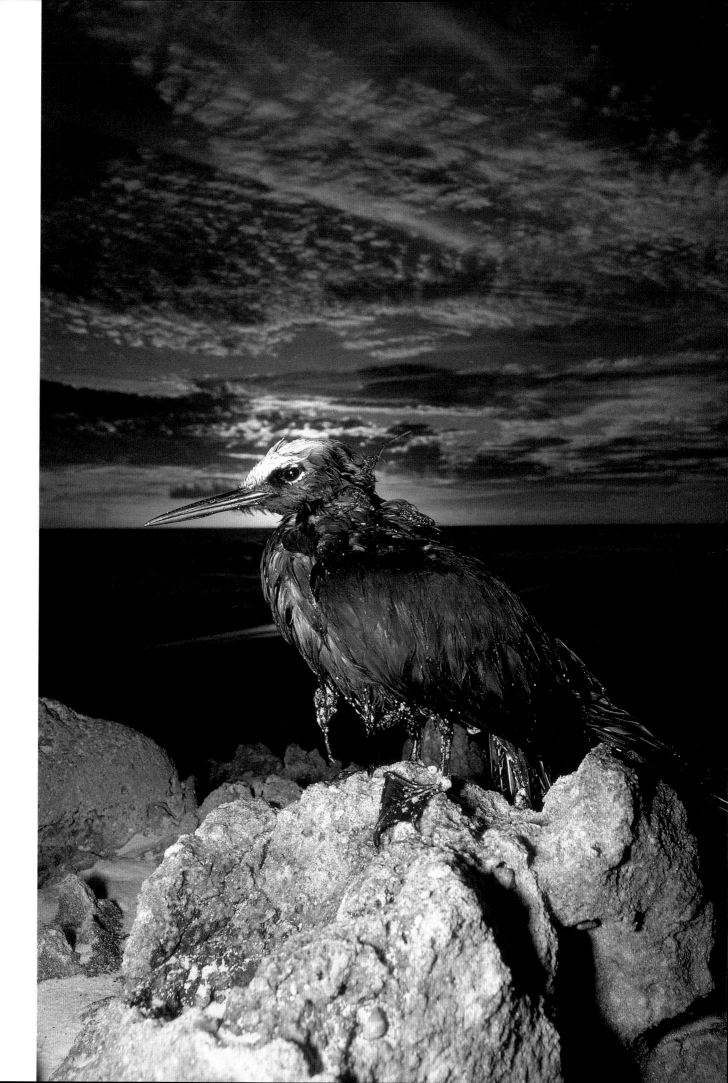

Acknowledgments

Gilles Martin would like to thank:

Dave Augeri
Bernard Bailly
Sandrine Boudas
Wilfried Boudas
Rémi Bruckert
Lindsay Chong Seng
Jacques Cuisin
Emmanuel Delfosse
Natalia Elcalamar
Frank Fouquet
Christophe Gottini
Philippe Huet
Yoshi Kasai
Guy Le Covec
Neil Lefaitest
Richard Lefarge
Stéphanie Lemonnier
Catherine Levesque
Jean-Louis Liegos
Guy Lionnet
Éric Male-Malherbe
Willy Mauboussin
Susan Pierce
Louis Richer
Marc Sauget
Yves Thonnerieux
Simon Thuriet
Michel Tranier
Tony Williams

Opposite

Wood nuthatch

Sitta europaea

Japan

This virtuoso climber can descend vertical tree trunks upside down. The nuthatch makes full use of their bark, extracting grubs or adult insects and wedging seeds and berries in the cracks so that it can peel them with ease.

Gilles Martin is especially grateful to Houria Arhab, Myriam Baran, Céline Moulard, Georges Plot, Richard Lippman, and Alain Florey for their invaluable collaboration, and Hervé de La Martinière for his commitment to this project.

Myriam Baran would like to thank: Dr. Rémi Bruckert of the Muséum d'histoire naturelle for his advice, and for being available; Mathias Schmidt for his help, Claudie Baran and Luc Marescot, who were kind enough to reread the word-processed manuscript; and Jean-Claude Baran for his superb skills as a field observer.

Bibliography

Alsop, Fred J. III. *Smithsonian Birds of North America* (New York: Dorling Kindersley, 2001).

Bird, David M. *The Bird Almanac: A Guide to Essential Facts and Figures of the World's Birds* (Richmond Hill, Ontario: Firefly Books, 2004).

Book of North American Birds (New York: Reader's Digest Association, 1990).

Burton, Robert. *How Birds Live* (London: Elsevier-Phaidon, 1975).

Chinery, Michael. *Predators and Prey* (New York: Crabtree, 2000).

Eibl-Eibesfeldt, Irenäus. *Ethology: The Biology of Behavior* (New York: Holt, Rinehart and Winston, 1975).

Gamlin, Linda, and Gail Vines, eds. *The Evolution of Life* (Oxford: Oxford University Press, 1990).

Löfgren, Lars Eric. *Ocean Birds* (New York: Random House, 1986).

McFarland, David, ed. *The Oxford Companion to Animal Behaviour* (Oxford: Oxford University Press, 1987).

Morris, Desmond. *World of Animals* (New York: Viking, 1993).

National Audubon Society: The Sibley Guide to Bird Life and Behavior (New York: Knopf, 2001).

National Audubon Society: The Sibley Guide to Birds (New York: Knopf, 2001).

National Audubon Society Field Guide to North American Birds (New York: Knopf, 1994).

Strange Worlds, Fantastic Places (New York: Reader's Digest Association, 2001).

Turner, C. Donnell. *General Endocrinology* (Philadelphia: Saunders, 1971).

Recommended Websites

American Bird Conservancy
www.abcbirds.org

American Birding Association
www.americanbirding.org

Bird Studies Canada
www.bsc-eoc.org

Birding Hotspots Around the World
www.camacdonald.com/birding

Birding In Canada
www.web-nat.com/bic

Birdzilla.com
www.birdzilla.com

Canadian Peregrine Foundation
www.peregrine-foundation.ca

Canadian Wildlife Service
www.cws-scf.ec.gc.ca

Cornell Lab of Ornithology
http://birds.cornell.edu

National Audubon Society
www.audubon.org

Nature Canada
www.cnf.ca

U.S. Fish and Wildlife Service
www.fws.gov

Opposite

Red crowned crane

Grus japonensis

Hokkaido, Japan

Man destroys many things, but some things he saves. In the 1920s, only twenty of these sacred cranes remained in Japan. A preserve was created to save the magnificent wader, a symbol of fidelity and eternity. Today, thanks to that effort, you can once again marvel at these black-and-white feathered creatures and their moving love dances.

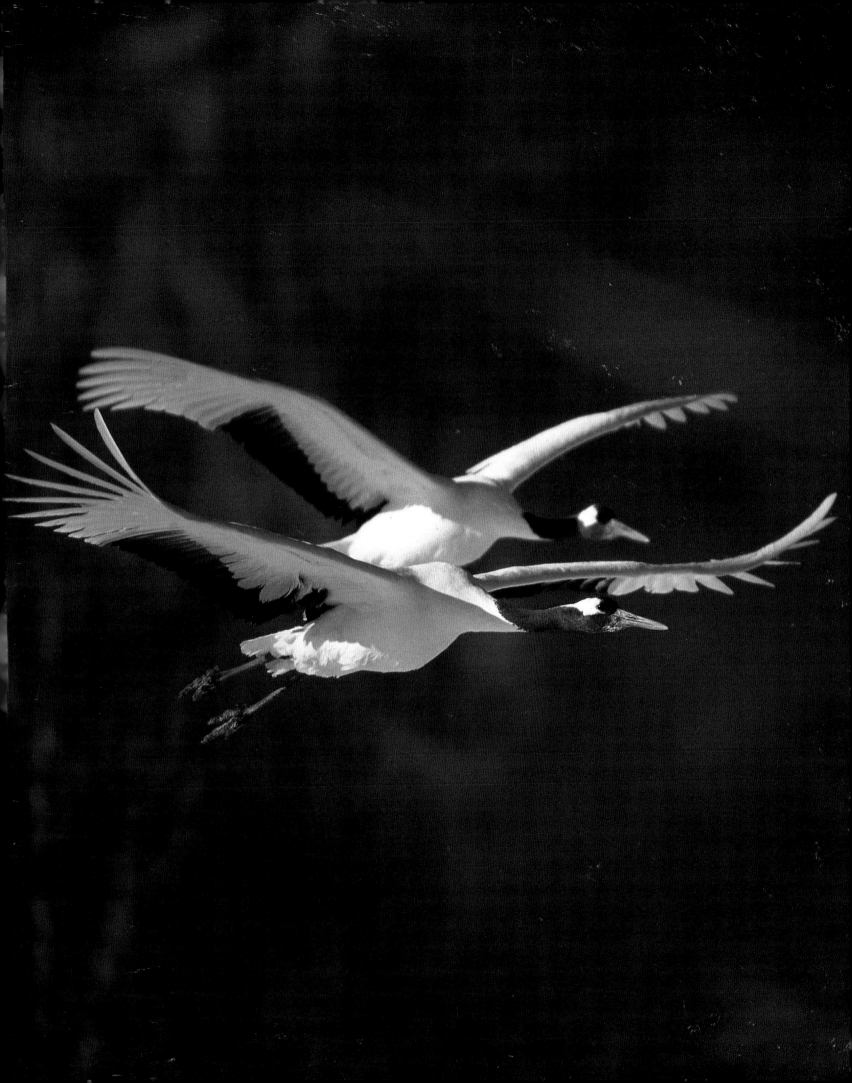

Project Manager, English-language edition: Susan Richmond
Editor, English-language edition: Virginia Beck
Jacket design, English-language edition: Michael J. Walsh Jr and Shawn Dahl
Design Coordinator, English-language edition: Makiko Ushiba
Production Coordinator, English-language edition: Norman Watkins

Library of Congress Cataloging-in-Publication Data
Martin, Gilles, 1956-
 [Oiseaux du monde. English]
 Birds of the world / photographs by Gilles Martin ; text by Myriam Baran ; translated from
the French by Simon Jones.
 p. cm.
 ISBN 0-8109-5889-9 (hardcover)
 1. Birds--Pictorial works. I. Baran, Myriam. II. Title.

 QL674.M295 2005
 598--dc22

 2004024409

Printed and bound in Italy
10 9 8 7 6 5 4 3 2 1

Harry N. Abrams, Inc.
100 Fifth Avenue
New York, N.Y. 10011
www.abramsbooks.com

Abrams is a subsidiary of

LA MARTINIÈRE
 GROUPE